Mao's New World

Mao's New World

Political Culture in the Early People's Republic

Chang-tai Hung

Cornell University Press
Ithaca and London

Publication of this book was made possible in part by a grant
from the Lee Hysan Foundation.

First published 2011 by Cornell University Press

Design and composition by BW&A Books, Inc.
Printed in the United States of America

Library of Congress Cataloging-in-Publication Data
Hung, Chang-tai, 1949–
 Mao's new world : political culture in the early People's
Republic / Chang-tai Hung.
 p. cm.
 Includes bibliographical references and index.
 ISBN 978-0-8014-4934-5 (cloth : alk. paper)
 1. Political culture—China—History—20th century.
 2. Communism and culture—China—History—20th century.
 3. Arts—Political aspects—China—History—20th century.
 4. Symbolism in politics—China—History—20th century.
 5. China—Politics and government—1949–1976.
 6. China—Cultural policy. I. Title.
 DS777.56H86 2011
 306.20951'09045—dc22 2010022629

Cornell University Press strives to use environmentally
responsible suppliers and materials to the fullest extent
possible in the publishing of its books. Such materials include
vegetable-based, low-VOC inks and acid-free papers that
are recycled, totally chlorine-free, or partly composed of
nonwood fibers. For further information, visit our website
at www.cornellpress.cornell.edu.

Cloth printing 10 9 8 7 6 5 4 3 2 1

For Wai-han, Ming-mei, and Ming-yang

Contents

Illustrations

Acknowledgments

Research for this book began in the mid-1990s. A project that takes many years to complete owes much to the advice and encouragement of friends, colleagues, scholars, and family members. I am particularly indebted to Dong Xiaoping who offered wise counsel, trenchant comments, and unfailing assistance in obtaining references and contacting people.

I also benefited enormously from the intellectual inspiration and moral support of many senior scholars. Two people meriting special mention are Bo Songnian, a wise and modest scholar who shared with me his profound knowledge of Chinese folk traditions and contemporary art scenes, and Dong Xijiu, an authority on Chinese dance and a dancer herself who graciously and patiently illuminated the importance of performing arts as a unique window to understanding China's political culture. I am also indebted to Li Zhun and Lin Zhu for their unstinting support and good advice.

My friends and colleagues R. David Arkush, Chen Yung-fa, Fung Yiu-ming, and William Tay generously shared with me the fruits of their research. For that special combination of helpful counsel and good cheer, I thank Chak Chi-shing, Chang Hao, Samuel Hung-nin Cheung, Chong Kim-chong, Chu Hung-lam, Karl Kao, Louie Kin-sheun, Steven Kwok-sun Luk, Shen Zhihua, and Ting Pang-hsin. Several excellent graduate students, especially Poon Shuk-wah and Hui Kwok-wai, helped me assemble essential newspaper materials.

I am profoundly indebted to many city planners, architects, artists, and museologists for granting interviews over the past fifteen years, sometimes more than once. Many of them were key participants in the building of the young People's Republic in the 1950s. Their recollections provided a unique perspective on the debates, politics, and emotions behind the cultural and political construction of a new nation. All the named interviewees are gratefully acknowledged in the notes, and here I extend my deep appreciation to those who wished to remain anonymous.

My work also benefited from the resources of many archives and libraries and their staff. I am particularly indebted to the Beijing Municipal Archives, the Shanghai Municipal Archives, and, in Taiwan, the Academia Historica and the Nationalist Party Archives. Closer to home, I have relied on the expert and

efficient assistance of the staff at the library of the Hong Kong University of Science and Technology.

Field research and the publication of this book have been aided by grants from the Research Grants Council of Hong Kong, the Lee Hysan Foundation, and the School of Humanities and Social Science at the Hong Kong University of Science and Technology.

Rita Bernhard has closely read every chapter of the book and offered valuable suggestions on stylistic improvement. At Cornell University Press, Roger Haydon deserves special thanks for showing initial enthusiasm for this manuscript and then wisely guiding it to fruition. Ange Romeo-Hall steered me through the publication process with patience and meticulous care. Katy Meigs copyedited the manuscript with skill and attention to detail.

Finally, on a personal note, I thank my daughter Ming-mei and my son Mingyang. They grew up alongside this book and patiently endured their father's lengthy preoccupation with this project. They are my source of joy and inspiration. Above all, I thank my wife Wai-han Mak. She has sustained me with love and care over these many years and has consistently served as the manuscript's first reader, best critic, and warmest supporter. I dedicate this book to her and to our two children.

Several chapters of this book are revised versions of previously published journal articles, and I thank the following publishers for their permission to reprint them here: (1) "Repainting China: New Year Prints (*Nianhua*) and Peasant Resistance in the Early Years of the People's Republic," *Comparative Studies in Society and History* 42, no. 4 (October 2000): 770–810; (2) "Revolutionary History in Stone: The Making of a Chinese National Monument," *China Quarterly*, no. 166 (June 2001): 457–73; (3) "The Dance of Revolution: *Yangge* in Beijing in the Early 1950s," *China Quarterly*, no. 181 (March 2005): 82–99; (4) "The Red Line: Creating a Museum of the Chinese Revolution," *China Quarterly*, no. 184 (December 2005): 914–33; (5) "Mao's Parades: State Spectacles in China in the 1950s," *China Quarterly*, no. 190 (June 2007): 411–31; (6) "Oil Paintings and Politics: Weaving a Heroic Tale of the Chinese Communist Revolution," *Comparative Studies in Society and History* 49, no. 4 (October 2007): 783–814; and (7) "The Cult of the Red Martyr: Politics of Commemoration in China," *Journal of Contemporary History* 43, no. 2 (April 2008): 279–304 (© Sage Publications Ltd).

Note on Romanization

The book uses the pinyin system of transliteration. Exceptions, however, are the names of well-known persons, for example, Sun Yat-sen and Chiang Kai-shek, for which established spellings have long been familiar in the West.

Abbreviations

BCCA	Beijingshi chengshi jianshe dang'anguan (Beijing City Construction Archives)
BJWSZL	*Beijing wenshi ziliao* (Historical materials on Beijing)
BMA	Beijingshi dang'anguan (Beijing Municipal Archives)
FEBA	Zhonghua renmin gongheguo Guowuyuan waiguo zhuanjiaju dang'anshi (Foreign Expert Bureau Archives, the State Council, the People's Republic of China)
GMBWG	*Geming bowuguan gongzuo yanjiu* (Journal of the Museum of the Chinese Revolution)
GMRB	*Guangming ribao* (Enlightenment daily)
JBRB	*Jinbu ribao* (Progressive daily)
JFRBS	*Jiefang ribao* (Liberation daily) (Shanghai)
JFRBY	*Jiefang ribao* (Liberation daily) (Yan'an)
JZSJ	*Jianzhu sheji* (Architectural design)
JZXB	*Jianzhu xuebao* (Architectural journal)
MAEA	Zhonghua renmin gongheguo Jianzhu gongchengbu dang'anshi (Ministry of Architectural Engineering Archives, the People's Republic of China)
MS	*Meishu* (Art)
MSYJ	*Meishu yanjiu* (Art research)
NBCK	*Neibu cankao* (Internal references)
RMHB	*Renmin huabao* (China pictorials)
RMMS	*Renmin meishu* (People's art)
RMRB	*Renmin ribao* (People's daily)
SB	*Shenbao* (Shanghai daily)
SMA	Shanghaishi dang'anguan (Shanghai Municipal Archives)
WW	*Wenwu* (Cultural relics)
WWCKZL	*Wenwu cankao ziliao* (Research materials on cultural relics)
XGC	*Xin guancha* (New observer)
YHB	*Yuehua bao* (Guangzhou post)
ZGDS	*Zhonggong dangshi ziliao* (Materials on the history of the Chinese Communist Party)

Introduction

*Fellow delegates, we are all convinced that our work will go down
in the history of mankind, demonstrating that the Chinese people,
comprising one quarter of humanity, have now stood up. The
Chinese have always been a great, courageous and industrious
nation; it is only in modern times that they have fallen behind.
And that was due entirely to oppression and exploitation by foreign
imperialism and domestic reactionary governments. . . . We have
closed our ranks and defeated both domestic and foreign oppressors
through the People's War of Liberation and the great people's
revolution, and now we are proclaiming the founding of the People's
Republic of China.*

—Mao Zedong, "The Chinese People Have Stood Up!" speech
given at the Chinese People's Political Consultative Conference,
September 21, 1949

When Chairman Mao Zedong (1893–1976) declared at the Chinese People's Po-
litical Consultative Conference (CPPCC), on September 21, 1949, in Beiping
(Beijing), that the "Chinese people have stood up!" (*Zhongguo renmin zhan qilai
le*),[1] this master propagandist was not merely announcing the founding of the
People's Republic of China (PRC), which was to occur officially on October 1, in
Tiananmen Square (Tiananmen guangchang). His words also carried powerful
symbolic meaning, signaling that a nation had been created anew, had broken
from its humiliating past, and had eliminated, once and for all, the imperialist
domination it had suffered since the late Qing dynasty. The words "stood up"
(*zhan qilai le*) announced the end of China's painful modern history, with its
successive plagues of political instability, its incessant wars, and its long course
of social dislocation, economic backwardness, widespread human suffering,
and, worse still, foreign aggression. Finally, China had achieved its long-desired
peace and unity, and it appeared that a new era had dawned at last.

Key words, Raymond Williams has argued, reflect the nature of society in that

they are essential to the understanding of social realities and political change.[2] But for Mao and his senior colleagues, language, especially the language of revolution, namely, fiery slogans, patriotic songs, and political idioms, including the phrase "stood up," were a motivating drive and a potent tool with which to communicate and persuade. Because of their visceral appeal, rousing slogans and speeches were easier for the general public to grasp than arcane Marxist phrases. These slogans, often invested with deep passion, were meant to sanction the Party's actions and articulate its goals.

Of course, Mao and his associates were not the first Communist leaders to recognize the power of words. Earlier, the Bolsheviks, to disseminate their political messages, had utilized a rich array of terms, including "revolution" (*revoliutsiia*), "uprising" (*vosstanie*), and "the people" (*narod*).[3] But the Chinese Communists proved to be even more seasoned and adept in this use of political language. Since the Yan'an era (1936–47), if not earlier, various stirring words and slogans, such as "liberation" (*jiefang*), "turning over" (*fanshen*), and "uprising" (*qiyi*), had become an integral part of the Chinese Communist Party's (CCP) revolutionary vocabulary.[4] These words brought a sense of camaraderie to its members. But political language could also be used, with equal vehemence, to define and demonize the "enemies of the revolution," pitting the good against the reviled. Foes of the revolution, in Mao's view, lurked in every dark corner and sinned in broad daylight, and he denounced them as "the running dogs of imperialism" (*diguozhuyi de zougou*), "antirevolutionaries" (*fan geming fenzi*), "spies" (*tewu*), and "local despots" (*eba*).[5] Atop Mao's list of evil forces and running dogs of imperialism was the Nationalist leader Chiang Kai-shek (1887–1975).[6]

The manipulation of political language, as I argue in this book, constituted one of the many forms of a new political culture that the Chinese Communists created in the early years of the PRC to give meaning to their revolution. I propose that we view the Chinese Communist Revolution not merely as a radical change of modern China's political, economic, and social systems but, more important, as the rise and dissemination of a new political culture dictated by the ruling Party for political reasons. The creation of a series of novel political-cultural forms fulfilled the pressing need of the CCP soon after taking power to consolidate its hold in China, justify its legitimacy, and instill a new socialist culture in the nation. To be sure, Mao and senior Party leaders believed that the struggle with their enemies could not merely be a military engagement or social conflict but rather was fundamentally a battle for the correct ideologies and ultimate transformation of Chinese culture. The reasons for this approach to consolidate the CCP's power may be found in the conditions the Party faced when it first established control of China in October 1949.

Historical Setting

The CCP, in October 1949, faced the daunting problem of a divided society, a collapsed economy, a disillusioned population, and a largely hostile world. Its legitimacy to rule was precarious at best, and the Party was barely prepared to take over a demoralized country that seemed to be spinning out of control. Earlier, during the civil war (1946–49), in fact, the astonishing rapidity of the successful military campaigns against the Nationalists caught the Communist leadership by surprise. Revolutionary optimism notwithstanding, Mao and his senior leaders were under no illusion that the prospect of governing a devastated land was going to be easy. Important decisions had to be made immediately to meet the new challenges. In an important conference held in March 1949, the Central Committee of the CCP decided that the "center of gravity of the Party's work has shifted from the village to the city."[7] This major policy change actually occurred earlier, during the Seventh Party Congress in Yan'an in April 1945, when Mao called on the delegates to "transfer [their] major effort [from rural] to urban, and be prepared to seize major cities," which would have included Beiping and Tianjin.[8]

But the Communists had little experience in governing China's urban centers. Mao warned, in 1949, that administering cities in the future would be a formidable task for the formerly rural-based Communists. "[We probably] would find that going to battle is much easier than administering a city," he cautioned.[9] The rapid collapse of the Nationalist regime also meant the sudden disintegration of a legitimate, though ineffective, administration and the ability to maintain daily operations. Thus the severe shortage of trusted cadres to preserve basic law and order was a major concern for the Party high command. In their earlier conquest of Manchuria in 1947, as Steven Levine has pointed out, the Communists had to transfer thousands of loyal comrades to the newly acquired region to exercise basic control.[10] This crisis became even more acute in 1949, as victory drew near. In their takeover of Hangzhou in May 1949, for instance, the Party again had to rush a large number of recently trained Shandong cadres to the southern city to oversee orderly administration.[11]

To ensure a smooth takeover and quickly restore people's confidence, the CCP shrewdly downplayed class struggle and confrontation in most public pronouncements, opting instead to present a united front under the then declared principle of "the people's democratic dictatorship." This approach, according to Mao, was "based on the alliance of the working class, the peasantry and the urban petty bourgeoisie, and mainly on the alliance of the workers and the peasants."[12] By 1953, the period of gradual socialist transformation had shifted to a more Stalinist model of social and economic development favoring rapid industrialization. In the next few years, operations seemed to be progressing according to plan, and by 1957 the Communist leaders had achieved remarkable results: Rural reform resulted in the redistribution of land; the industry was

nationalized; the Three Antis and Five Antis campaigns were launched in the cities in the early 1950s, and each, respectively, had reorganized the party bureaucracy and attacked the bourgeoisie's unlawful business practices; a new constitution was proclaimed in 1954; China's international standing was growing, the result of China having brought the world's greatest power to a standstill in the Korean War, and its later participation in the Bandung Conference in 1955 further enhanced its reputation; and the First Five-Year Plan (1953–57), based on the Soviet model, was a considerable success. The early years of the PRC were thus regarded by historians as a golden age of consolidation, construction, growth, and stability.

True, during this phase of regime consolidation of the young PRC, troubles were not uncommon: a leadership crisis precipitated by the Gao Gang (1905–54) and Rao Shushi (1903–75) affair in 1954 and the nationwide anti–Hu Feng campaign in 1955 are two examples. Recent scholarship based on newly opened archives also paints a much more cynical picture of the Communists' grip on power, especially its coercive land reform in the countryside and the brutal Campaign to Suppress Counterrevolutionaries in the early 1950s, which resulted in the killing of as many as seven hundred thousand people.[13] The Hundred Flowers Campaign, mounted by the CCP between 1956 and 1957, saw the Party granting greater freedom of expression to intellectuals and artists. But when the increased freedom gave rise to a series of sharp criticisms of the government, the Party reversed its policy and, in mid-1957, initiated the Anti-Rightist Campaign, which eventually led to the political persecution of more than half a million intellectuals, artists, and skilled people. But the view that the regime had achieved a considerable degree of success by 1957, especially political stability, remains indisputable. These astonishing achievements prompted a confident Mao to launch his ambitious Great Leap Forward in 1958, soon to have cataclysmic results. But what accounted for the Communists' successes?

Early scholarship on the history of the young PRC generally focused on the Party's political consolidation. Two notable examples are Ezra Vogel's study of the Communists' strengthening of political organizations in the southern city of Guangzhou,[14] and Kenneth Lieberthal's monograph on the CCP's control of key economic enterprises and the initiation of mass mobilization programs in Tianjin, a major city in the north.[15] But the Chinese Communist experiment in establishing a new society after 1949 went beyond a political or organizational restructuring to encompass an extensive transformation of China's cultural landscape. Mao and the Party leaders realized that to win the support of the people, they had to convert a military conquest into a nationwide cultural renewal. Few works, however, have paid sufficient attention to this key aspect of change.

In recent decades scholars have drawn on previously untapped historical sources and new theories of art and literature to address broader cultural and

literary issues that arose in the 1950s. The new directions in research include studies of popular drama, political theater, and peasant operas,[16] and the language of Chinese politics,[17] as well as official art policies, the frustrated life of artists under the tightening Party rule,[18] Chinese cinema,[19] conflicts between Western music and the Maoist revolution,[20] and the Party's control over writers and intellectuals.[21] Lately scholars are also exploring other new terrains that include reform of local operas for political purposes following the Communists' seizure of the city of Hangzhou in 1949,[22] and the reform of traditional *xiangsheng* (comedians' routines)—a popular performance art—to turn it into a tool of socialist education in the early People's Republic.[23] Innovative as these new researches are, a more comprehensive treatment of the Communists' transformation of culture remains to be done; nor do these works scrutinize how the Party systematically utilized culture as a propaganda tool. Rarely explored are the complicated processes of manufacturing, disseminating, encountering, receiving, and appropriating the government's cultural forms, including the creation of a language of revolution, as in Chairman Mao' use of the phrase "stood up." Using an interdisciplinary approach that combines historical inquiry with cultural and anthropological analyses of symbols, rituals, and pictorial representations, this book analyzes how the CCP introduced a new political culture into the young PRC that transformed the nation into a propaganda state with the aim of consolidating the Party's power. The CCP accomplished this by constructing monumental public buildings with patriotic and cultural themes, as well as mounting spectacular celebratory parades and disseminating propaganda through oil paintings, *nianhua* (New Year prints), and a revised history of the CCP's exploits. The book proposes a more panoramic approach to the examination of power in motion: the formulation, propagation, and manifestations of a new host of government-initiated political-cultural forms and their impact on the public. These official forms were either newly created or reinvented, with added contemporary features, but they were based on pre-1949 models, especially those of the Yan'an era, to highlight and advance the CCP's political goals.

Political Culture

The term "political culture," first coined by American political scientists in the 1950s, is a nebulous concept that cannot easily be defined.[24] The term is used here not to mean formal politics and institutions but shared values, collective visions, common attitudes, and public expectations created by high politics. These shared views underscore the primacy of politics in shaping everyday life and are expressed through symbols, rituals, rhetoric, and visual images. Political leaders use them to advance their goals, shape public opinion, and keep opposing forces in check. But although these collective values are initiated by the ruling elites, the process is never unilaterally imposed from above, as the leaders

must constantly adjust their strategies in response to the reactions, sometimes resistance, from below. The process, therefore, is a negotiated one, forever in flux, although in the end the leaders always have the upper hand. This book emphasizes the role of propaganda and manipulation in China's political culture, as political values in the PRC were instilled among the populace through a system of indoctrination and control.

Traditional Marxists hold that cultures are shaped by social classes that are determined primarily by socioeconomic conditions and the relation to economic production. Such an observation has long been rejected by critics as needlessly reductive and overly schematic. Scholars of the French Revolution, most notably François Furet, Mona Ozouf, and Lynn Hunt, have taken a different approach.[25] Rejecting what he calls Marxist "revolutionary catechism" of bourgeois takeover, Furet, following Rousseau, reemphasized the importance of politics, not economic forces, in fashioning people's values and ways of thinking during the French Revolution. He argued that politics was at the foundation of social life, acting as a principal driving force for social actions.[26] As demonstrated in the works of Maurice Agulhon and Lynn Hunt, this perspective became even more apparent when politics—in the forms of the tricolor cockade, the liberty tree, and festivals—was used to recreate values and citizenship in the French Revolution.[27]

Furet's and Agulhon's studies of the French Revolution are part of a growing trend in the study of political culture that was informed by theories of anthropology, sociology, and art (iconography, in particular), and opened new avenues of historical research and analysis. This cross-disciplinary approach yielded provocative results when scholars investigated the traditional monarchies of France, Russia, England, and Spain,[28] as well as modern political regimes in Germany, the Soviet Union, and Italy.[29] Notwithstanding their different approaches and the diversity of the political systems they studied, some similarities may be discerned in these scholars' examination of political culture.

The first common thread is the view of polities as an ordered and coherent activity, with a hierarchical structure ruled by a central authority. Clifford Geertz called this a form of "master fictions," governed by a clear political center and aided by "a collection of stories, ceremonies, [and] insignia."[30] In modern Communist systems, the Party assumed the central role, and the political order the Party espoused was largely manifested through the recreation and repetition of the ruling regime's master narrative, for instance, the Bolsheviks' interpretation of history on their own terms. Their military might and repressive control enabled the Bolsheviks to rewrite national history, highlighting only certain historical events and even inventing traditions to chart their own unshakeable road to power.[31]

The second similarity in these interdisciplinary studies is their emphasis on political symbolism. Inspired by certain principles of anthropology, sociology, and art, historians began to study politics not in terms of formal institutions

but rather as a network of cultural and symbolic interactions and negotiations. Political symbols comprise both linguistic (slogans, speeches) and nonlinguistic (rituals, myths) forms. By exploring slogans, state rituals, ceremonies, and pageantry, historians investigate the multiple channels through which political symbols may influence society. The ubiquitous emblem of hammer and sickle, for instance, represents the union of workers and peasants in Communist states, highlighting the distinction between the new regime and the one recently overthrown by the Communists.

The third common feature in these scholarly works is their close attention to visual images, especially the regime's use of pictorials to manipulate public opinion. The trend toward greater reliance on visual images to understand complex cultural phenomena, which W. J. T. Mitchell labeled "pictorial turn," encourages a fruitful dialogue between history and art.[32] In politics, the official choice of a visual image—pictures, iconography, clothing, gestures—is often politically motivated. Like decrees and documents, official pictorials can be read as statements about the government or the leaders' visions. The iconography of the leaders, as it appears in paintings, cartoons, woodcuts, and posters, provides important insights into political intrigue.

Building on the conceptual frameworks developed in these pioneering works, the following chapters examine the rise of new political-cultural forms fashioned by the CCP and implemented with its ever-tightening rule to reshape Chinese society according to its images in the first decade of the PRC. It will be seen that the Party defined its own identity and affirmed its legitimacy to rule through the spatial, linguistic, visual, and symbolic manifestations of state-sponsored political culture.

Politics is examined here in a broader sense, reaching beyond formal institutions, organizations, procedures, and decisions, or who governs and how they govern. Rather, politics is examined as policies drawn up, implemented, and disseminated by the authorities to reach the public through political symbols—parades, museums, and New Year prints—in action. This is therefore a study of power as a form of social relations between the CCP and the populace, and of the evolution of these political-cultural forms over time as they responded to changing political realities in the 1950s. A major ingredient here is the Party's mass mobilization plans. Based on the Leninist concept of tight party organization and the monopoly of media and other cultural activities, the CCP mounted successive mass campaigns, such as the nationwide Resist America, Aid Korea Campaign in the early 1950s, to socialize and reeducate the public. These cultural forms did not simply respond to political and societal changes. Monitored and controlled by the Party and government agencies, especially the Propaganda Department (Zhonggong zhongyang xuanchuanbu, commonly known as Zhongxuanbu) of the Party's Central Committee and the Ministry of Culture, they were produced to actively promote a sanguine future, motivating the masses to follow steadfastly along the Party line. But the state policy encountered a problem:

audiences sometimes read, debated, and negotiated the imposed ideologies differently from the ways that the authorities intended, with unpredictable, often undesirable, results.

The Scope of the Book

Part 1: Space

The first part of this book (chapters 1 and 2) discusses the significance of political space in the new capital Beijing: the expansion of Tiananmen Square—the creation of a novel sacred center—in the early days of the PRC and the construction of ten monumental buildings in the late 1950s.

Interest in Tiananmen Square and Beijing's major political buildings in the early PRC has recently grown among Western scholars. A notable example of this interest is Wu Hung's book *Remaking Beijing: Tiananmen Square and the Creation of a Political Space*.[33] Wu's book, however, is written from the perspective of art history, with an emphasis on aestheticism, symbolism, and monumentality. No scholarly work, as far as I know, has actually delved into the political debates concerning the building of Tiananmen Square and other key structures. My goal here is to fill this void by adopting a historical-cultural, institutional, and comparative approach. Based on untapped archival sources and interviews with surviving participants, all key players in these construction projects, I examine the factional debates, institutional manipulation, and foreign influence (especially that of the Soviet Union) surrounding the cultural constructions of the new capital.

When Beiping, the old Guomindang-controlled city, reverted back to Beijing, its name prior to 1928, and became socialist China's new capital on October 1, 1949, this ancient, fabled city gained instant symbolic prominence. To cast itself anew, Mao and his senior associates realized that China must be recreated not only ideologically but also spatially. As such, the design of a fresh socialist capital became of utmost importance. The first step in the reconstruction of Beijing was the expansion of Tiananmen Square, a previously enclosed space south of Tiananmen Gate, the main gate to the Forbidden City, the former imperial palace. Starting in 1949, the expansion of the square took several phases, done largely by a concerted effort of Beijing Municipal Party officials, Soviet advisers, architects, and urban planners, with the central CCP machine monitoring their every move. By the time the expansion was largely completed in 1959, to celebrate the tenth anniversary of the founding of the People's Republic, the square was enlarged to 44 hectares, one of the largest political squares in the world.

Inspired by Red Square, which many Communist leaders admired and had witnessed during their earlier trips to the Soviet Union,[34] the senior Party leaders early on viewed the construction of a vast space in the capital as a golden opportunity to project the nation's much-needed identity at a critical juncture of Party consolidation. In her study of the role of landscape and architecture in the

French Revolution, Mona Ozouf argues that because verticality suggested hier-archy, the revolutionary planners chose open, horizontal, outdoor space to rep-resent an open society. "In the open, in the healthy neutrality of a free space, all distinctions seemed to fall away," writes Ozouf.[35] However, Tiananmen Square was conceptualized differently from the start. The Chinese city planners, ar-chitects, and Soviet advisers, who arrived in China at the time, first debated about the future shape of the city center. But the final decision rested with the central CCP leadership. The end result was a mammoth, closely monitored square where massive political gatherings could be held and, more important, national parades, notably the National Day and the May Day celebrations, could be staged annually. The enlarged square also surpassed its rival, Red Square, in size and significance.

The expansion of Tiananmen Square was merely the first major realization of the state's spatial politics. The second project was the construction of the ten huge buildings—commonly known as the Ten Monumental Buildings (Shida jianzhu)—in the capital in the 1950s. The construction of these buildings began in 1958 and was completed a year later, at unprecedented speed and on an im-mense scale; they include the Great Hall of the People and the Museums of the Chinese Revolution and of Chinese History, flanking Tiananmen Square, re-spectively, at its western and eastern edges. They were symbolically located to reaffirm the regime's supremacy.

The Ten Monumental Buildings were intended as a triumphant statement—a celebration of the magnificent achievements of the new regime in its first ten years. These tall structures were visible and tangible confirmation of China's coming out celebrations. For Mao and the senior leaders, the construction plan would show that China was no longer a backward nation but an emerging gi-ant on the world scene. The construction of massive buildings and the expan-sion of Tiananmen Square in the capital, completed during the frenetic days of the Great Leap Forward, were aimed at equaling or surpassing the Soviet coun-terparts in architectural achievements, and thus moving toward becoming the center of the Communist universe.

One of the world's largest open squares, Tiananmen Square was often re-ferred to in China as "the People's Square" (Renmin guangchang).[36] However, the square never belonged to the populace, nor was it open to the public in the sense that it was free and without control. The state-initiated massive gatherings in the square, often infused with nationalistic passion, were staged according to official scripts in strictly monitored and specified settings.

Part 2: Celebrations

The second part of the book (chapters 3 and 4) centers on celebrations. These chapters focus on political dances (in particular, *yangge*) and national parades—the two popular festivities that constituted another key component of the CCP's new political culture. The new version of yangge (literally, "rice-sprout

song")—originally a popular rural dance in North China—was performed regularly in the early years of the PRC to announce the arrival of a new regime. Parades were staged annually on May Day (May 1) and the National Day (October 1) in Beijing and other major cities in the 1950s and 1960s to celebrate the regime's achievements under the CCP's leadership. Politics thus became high drama and a performance theater, presented colorfully on the streets and aimed at creating the most dramatic effect on the audience.

How should we approach these subjects of human drama? Victor Turner advises: "We have to view them in action, in movement, in becoming, as essentially involved in process."[37] Indeed, yangge and national parades are best studied on the streets, in motion; only then can we understand the dynamics and complexities of these public spectacles. But different from the notion of fertility and productivity commonly associated with rural festivals, the two Chinese Communist forms of festivities of concern here were political performances closely supervised by the officials and mounted in open but controlled space.

To be sure, in the early days of the PRC the popular yangge dance was not entirely new; it was an "invented tradition," to borrow Eric Hobsbawm's term.[38] The new yangge appeared on the streets in major cities in 1949–50 and drew its forms and inspiration from its predecessor in the Yan'an days. The year 1949, therefore, did not mark a great divide between new and old China. On the contrary, one sees extensive cultural continuities between the two periods. But the Communists were outraged by the spiritual and erotic elements in old yangge, and they quickly moved to transform it into a new dance known commonly as Struggle Yangge (*douzheng yangge*). The new dance was infused with the themes of class struggle,[39] and became closely identified with the CCP as a tool for political indoctrination.

When the Chinese Communists took power in 1949, they introduced the transformed rural dance into the cities, and instantly the dance became synonymous with the radical outlook of the new socialist regime. For many urban dwellers it was an unwelcome oddity. The Communists never hid the provenance of the new dance, for it was wise for them to proclaim that yangge was deeply rooted in the peasant culture, a place deemed to be the repository of folk wisdom from which the Communists drew vital support. In the early 1950s, Communist artists created new yangge musicals to convey socialist messages and nationalistic appeals. Through the musicals, the Party attempted to construct what I call "a narrative history through rhythmic movements" in an effort to weave the developments of the Party's history into a coherent success story. These new performances focused on a number of themes: the support of the people for the Communist Revolution, the valor of the Red Army, the wise leadership of the Party, and the country's bright future. Taken together, they constructed the triumphant history of the CCP in dance and in great jubilation.

The significance of yangge, however, must be viewed in the larger context of the government's annual staging of the two grandest state spectacles: the

May Day and National Day parades. These parades, marked, respectively, the regime's two special occasions: the solidarity of proletariats in the world and the birth of a new nation. In the capital, the Beijing Municipal Party was officially responsible for staging the parades, but the supervising role clearly rested with the powerful Propaganda Department of the CCP's Central Committee, which ensured that the projects would go smoothly.

The parades were celebrated with great pomp. On May Day and National Day, the cities—Beijing and Shanghai especially—were brightly decorated, and festivity filled the air. In the processions, the bright floats, red banners, balloons, revolutionary songs, and columns of paraders marching in precision combined to make a most memorable sight. Every year hundreds of thousands of paraders were selected; they marched from east to west, normally from Dongdan, and filed through Tiananmen Square in front of Tiananmen Gate, to be reviewed by Mao and senior Party leaders from atop the gate. This important national festivity was coordinated by the top-ranking officials, with tight controls on the predetermined marching route and the precise number of marchers representing appropriate segments of society, including workers, peasants, and urbanites. A large degree of theatricalization was evident in the parades, both in their striking effects and joyful spirit, but the state's purpose was to forge a sense of total involvement through these massive gatherings of people. The Communist Revolution was both reenacted and theatricalized annually in Beijing's Tiananmen Square and in Shanghai's People's Park.

May Day and National Day parades were, in political terms, forms of integrational propaganda that, in the words of Jacques Ellul, "seeks not a temporary excitement but a total molding of the person in depth."[40] They were well-organized political rituals with multiple purposes: festivals of iconoclasm, demolishing the old order and embracing the new era of socialism; a display of myriad achievements under Communism; an affirmation of Mao's central role in modern Chinese revolutionary history; and a declaration of China's presence in the international socialist camp. In the end, Mao Zedong and his senior Party leaders, acting both as actors and directors, carefully controlled and choreographed the Tiananmen Square paraders, who were themselves the audience, to heap praise on the achievements of the Party and its chairman.

Part 3: History

Chapters 5 and 6, which make up part 3, concern the CCP's interpretation of modern Chinese history in its effort to develop a master narrative of the Party's path to victory. History writing in the PRC was a political undertaking of the utmost importance, as it touched on the controversial myth underpinning the Party's claim to legitimacy. These chapters explore how the Party's "master fiction" was constructed through two venues: the building of the Museum of the Chinese Revolution (MCR) and the commission of a series of oil paintings depicting the heroic course of the Party's road to victory, which would be hung in

the museum when it opened its doors in 1961. The Party history was therefore not recounted in script but through artifacts displayed in a museum, as well as by a visual medium introduced from the West.

China, of course, has a long record of writing standard dynastic histories sponsored by emperors ever since the Tang dynasty (618–907),[41] but distinguishing the Chinese Communists from their predecessors was their dogmatic and tight control over how the histories were fashioned, always under the sway of dominant ideological interests. The writing or rewriting of an official history was routinely a practice carefully controlled and invented by the CCP's top ranks. The Chinese Communists lacked a single pivotal episode equivalent to the French storming of the Bastille or the Russian storming of the Winter Palace that would allow them to distill their revolution into one magic moment.[42] True, their liberation of Beiping in late January 1949 was a remarkably peaceful experience: the city fell to the People's Liberation Army (PLA) after weeks of siege when the Nationalist generals capitulated, but the event lacked the high political drama and theatrical military dimension of their French and Russian counterparts. This does not mean, however, that the narration of the Party's history was anything less important for Mao and his leadership circle.

Like the French and Soviet revolutionaries, Mao and his senior associates, early on, confronted the issue of coming out with a historical account to justify their authority. Mao's conception of Chinese history theoretically falls in line with the Marxist framework of class struggle and carries a similar grand view of an unchanging teleology of historical progress; in practice, however, Mao lacked the strong metaphysical, millenarian vision of human advance as envisioned in orthodox Marxism. Mao was far more interested in practical matters, not abstract philosophizing. When he called for the "sinicization" of Marxism during the Yan'an period, he was warning against empty generalizations of arcane, foreign theories in China, which he thought were useless unless they were firmly placed within specific sociohistorical contexts.[43] His views of history undoubtedly were shaped by concrete Chinese conditions deeply rooted in his native soil. This was clearly evident in his influential 1940 essay, "On New Democracy," where he outlined the general framework of modern Chinese history from the Opium War to, in his view, an inevitable Communist victory.[44] That period was further defined when, in the early 1950s, it was divided into two stages: the Old Democratic Revolution (1840–1919) and the New Democratic Revolution (1919–49).[45] Mao's views of the two periods were developed even more specifically by Hu Qiaomu (1912–92), deputy director of the Propaganda Department and Mao's personal secretary, in his *Thirty Years of the Communist Party of China* (*Zhongguo gongchandang de sanshinian*), published in 1951.[46] Hu's text, endorsed by Mao, became a guideline for the official narrative of the Party. It was on this basis that the history of the CCP would be told. One way to do this efficiently and effectively, as they discovered, was to put the CCP on display, which meant constructing a museum and using revolutionary artifacts to

chronicle the Party's history. However, the process of arriving at an acceptable, integrated narrative of the revolution proved to be convoluted.

The building of the Museum of the Chinese Revolution, located at the eastern part of Tiananmen Square, was carefully used to immortalize the role of the CCP and establish Mao's centrality in the Chinese Revolution. The museum, as mentioned earlier, was one of the Ten Monumental Buildings erected to commemorate the tenth anniversary of the founding of the PRC. From the beginning, the museum was never intended to be an artistic enterprise but was conceived as a political institution to trumpet the success of the Party. The Party was ubiquitous in the entire process of constructing the museum, exercising close control through various agencies, especially the Party's Propaganda Department, which was the gatekeeper of the Party's official image. Museum staff members collected artifacts related to the Chinese Communist Revolution, including Mao's writings and personal belongings. All these were carefully arranged according to the official historical periods stipulated by Mao.[47] The museum thus became a temple of political education for the public.

The opening of the museum, originally scheduled in 1959, was delayed until 1961, as a result of an internal Party clash over how to tell the correct official story, especially the role of Chairman Mao as opposed to his senior contemporaries in Party history. The clash was known as the "Red Line" dispute. Eventually the correct leadership of Mao—the true "Red Line"—was reaffirmed; opinions differed within the Party regarding Mao's centrality in the Chinese Revolution, but the real objective of the MCR was never in doubt: to become a distinctive political institution set up to control the collective memory of the nation.

The Communists also knew that history was best told visually. Since the Yan'an days, the propagandists fully understood that if they wanted to draw the widest popular support, they would have to rely on vehicles other than scripts and writings, especially in a land with high illiteracy. This time the officials found an answer in oil paintings, a medium introduced from the West. In the 1950s and early 1960s the MCR commissioned a series of oil paintings to recount the rise and triumph of the CCP. Again, the Party oversaw the choice of historical themes, selected trustworthy artists, approved the final products, and ensured that these works of art satisfied guidelines issued by the Party. These paintings focused on the martyr, the military campaign, the leader, the worker, and the founding of the nation, and they were meticulously distributed in the museum to coordinate with a specific historical incident. Thus museum displays and pictorial representations of key events, decisive battles, and influential personages combined to give the Party history its striking colors and visual storylines. Collectively, these images weaved a heroic tale of the CCP and defined the essential meanings of the Chinese Communist Revolution. In his study of Soviet museums, Boris Groys argues that the authorities created in museums "a single, total visual space within which to efface the boundary separating art

from life."[48] The MCR no doubt followed suit, becoming an official citadel to educate the public about the Party's glorious past.

Part 4: Visual Images

The monopoly on history writing was only one of the many measures that the CCP attempted in order to dictate its political agenda in China. The other equally—perhaps even more—important means was the manipulation of visual images for propaganda purposes. This was again an old Yan'an practice being invented anew. It is clear that in the early founding days of the PRC, a wealth of popular and folk art forms, including cartoons, nianhua, and serial pictures, played a critical role in winning support for the new regime. The discussion of these forms is the focus of chapters 7 and 8, in part 4 of this book.

Popular art forms were used by Chinese propagandists for two opposite but complementary purposes: to demonize enemies, on the one hand, and to exalt a new socialist regime, on the other. Whereas Communist artists largely employed cartoons and *lianhuanhua* (serial picture stories) to denounce their foes, Chiang Kai-shek and U.S. imperialists, they used nianhua to pay tribute to government policies.

The use of cartoons and serial picture stories for political purposes was already a familiar practice in the Yan'an days.[49] Here, too, the Yan'an technique clearly was continued in the early PRC. The major difference was that after 1949 the propaganda network became more centralized and better controlled by the Party machinery and government agencies. In this regard, the PRC contrasted with its Soviet counterpart, which had no concrete plan for a propaganda system when it came to power.[50]

Early on, the Communist propagandists saw the revolution in stark Manichaean terms of the exploited versus the exploiter, good versus evil, light versus darkness. This binary model came partly from the traditional folk belief of the diametric opposites of heroes against villains and, more recently, from the Marxist idea of class struggle (the proletariat versus the bourgeoisie). This division simplified a complex issue and triggered an immediate reaction from its audiences. Political cartoons, because of their directness and distortions, were a perfect tool for a timely commentary on current events. Likewise, serial picture stories, which relied on a traditional and beloved storytelling format, were often adopted to tell a current story in a coherent fashion. Appearing regularly in major Party-controlled newspapers (such as the *People's Daily* [*Renmin ribao*]), these two art forms became familiar weapons for attacking U.S. imperialists, the Guomindang (Nationalist Party) regime, spies, capitalists, landlords, and bourgeois intellectuals.

The messages generated by cartoons and serial picture stories were mostly furious indictments of enemies, but pictorial expressions also served as a positive stimulus: to pay tribute to the Party now in power and to help build a new socialist era. The nianhua prints, a well-liked folk art in rural China, were a

principal vehicle for paying tribute. The choice of this art form seemed obvious, for its stunning colors and exaggerated designs were often used in traditional China for celebratory purposes: bumper harvests, rosy-cheeked children, door gods, and benevolent deities, reflecting the mental world of a rural population longing for a safe and productive life. But, again, the post-1949 nianhua prints were reshaped to reflect a new era by eliminating the religious prints of the Stove God, among others, and by adding new socialist content. Now, instead of cheerful children and door gods, the reformed nianhua prints were about children picking up guns to fight against American invaders and model workers and peasants as representative of the supreme value of labor.

The production of nianhua, now under the supervision of the Ministry of Culture, surely reflected the continuing and proven practice of the technique of "pouring new wine into old bottles" (*jiuping zhuang xinjiu*)—promoting new ideas through old methods—used to great effect before 1949. Their printings not only indicated that political artists continued to appropriate the rich traditions of Chinese folk culture for current use, but that the prints carried a strong nationalistic appeal, as Chinese artists deliberately recycled this age-old folk product to distance themselves from foreign works, including those of the Soviet Union.

Certainly the visual images were not produced for aesthetic objectives but were conceived and executed for purely political purposes. This politically motivated art was closely tied to the developments of state policies in the 1950s. One sees, for example, strong anti-American cartoons during the Korean War, but the bulk of the pictorial representations clearly shifted to promoting rapid industrialization and quick progress during the Great Leap Forward in 1958. These artworks, therefore, formed an important historical source chronicling the Party's policies at the time.

However, the new nianhua of model workers and contemporary political scenes met resistance from the populace. Peasant consumers often found them unfamiliar, incomprehensible, and unappealing for lack of a good traditional storyline, and hence they refused to buy them. In the nianhua campaign, the state thus found that it had limited control over people's lives. Clearly this time the voice from the grassroots was loud and uncompromising.

Part 5: Commemoration

Chapters 9 and 10 conclude the book with a discussion of commemoration, or the concept of national sacrifice, which grew in importance after 1949. How did the Communists come to terms with the terrible human losses of their comrades in the countless pre-1949 battles in the name of national liberation and class struggle? Whereas national parades were a festival of the birth of a new nation in the guise of massive processions in Tiananmen Square on National Day, commemoration honored vast numbers who died in war for a better future. Thus war and remembrance form yet another centerpiece of the Communist political culture.

In the 1930s the CCP had to confront the painful problem of dealing with the vast scale of deaths in its rank and file in the wars against Japan and the Nationalists. War and sacrifice would be futile without a meaningful explanation or a higher goal. Could mass slaughter on the battlefield be transcended by some noble principle of a "just war"? How should the bereaved live with the loss of loved ones? And how should their deaths be remembered? The Chinese Communists began to promote the cult of the red martyr during the late Yan'an era, when Mao commemorated the death, by accident, of a young peasant Red Army soldier.[51] This later developed into a nationwide remembrance of the dead after 1949.

The politics of the red martyr is fundamentally a question of "collective memory," the act of communal remembering described by the pioneering French sociologist Maurice Halbwachs in the 1920s. Although individuals remember, Halbwachs observed, "it is individuals as group members who remember."[52] Only collective memory endures, and it is social groups, not individuals, that determine what is worthy of remembrance as well as how events should be remembered. Memories are highly malleable and easily susceptible to manipulation by the elite. In the words of Pierre Nora, memories are "vulnerable in various ways to appropriation and manipulation."[53] In the CCP's case, Halbwachs's "social groups" took on a political connotation: they were transformed into a powerful state machine that controlled the remembrance of the past as well as how the dead should be honored.

After 1949, the CCP lost no time in utilizing the experience of death to promote its political agenda by creating the cult of the red martyr. The cult was to serve multiple purposes: diverting attention from the destruction of war, justifying armed conflict as a means to fight enemies, providing psychological comfort for the bereaved, and, finally, educating future generations about socialist goals, thus serving, in the words of Premier Zhou Enlai (1898–1976), "to commemorate the dead and inspire the living."[54]

The red martyr cult was developed through various commemorative practices; most important among these was the reshaping of the Qingming Festival into Martyrs Memorial Day. To honor the dead heroes at the Qingming Festival was to look upon them as ancestors of the nation for which they had sacrificed their lives. In addition to Martyrs Memorial Day, the new cult spread to other venues, including red funerals, public trials of enemies, the building of war cemeteries, and, perhaps most important, the creation of a national cemetery—the Babaoshan Revolutionary Cemetery in the western part of Beijing—as a place of national pilgrimage. The cemetery signaled the Party's clear intention to forge a unified national symbol of heroism.

Halbwachs's observation continues to be useful here, as it stresses the significance of the semiotics of place in understanding collective memory. He argues that collective memory is best understood in landscapes.[55] Pierre Nora echoes this view in his study of "sites of memory" (lieux de mémoire) in France.

Although Nora's sites broadly include emblems and sculptures, the phrase refers principally to physical sites and memorial spaces.[56] Like Western cemeteries, the idea of building a garden cemetery in an idyllic setting, as in the case of the Babaoshan Revolutionary Cemetery, was to blend it with nature to mask the harsh realities of destruction and grieving. The comfort of eternal rest in this national shrine transcended wartime slaughter and produced a comforting atmosphere. The Babaoshan cemetery is, of course, devoid of Christian piety and symbols of resurrection that characterize those in the West,[57] but it serves in peacetime as a reminder of the glory of war, as well as a representation of collective goals.

In addition to war cemeteries, monuments are another tangible way to anchor collective memory to physical sites, usually in prominent public spaces. The flowering of public monuments after 1949, with hundreds of thousands built across the nation, testified to the rising nationalism, in the same vein as Mao's slogan "China stood up!"[58] Among these monuments, the Monument to the People's Heroes (Renmin yingxiong jinianbei) in Tiananmen Square is the most prominent. When the monument was finally unveiled on Labor Day, May 1, 1958, the frontal part on the north, facing Tiananmen Gate, bore Mao's huge characters, "Eternal Glory to the People's Heroes." On the back, facing south toward Zhengyang Gate, is an epitaph drafted by Mao and written in Zhou Enlai's calligraphy, calling people to honor "the people's heroes"—those who died, ever since the Opium War, for the sake of "the nation's independence and the people's freedom and well-being."[59]

The monument is a history written in stone as well as a noble reminder of the struggle of the Chinese people to liberate themselves from foreign imperialist powers and the yoke of domestic bondage. But, as discussed later in this book, this building turned out to be a highly contested project that triggered several thorny questions during the construction period. Should the style of the monument be native or foreign? Which events should be included in the monument's eight reliefs that trace the history of modern China? How should the designers properly place the role of the CCP in modern Chinese history? These issues were debated, often heatedly, by officials, historians, architects, and artists directly involved in the project. It was never the smooth production depicted in official media. The one certainty was that this was a "people's monument" to be situated in a "people's square." The CCP claimed to rule in the name of the people, and in the construction of this national monument the Party played a decisive role in the building of collective identity and group memory.

A Propaganda State

Three themes in this book weave together the various political-cultural forms: the Soviet influence, nationalism, and the authoritarian rule of the party-state. Soviet influence—an important chapter in contemporary history rarely told in

China today—was not only evident in the thousands of Soviet advisers sent from Moscow but also in their influence on city planning, the expansion of Tiananmen Square, national parades, art, and the construction of museums. In the early days of the PRC, Mao's pro-Soviet policy was strategically and political necessary. At that time Mao had few other options, for at the critical juncture of the founding of a new regime the Chinese Communists were isolated internationally and threatened by Western forces. But the Chinese leaders would soon clash with their Soviet mentors, as the Chinese, prompted by domestic situations and driven by nationalistic pride, sought a more independent road, which they believed was more appropriate for the nation. This may have been necessary because Mao and his senior associates fully realized that their legitimacy was based not on acting as a slavish follower of foreign models but on maintaining China's independence, a goal that many Chinese had fought for since the end of the nineteenth century. Thus the nationalization of political culture was inevitable. The pursuit of independence was intensified as the relationship between Beijing and Moscow deteriorated in the late 1950s. It is in this light that one should understand the building of a vast Tiananmen Square that dwarfed Red Square, as well as the search for an indigenous art form. Deep down, however, nationalism was merely a means for the CCP to consolidate its rule rather than just compete with Moscow. As a Leninist party, the CCP perceived tight organization and central control as essential tools to secure its power. The Party tolerated neither dissension nor opposition. One of the best ways to ensure its continued grip on power was to invent a master narrative of the triumphant history of the Chinese Communist Revolution through various political-cultural forms. To retain their grip on the people, Communist leaders turned China into a vast apparatus for generating propaganda.

If the new political culture was a series of representations of Communist power in action, then, one might argue, propaganda was a vehicle to maximize those representations. Historians, however, have traditionally underestimated the significance of propaganda, paying scant attention to both the ideas and instruments of political persuasion. If acknowledged at all, the subject tends to be a domain of political scientists. Readers may recall the words of Hannah Arendt: "Only the mob and the elite can be attracted by the momentum of totalitarianism itself; the masses have to be won by propaganda. . . . Propaganda . . . is one, and possibly the most important, instrument of totalitarianism for dealing with the nontotalitarian world."[60] In this book I argue that a Communist regime uses propaganda not only to persuade and coerce but also to deliver its socialist message to the masses and mobilize them for political gain. Here, one is reminded of Peter Kenez's description of the Soviet Union as a "propaganda state," because "Leninist-Stalinist methods of mass mobilization and indoctrination came to be essential aspects."[61] The term "propaganda state" is equally applicable to the PRC, perhaps even more so, in terms of the early initiation of propaganda policies and the wide range of controls the government wielded

over people's cultural lives. In contrast to the Soviets, who did not come up with a well-organized propaganda system until August 1920,[62] the CCP, to its advantage, started its propaganda machine long before the Party came to power.

Although the CCP early on developed a propaganda network, that system did not adopt an orderly and coherent approach until the Yan'an days, when the highest authority of control was assumed by the Propaganda Department of the CCP's Central Committee.[63] After 1949 the Party established a far more comprehensive propaganda network, and its control of Chinese society progressively became more imposing and overbearing. The Ministry of Culture played a crucial role in shaping cultural policies, coordinating the construction of the Museum of the Chinese Revolution and the production of the nianhua prints, but absolute power was usually wielded by the CCP Propaganda Department headed by Lu Dingyi (1906–96). A hierarchy of organizations was apparent from the beginning. Deng Tuo (1912–66), a veteran Communist and editor of the *People's Daily*, summed up this layered political structure aptly as a form of "twofold leadership" (*shuangchong lingdao*), namely, that a tentative decision was first reached at the lower level—in his case, the *People's Daily*—but the final approval came from the top: the Propaganda Department.[64]

To say that the People's Republic of China was a propaganda state does not imply that the CCP had a preconceived master plan of propaganda or that everything was carefully crafted to instill official ideas into the public. One cannot deny the Party's monopoly of power, but even though the propaganda activities were tightly controlled, the Party's power was not always absolute, particularly in the early years of the PRC when the government attempted to attract non-Party members through a more accommodating "people's democratic dictatorship" policy. It is also too simplistic to assume that the propaganda system worked with equal effectiveness in all its agencies. In reality, the propaganda apparatuses in both the Party and government tried to work together, with varying degrees of success at various times and in different arenas.

The study of the new political culture forms must also be viewed from the standpoints of agencies, creators, audience, and settings in which these forms were produced. In addition to examining institutions or bureaus that initiated the propaganda, this book also looks at the artists, architects, and museum staff involved in the undertaking. The task of artists and intellectuals was to create images in response to the needs of the political movements mandated by the state. But did the state exercise total control on the unwilling artists? Did they work under duress with no autonomy, or did they willingly comply with or passionately support the state's policies?

The relationship between the state and the intellectuals is a complex story. The notion that artists were forced to work because of the state's coercive constraints on them tells only a partial story. As discussed later in this book, the shaping of political culture cannot be explained simply as an imposition from above by a hegemonic party on unsuspecting artists and architects. The founding

of the PRC created an unprecedented euphoria and a sense of hope among many intellectuals and artists. In the early years, the CCP was heartily welcomed by many individuals who, though not necessarily agreeing with or understanding Marxist philosophy, saw it as China's best hope to free a nation long mired in social dislocation, poverty, and foreign humiliation. Many were disillusioned with the Nationalists' ineffectual rule. Mao's words the "Chinese people have stood up!" no doubt struck a common chord in them: the chairman had echoed their collective anti-imperialistic stand and long-standing desire for a strong nation. In the 1940s, Mao's "New Democracy" was a blueprint for China that preached a program of unity among various political parties and won many followers. Some intellectuals were also drawn to Mao's lofty Marxist-type promise of a future world where "classes, state power and political parties will die out very naturally and mankind will enter the realm of Great Harmony."[65] Many leading scholars and non-Party intellectuals, including the painter Xu Beihong (1895– 1953), envisioned the dawning of a new era and threw themselves into nation building with zest and energy.

The majority of veteran intellectuals and artists whom I interviewed in recent years still recalled with great excitement their days in the young PRC.[66] Such nostalgic recollections challenge the conventional view of the relationship between a hegemonic state and the victimized elite. What we saw in the 1950s was a cultural landscape engineered by the authoritative state and aided by the active involvement of idealistic artists and writers. This flirtation with politics by intellectuals soon took a tragic turn, when the Party unleashed its repressive Anti-Rightist Campaign in 1957.

The issue of audience reception is another critical link in the discussion of the PRC's new political culture. Whether the state-imposed policies were effectively employed must be measured against the public's reaction to the cultural projects. Scholars can study the images, the content of political language, and the parades, but these activities tell us little about what exactly the audiences perceived. Audiences often came with preconceived ideas or prior opinions, which no doubt influenced what they saw and valued. Moreover, multiple meanings clearly can be read into artistic productions. Some cultural artifacts are by nature less ambiguous than others. A political cartoon attacking the pernicious involvement of the United States in the Korean War that appeared in the *People's Daily* is surely easier to comprehend than the Monument to the People's Heroes, which, as I argue in chapter 10, is an intricate amalgam of reinvented historical narratives, conflicting artistic styles, and a public announcement of government ideologies. Regardless of strong official guidance, viewers can still interpret the monument freely and creatively, without following the prescribed path intended by its designer.

When studying Communist political culture, one is constantly reminded of the danger of being misled by the promising results of a propaganda program as reported in official media. In the absence of direct and reliable accounts of

the audiences' reactions, I have depended on archival sources, interviews, survey reports, memoirs, and, if available, sales figures (as in the case of the nianhua prints). This information revealed a far more complicated and often contradictory world from that of official reports. Although millions of nianhua were issued in the early 1950s, for example, audiences were often critical of the new and reformed pieces, such as turning traditional door gods into soldiers of the People's Liberation Army. Worse still, many new images were incomprehensible to the peasants. Artists who produced these popular art forms were commonly considered of low status, which, of course, dampened their enthusiasm. A more serious problem was that the confining role played by the Party allowed little room for artistic creativity and resulted in the production of stale and dreary works.

This book examines how the various images of the PRC were constructed visually and spatially, arguing that political culture is an important and valuable means for understanding the nature of PRC politics. To view culture as mere epiphenomena of social and economic policies is to distort the fundamental nature of the Chinese Communist Revolution. In the PRC, the new political culture—made up of spatial politics, parades, history writing, visual representations, and commemorations—did not necessarily follow socioeconomic conditions nor was it dictated by them. Instead, it shaped social opinions, rewrote the past, changed attitudes, and helped to create a novel and promising milieu within which government policies were conducted in the light of building a better future. In this book I contend that one of the major achievements of the Chinese Communist Revolution was the designing (and reinventing), production, and dissemination of a new political culture. The entire process was overseen by a system of propaganda agencies in the PRC. This political culture was critical in helping to cement CCP rule in the 1950s.

I. Space

1. Tiananmen Square
Space and Politics

In waves of red flags and jubilant songs,
A sea of people celebrates their liberation;
Common folks are now masters,
The Imperial Palace is transformed into a new Red Square.

The above appeared on a poster at a grand rally in Tiananmen Square in February 1949.[1] This celebration in what was then Beiping, soon to reclaim its former name of Beijing, was organized by the Chinese Communist Party to mark the liberation of this fabled city by the Red Army on January 31. The analogy the poster drew between Tiananmen Square and Moscow's Red Square was common in the early days of the People's Republic of China.[2] The announcement by Mao Zedong of the founding of the PRC in Tiananmen Square on October 1, 1949, captured the world's attention. The square soon occupied a central place in the new government's ambitious plan to rebuild its new capital, Beijing. The plan, however, turned out to have a lengthy and contentious history.

Newly established regimes in Europe typically announced the birth of a glorious era by widely creating symbolic landscapes or structures and remaking political spaces such as vast public squares and imposing buildings. After the French Revolution in 1789, the new government brought in a new national assembly, built new monuments, and staged grand festivals to demonstrate its break with the traditional monarchy.[3] The French revolutionaries recast time and space to shape a new culture of openness and equality, contended the historian Mona Ozouf.[4] After the October Revolution Lenin issued a "Plan for Monumental Propaganda" in April 1918, ordering all the tsar's statues in the streets of Moscow and Petrograd dismantled and replaced by statues of admired revolutionaries, philosophers, and progressive personalities including Marx, Engels, Marat, and Fourier. The plan underscored the Soviet leader's belief that architecture was a potent means to demonstrate the new regime's political power.[5] The same was true in China after the CCP came to power. In addition to introducing a new socialist system, the CCP had created a new political space by, for example, expanding Tiananmen Square. The enlargement of the square

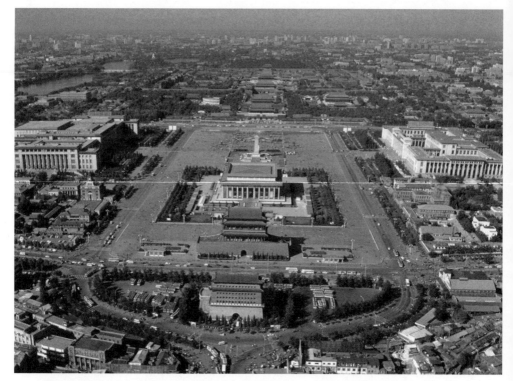

Figure 1. Tiananmen Square today. *Source*: Courtesy of *Shijie bolan* (World vision), Beijing.

was a central element of the government's overall plan to rebuild the capital that would also include the construction of two colossal structures around the square: the Great Hall of the People and the Museums of the Chinese Revolution and of Chinese History (figure 1).[6] What was the purpose of expanding Tiananmen Square, and did the Chinese leaders really intend to model the square after Moscow's Red Square? Was its expansion influenced by the Soviets? What was the precise nature of the Tiananmen Square project? These questions can be answered by placing this project in the larger context of the debates, in the early years of the PRC, concerning the location of the new government center.

The New Administrative Center

When Mao and his Party took power in 1949, they immediately faced the pressing issue of where to locate the central government offices. The choices were either the former Imperial Palace in the old Forbidden City or to build an entirely new center elsewhere in or near Beiping. In May of that year, the CCP created the Beiping Municipal Planning Committee (Dushi jihua weiyuanhui; MPC), headed by Mayor Ye Jianying (1897–1986), to decide the issue and develop

a comprehensive plan. The committee's inaugural meeting in Beihai Park on May 22, 1949, was attended by Beiping's vice mayor Zhang Youyu (1899–1992), the city's Construction Bureau head Cao Yanxing (1909–84), renowned Tsinghua University professors and architects Liang Sicheng (1901–72) and (his wife) Lin Huiyin (1904–55), and engineer Hua Nangui (1875–1961). The committee resolved that Liang Sicheng and his colleagues at Tsinghua's Department of Architecture should "draft a plan for a new urban center in the western suburb of the city."[7] That decision would generate bitter debates among municipal Party officials, architects, and Soviet advisers: on one side, Liang and his colleagues jumped at the opportunity to build new government headquarters in the rural part of western Beiping, but opposing this plan were the influential architects Zhao Dongri (1914–2005) and Zhu Zhaoxue (1900–65), who argued for renovating Beiping's historic districts rather than building a completely new urban center.

Liang Sicheng, the son of Liang Qichao (1873–1929), one of China's foremost intellectuals at the turn of the twentieth century, was a scholar steeped in two cultures: As a youth he was taught classical Chinese by his father, and later he studied architecture at the University of Pennsylvania in the United States under the renowned French architect Paul P. Cret, a student of the influential École des Beaux-Arts. Besides studying Western new classicism and modern architecture, the young Liang admired China's ancient architecture. In 1928 he returned to China with his wife, Lin Huiyin, and the couple devoted themselves to studying China's rich architectural history. They traveled to remote places to study ancient buildings, and they became fervent advocates for preserving the nation's priceless historical structures and temples.[8] To Liang, one of the world's greatest architectural marvels was Beijing. The Chinese capital, he observed, was planned so that the "Forbidden City was situated at the center of the inner city, with the rest of the city built around it. Uniting the city is a central axis stretching eight kilometers from north to south, the longest and most extraordinary configuration [in any city] in the world." Liang went on to describe Beijing as "an unparalleled masterpiece in city planning."[9] To Liang, the assignment to design a new urban center in Beijing was a dream come true.

But exactly where should the new government center be located? Although Liang Sicheng recommended the western suburb of the capital to preserve the old city, his specialty was not city planning and so he sought help from Chen Zhanxiang (1916–2001), a friend who had studied city planning in England and shared his views. In February 1950 the two men wrote the famous "Proposals on the Location of the Administrative Center of the Central Government," commonly known as the Liang-Chen Proposal (figure 2). They pointed out that the new administrative center required ample space for large-scale constructions that the old city, with its cultural relics that had to be preserved, simply could not provide. Reestablishing the new government center in the old city district would mean a massive demolition of some 130,000 houses and unnecessary

行政區內各單位大體部署草

附与旧城区之关係

eviction of countless residents, which Liang and Chen called "wasting money and manpower." Thus building a new administrative center in the rural part of western Beijing—east of the Princess Tomb and west of Yuetan—made sense and was the ideal solution.[10] To be sure, the Liang-Chen Proposal was influenced by the 1938 Japanese plan to create an urban region west of Beijing to assert its military domination of Beijing and accommodate Japanese immigrants.[11] Undoubtedly, however, the motivations of the two designs differed in that the Japanese were solidifying their colonial rule, whereas Liang and Chen were protecting the old capital.

内五区
4.89方公里
23699户
107845人
22000人/km²

内六区
7.597方公里
16513户
77896人
10140人/km²

北海

景山公园

内三区
6.197方公里
34800户
159195人
25600人/km²

西四

中

海

南海

故宫博物院

内一区
5.278方公里
33095户
157980人
30000人/km²

王府井大街商业区

西四商业区

新华门

中山公园

太庙

东单

西交民巷

金融商业区

建国商场

东交民巷使馆区

东单广场

内七区
3.121方公里
9119户
1938人
14350人/km²

前门

九区(外二区)
2.274方公里
2098户
98706人
43400人/km²

前门商业区

八区(外一区)
1.569方公里
14210户
66428人
42300人/km²

十区(外三区)
6.719方公里
25305户
105762人
15700人/km²

十二区(外五区)
7.580方公里
29442人
121228人
16000人/km²

Figure 2. Liang Sicheng and Chen Zhanxiang, "Proposals on the Location of the Administrative Center of the Central Government." On the right is the old city, with Tiananmen Square at its core; on the left is the proposed new administrative center in western Beijing. *Source*: Liang Sicheng, *Liang Sicheng wenji* (Collected writings of Liang Sicheng) (Beijing: Zhongguo jianzhu gongye chubanshe, 1986), 4:2–3.

The Liang-Chen Proposal quickly came under fire. The first criticism came from the professionals. In April 1950 the Belgium-trained engineer Zhu Zhaoxue and the Japan-trained architect Zhao Dongri, both with the Beijing Construction Bureau, presented an opposing view in their proposal, "Concepts for the Design of the Capital," generally known as the Zhu-Zhao Proposal. Contrary to the Liang-Chen Proposal, Zhu and Zhao argued that no new administrative centers should be built at this time, as old Beijing "has a magnificent and elegant layout endowed with modern facilities, amply qualified to serve as the foundation for the development of the capital of the People's Republic. For logical and

economic reasons, it should be used as a focal point for building the capital." Although Zhu's and Zhao's concerns were mainly economical—it was less costly to renovate the old districts than to construct an entirely new center—their proposal would prevent the old town from deteriorating, and thus help it to become more "prosperous."[12]

The Zhu-Zhao plan was similar to a plan for developing Beijing that had been advanced the previous year by Soviet architects and was based on Stalin's 1935 "General Plan for the Construction of Moscow." After 1949, under China's pro-Soviet policy—"leaning to one side," as Mao put it[13]—a host of Soviet experts had arrived in China to support various kinds of development. From 1950 to 1956 an estimated 5,092 Russians were working in China—including city planners, architects, transportation specialists, metallurgists, and military advisers—and more would come later.[14] One of the earliest Soviet delegations—a team of city planners and architects headed by Moscow's vice mayor, P. V. Abramov—had already arrived in Beiping in mid-September 1949, even before the official founding of the PRC.[15] In December, after several surveys of the city, a team member, the architect M. G. Barannikov, presented the Municipal Party with his "Plans for the Future Development of Beijing." Stalin's 1935 plan had the Soviet capital laid out in radial pattern, with concentric boulevards spreading out in ever-widening circles from the city center of the Kremlin and an expanded Red Square. Barannikov envisioned the Chinese capital developed in the same vein, and he pointed out:

> To ensure that Beijing's appearance would remain impressive in the future, a thoroughfare or a public square had to be reconstructed in the city. The status of Tiananmen Square, the city's historic center, was recently enhanced with military parades and grand processions during the founding ceremony of the People's Republic, and this development adds weight to the argument that the square should be the heart of the capital, and from there the construction of future major roads should be planned and determined. No city planners should deviate from this principle.

Barannikov also suggested that the first group of key administrative buildings should be "built on the south side of East Chang'an Avenue," which ran past Tiananmen Gate.[16] Clearly Barannikov believed that Beijing should have a single principal city center, whereas the Liang-Chen Proposal called for two centers, one in the old city and the other at a new administrative site. Abramov supported his Russian colleague's plan, maintaining that "Beijing is a splendid city, and there is no reason to abandon it. It would take decades to build structures like the Imperial Palace, as well as the parks and rivers that you now have."[17] Liang Sicheng disagreed, and the two sides found themselves at loggerheads, unable to resolve their differences.[18]

Liang's primary concerns were both cultural and political. He pictured the new Beijing as "somewhat similar to Washington D.C., a political center without industrial development."[19] But his desire to protect the priceless traditional

architectural structures in the old city ran counter to the official plan. In 1949 the government had every intention of transforming the capital from "a consumer city" to "a producer city."[20] Summing up the official policy in 1949, Mayor Peng Zhen (1902–97) wrote: "According to the resolution of the Second Plenum of the Seventh Party Congress, the current focus of the Party's work has shifted from rural to urban, and the main task of city work is to revive and develop our own productivity."[21] This, of course, reflects the Marxist axiom that a socialist country should rest on a strong industrial foundation. The Stalinist model of rapid industrialization guided by a single, rigorously centralized plan would soon be in full force when the Chinese government initiated the First Five-Year Plan in 1953. Although Liang's cultural approach found a sympathetic ear in the city's vice mayor, Zhang Youyu,[22] it was drowned out in the government's fervent drive to industrialize the urban sectors. Another Soviet advisor, S. A. Boldyrev, arrived in Beijing later and gave blunt advice to the Municipal Party officers: "In our country, our Party and government repeatedly instructed us to pay attention to economic issues. . . . You cannot let architects do whatever they please; someone should put bits in their mouths to control them."[23]

Yet the harshest criticism against the Liang-Chen Proposal was not from the Soviet advisers or Liang's professional rivals but from the Communist Party itself. In 1953 Zheng Tianxiang (b. 1914), a key member of the Municipal Party, openly disparaged Liang's proposal as "a mistake." In Zheng's opinion, building a new government headquarters at a time of scarce resources in the founding days of the PRC would severely strain the government's already meager resources.[24] But the determining factor here was politics, not finances: the highest level of the CCP rejected Liang's plan purely for political reasons. Although the Party's central archives remain inaccessible to outsiders, indirect sources indicate that Mao himself was involved in the final decision. In a 1949 speech delivered in Beijing, Abramov revealed that Peng Zhen had told Soviet advisers that the mayor had "consulted with Chairman Mao [on this issue], and the chairman maintained that [key] government offices had to be set up inside the city, whereas offices of lesser importance could be located in the new district." Abramov added, "We believe that this was the right decision, and the most economical one."[25] In 1949 Mao and his inner circles had already moved into Zhongnanhai, the new government compound in the former Imperial Palace, which instantly became the power center of the new regime. To the CCP, Tiananmen Square, close to Zhongnanhai, was a unique place invested with rich symbolic meaning. It was here, according to Mao, that the May Fourth student demonstrations began in 1919, marking "a new stage in China's bourgeois-democratic revolution against imperialism and feudalism," and which also eventually gave birth to the CCP in 1921.[26] Here Mao had proclaimed the founding of a new republic, making the square the birthplace both of the CCP and of the new socialist China, and thus a pivotal ideological link between past and present.

The Background of the Expansion of the Square

The expansion of Tiananmen Square was a complicated political decision involving four interrelated questions: Should the antique structures such as the original red walls on the east and west sides of the square and Zhonghua Gate be retained? What size should the future key buildings be in the vicinity of the square? What were the ideal dimensions of Tiananmen Square? Most important, what would characterize the spirit of the square? These questions can only be answered by tracing the square's intricate course of development.

In the Ming (1368–1644) and Qing (1644–1911) dynasties, Beijing was divided into the outer city, the inner city, the Imperial City, and the Forbidden City. Tiananmen Gate was the front gate of the Imperial City, an old palace ground in the form of a long narrow "T" (figure 3). The square, following the north-south axial line according to the classic *Rites of Zhou* (*Zhou Li*), is deeply rooted in China's architectural tradition. *The Rites of Zhou* dictates that the structures along the north-south axial line must be arranged in a well-articulated, symmetrical fashion. In the past, the square was enclosed on four sides to keep out commoners. After the Revolution of 1911, the Republican government opened the Left Chang'an Gate (known commonly as East Sanzuomen) and the Right

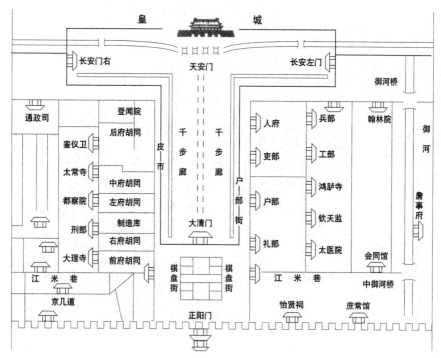

Figure 3. A sketch of Tiananmen Square in the Qing dynasty. *Source: Shijie bolan*, no. 2 (2008): 20.

Chang'an Gate (West Sanzuomen) on Chang'an Avenue near Tiananmen Gate.[27] Initial work to expand the square had already begun in earnest even before the PRC was founded. In late August 1949 the new Beiping Municipal Government, together with the MPC and the Public Security Bureau, had concluded that the part between East and West Sanzuomen would be expanded to make room for the founding ceremony on October 1. By the time it was completed in late September, the enlarged square could hold 160,000 people.[28] The initial reconstruction was limited in size, however, confined mainly to repainting the walls, erecting a flagstaff, building a temporary podium for the founding ceremony, and collecting trash from bygone eras.[29]

The enlargement of the square was at the heart of the Beijing redevelopment project, and it continued unabated. From 1950 to 1954 the MPC and other related departments had developed a total of fifteen reconstructing plans (figure 4).[30] The plans specified that the central portion of the square would house the major government buildings without altering the square's traditional "T" shape. To enlarge the space, in 1952 the municipal government tore down East and West Sanzuomen, thus broadening the area. It also replaced the temporary podium in front of Tiananmen Gate with a reinforced concrete one designed by architect Zhang Kaiji (1912–2006).[31] In 1955 the workers demolished the red walls on the east and west sides of the square, paved the floor with reinforced tiles, and enlarged the southern side so that it encompassed 12 hectares. But this was just the beginning. One of the plans, according to Zheng Tianxiang, was to further expand the square to "20 to 30 hectares in the future." "The central government's main offices," he added, "will be set up near Tiananmen Square or built along the avenues in the city's center."[32]

In August 1958, the expansion of Tiananmen Square took a momentous step. At an expanded meeting of the CCP Politburo in Beidaihe, east of Beijing, the delegates decided to build in the capital, in less than a year, a large number of major structures known collectively as the "National Day projects" (Guoqing gongcheng) to commemorate the tenth anniversary of the founding of the PRC in the following year. These projects had two major goals: the expansion of Tiananmen Square and the construction of ten key buildings—among them the Great Hall of the People, the Museums of the Chinese Revolution and of Chinese History, and the Cultural Palace of Nationalities—commonly known as the Ten Monumental Buildings (see chapter 2). By late 1958, the total number of the proposed National Day projects reached seventeen.[33] The Beidaihe decision was hailed as "historic," for it was the first time the new capital would undergo major reconstruction.[34] To carry it out the Municipal Party called together more than a thousand architects and artists countrywide to propose plans and chart the course of construction. In late 1958 Premier Zhou Enlai presented the final proposals to the Politburo, which then gave its final approval.[35]

The rebuilding of Tiananmen Square in 1958 proceeded at record speed. The end of 1958 saw the removal of the ancient Zhonghua Gate (built in 1420) on

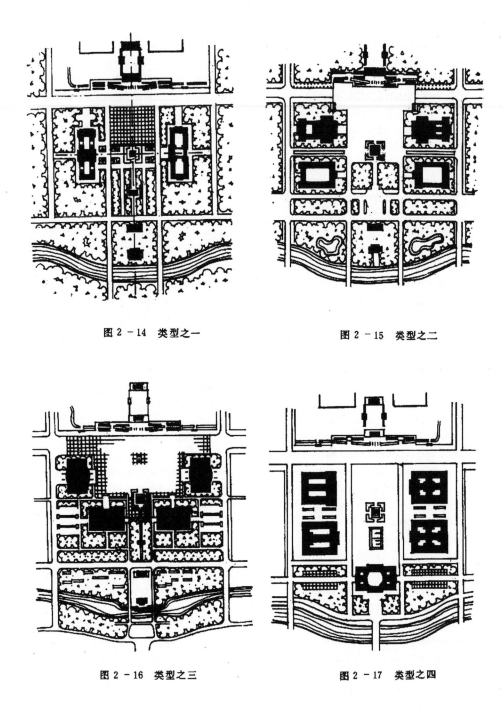

图 2 – 14 类型之一

图 2 – 15 类型之二

图 2 – 16 类型之三

图 2 – 17 类型之四

Figure 4. The four reconstruction plans for Tiananmen Square. *Source*: *Jianguo yilai de Beijing chengshi jianshe* (Beijing's city construction since the founding of the nation), ed. Beijing jianshe shishu bianji weiyuanhui (Beijing: n.p., 1986), 45.

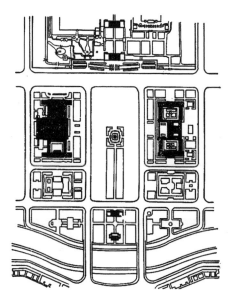

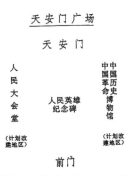

天 安 门 广 场

天 安 门

人民大会堂

人民英雄
纪念碑

中国革命博物馆　中国历史博物馆

（计划改建地区）　　　（计划改建地区）

前 门

Figure 5. The blueprint for the reconstruction design of Tiananmen Square, 1958–59. *Source*: *WW*, no. 9 (September 1977): 11; *WW*, no. 5 (May 1973): 10.

the square's southern side (now the site of the Chairman Mao Memorial Hall). The surface was paved with reinforced tiles, and power lines were buried underground. Chang'an Avenue in the north of the square was broadened from a width of 24 meters to 120 meters. A specific parade route was constructed that ran from Nanchizi in the east to Nanchang Street in the west, measuring 1,239 meters long and 80 meters wide, which would allow 120 paraders to march side by side. The original north-south central axis was clearly retained. Equally important, the widened and extended East and West Chang'an Avenues converged in front of Tiananmen Gate to form a new east-west axial line. The expanded square now reached 44 hectares, measuring 500 meters from the Museums of the Chinese Revolution and of Chinese History in the east to the Great Hall of the People in the west, and stretching 880 meters from Tiananmen Gate in the north to Zhengyang Gate in the south. The vast space could now hold five hundred thousand people in gatherings, and, with the additional space of nearby East and West Chang'an Avenues, the capacity was as much as one million (figure 5).[36]

The successive phases of the Tiananmen Square development required removing thousands of homes in the designated construction areas (figure 6), an event rarely reported in the official media. The demolition activities intensified in 1958, when a more ambitious expansion plan was ordered. The assignment fell to the vice mayor and head of the Public Security Bureau Feng Jiping (1911–83). The demolition work began on September 10, 1958, and "after 30 days of labor, on October 10, the resettlement task was basically completed." It was done at "unprecedented speed," noted one official report. In that short time, more than 16,000 houses were torn down, including 4,600 within the old Tiananmen

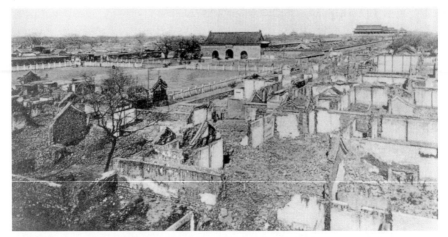

Figure 6. Demolition of nearby residential dwellings for the expansion of Tiananmen Square in the mid-1950s. In the middle is Zhonghua Gate before it was dismantled; in the far upper right is Tiananmen Gate. *Source*: *Shijie bolan*, no. 2 (2008): 20.

Square and 2,610 on the future site of the Great Hall. The project was guided by the principle of the "mass line," the report pointed out. Hasty preparations caused many to suffer, as "some workers dismantled houses, and cut down power lines and the water supply" before residents had evacuated.[37] Such a massive eviction was unprecedented in the modern history of Beijing, but under the grand vision of building socialism, it seemed trivial in the eyes of officials.

Influence of Soviet Advisers

A critical facet of the expansion of Tiananmen Square was the heavy involvement of Soviet advisers. Existing official literature in the PRC, however, says little about this episode of foreign aid, largely because the government downplayed the contributions of Russian advisers after the Sino-Soviet split in the late 1950s. In reality, however, archival sources amply demonstrated that the Soviet experts were active participants in the rebuilding of the capital. The differences in perceptions between the Chinese and Soviet advisers about the future Beijing and Tiananmen Square also spoke volumes about the political nature of the entire undertaking. Clearly the Communist leaders saw the expanded square as a potent symbol affirming their legitimacy to rule as well as to promulgate the principles of self-reliance and national independence. These principles were particularly pertinent in 1958, when the whole nation was engulfed in the Great Leap Forward, and when the gradual deterioration of Sino-Soviet relations prompted Mao and other senior leaders to seek a more independent road of development different from that of the Soviets.

When the Chinese Communists came to power they were utterly inexperienced in city planning, and so the Soviet model naturally caught their attention.[38] In the Beijing Municipal Party's early discussions of how to develop the future capital, its members repeatedly admitted: "We have to learn from the Soviet's advanced experience."[39] This view resonated among key architects such as Liang Sicheng. Liang strongly advocated an organic and holistic development of the city, and so, at least on the surface, he found the Soviet model of central planning attractive. After visiting the Soviet Union in May 1953, Liang praised the 1935 General Plan for the Reconstruction of Moscow as "an epoch-making historic document." He agreed that this plan "required architects to treat the city as an architectural whole made up of many individual units." The Moscow plan, according to Liang, demonstrated the "socialist content" in buildings such as young pioneer palaces and workers' clubs. The plan was also distinguished by the unity of the reconstruction, which was evident in the spatial relation between Moscow State University on Lenin Hill and the Palace of the Soviets, a design he called "in harmony."[40] The Soviets' experience of establishing specific committees, and their emphasis on the division of labor within a general framework of development, also deeply impressed the Chinese. In August 1951, for example, the MPC established three separate committees to design roads, gardens and parks, and rivers and lakes, a decision, the MPC acknowledged, influenced directly "by the Soviet Union."[41]

The Chinese government did not have a central office coordinating the invitation of Russian urban-planning experts. Different agencies made individual requests through the government according to their anticipated needs, thus causing confusion. Abramov and Barannikov were invited by the Municipal Government, and, in the early 1950s, the city planners A. S. Mukhin and D. D. Baragin were recruited by the State Council's Foreign Experts Bureau.[42] The two men were assigned to different units—Mukhin worked for the Construction Engineering Ministry and Baragin for the city's General Office of Urban Construction[43]—but the Municipal Government eagerly sought their advice nonetheless.

Keeping with Stalin's policy of "socialist in content and nationalistic in form," Mukhin encouraged Chinese experts to create structures rich in national style.[44] In Mukhin's words:

> It is necessary to have a few centers, but there should also be a "principal center," where the central Party and government as well as municipal organizations should be concentrated. In planning a central district, first and foremost is a major public square surrounded by big buildings. Or a few commercial centers could be connected by major roads. Each center should represent some kind of architectural art that forms the backbone of the metropolis.[45]

Essentially Mukhin's views differed little from Abramov's and Barannikov's, especially over the single city center. But setting him apart from others was that

his development plan was more comprehensive, and he valued immensely the artistic nature of architecture and favored keeping the city's old walls.[46] This perhaps explains why Liang spoke highly of Mukhin despite the former's differences with many Soviet city planners.

In the eyes of many Chinese, Baragin was an iconoclast. Although he admired Beijing's time-honored north-south central axial design—the previously mentioned eight-kilometer-long line stretching from Bell and Drum Towers in the north to Yongding Gate in the south—he did not see it as sacred and untouchable. During a discussion with his Chinese counterparts about the future Beijing, Baragin penciled in a line extending the central axis northward beyond where the Bell and Drum Towers stood. This unusual suggestion startled Chinese architects. As the city planner Li Zhun (b. 1923) recalled, "Baragin called this line 'the extension of the central axis.' What a radical idea! We would never dare do that."[47] Though many marveled at Baragin's idea, extending the central axis meant a fundamental reconception of traditional spatial thinking, which, at the time, was unacceptable to the Chinese.

In February 1955 the government established a new organization, the Municipal Development Committee (Dushi guihua weiyuanhui; MDC), to replace the original Municipal Planning Committee. Headed by Zheng Tianxiang, the name "MDC" suggested that future construction would become more systematic and better coordinated, with a strategy well thought out, especially concerning the development of Tiananmen Square. Two months later the Municipal Government recruited another group of Soviet experts as consultants to "conduct research and devise an overall development plan."[48]

Headed by the city planner S. A. Boldyrev, the nine-member group included the urban design experts V. K. Zmievskii and G. A. Aseev, the economist A. A. Iunina, the public transportation consultant G. M. Smirnov, and specialists in gas- and water-supply systems. Members arrived in Beijing separately in April and July 1955, and they were received by Mayor Peng Zhen himself, a signal of the nation's respect. The Soviet advisers' appointment was for two years, and most returned home after their contracts expired at the end of 1957. But some, like Boldyrev, extended their contracts to provide continuing help. Because of their lengthy stay, some were even accompanied by their wives, Aseev for one.[49] Though they were not considered first-rank in their home country, the Soviet specialists were highly respected veterans in their own fields. Boldyrev, for instance, had directed the Construction Planning Workshop of the Moscow Overall Planning Academy, and Aseev had once led the construction unit at the Moscow Design Institute (figure 7).[50] The Chinese had prepared a tight working schedule for them (including learning the Chinese language) and assigned them into units for overall planning, urban administration, transportation, energy, and construction.[51] The Russians also delivered lectures on urban planning to the MDC staff.[52] Among the works Boldyrev and his associates supervised, the Tiananmen Square project was considered one of the most important.

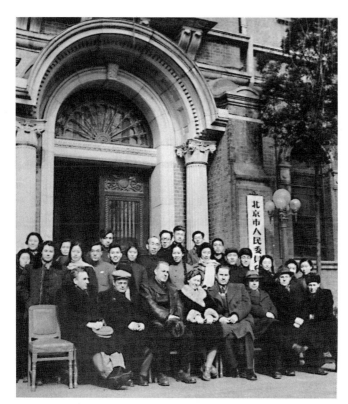

Figure 7. Soviet experts and the Chinese translation team (1956). *Source: Dangshi dashi tiaomu, 1949–1992* (Major events in the history of the CCP, 1949–1992), ed. Beijingshi chengshi guihua guanliju and Beijingshi chengshi guihua sheji yanjiuyuan dangshi zhengji bangongshi (Beijing: n.p., 1995), photo.

In addition to Boldyrev, two other members, Zmievskii and Aseev, were also actively engaged in this assignment. Boldyrev and Zmievskii focused on formulating the overall plan of both Tiananmen Square and the city, and Aseev was responsible for specific design works.

As mentioned before, the MPC's first series of fifteen Tiananmen Square reconstruction proposals made from 1950 to 1954 envisioned a square of "20 to 30 hectares," with its traditional "T" shape intact. But in 1955 Boldyrev and his team, working under the new MDC, proposed ten additional plans that offered three major suggestions: no key edifices would be erected inside the square; the proposed buildings surrounding the square should not be higher than Tiananmen Gate; and the work should preserve Tiananmen Gate (the front gate of the Imperial Palace) and Zhengyang Gate (the main gate of the inner city).[53]

On closer inspection, the new proposals clearly suggest that they were primarily inspired by the 1935 General Plan for the Reconstruction of Moscow, first promoted by Barannikov as early as 1949 in his report on Beijing's future development.[54] A later statement issued by the Municipal Government in November 1953 had seriously entertained the Moscow plan as a possible blueprint for China's new capital.[55] This time Boldyrev was even more enthusiastic in selling the

Russian plan to the Chinese, as he outlined it repeatedly in a number of talks delivered at MDC meetings.[56]

Certainly the 1935 General Plan for the Reconstruction of Moscow had a major impact on the radial design of the Soviet capital and beyond. The architects of the plan were the city planner V. Semenov and the architect S. Chernyshev, who, with Stalin's approval, carried out a large-scale remodeling of the Soviet capital. The guiding principle was to preserve Moscow's traditional center, with the Kremlin as the heart of the city, and develop the city into a shining modern metropolis along a long-established radial pattern. The proposals encompassed five key features:

- limiting the city's residents to no more than 5 million (Moscow's population was 3.6 million in 1936) and stopping industrial expansion to avoid the influx of large numbers of workers;
- revamping the transportation network, widening the main roads, and building a subway system and additional railways;
- expanding the size of the city by dividing it into thirteen residential, industrial, and recreational districts and developing each district in harmony with the rest of the city;
- creating abundant green zones; and
- doubling the size of Red Square.[57]

The remodeling of Red Square was essential to this grand redevelopment plan. The making of the modern Red Square had actually started well before 1935. In 1930 the architect Aleksei Shchusev designed a permanent granite and marble Lenin Mausoleum that was at the center of Red Square and on the same central axis with the Supreme Soviet buildings in the Kremlin, replacing the two successive wooden structures of the Lenin grave built in 1924. Red Square instantly became the permanent sacred site of the socialist revolution. Atop the Lenin Mausoleum a platform was added for Soviet Party officials to review the festive parades celebrating May Day and the October Revolution. Before 1935 Stalin had removed the old city gate in the northern end of Red Square so that military and parade groups could march in from the expanded Gorky Street (now Tverskaya Street) and move freely through the newly built Manezhnaya Square to Red Square. After 1935 the borders of Manezhnaya Square were further expanded to broaden the area of Red Square.

Closely related to the redevelopment of Red Square was the widening of main avenues in its vicinity, most prominent among them the Gorky Street project north of the square headed by the renowned architect A. G. Mordvinov.[58] Mordvinov had dismantled several churches along the street, erected tall buildings, and increased the width of the roads carrying heavy traffic to Red Square from 16 to 18 meters wide to 49 to 61 meters.[59] The broadening of major roads and the retention of the radial pattern were, indeed, the most critical aspects of the 1935 plan, as all main arteries now converged on Red Square and the Kremlin, drawing Moscow into a singular unit. After the restoration, Red Square was turned

into an even more powerful symbol as both the site of Soviet authority and the grand stage of the world's first proletarian revolution. Here May Day and the October Revolution were celebrated with dazzling marches and military parades. Stalin's close aide, Lazar Kaganovich, expressed it well: *"My* aesthetics demands that the demonstration processions from the six districts of Moscow should all pour into Red Square at the same time."[60]

The sweeping remake of Moscow is reminiscent of the nineteenth-century reconstruction of Paris by the French architect Georges-Eugène Haussmann. That epoch-making project transformed the French capital into a world-famous city lined with grand boulevards, efficient transportation networks, and stately monuments everywhere. In the Soviet case, the Moscow reconstruction project had far-reaching repercussions domestically and internationally. By the beginning of the Second World War, three hundred cities had already been rebuilt according to the Moscow model.[61] Stalin did not simply demand a city reconstruction; he wanted to transform Moscow into a modern international metropolis, and, more important, to mold it as the mecca for all socialist nations.[62] The renovated Red Square was mute testimony to the Soviet ruler's grand vision of world revolution.

The expanded Tiananmen Square, too, was shaped in the image of Red Square, as the Soviet advisers had energetically promoted. Although Beijing and Moscow were laid out differently—the former a rectangular grid and the latter a web of concentric orbits—both had a single center that was the seat of national power. The Soviets' plan thus reinforced the senior Chinese Communists' basic conviction that the new government headquarters should be located in the old city. Deep down, however, the Chinese leaders did not want to make Tiananmen Square merely an exact replica of Red Square; they wanted to create a new political space, with distinct Chinese characteristics, that would surpass its Soviet counterpart in design and symbolic significance.

The Size of Tiananmen Square

In the early 1950s planners had two opposing visions for the expansion of Tiananmen Square. Some believed that the square should be seen as a symbol of the nation's political authority and thus should be surrounded by major government buildings. Others wanted this vast space to become a cultural hub with libraries and museums as its principal structures.[63] Boldyrev and Aseev favored the former view, suggesting that solemn memorial halls be constructed for the proletarian revolutionaries and martyrs. As a political center, it should not be a location for public activities with massive assemblies of crowds and traffic jams. These Soviet planners surely had Red Square at the back of their minds when they presented this argument. The architect Zhang Bo (1911–99), who was a student of Liang Sicheng and who had worked with the Soviet experts, described their concept as "an integration of commemorative and political characteristics."[64]

Boldyrev's and Aseev's proposals accorded with their Chinese hosts' initial conception, which never seriously entertained the cultural option. As early as September 30, 1949, on the eve of the founding of the PRC, the People's Consultative Conference had decided to erect the Monument to the People's Heroes in Tiananmen Square—the very first structure at the site—to commemorate past Chinese martyrs who gave their lives for the eventual triumph of the Chinese Revolution in 1949 (see chapter 10). Several years later, in 1959, this integration of politics and commemoration became even more pronounced with the completion of the Great Hall of the People and the Museums of the Chinese Revolution and of Chinese History (today's National Museum of China), located, respectively, at the western and eastern edges of Tiananmen Square. The Soviet team's advice encouraged the Chinese officials to pursue their future development plan for the square.

However, a fundamental question remained that was hotly debated: How big should Tiananmen Square be? Some said that, in 1958, Mao Zedong's instructions were to build "a square to hold a million people" in the capital,[65] but there is no archival evidence to substantiate this statement. Sources indicate that suggestions were made at municipal meetings to enlarge the square to an area of 20, 30, or 50 hectares.[66] But a bigger Tiananmen Square was not what the Soviet advisers envisioned. Indeed, Baragin and Aseev favored a smaller plan, as Beijing's urban population at that time was only 1.4 million, and most of the city squares in the world were only about "5 or 6 hectares," not large at all.[67] Baragin believed that a public square could at most be "expanded to 25 hectares but certainly not to 40 hectares." In his words, "a 40-hectare square could no longer be called a square; it would resemble Leningrad's drill grounds." "Red Square," he noted, "is not gigantic, and not that many people march through [the square] in parades."[68] Zmievskii concurred, contending that if Tiananmen Square were too huge, it would be "difficult to construct buildings in correct proportion [to it], creating unsightly views."[69] Chinese officials and architects strongly opposed the Soviet advisers' views, maintaining that Tiananmen Square should be much larger to reflect the undeniable fact that China was the most populous country in the world. Moreover, because Tiananmen Square was the "center for mass parades and rallies" during major political events, it had to be made bigger.[70] Beijing's vice mayor Xue Zizheng (1905–80) worried that the current square's limited space had become a hindrance to holding mass rallies and military parades on May Day and National Day, and so he declared "a pressing need to expand the square."[71]

In 1956 Peng Zhen issued a clear instruction:

Tiananmen Square must be made bigger, it should not be too small. But whether it should be extended to Zhengyang Gate is undecided. Don't tell me that we cannot build one just because no such colossal square now exists in the world. . . . Before the October Revolution there was not a single socialist country in the world, so did that mean that Lenin should not have started one? This

is a reactionary, archaic thought. [Making Tiananmen Square bigger] is a practical necessity.[72]

And, Peng added emphatically, "We cannot always follow the actions of others but must guide our behavior based on specific circumstances and practical needs."[73]

Also controversial was the future shape of the expanded Tiananmen Square. The issue was whether it should retain the age-old rectangular form or somehow be reshaped. The Soviet advisers at first proposed several shapes, including a semicircle, a polygon, and a rectangle.[74] Baragin favored the semicircle, believing it would be "an aesthetic addition."[75] The Chinese rejected the semicircle and the polygon, and they continued to adhere to the city's traditional rectangular design, with its architecture running north and south. After heated discussions, the Russians agreed that if the main purpose of the square was for national parades or mass rallies, then a semicircle or a polygon would not be the ideal form, for it would limit the maximum use of space in the area.[76] The determination of the Chinese to keep the existing layout of the capital finally prevailed. Aseev was quick to add that Red Square was, after all, "rectangular."[77] Surely this dispute over the shape of Tiananmen Square reflected differences in each side's historical perspective. The Chinese firmly believed that the future Tiananmen Square should not only closely resemble the original rectangular design but should also retain the traditional symmetry between the left and right sides as well as a prominent central north-south axial line running through it. The Soviets were never bound by this historical legacy. The Kremlin was actually a group of buildings arranged in a triangle, and the right and left sides did not appear symmetrical. But even if one accepts Aseev's argument that Red Square was rectangular, it still differed from Tiananmen Square in that Tiananmen ran north and south, whereas Red Square extended between the northwest and the southeast. The Chinese officials' insistence on the traditional shape for the square should not be labeled merely anachronistic nostalgia, for it actually emphasized the Chinese Communist leaders' continual quest for an indigenous identity, for a site they could use to build national pride.

The Width of Chang'an Avenue

Another bone of contention between the Chinese and Soviet city planners was the expansion of Chang'an Avenue, a pivotal component of the overall Tiananmen expansion plan, as it was the major artery in front of Tiananmen Gate. In the early 1950s the Chinese experts envisioned four types of roads with different widths for the future Beijing: grand boulevards would be 110 to 120 meters wide; somewhat less impressive thoroughfares, 60 to 90 meters wide; still less imposing types, 40 to 50 meters wide; and narrow branch roads, 30 to 40 meters wide.[78] However, the Soviets thought these widths were excessive, beyond the city's practical needs, as few people owned cars and Beijing traffic volume was

moderate.[79] This reasoning once again was based on experience in the Soviet Union, as Boldyrev opined that "streets in Moscow are mostly 40, 50, or 60 meters wide and hardly ever exceed 60 meters."[80] A more recent comparison for the Soviets was the broadened Gorky Street; although it was one of Moscow's principal thoroughfares for its theaters, hotels, new apartment blocks, and meticulous planning, it was merely 61 meters at its widest point. When Soviet advisers learned that some Chinese officials had gone even further than their original plan and suggested broadening East Chang'an Avenue from Dongdan to the Beijing Hotel to 140 meters, they criticized it as "a terrifying thought."[81]

The Soviets' proposals of a narrower Chang'an Avenue found few supporters among the Chinese, but they struck a chord with Liang Sicheng. Although Liang had rejected the Russians' advice to establish the administrative center in the old city, he concurred with their proposal to only moderately expand the width of East and West Chang'an Avenues. Liang feared that unwarranted expansion of the avenues meant needless demolition of homes, and, in any case, "if West Chang'an Avenue is too wide, it would take eleven seconds for a short-distance runner to cross it; as for the general public, it would require one minute; for an elderly lady with bound feet, it would be even more difficult [to traverse]."[82] A harmonious mix with its milieu, not disproportionate size, was the cornerstone of road designs, said Liang. His ideal plan was to turn Chang'an Avenue into "a tree-lined boulevard."[83]

Liang's rejection of a very broad Chang'an Avenue reflected his greater concern: the needless destruction of antiquated buildings in the old capital. This pitted him against powerful officials such as Mayor Peng Zhen, who envisioned a very different Beijing. A case in point was the government's removal in 1952, despite Liang's impassioned pleas to the contrary, of East and West Sanzuomen at the two ends of Tiananmen Square, which were perceived as obsolete physical structures obstructing processions during the annual National Day parade.[84] Liang argued that the arbitrary removal of ancient gates would cause irreparable damage to the architectural unity of the Forbidden City. It would be "foolish," said Liang, to criticize age-old walls and traditional gates as worthless relics from the feudal past. These structures were an invaluable cultural heritage with unique native characteristics. As Liang stated:

> Isn't it true that the Forbidden City was formerly an Imperial Palace but today has become the people's museum? Isn't it true that Tiananmen Gate was formerly the front gate of the palace but is now the birthplace of the People's Republic of China, announced to the world by Chairman Mao? Do not forget, all these architectural relics are masterpieces created by countless laboring people from ancient times.[85]

On one occasion, Liang spoke with indignant sarcasm, saying, "I suggest that we also demolish the Forbidden City!" He continued, "We are doing a great disservice to our descendants and letting our ancestors down if we do not cherish

cultural artifacts. . . . Fifty years from now, someone will regret this."[86] The officials disagreed with Liang. Old city walls and gates, they contended, were now dilapidated, and many of them had even collapsed, posing a great danger to the people and causing problems for everyday traffic. Senior Municipal Party officials, such as Zheng Tianxiang and Liu Ren (1909–73), advocated demolishing most of these walls. Mayor Peng Zhen agreed: "I firmly support the demolition of Beijing's city walls. We only need to preserve a few sections of the Great Wall, which will sufficiently represent these cultural relics."[87] But the final decision came from the very top of the CCP. Mao made it clear in 1953: "Such important decisions as the erection of the Monument to the People's Heroes in Tiananmen Square and the demolition of Beijing's city walls were made by the Central Committee and carried out by the government."[88] Party officials later criticized Liang's fervent calls to preserve the city walls as "bourgeois thoughts."[89]

In disagreeing with their Soviet counterparts and with Liang Sicheng about the width of Chang'an Avenue, most Chinese experts were concerned about the serious traffic congestion in the world's largest cities, and they believed it was wise to widen the main thoroughfares now in preparation for future development.[90] They also argued that there was an urgent military consideration; under the threat of the imperialists' air assault, according to Zhang Bo, the Beijing thoroughfares had to be built bigger and wider so they could be used as runways for small airplanes and helicopters in times of emergency.[91] Mayor Peng Zhen endorsed this idea as well. At a meeting of the Standing Committee of the Municipal Party in October 1956, Peng delivered an important speech, "Issues Concerning Beijing's City Planning," in which he disclosed Chairman Mao's concept of a very large Beijing. The mayor said, "Chairman Mao asked: 'Shouldn't we have 10 million people in Beijing? In the future everyone wants to come here, what can you do?' Here is my personal thought: the city's population will reach five million in the future and then it could exceed ten million. This trend is inevitable whether you like it or not." Peng said that he was aware of the traffic problems in London, Tokyo, Paris, and New York; the situation in Moscow was also not getting better. "We must learn from this kind of experience," he added. Finally, Peng Zhen concluded, "The roads [in Beijing] cannot be too narrow. It was suggested in 1953 that the road from Dongdan to Xidan be widened to 90 meters, but this idea was criticized as 'Big Road Chauvinism.' Big Road Chauvinism? So be it! Don't be afraid; what is important is that it meets our developmental needs. . . . The problem for us is that the roads are too narrow, never that they are too wide."[92] The root issue concerning Chang'an Avenue, of course, was never just the traffic. More important, the thoroughfare was to provide ample space for grand parades and political rallies. Archival sources indicate that, as early as 1950, congestion during the May Day and May Fourth parades caused grave concern among senior officials. Nie Rongzhen (1899–1992), then mayor of Beijing, reported that "the narrowness of East and West Chang'an Gates could only allow twenty-three people to pass through side by side. . . . With a total

number of two hundred thousand marchers, it would take four and a half hours to conclude the entire procession. The traffic was jammed and the participants exhausted."[93] Thus a suggestion was made in 1950 to build a "parade pathway" so as to "accommodate a mass procession of one million people in the future."[94]

Questions about the mass and height of structures occur commonly in architecture. Politically, such questions mostly involve the symbolic meanings the structures will convey. That a structure's height may be seen to signify the strength of a political power was vividly illustrated when the new Soviet government, in 1919, recruited the Russian constructivist sculptor Vladimir Tatlin to design the Monument to the Third International. Tatlin's plan envisioned the monument at a height greater than 400 meters, surpassing the stature of the Eiffel Tower in Paris, which reached 320 meters.[95] This colossal Russian edifice was to demonstrate to the world that the brilliant achievements of socialism had far exceeded those of capitalism.

In envisioning a new Beijing, senior CCP leaders also emphasized a structure's grand size and height. Once again Mao was directly involved in the major decisions. In his memoir, Zheng Tianxiang recalled:

> Dozens of proposals and countless suggestions were made on the design and layout of Tiananmen Square. Finally, everything was settled by Chairman Mao's personal instructions to Comrade Peng Zhen at Tiananmen Gate. . . . Following Chairman Mao's directions, Tiananmen Square was transformed into a magnificent site, simple in layout but solemn in appearance. The square is 500 meters wide from east to west, and 860 meters long from Tiananmen Gate to Zhengyang Gate, a total area of more than 40 hectares.[96]

The expansion of Tiananmen Square and the widening of Chang'an Avenue, forming a new east-to-west axial line, created a new spatial layout in Beijing. It also reflected a time when China was at a crossroads in its search for a way to build socialism with native colors. In 1958 the frenzied Great Leap Forward was in full force. The gradual deterioration of Sino-Soviet relations in the late 1950s also prompted Mao to find a different path for China's development. Even when Soviet models of urban planning were endorsed in the mid-1950s, Chinese officials were often quick to point out that "we need to make foreign things serve China and choose our own path."[97] Peng Zhen was even more explicit. In his view, the purpose of broadening the main arteries was to meet China's practical needs, "not to create something to be viewed by foreigners."[98] In that light, it was clear that Chinese officials and architects wanted to build a public square in central Beijing that was different from Red Square. When the expansion project was completed in 1959, Tiananmen Square's mammoth size of 44 hectares dwarfed the 9-hectare Red Square by a wide margin. The expanded square acquired new symbolic meaning: because Tiananmen Square was far larger than Red Square, it was superior to that Soviet landmark and made Beijing, not Moscow, the center of the socialist world. This implicit belief was further solidified when, in December 1959, the Soviets requested permission from the Chinese government

to send a team of three experts to Beijing to learn about the construction and design of the Great Hall of the People.[99] In addition to the prestige this gave the Chinese, the newly expanded square created a novel political space at the heart of the city. According to one official text: "It forever changed the old concept that the Forbidden City was the very heart of the old city. Instead, the new layout reflected the center of a socialist capital where the laboring people were now in charge."[100] The expanded square symbolically shifted the nation's focal point from the Forbidden City to the new space in front of the antiquated Tiananmen Gate, the main entrance to the Imperial Palace in the Ming and Qing dynasties. As such, it signifies a break with the detested past and the creation of a novel era. In the words of the historian Hou Renzhi and the architect Wu Liangyong, the Forbidden City, the symbol of the imperial past, had "retreated to occupy a secondary position, something like the 'backyard' of the public square."[101]

The Political Nature of the Square

The concept of the public square originated in the West. The Roman architect Vitruvius, in his famous *Ten Books of Architecture*, wrote that public squares (he called them "forums") played a vital role in city life. Vitruvius saw squares closely tied to the daily activities of the general public. The design of a square thus depended on the size of the city's population and the livelihoods of its citizens; too small a square would have no significance in people's lives, but too big a square would make the area appear "deserted."[102] The Renaissance scholar Leon Battista Alberti followed the same argument, but he gave it a more practical interpretation. What impressed Alberti most about the Italian piazza, for example, was its pluralistic nature that embodied two qualities: the host of daily activities and the different shapes and sizes of the piazzas.[103] The late-nineteenth-century city planner Camillo Sitte, in his study of public squares in Europe from the Middle Ages to the Renaissance, depicted urban squares more colorfully: in the square "people trafficked, public celebrations took place, plays were put on, state proceedings were carried out, laws proclaimed, and so on."[104] These various activities later became the fundamental characteristics of public squares in the West.

The traditional European public squares, however, were not all carefully planned; many were surrounded by buildings, not all of them were large, and, as Alberti pointed out earlier, they reflected various shapes from the typical rectangle to Florence's pentagonal Piazza di Santa Maria Novella. By the seventeenth and eighteenth centuries, large public squares gradually became popular.[105] A driving force in this change was the French Revolution, when the revolutionaries envisioned a larger open space to air the people's democratic appeals. Such uninhibited spaces, according to Mona Ozouf, were built "in the open, [and] in the healthy neutrality of a free space, all distinctions seemed to fall away," a marked difference from the traditional, aristocratic plazas that were

"enclosed, divided, and isolated."[106] After the Revolution, the French rebuilt the Place Louis XV in the center of Paris, renamed it Place de la Révolution, and then again renamed it Place de la Concorde. Public squares in modern-day Europe, North America, and Latin America have inherited these open, spacious, uninhibited characteristics conducive to festive activities where citizens can relax and speak their minds openly.[107]

Unlike public squares in the West, however, Tiananmen Square is a political space serving only the interests of the CCP. Despite its vast, open area, this is a closed, government-controlled territory under close supervision. When Mao proclaimed the founding of the People's Republic atop Tiananmen Gate in 1949 and held a grand parade of celebrations, the nature of Tiananmen Square had already been unambiguously established. In 1959, when the Great Hall of the People and the Museums of the Chinese Revolution and of Chinese History were built, this vast landscape was further cemented as the political center of the entire nation. It became an ideal setting for grand parades on May Day and National Day to rekindle the spirit of socialist revolution (see chapter 4), and a convenient platform for mass rallies denouncing imperialist powers, as in the case of the Resist America, Aid Korea Campaign in the early 1950s. But in the CCP's propaganda machine, Tiananmen Square was more than a political space, it was also a "people's square."[108] Here major political campaigns were directed and disseminated from on high in the name of the people. This people's square in Beijing became a model for other cities to follow, and similar settings were extensively built in major cities, including Shanghai and Tianjin, to reaffirm the Party's rule.[109]

What did the masses really think about a square built in their name? One searches in vain for an answer in a land where the media is controlled by the Party and direct criticism of the government is forbidden. In one instance, however, the architect Luo Jianmin questioned the public benefit of the new square in the article "An Evaluation of the Design of Tiananmen Square," published in the authoritative *Architectural Journal* (*Jianzhu xuebao*) in May 1981, under the more relaxed policies of Deng Xiaoping (1904–97). Luo stepped into the treacherous political terrain and raised what he called "three questions worthy of investigation" concerning Tiananmen Square. The article deserves to be quoted at length:

> Tiananmen Square is a world renowned public square. . . . But as time goes by, one increasingly finds features of its overall planning that do not meet the needs of society. . . .
> A number of problems are worthy of our attention:
> 1. [The designers] merely underscored the political purposes of the square but overlooked the other functions that the city hoped the square would provide.
> Tiananmen Square lies at the heart of Beijing. Not only is it the political center of the capital, it is also, from the perspective of city planning, the center of

transportation, architecture, and other important functions. . . . These daily activities are more practical and important than the sporadically held festivals and parades.

However, in the initial stage of design to determine the nature of the square, the decisive factor was to build a square that could hold "a million people in grand assembly." Thus the political importance of parades and assemblies overrode the practical needs of the city, reversing the primary and secondary functions of the square. . . . During the festivals and parades, one hundred thousand people will be gathered here to display formations embellished by colorful flowers and bright costumes. A gigantic decorative arrangement of one hundred thousand people can only be seen by a few leaders standing atop Tiananmen. As for those thousands and thousands of participants who are lost in the waves of flags and banners and under the scorching sun, they are unable to see anything.

2. The buildings surrounding the square are monotonous.

To maximize the full intent of Tiananmen Square, its surroundings should be endowed with a rich array of magnificent buildings. But as it turns out, in this regard the current square has a major functional defect. At present, there are only political and commemorative structures but no necessary cultural, educational, and social service buildings. . .

3. The land in the square is poorly utilized.

. . . Tiananmen Square appears to have been designed only with a large open space [in mind], leaving the buildings loosely scattered and its land underutilized.[110]

Luo Jianmin suggested a number of improvements to make the square more attractive to the public: plant more trees, construct fountains, build a national theater and youth clubs, install sculptures and cultural displays, and establish a plan to regulate traffic in the square.

Similar to Liang Sicheng's criticism, Luo's main objection to the overall Tiananmen Square project was the domination of its political purpose. This, however, was exactly what Mao and his senior associates had intended, especially in their manipulation of the vast space as a demonstration of the CCP's supreme authority and great achievements. Luo's observation that while national leaders could see the participants in national parades in Tiananmen Square, the participants could see almost nothing of the great assembly resembled what the Russian scholar Vladimir Paperny observed in his study of Stalin's parades in Red Square. "Who," Paperny asked, "were the spectators of the pompous parades and demonstrations of the 1930s? In the pre-television age, who could see them but a few Party leaders standing on top of Lenin's Tomb? . . . the leaders were not the audience, they were the actors, while the demonstrators acted as [the] audience . . . the 'nonparticipating, but applauding' audience was 'hauled' in front of the stage to give everybody a chance to see the 'king and his staff'."[111] In the Chinese case, Mao and his associates obviously worked steadfastly to create an indigenous political space in Tiananmen Square that would be different from

Red Square, although initially their admiration for the Russian site had inspired their early planning. But despite their differences, the fundamental nature of the two squares remained the same: they were created to serve the ideological interests of the two communist parties.

The expansion of Tiananmen Square after 1949 was a crucial symbolic move by the CCP to emphasize its rule and establish its legitimacy through the manipulation of a new political space. The Party transformed a traditional, enclosed sacred space at the heart of Beijing into a new ideological arena.

Although the Chinese Communists had created, in theory, a new regime based on socialist doctrines, still they appealed forcefully to the populace's support based on nationalistic sentiments. To be sure, nationalism was one of the most influential ideologies in modern Chinese history; it bitterly reminded the Chinese of their nation's past history of humiliation under foreign domination, and, more important, it was an indispensable motivating force for affirming China's sovereignty. Searching for a native Chinese approach to development stemmed largely from a passionate nationalistic response to external aggression. Peng Zhen's saying, "We cannot always follow the actions of others," summed up this feeling well. Although the expansion of Tiananmen Square was heavily influenced by the design of Red Square, the CCP would not and could not follow in lockstep the Soviet model when planning its own sacred political space. Doing so would have seriously undermined the CCP's legitimacy to rule based on national independence. Building a square five times larger than its Soviet counterpart was necessary, not just because China was the most populous country in the world, but, more important, because China under Mao would realize that its own road of development was far superior to that of its estranged teacher, the Soviets. Tiananmen Square was a national symbol of pride and patriotism.

From the viewpoint of political history, the development of Tiananmen Square symbolized the CCP's consolidation of both its internal authority and external policies versus the Soviet Union and Western imperialist powers. In the 1950s Tiananmen Square gradually evolved from an enclosed palace square of the Ming and Qing dynasties to become one of the largest public squares in the world. Ironically, although the old palace walls were torn down, vastly expanding the once confined space, today Tiananmen Square is one of the most restricted sites in the world, an area under the tight political control of an authoritarian state.

2. Ten Monumental Buildings
Architecture of Power

Political power is typically exercised through military might, an entrenched bureaucracy, public ceremonies and parades, and, in Weberian terms, a charismatic leader. But, as Harold Lasswell has noted, power can also be fully displayed through new architecture and imposing buildings.[1] In the past, politicians created and used new edifices and novel urban space to assert their authority and affirm their legitimacy to rule. The most widely known modern examples of power manifested as architecture may be the grandiose building programs initiated by Joseph Stalin in the Soviet Union and Adolf Hitler in Nazi Germany. Stalin's 1935 General Plan for the Reconstruction of Moscow was presented to the world as the model of urban redevelopment, and it trumpeted Moscow as the workers' capital of the world. The plan would have turned Moscow into a city crisscrossed by grand boulevards and massive buildings rivaling those of Paris and Rome. Most important, the socialist city would be crowned by a towering monument to Lenin—the Palace of the Soviets—a paean to the glories and supremacy of Soviet Communism.[2] Similarly, Hitler accorded architecture a most prestigious position. "Every great period," the Nazi leader once said, "finds the final expression of its value in its buildings."[3] Indeed, he believed that architecture symbolized the unity and power of the great German nation, and this formed the core of his ostentatious schemes of redesigning Berlin and Nuremberg. In Hitler's vision, the new Berlin, planned by his chief architect Albert Speer, would be not only the capital of the Third Reich but also the center of Europe's new order.[4]

Following the similar undertakings of European political leaders, Mao and his senior associates, after the founding of the People's Republic, used new architecture and huge buildings as forceful manifestations of their authority, reshaping the new capital into their own image. In addition to the expansion of Tiananmen Square, at the meeting of the Politburo in Beidaihe in August 1958, the CCP announced that the construction of Ten Monumental Buildings would be completed in a year to celebrate the tenth anniversary of the founding of the PRC. However, the decision to build ten huge buildings in Beijing has to be

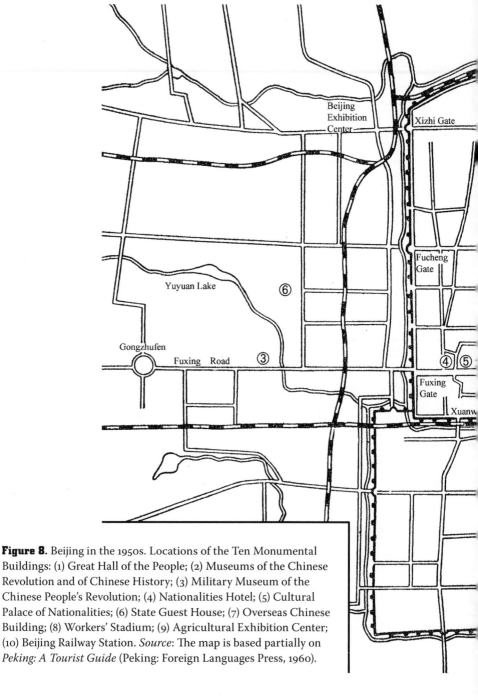

Figure 8. Beijing in the 1950s. Locations of the Ten Monumental Buildings: (1) Great Hall of the People; (2) Museums of the Chinese Revolution and of Chinese History; (3) Military Museum of the Chinese People's Revolution; (4) Nationalities Hotel; (5) Cultural Palace of Nationalities; (6) State Guest House; (7) Overseas Chinese Building; (8) Workers' Stadium; (9) Agricultural Exhibition Center; (10) Beijing Railway Station. *Source*: The map is based partially on *Peking: A Tourist Guide* (Peking: Foreign Languages Press, 1960).

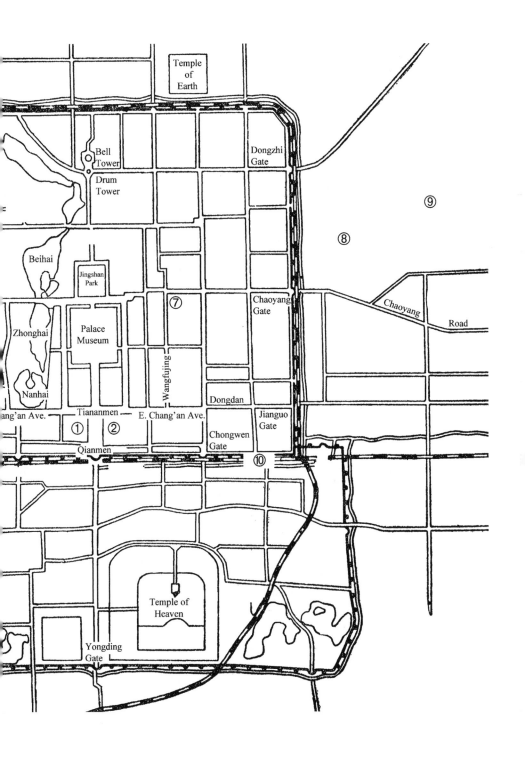

Temple
of
Earth

Bell
Tower

Drum
Tower

Dongzhi
Gate

⑨

⑧

Beihai

Jingshan
Park

Chaoyang
Gate

Chaoyang

Road

Zhonghai

Palace
Museum

⑦

Wangfujing

Nanhai

Dongdan

Jianguo
Gate

ang'an Ave. Tiananmen E. Chang'an Ave.

Chongwen
Gate

① ②

Qianmen

⑩

Temple
of
Heaven

Yongding
Gate

placed within specific historical contexts. The Great Leap Forward unleashed by Mao was then in full swing; included in this aggressive campaign was the drive to rapidly modernize the nation both industrially and agriculturally, and to build an advanced socialist state. Politically, the building program also underscored Mao's determination to find a unique Chinese road to socialism that was distinct from the Soviet model. As it turned out, however, the Ten Monumental Buildings were hurried products infused with strong national pride. The Beidaihe announcement also came on the heels of an official campaign, in 1955, against the traditional architectural style commonly known as *dawuding*, or "big roof," characterized by a curved roof with overhanging eaves. The principal advocate of that ancient design was Liang Sicheng. The government criticized Liang's fervent promotion of traditional Chinese architectural styles and protection of historic buildings as "a return to antiquity," practicing "formalism" and engaging in "waste" and "excessiveness" in a time of limited national resources.[5] However, the traditional architectural style soon resurfaced in the Ten Monumental Buildings project to affirm, once again, the value of China's identity.

When the ten buildings were officially unveiled on National Day, October 1, 1959 (figure 8), among them were the Great Hall of the People (figures 9, 10, 11, and 12), the Museums of the Chinese Revolution and of Chinese History

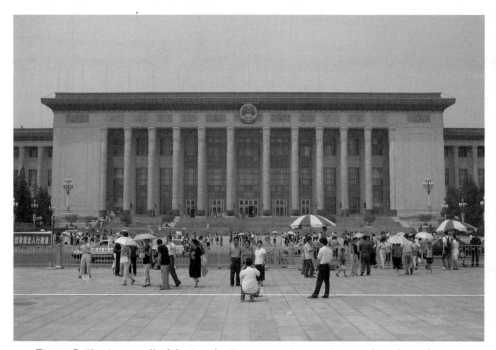

Figure 9. The Great Hall of the People, Tiananmen Square. *Source*: Photo by author, August 1, 2004.

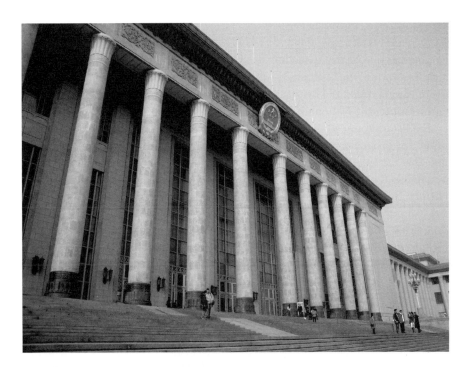

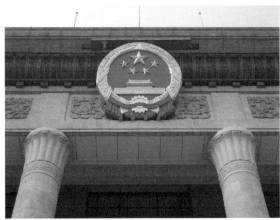

(above) **Figure 10.** The Great Hall of the People (detail). *Source*: Photo by author, January 20, 2007.

(left) **Figure 11.** The national emblem, the front gate of the Great Hall of the People (detail). *Source*: Photo by author, January 20, 2007.

Figure 12. A column base, the front gate of the Great Hall of the People (detail). *Source*: Photo by author, January 20, 2007.

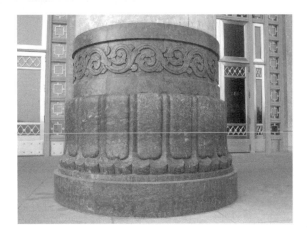

(counted as one, as discussed below), the Military Museum of the Chinese People's Revolution, the National Agricultural Exhibition Center, the Cultural Palace of Nationalities, the Beijing Railway Station, the Workers' Stadium, the State Guest House, the Nationalities Hotel, and the Overseas Chinese Building.[6]

The list announced on National Day, however, did not exactly duplicate the initial list proposed by the CCP Central Secretariat at the 1958 Beidaihe meeting. That list called for the construction of the Great Hall of the People, the National Theater, the Museum of the Chinese Revolution, the Museum of Chinese History, the National Agricultural Exhibition Center, the Military Museum, the Art Museum, the Science and Technology Museum, the Cultural Palace of Nationalities, and the State Guest House.[7] The buildings actually erected did not include three from the original list—the National Theater, the Art Museum, and the Science and Technology Museum; and four new ones were added—the Workers' Stadium, the Nationalities Hotel, the Beijing Railway Station, and the Overseas Chinese Building. Further, the Museum of the Chinese Revolution and the Museum of Chinese History were counted as one building, instead of two as in the initial 1958 proposal.

Why these changes? On the surface, the changes reflected the enormity of these government projects. At a deeper level, however, they revealed the Party's overly ambitious plans and inexperience, which caused confusion and led to frequent and urgent modifications of the plans. The debates among architects concerning the style of these structures were also a problem for the Party. The story of the National Day projects can be seen as the new Communist regime's passionate drive to convey its political authority through architectural forms and to inculcate a sense of national pride, but the path to these goals turned out to be a winding and treacherous one.

Construction

The leading official in the Politburo to oversee the National Day projects was Premier Zhou Enlai, but the man directly in charge of daily construction operations was Wan Li (b. 1916), vice mayor of the Beijing Municipal Government. Wan set up a department called the National Day Project Office (Guoqing gongcheng bangongshi; NDPO) to coordinate work, which began in a hurry.[8] Time did not allow for an international competition regarding the design of the buildings, but the CCP never had any intention of inviting foreigners to compete. Buoyed by the nationalistic fervor of the Great Leap Forward, the Party decided early on that the architects hired must be Chinese and thus planned for their selection only through national competitions. At a mobilization meeting on September 8, 1958, Wan Li announced the grand plan in front of a hastily assembled group of more than one thousand officials, architects, and urban planners from all over China. He repeated the familiar dictum of the Great Leap

Forward—"More, faster, better, cheaper"—and told the audience, "We are build-
ing a series of National Day projects to reflect the great achievements of the na-
tion in industry and agriculture, as well as in other areas in the past ten years
since the founding of the nation." He then praised intellectuals for their "talent,
strong sense of patriotism, and national pride" and called on them to do their
best to help realize this mission.[9]

The NDPO drew most of the country's creative architects, including Bei-
jing's Liang Sicheng, Zhao Dongri, and Zhang Kaiji, as well as Nanjing's Yang
Tingbao (1901–82), and Shanghai's Chen Zhi (b. 1902). It was a state assign-
ment that many felt honored to accept.[10] After a brief hectic period of consulta-
tions and assessments, the groundbreaking took place in the early fall of 1958,
and construction commenced on the Great Hall of the People on October 28.[11]
The NDPO's foremost concern was whether all these buildings could be con-
structed in less than a year's time, ten months to be exact, and still leave the fi-
nal few weeks for mandatory inspections and other finishing touches before the
official opening date in October. "The time normally required to build a colos-
sal structure like the Great Hall of the People," officials admitted, "is a year of
design, six months of preparation, and three years of actual construction."[12]
The NDPO had no choice but to carry out the work simultaneously along three
fronts: designing the buildings, making preparations, and actually constructing
the buildings along the way.[13]

Immediately after the NDPO determined that construction sites would be
around Tiananmen Square and in the vicinity of Chang'an Avenue, demoli-
tion proceeded apace. Houses were torn down and old burial grounds (such as
those near the Military Museum in west Beijing) were removed. The NDPO also
bought up land from the residents.[14] However, because of hasty, poor prepara-
tion, officials admitted, the relocation "aroused the ire of many locals."[15]

The projects also faced a scarcity of skilled workers and resources. The Mu-
nicipal Party appealed to the central government for help in October 1958, stat-
ing that "the city of Beijing simply could not handle this gargantuan task alone"
and requesting that experienced workers be brought in from Tianjin, Shang-
hai, and Wuhan, cities traditionally known for their higher quality of construc-
tion. The Party also requested that veteran stonemasons be brought in from
Shandong and Hebei provinces.[16] Within a short time, thousands of workers
were assembled. In March 1959, for example, more than fifty thousand workers
were involved at various construction sites, operating round-the-clock in three
shifts.[17] At its peak, more than seventy thousand workers were involved in all
these construction projects,[18] but the quality of their work was uneven. Many
local workers recruited from nearby villages had "poor skills and were ineffi-
cient," one official complained.[19] The entire operation soon took on the features
of a military operation. The vocabulary of war, with its ritual chants of "theaters
of operation" (*zhanqu*) and "waging the battle of annihilation" (*da jianmiezhan*)

became common slogans at the building sites.[20] This manipulation of language, combined with an appeal to nationalistic pride, was clearly intended to arouse the workers' spirits and generate excitement.

The shortage of building materials in Beijing was another obstacle, and so most of the materials had to be brought in from outside. With the help of the central government, the NDPO coordinated a nationwide effort to assemble necessary construction materials including a large quantity of steel windows from Shanghai, granite from Shandong, and marble from Hubei.[21] The NDPO promoted the entire operation as a "chess game," underscoring the importance of working as a team to realize the goals of the project.[22] Weather was another impediment, as the forbidding Beijing winter set in soon after construction commenced in October 1958, making working conditions unbearable.[23]

Premier Zhou Enlai placed the utmost importance on the projects. His overriding concern was safety, especially regarding the construction of the ten thousand–seat auditorium in the Great Hall of the People.[24] A tragic event in Yan'an continued to haunt him. During the celebration of the Seventh Congress of the CCP in Yan'an in the summer of 1945, a cantilevered balcony in a hall collapsed, killing a number of spectators who had leaned to one side to see the performance. Zhou himself was hurt while rescuing the wounded. This time the projected auditorium in the Great Hall would have two gigantic cantilevered balconies, and when completed would each seat an audience of more than two thousand. Zhou was so concerned about the safety of the balcony that one night, in January 1959, he summoned Wan Li; Zhao Pengfei (1920–2005), director of the NDPO; and Shen Bo (b. 1918), head of Beijing's Institute of Architectural Design, to his office in Zhongnanhai and instructed them, in unmistakable tone, to give the safety issue top priority. As Zhou warned, "If anything goes wrong [with the balconies], you three will be held accountable."[25] But in these complicated, multiple projects, and given the frantic pace of construction, mistakes, sometimes serious ones, were unavoidable. Often key building materials were found to be substandard; for example, it was discovered in February 1959 that critical steel frames needed to support the roof of the Great Hall were faulty, and remedies were urgently sought.[26] Accidents were also common. In March 1959 fire broke out on the first floor of the Great Hall,[27] and, by August, thirty-seven incidents were recorded at the construction site of the Nationalities Hotel,[28] prompting officials to issue frequent safety warnings.[29]

A further problem created by the hastiness of construction was waste. Because of inexperience and poor coordination, large quantities of construction materials were mistakenly assembled or squandered.[30] Although numerous inspections were mounted in the course of the construction, often mistakes were detected too late to be corrected, provoking one architect to complain, indignantly, that "it is futile to make suggestions once the building is completed."[31]

Number of Projects

As mentioned in chapter 1, the total number of planned constructions in the initial National Day Projects, including the Ten Monumental Buildings, stood at seventeen in late 1958. The list included a new department store in Xidan to be funded by the Ministry of Commerce, and a grand cinema proposed by Zhou Yang (1908–1989), the vice minister of culture.[32] The number had to be quickly reduced, however, in light of the dearth of skilled labors and building materials. Zhao Pengfei immediately saw problems in these additions, concerned that the extra projects would drain the already scarce resources and cause unanticipated technical hurdles. Even worse, he argued, each new project had a tendency to spiral upward with seemingly never-ending requests for additional features. "The total building area of the departmental store," Zhao pointed out, "has been increased from the original 50,000 square meters to 64,000 square meters."[33] Indeed, the total area of the planned ten projects had mushroomed from 305,000 square meters in late 1958 to 600,000 square meters by early 1959.[34] Zhao warned that matters could spiral out of control.

By December 1958, a change of course was brewing, as senior officials began to seriously entertain the idea of prioritizing the projects. Five buildings were identified as "key targets": the Great Hall of the People, the Museum of the Chinese Revolution and the Museum of Chinese History—now increasingly regarded as a single project—the State Guest House, the Cultural Palace of Nationalities, and the Military Museum. "The immediate, central task," the NDPO instructed, "is to make a concentrated effort to finish these jobs quickly."[35]

The formal strategic shift came in January 1959 when Premier Zhou Enlai realistically assessed the situation and ordered the work to be divided into three categories: The first was "those that must be completed" (*bicheng*), which included eleven structures—the Great Hall of the People, the Museum of the Chinese Revolution, the Museum of Chinese History, the National Agricultural Exhibition Center, the Military Museum, the Cultural Palace of Nationalities, the State Guest House, the Workers' Stadium, the Nationalities Hotel (also known as the Chang'an Hotel), the Overseas Chinese Building, and the Beijing Railway Station—all to be officially unveiled on the tenth anniversary of the PRC in October. The second group was the "anticipated works" (*qicheng*), comprising the Science Museum, to be built on East Chang'an Avenue, and the Art Museum, to be located in the eastern part of Tiananmen Square. Finally, the "postponed works" (*tuichi*) included the National Theater, to be built west of the Great Hall, a grand cinema outside Fuxing Gate, and a large department store in Xidan.[36]

Evidently several changes were made even in this modified list. First, the total number of "must build" structures was listed at eleven. Second, dropped from the initial 1958 list were the National Theater, the Art Museum, and the Science and Technology Museum, as Zhou Enlai was informed that these three could not be completed in time. Third, four new structures—the Workers' Stadium,

the Nationalities Hotel, the Beijing Railway Station, and the Overseas Chinese Building—were added. Among these four, the Beijing Railway Station and the Overseas Chinese Building were not on the initial list but actually underwent construction, even before the summer of 1958, under separate projects; so now they were added to the roster to make up the total number.[37] The reshuffling of the list of buildings indicated that the NDPO had to make quick changes to meet the goals, even by including some work previously started. The office instructed that from now on resources could only be channeled to the "must complete" projects to ensure their timely completion.[38]

When the National Day deadline of October 1, 1959, drew near, one last change was made: the total number of buildings was reduced to ten. This was made possible by counting the Museum of the Chinese Revolution and the Museum of Chinese History as one building.[39] The number ten (*shi*), of course, implied perfection, as in the common saying of "Perfection in every way" (*shiquan shimei*). Besides coinciding with the tenth anniversary of the founding of the PRC, the number ten was rooted in history; one recalls Emperor Qianlong's Ten Perfect Campaigns of conquest and military success in western China, integrating vast territories into the Qing state in the eighteenth century. For critics, however, the number ten was merely a manipulation by the Communists, "nothing more than a contrived number (*coushu*)," as one detractor later remarked.[40]

Debates

For the Chinese Communists, the term *da* (monumentality; literally, "large") in "Shi*da* jianzhu" (Ten Monumental Buildings) connoted more than the sheer size of a building; it also signified a building's height and the physical space it occupied. Indeed, all the buildings were massive in structure, soaring in appearance, and centrally located. The ten edifices articulated a close affiliation between political power, architecture, and space, a design to command respect and to intimidate. Their imposing grandiosity stood for the authority of the CCP and glorified the achievements of the present epoch.

The monumental nature of the buildings was first reflected in their size. With its total floor space of 171,800 square meters, the Great Hall of the People was the grandest of all. The Museums of the Chinese Revolution and of Chinese History (figure 13) (see chapter 5) and the Military Museum (figure 14) were second and third in size, measuring 66,000 square meters and 60,000 square meters, respectively. The smallest, at 13,000 square meters, was the Overseas Chinese Building.[41] The tallest part of the Great Hall's central building reached 46.5 meters, and its main gate, facing east to Tiananmen Square, stood 40 meters high, about six meters higher than the historic Tiananmen Gate.[42] The Museums of the Chinese Revolution and of Chinese History are equally impressive, with columns reaching 32.7 meters in height, and pylons, at both sides of the main entrance, facing Tiananmen Square to the west, soaring to 40 meters.[43] The

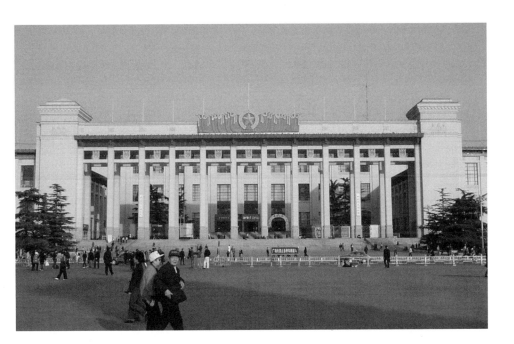

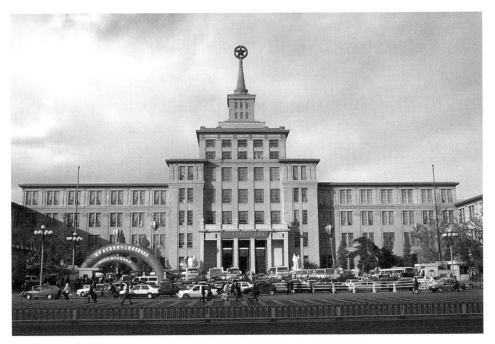

(top) **Figure 13.** Museums of the Chinese Revolution and of Chinese History, Tiananmen Square. *Source*: Photo by author, October 13, 2002.

(bottom) **Figure 14.** Military Museum of the Chinese People's Revolution, Fuxing Road, Beijing. *Source*: Photo by author, October 26, 2002.

highest edifice, at 94.7 meters, was the central building of the Military Museum of the Chinese People's Revolution, outside Fuxing Gate, where a star sat at the top, inscribed with the Chinese characters "Eight One," signifying the August 1, 1927, Red Army Uprising in Nanchang.[44] Finally, the key buildings were also symbolically placed in Tiananmen Square, the core of the capital and China's symbolic center. The two most important buildings—the Great Hall of the People and the Museums of the Chinese Revolution and of Chinese History—flanking the square's western and eastern sides, respectively, were clearly planned with regard to this ideological center.

Among the ten buildings, the Great Hall of the People reigned supreme— "the crown among the most important of them" (*zhong zhong zhi zhong*),[45] as described by Chinese officials. According to Shen Bo, as early as the Yan'an days Mao had envisioned building a grand hall after the Communist victory in China so that "Party leaders and the people could gather there to discuss national affairs."[46] After the founding of the PRC in 1949, the need for a hall to hold major political and legislative meetings became more urgent. Government plans were already under way in 1956, and in July 1958 a team of urban designers and architects from the Municipal Party was dispatched to the Soviet Union to learn from the Russian experience.[47] Finally the idea was officially endorsed at the 1958 Beidaihe meeting. In its conception, the Great Hall of the People (Renmin dahuitang) implied the unity of the CCP and the people, for it was in the people's name that the Party claimed to rule. Because of its symbolic significance, Premier Zhou Enlai frequently visited the construction site to oversee the project. Mao also paid a rare visit to the site on September 9, 1959, in the final phase of construction.[48]

The Great Hall, an edifice of reinforced concrete and steel frames, was not only the biggest building but also the most expensive to build.[49] It comprises an auditorium that seats ten thousand, a banquet hall that accommodates five thousand, and the offices of the Standing Committee of the National People's Congress. The auditorium, where the congresses of the Chinese Communist Party and the National People's Congress are held, is the most significant space of all, hence its central position in the building. The banquet hall is in the north side of the building, and the offices of the Standing Committee of the National People's Congress are in the south. The building complex consists of three hundred meeting halls, lounges, and offices. Each meeting hall is named after a province, a municipality, or an autonomous region and is furnished according to the local style.

In the fall of 1958, immediately after the announcement of the Beidaihe plan, a national competition was held for the design of the Great Hall of the People. Of the 273 entries submitted to the NDPO, the winning design was by the architect Zhao Dongri working jointly with a woman architect, Shen Qi.[50] Zhao had earned his reputation earlier in 1950, when he proposed to retain old Beijing as the new government's administrative center, in opposition to Liang Sicheng's

and Chen Zhanxiang's plan to build a new government center in the western part of Beijing. Zhao and Shen had cooperated earlier in designing the much-acclaimed People's Consultative Conference Hall in the western part of the city, which had won the approval of Liu Ren, the influential Municipal Party boss.[51]

Trained in Japan, Zhao Dongri joined the CCP in 1957 and, in 1958, had assumed a powerful new post as the chief architect of the Beijing Planning Bureau, responsible for the planning of the city. Zhao harbored high aspirations. His plan for the Great Hall was a colossal structure patterned partially on a European neoclassical style that emanated a sense of proportion and balance. The original plan called for a 70,000-square-meter building,[52] but Zhao saw this as far too small and restrictive. His concept was to build the future hall on a scale corresponding to the anticipated expansion of Tiananmen Square, which was expected to reach more than forty hectares. After completing the design of the auditorium and the banquet hall, however, Zhao found that he had already exhausted the space allotted. Nevertheless, he boldly added the offices of the Standing Committee of the National People's Congress to the building's south side. Later, he introduced individual meeting halls for the provinces and municipalities, finally reaching a gigantic spread of more than 170,000 square meters, two and a half time larger than the initial plan.[53]

To underscore the auditorium's singular importance, Zhao moved it to the back, away from the main entrance facing Tiananmen Square to its east. In this way, participants would have to walk a considerable length from the front gate, past several doors, in order to reach the hall, where they would be greeted by a vast assembly space decorated with red flags and huge banners, the site of the most important national events. The design of layered entrances, according to Zhao, was inspired by the traditional Chinese mansion, where visitors would have to walk past successive doors to enter the main hall.[54]

To find space to accommodate all these expansions, Zhao, in a bold stroke, extended the southern edge of the building beyond Zhonghua Gate toward Zhengyang Gate, the front gate of the traditional inner city. "This was a daring move," one admirer commented, "for it opened a grand landscape [for the building]."[55]

What inspired Zhao Dongri to make his project so vast? Although he claims that his inspiration came partly from the Diet buildings in Japan and the round colonnades in the Soviet Union,[56] this claim is difficult to substantiate. What we can attest to, however, is the architect's predilection for things grandiose, as he himself confessed:

> I was wavering between a design that would either meet the stipulated dimensions [of the government] or meet the actual needs. If I had gone with the latter, it would have been incompatible with the requirements, and my entry probably would not have been selected. But I am willing to accept criticism for making it bigger in order to reflect the majesty of a national hall.[57]

Zhao's insistence on enormity, however, had many critics, and the most out-spoken was Liang Sicheng. In a November 1958 meeting convened by Premier Zhou Enlai to discuss Zhao Dongri and Shen Qi's approved plan of the Great Hall (which neither attended to avoid potential embarrassment), Liang was the first to voice his criticism. To demonstrate the excessive scale of Zhao and Shen's model, Liang, right there at the meeting, in front of the premier, drew a child with a disproportionately huge head. The two architects made the error, accord-ing to Liang, of "magnifying a child" disproportionately.[58] The problem with the proposed design, Liang contended, was tantamount to the earlier mistakes made in the design of St. Peter's Basilica in the Vatican, where ceiling height, bay width, windows, and doors were disproportionately enlarged to twice their size, making visitors feel as if they were entering a kingdom of giants. Thus, Zhao's proposal of the Great Hall, in Liang's words, unfortunately was repeating "a his-torical mistake."[59]

Liang believed that Zhao Dongri's huge structure embodied the worst fea-tures of functionalism, which emphasized the principle of utilitarian rational-ism while ignoring the most important humanistic spirit of a building. In a mammoth structure, people could easily be dwarfed by the great void and lose their sense of balance, thus alienating them from the surroundings they were supposed to embrace. Liang was deeply convinced that the aesthetics of a build-ing was as important as its technical and functional values. For Liang, the ideal landscape was a Tiananmen Square graced by an array of cultural monuments serving as a communal space for the people.

The dispute over the size of the Great Hall was the second time that Liang Sicheng and Zhao Dongri were at odds over the capital's future development plan. But this time Liang was not the only one to frown upon the excessive di-mension of the projected building. Others voiced similar objections. For ex-ample, Wang Huabin, a chief architect at the Beijing Industrial Design Insti-tute, disparaged the building as "grandiose and impractical" (*da er wu dang*).[60] Others also questioned whether the massive building would be difficult to use efficiently, resulting in its not being cost-effective.[61] In a recent interview in Bei-jing, one architectural critic said that "the rooms in the Great Hall are so big that even hearing each other in a meeting was difficult. . . . Few gatherings actu-ally took place there."[62]

Zhao Dongri demurred: "Should the nature of Tiananmen Square be politi-cal or cultural?" he once asked.[63] For him, the square was clearly a political space, and hence its adjacent buildings must serve this end. He stressed the primacy of function, insisting that the Great Hall should be built to fully serve the state's political and practical purposes. Liang Sicheng, of course, did not deny the importance of politics and utility, but he firmly believed that the Great Hall must be part of the larger organic development of Beijing as a cultural city, deeply rooted in China's rich heritage of unique architectural character-istics. As such, he was also against designing the Great Hall along the lines of

the Renaissance classical style, as Zhao Dongri had proposed. The building, according to him, would best be built in the "Chinese style with a modern look," although he never explained this concept clearly.[64] Zhao's classical approach was not unique. As Spiro Kostof has noted, this approach was prevalent in public architecture in the 1930s in countries as diverse as the United States, Hitler's Germany, Mussolini's Italy, and Stalin's Russia, for it projected "order, stability, grandeur, enduringness."[65]

There is no question that Liang held a low opinion of Zhao and that this feeling was fully reciprocated. Liang doubted Zhao's intellectual depth and believed that he was a mediocre architect with a poor understanding of architecture as a holistic, humanistic discipline. That Zhao was close to Liu Ren, and hence adhered to the rigid official line, was another factor Liang could not abide. Zhao, on the other hand, viewed Liang as a pedant who had completely lost touch with China's reality. Liang and Zhao, the idealist and the Party loyalist, had irreconcilable visions of the capital.

Liang Sicheng's opposition to a colossal great hall fell on deaf ears, for Zhao's model had the full backing of Municipal Party chief Liu Ren.[66] Liu, of course, was not acting on his own but merely reflecting the views of the senior leaders. Never once did Premier Zhou Enlai consider that the Great Hall was too massive a structure. In his memoirs, Zhang Bo, Liang's student and the chief designer of the Cultural Palace of Nationalities, mentioned that it was the premier's personal instruction that "a five-thousand-person banquet hall be built."[67] Zhao Dongri, in defending his plan, also reminded others that, when commenting on the height of the auditorium in January 1959, the premier had voiced his approval: "When standing beneath the sky, we do not find that the sky is too high; nor do we find, when standing at the shore, that the sea is far away."[68] In other words, the size of the building had already been predetermined by central Party leaders. The enormity of the Great Hall and the other buildings was precisely what they wanted. They saw clearly that the expansion of Tiananmen Square to a mammoth size of more than forty hectares would require that the surrounding buildings also be enlarged. The huge Great Hall would thus serve as a perfect example. By making these National Day projects monumental and memorable, senior officials intended to show the people the great accomplishments of the Party and also tell the world that the Chinese could perform miracles of architectural design, perhaps even surpassing their Western counterparts. Zhao Dongri surely read the political wind far better than Liang Sicheng. In the words of one contemporary critic of architecture: "Zhao Dongri truly understood what the leaders wanted, and so he exerted every effort to make the building as big as possible."[69] Critics ridiculed Zhao's propensity to toe the Party line, calling him "merely a tool of the government."[70]

To be sure, the monumental dimensions of Beijing's ten buildings closely resembled those erected in Stalin's Russia and Hitler's Germany in the 1930s and 1940s, respectively. When Stalin conceived the Palace of the Soviets in the early

1930s, he envisioned the structure as the ideological center of the Red Capital. The palace, designed by architects Boris Iofan, Vladimir Gelfreikh, and Vladimir Shchuko, was to rise a triumphant 415 meters from the banks of the Moscow River, crowned with a 100-meter statue of Lenin pointing toward the bright Communist future. Exceeding the height of the newly constructed 381-meter Empire State Building in New York City, the palace would be the world's tallest building.[71] Stalin's ambitious plan did not escape Hitler's attention. The Führer, according to his chief architect, Albert Speer, "was deeply irked" when he learned about the Soviet design, for it competed with his own plan for a House of the People, capped with a new dome of unprecedented size, in the center of Berlin. However, Hitler believed that his own design would be far more original. "What does one skyscraper more or less amount to, a little higher or a little lower. The great thing about our building will be the dome!" he said.[72] Indeed, his dome would be sixteen times the size of St. Peter's. The architectural competition between Stalin and Hitler was fierce and intense. At the 1937 Paris World Exposition, for example, Boris Iofan's Soviet pavilion and Albert Speer's Nazi counterpart competed for public attention: challenging Speer's giant eagle with the swastika in its claws at the top of German pavilion was Vera Mukhina's sculptural group, *Worker and Collective Farm Girl*, atop Iofan's Soviet pavilion. Enmity and jealousy notwithstanding, both pavilions clearly showed a trend toward grandiose monumental edifices.

It was this style of enormity that Beijing's ten buildings shared with their European counterparts. The Chinese Communists, however, hoped to outdo the Europeans in terms of number (seventeen in the original plan), speedier construction (completion in less than a year), and, most important, actually finishing the buildings, as Stalin's Palace of the Soviets and Hitler's House of the People remained on the drawing board because of World War II. The successful completion of their projects in record time would indicate that the Chinese were far superior in executing their plans, once they had set a goal.

Eclectic Style

Sigfried Giedion, a staunch advocate of modernism, has viewed the pursuit of national form in architecture as a relic of the past.[73] China's National Day projects, however, tell a different story: nationalism was at the heart of the plan to develop these political buildings. That the CCP decided to commission only native architects for these projects indicated the Party's emphasis on the principle of "self reliance," a popular slogan during the Great Leap Forward. Historically, to be sure, rarely has a new regime created its own architectural designs totally anew. Soviet architecture, for example, was deeply rooted in the nation's past, despite its love affair with the neoclassical style in the 1940s. The distinct spires of Stalin's buildings, as in the Ministry of Foreign Affairs building, bore a close resemblance to the Kremlin towers and seventeenth-century tent churches, but

the architectural style of China's ten buildings was far more complicated. The Ten Monumental Buildings project, from the beginning, was never meant to be a slavish imitator of Western styles. Rather, something uniquely Chinese had to be created. Propelled by rising nationalistic sentiments, the Great Leap Forward, then in full force, called for an affirmation of Chinese identity. Ironically, as a result, the traditional Chinese curved-roof architectural style, which not long ago had been condemned as "wasteful," as in Liang Sicheng's big-roof design, now returned with an official blessing.

A closer look at the ten buildings reveals, however, that they are, in fact, a blending of native and Western designs, an eclectic formation with no distinct identity of their own, although at different levels ingenuity went into satisfying the inevitable pressure for a more indigenous approach. An example is the spatial configurations. Clearly, the two principal buildings—the Great Hall of the People and the Museums of the Chinese Revolution and of Chinese History— are rectangular in shape, with their four sides directly facing the customary cardinal directions. The two are roughly the same length—the Great Hall is 336 meters from north to south and 206 meters from east to west, and the Museums of the Chinese Revolution and of Chinese History measure 313 meters from north to south and 149 meters from east to west.[74] The round columns of the Great Hall of the People were designed to parallel the square columns of the Museums of the Chinese Revolution and of Chinese History at the opposite end of the square. Moreover, the courtyard entrance of the museums is in direct contrast to the facade of the Great Hall, forming what Chinese architects called a "one void one solid" (yi xu yi shi) configuration.[75] The two buildings thus face each other under the principle of coordination, "complementing each other on the left and right sides [of the square]," according to one government report.[76]

The main gate of the Great Hall is on the same straight line with the Museums of the Chinese Revolution and of Chinese History at the opposite end of the square. The line, however, does not pass directly through the Monument to the People's Heroes in the center of the square but passes north of the monument, so that the central sections of the three structures are not on the same straight line. This deliberate imbalance was made under the order of Liu Ren, presumably with the approval of the central Party officials, so that, in Liu's words, "the living [the Great Hall of the People] does not face the dead [the Monument to the People's Heroes] (huoren budui siren)."[77] Such a view clearly reflected the Communist leaders' superstition, despite their avowed official atheistic stand.

Traditional interior spatial designs were carefully provided. As mentioned earlier, delegates entering the Great Hall must pass through several gates to reach the grand auditorium where the National People's Congress meets. The gradual approach from the front to the center was intended to create a solemn experience for the participants.[78] Other examples abounded, such as the impressive colonnades on four sides of the building, circular in shape, to symbolize, according to the designers, "the centripetal force of the Chinese people

rallying around the Party."[79] The colonnade of the main gate may be the most impressive of these special patterns, with its twelve columns, each 25 meters in height, set on bases of traditional floral design. The total number of columns equaled the number of pillars of the Hall of Supreme Harmony in the Forbidden City, the grandest edifice of all in the palace compound.[80] The colonnade was also made, as instructed by Mayor Peng Zhen, in the Chinese style, characterized by different spacing between the columns, with the widest spacing at the center and receding in width to the corners. This pattern adheres to the long-established Chinese practice of unequal spacing to differentiate between what is of primary and secondary importance.[81] This differs from the Western practice, where columns typically are separated at an equidistance.

The use of traditional glazed tiles on building roofs is a common indigenous practice in China, and the plinths and capitals of the columns were shaped in the conventional lotus petals, a favorite symbol of purity and uprightness. Zhao Dongri understood full well that multilayered platforms were another familiar pattern in Chinese architecture, so he built three flights of steps, with two layers of platforms: at the bottom is a two-meter base topped by a three-meter traditional *xumizuo*, or high base with decorated moldings, elevating the building to a new height and adding additional symbolic weight to the structure.[82]

These Chinese architectural motifs did not necessarily add up to distinct Chinese characteristics, however. The native architectural style formed only part of the National Day projects. What counts most is the overall design of the Great Hall, which, as Liang Sicheng correctly pointed out, followed more or less the Renaissance and neoclassical traditions, especially in its colonnade formation, overall rectangular exterior, and an emphasis on proportion and regularity of segments that traced back to classical architecture.[83] The elevation of the Great Hall could be viewed as roughly akin to a Western classical public building with a roof, entablature, columns, and crepidoma, expressing a human harmony of scale and universal art. The tall columns, even with lotus petals added, resemble an adaptation of Western aesthetic, and the details of the upper parts of the facade supported by these columns are similar to the classical buildings. Overall, the Western neoclassical style of the Great Hall of the People reflected reason and classical values, but, more important, it also projected monumentality and the weight of state power, a style that had become influential in Europe and the United States since the eighteenth century.

The traditional big-roof design did return, most notably in the Cultural Palace of Nationalities (figure 15), the National Agricultural Exhibition Center, and the Beijing Railway Station, but it was not the most dominant style in the project. Viewed as a whole, the ten buildings were an eclectic synthesis of Chinese and Western architectural forms. Years later, in 1988, Zhao Dongri had to admit that China had yet to develop "its own distinctive style" in terms of architectural design.[84] Most essential to senior Party officials was not the buildings' artistic appearance as much as their practicality. Zhou Enlai summed this up

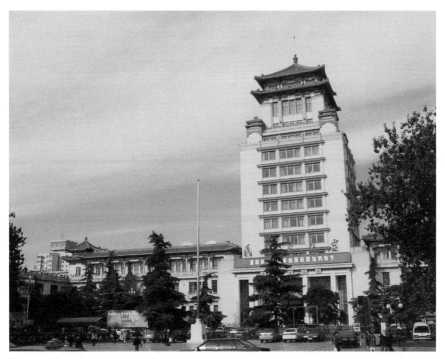

Figure 15. Cultural Palace of Nationalities, Xidan, Beijing. *Source*: Photo by author, October 21, 2002.

best: "We need to be inclusive; as long as it is useful to us, be it native or foreign, ancient or modern, we will use it!"[85] Emphasizing this pragmatic approach fulfilled the political need for the edifices to speak a strong Party language. The end results must have pleased the Party greatly, for the symbols of the CCP's dominance were unmistakable in these structures. Two architectural features demonstrate this most forcefully: the huge national emblem adorning the Great Hall's front gate and the big red star in the ceiling of the Great Hall's auditorium, a symbol of the "leadership of the Chinese Communist Party."[86] Moreover, the giant star atop the Military Museum's spire announces the authority of the People's Liberation Army.

Did the Soviet architects ever participate in the National Day projects? And, if they had, would that have diminished the nationalistic pride the Chinese architects fought so hard to instill in the buildings? Soviet architectural styles, Zhang Bo admitted, unquestionably were influential in China in the 1950s. For example, the style of the buildings at Moscow State University influenced many Chinese designs at the time.[87] The spire of the Military Museum was obviously inspired by the Soviet model, but the architects interviewed for this book emphatically denied any direct assistance from the Soviet experts. "We received no assistance from foreigners," said Zhang Kaiji.[88] "We didn't even want the

Russians to know about the Ten Buildings project," Liu Xiaoshi (b. 1928), another architect involved in these projects, emphatically stated.[89] This appears to be true for major projects, though not for lesser ones, as the National Day projects were planned and constructed at a time when relations between China and the Soviet Union were rapidly deteriorating. It would have been embarrassing, if not humiliating, to seek direct help from an estranged friend, soon to become a bitter enemy. Archival sources, though indeed lacking evidence that the Soviets helped in the planning of the key projects such as the Great Hall of the People, do indicate that the Soviets provided considerable technical aid on some lesser projects such as the Beijing Railway Station and the National Agricultural Exhibition Center.[90] A government report reveals that Soviet advisers were "very upset" when their contributions were not publicly acknowledged. As one Soviet technician complained, "you looked for us when you encountered problems; but we were nowhere to be seen at the opening ceremony."[91] Wan Li hurried to correct this oversight by arranging a banquet in honor of Soviet experts, in September 1959, where he openly "expressed gratitude for their help."[92] Wan's speech, of course, was never made public.

Representations

In 1949, when Mao and his senior associates decided to place the nation's political headquarters in Zhongnanhai, in the old Imperial City, thus rejecting Liang Sicheng's proposal to set up a new administrative region west of Beijing, Tiananmen Square received additional symbolic aura. Early on, the government issued clear instructions: "The most important buildings of national significance should be placed near Tiananmen Square as well as along Chang'an Avenue."[93] The ten buildings were distributed in and around Tiananmen Square along two related spatial formations, following a strict hierarchy of representations. The edifices were arranged concentrically with reference to the square, placing the two most important structures—the Great Hall of the People and the Museums of the Chinese Revolution and of Chinese History—in the square. The plan also worked horizontally; the buildings of lesser importance were set along the extended Chang'an Avenue, a new east-west axial line built after the founding of the PRC, that crosses the north-south axis in front of Tiananmen Gate.

To realize this architectural design, Chang'an Avenue was greatly expanded in the 1950s to a width of 120 meters around Tiananmen Gate. In 1958 the Municipal Government decided to further expand West Chang'an Avenue from Xidan to Fuxing Gate.[94] Later, the road was extended beyond Fuxing Gate to the west, now reaching as far as Shijingshan. Along this horizontal line, near Xidan, the Party built the Cultural Palace of Nationalities and the Nationalities Hotel, which, following the age-old architectural bearing, face south. Beyond Fuxing Gate, farther west, was the Military Museum, also facing south. Other buildings were arranged concentrically in relation to Tiananmen Square. These

included the State Guest House to the northwest; the Overseas Chinese Building, the Workers' Stadium, the National Agricultural Exhibition Center—all to the northeast; and the Beijing Railway Station to the southeast.

Each of the ten buildings was significant both in its spatial design and the political symbolism that corresponded to its specific function. The symbolic components representing the PRC included the people, manifested in the Great Hall of the People; the workers, the Workers' Stadium; the peasants, the National Agricultural Exhibition Center; the Red Army, the Military Museum; and the national minorities, the Cultural Palace of Nationalities and the Nationalities Hotel. Meanwhile, the CCP's pivotal role in modern Chinese history was further highlighted in the Museums of the Chinese Revolution and of Chinese History. Finally, foreign guests and international friendship were represented by the State Guest House, overseas Chinese by the Overseas Chinese Building, and the nation's transportation system by the Beijing Railway Station.

No building officially associated with the workers had originally been contemplated, but it would have been disastrous politically to leave out the proletarians, as the 1954 Constitution had declared that "the People's Republic of China is a people's democratic state led by the working class and based on the alliance of workers and peasants."[95] The initial oversight of the workers was remedied by renaming the stadium, which, when construction began, had simply been called "the stadium" (Tiyuchang) to connote its function or "the stadium in the eastern suburb" (Dongjiao tiyuchang) to specify its location.[96] In the summer of 1959, however, the stadium was properly named the "Workers' Stadium" (Gongren tiyuchang),[97] and thus the proletariat were appropriately represented.

Representing the national minorities was also a major concern for Party officials. The hotel for ethnic minorities, in its construction stage, was often simply called the Chang'an Hotel (Chang'an fandian),[98] signifying its location along West Chang'an Avenue, but the name was later changed to the Nationalities Hotel (Minzu fandian), giving it a more political connotation. That now two buildings—the Cultural Palace of Nationalities and the Nationalities Hotel—represented national minorities pointed up the political sensitivity of the issue and its importance to the Party.

The centrality of Tiananmen Square underscored the supremacy of Beijing as a capital. The dominating role of a single city was unprecedented even compared to the role that different European cities played in European countries. Igor Golomstock has argued that in Stalin's Russia and Hitler's Germany, key cities were arranged in what he calls "the totalitarian hierarchy of space."[99] The Soviet Union had more than one dominant city, Golomstock points out, contending that Moscow, the city of politics, was rivaled by Leningrad, "the cradle of the Revolution." Hitler's Germany also had multiple centers: Berlin was the capital, but Munich was "the capital of the Nazi movement" and Nuremberg was "the city of Party Congresses." Beijing, on the other hand, was unparalleled, unchallenged by others, not even by Shanghai, a city with a dubious capitalistic

past. It was through Beijing, home to numerous colossal buildings, that the CCP ruled uncontested, both politically and spatially.

A Communist representative from Australia, who had been invited to participate in the tenth anniversary celebration of the founding of the PRC in October 1959, declared, "The majesty of the Great Hall of the People has surpassed that of Rome's Parliament Building, a grand achievement possible only under socialism." A Polish guest added, "The speed of its construction has broken the world record."[100] Indeed, nothing was more gratifying for Chinese Communist leaders than these rave reviews from foreign friends, even if they were merely the inflated rhetoric of courtesy. Still, what was the true significance of these building projects?

The Ten Monumental Buildings must be examined in the larger context of the Great Leap Forward. Like the slogan characterizing the Great Leap—"More, faster, better, cheaper"—the National Day projects were launched with similar ambitions: countless number of constructions, finishing at record time, using minimal resources.[101] Rhetoric notwithstanding, the entire undertaking, dominated by rigid Party control, was a nightmarish assignment for architects and workers alike, a grueling task beset with obstacles. Many mistakes were made along the way, and often when it was too late to correct them. Shen Bo confessed, "We had absolutely no time to calmly think through complicated issues."[102] Other critics were more outspoken; for example, an architect on the project recently declared that "the Ten Monumental Buildings project was the result of the gross vanity of the government, which was possible only in the frenzy of the Great Leap Forward."[103]

But hardship was a small price for Chinese Communist leaders to pay in their effort to create a new spatial politics in the capital to encapsulate the CCP's great achievements in the first decade of the PRC. Construction of the Ten Monumental Buildings, undoubtedly propelled by a nationalistic drive to show the marvelous feats that the Chinese people could accomplish without the help of foreigners, exemplified how the Chinese Communists manipulated both mammoth structures and indigenous spatial representations to serve politics. By building a series of imposing structures in the capital, especially in Tiananmen Square and along Chang'an Avenue, the CCP created a new political space to announce its presence and affirm its rule.

II. Celebrations

3. Yangge
The Dance of Revolution

Unlike the Bolsheviks, who had little experience with political art forms at the time of the October Revolution of 1917, the Chinese Communists, even before they seized power in 1949, had skillfully employed popular art media in effective propaganda campaigns among the mostly illiterate peasant inhabitants of rural China. Prominent among these art media was rural yangge dance, which was actively promoted by the Communists during the Yan'an era.[1] Yangge became an even more conspicuous presence in the early days of the Communist takeover; the dance became synonymous with the Chinese Communist Revolution and its eventual success, and the new regime wasted no time in turning it into an essential political instrument to explain its policies and organize its supporters.

The yangge (literally, "rice-sprout song") is a popular traditional folk dance performed in the open air in rural North China. It is a performance that combines spirited dance, garish costumes, and loud music to form a colorful blend of rhythmic movements. The dance was closely associated with New Year's rituals and celebrations, intending to dispel evil and to ensure a bumper harvest in the coming season.[2] The yangge troupe is led by a lead dancer known as *santou* (Umbrella Head), who holds an umbrella and directs the movements, and consists of a few dozen to more than one hundred dancers (with men playing women's roles), who twist and dance according to a set of prescribed steps to celebrate the beginning of a new year. Accompanied by drums, gongs, cymbals, and *suona* (a shawm-like instrument), and with farcical acts (played by clowns) and erotic moves, the performance often draws loud applause and laughter among the villagers. During the performance, simple plays (*yangge xi*) are often enacted, mostly on topics relating to everyday life in rural China.[3]

After Mao Zedong's influential 1942 "Talks at the Yan'an Forum on Literature and Art," which called for the use of literature and art as a political tool to serve the masses,[4] the Communists in Yan'an launched the new yangge movement and infused the dance with socialist elements. A new type of yangge, known as Struggle Yangge, emerged. In the reformed dance, the hammer and sickle

replaced the umbrella as the leader's guiding tool; new faces such as workers, peasants, and soldiers took center stage, replacing the traditional male and female roles. The part of the comical clown was abandoned, and flirtation in the dance was eliminated as morally repugnant. Moreover, new dance patterns were added, among them a five-pointed star, a potent symbol of the Chinese Communist Party.[5] Thus many new yangge plays emerged, including *Brother and Sister Clear Wasteland* (*Xiongmei kaihuang*), which extols hard work and production in the Communist-ruled border regions, and *The Wounded Soldier Niu Yonggui* (*Niu Yonggui guacai*), a play that lauds the heroic deeds of the Red Army. Taken together, these new plays, collectively known as Shaanbei Yangge (Northern Shaanxi yangge), were used by the Communists as a political tool to portray a socialist paradise in the making. Their production, as David Holm argues, was designed to be a mass movement, and it involved "cadres and soldiers of working-class and peasant origin, as well as urban intellectuals."[6]

During the civil war, as the Communist forces extended their presence in North China, the CCP promoted a host of other yangge dances in addition to the Shaanbei style, each with its distinct regional variations in style and movements. While the Shaanbei dance is known for its free, bold, majestic, and enthusiastic moves, Hebei Yangge is more regulated and controlled, Jiaozhou Yangge in Shandong is famous for its graceful steps and soft touches, whereas Dongbei Yangge in northeastern China is noted for its vigorous swings and articulated steps.[7] But it was Shaanbei Yangge that received the most publicity and became the most well-known form of the dance because of its robust moves and its proximity to Yan'an, the center of the Communist Revolution during the War of Resistance against Japan (1937–45).

The civil war period not only witnessed the shift of the Communists' strategy from a rural campaign to a battle for control of the cities and industrial sectors, but also the CCP's relentless effort to mount an even more aggressive propaganda campaign against the ruling Guomindang. A good opportunity came in the Lunar New Year of 1945, when several yangge plays (including *Brother and Sister Clear Wasteland*) were staged in the office of the *New China Daily* (*Xinhua ribao*) in Chongqing, China's wartime capital. To draw wider attention to the performance, Zhou Enlai invited artists and writers to attend. The impact was immediate. Dai Ailian (1916–2006), a gifted dance instructor at Yucai School near Chongqing, who also attended the show and had been taught yangge by Zhou, began to teach the dance in her school.[8] *Brother and Sister Clear Wasteland* was later staged in Shanghai in May 1946 and created quite a sensation.[9]

In this period yangge pamphlets were also printed, and underground Communists taught the dance surreptitiously on university campuses. A dance group, the Folk Dance Society (Minjian gewushe) at Peking University, for example, became a hotbed for the introduction of this new technique to students in Beiping, concentrating primarily on the freer style of Shaanbei Yangge.[10] But these

activities did not escape the watchful eyes of Nationalist agents, who regarded the dance as an integral part of the larger Communist conspiracy to destabilize the government. They wasted no time in banning it.[11] "Before Liberation dancing yangge carried a great risk, since university campuses were under the close surveillance of Guomindang agents," a former Peking University student and yangge dancer, informed me.[12]

With the establishment of the PRC in 1949, however, the status of yangge was completely reversed. Now the rural dance, regarded earlier by the Nationalists as a subversive art form, had been transformed into an official celebratory art. It now became a prominent vehicle of propaganda, which the CCP actively advanced in the cities to create a euphoric sense of victory.

The Early Years of the People's Republic

By early 1949, after Communist troops occupied Beiping in late January, yangge had become ubiquitous in this city long famed for its rich literary culture and architectural grandeur. On February 3, Derk Bodde, a young American Fulbright scholar studying in Beiping at that time, witnessed the Red Army's official march into the city in a symbolic triumphant parade. He wrote in his diary:

> Today's big event has been the grand victory parade signalizing the formal take-over of the city. . . . Prominent in the parade were thousands of students and workers from schools and organizations throughout the city. . . . Some groups danced to the rhythmic drum-and-gong beat of the *yang ko* [yangge] or "planting song"—a simple traditional peasant dance performed in unison by large groups, which is already becoming enormously popular here as the result of the general Communist emphasis upon folk art.[13]

Indeed, the dance was closely associated with the Communists' military campaigns, forming a close link between this rural art and the Chinese Communist Revolution. When the Red Army seized Nanjing in April, Shanghai in May, and Guangzhou in October, yangge was seen as both a symbol and a celebration of the political changeover, with people dancing in the streets to mark the Communist victory.[14] Rong Gaotang (b. 1912), a high Party functionary and a yangge dancer himself, proudly proclaimed, "Wherever there is liberation, there is yangge."[15]

However, the type of urban yangge that emerged during the early years of the PRC was a much simpler form of the dance than those forms practiced in rural North China. A survey uncovered that there were more than three hundred dance patterns in north Shaanxi,[16] but that the urban yangge dancers in the early 1950s performed only a few simple patterns, such as Double Cabbage Heart, a spiraling move, and Dragon Waves Its Tail, a snakelike procession. "The moves were relatively simple," one yangge dancer told me. "The uncomplicated steps were intended to express an exuberant mood and to invite as many people as possible to share in the joy," she added.[17] Indeed, the power of urban yangge

as a political symbol in the early years of the PRC rested on its simplicity and visibility. Unlike its earlier rural incarnation, with all its vast variety of dance patterns, the current urban versions were clearly aimed at reaching a wider audience and generating maximum enthusiasm by adopting only simpler forms of dance patterns. To be sure, the exigencies of the time also called for a less complicated format. In the months following the Communists' seizure of power, this type of yangge spread rapidly in China, employed primarily by officials to draw the populace into public displays of support for the new regime in the most visible manner.

Organizing a superior propaganda network also became a top priority for officials. Even before the founding of the PRC in October 1949, the CCP had already started to mount a coordinated effort to exercise tighter control of cultural propaganda efforts. Early in 1949 the Beijing Literary and Arts Committee, an arm of the Beijing Municipal Party, mounted a drive to propagate socialist information to the grassroots, especially among factory workers. The committee established fifteen new yangge troupes, trained more than two thousand members, and gave a total of eighty-two performances, all reformed yangge plays.[18] After the founding of the PRC, the Propaganda Department of the Party's Central Committee and the Ministry of Culture were assigned the task of coordinating propaganda activities to promote the socialist agenda. Cultural Minister Shen Yanbing (Mao Dun [1896–1981]) personally called on artists to take advantage of the Spring Festival in early 1950, the first after the Communist takeover, to make use of yangge in order to explain the government's new policies.[19] The dance was also actively promoted in schools and staged in theaters.[20] The powerful print media, now firmly in the hands of the Party, became another efficient way to promote yangge, as was evident in newspaper stories in the southern city of Guangzhou.[21]

Media coverage notwithstanding, yangge drew the most attention when it became a staple of official festivals. Like their Soviet counterparts in the 1920s,[22] the Chinese Communists understood that meticulously choreographed parades and dignified processions were ideal occasions to display the new regime's authority and achievements. And yangge could be used at such occasions to yield significant results, for it was a distinct native art that reinforced the kind of nationalism the Communists had actively cultivated since the Yan'an days. The yangge troupes were a prominent presence in large-scale parades. The most memorable moment came on Saturday, October 1, 1949, when the dance troupes formed part of the grand procession of the PRC's Founding Day Parade in Tiananmen Square. The impressive parade was staged with pomp and pageantry, and the yangge troupe, composed entirely of experienced dancers from the Department of Literature and Art of North China University (Huabei daxue, commonly known as Huada), a major training ground for Communist cultural cadres, made a most imposing appearance following the military march (figure 16).[23] Cities throughout the country followed suit. In Wuhan, for example, as

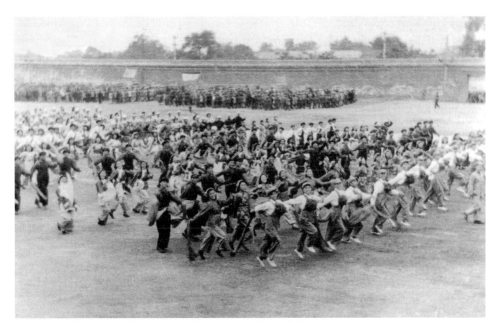

Figure 16. Students of North China University performing a *yangge* dance at the founding ceremony of the People's Republic, October 1, 1949, Tiananmen Square. *Source*: Courtesy of Dong Xijiu.

many as fifteen hundred people performed yangge in the streets to celebrate this special occasion.[24] As time passed, the dance continued to be a vital part of the Communists' political culture. When the Korean War broke out in June 1950, yangge was again used as a propaganda tool to support the Resist America, Aid Korea Campaign.[25]

The New Dance: A Narrative History through Rhythmic Movements

The full significance of the new yangge, however, does not lie in its individual appearances in parades or exhibitions but in the Communists' overall use of the dance in constructing what I call "a narrative history through rhythmic movements"—that is, using yangge to weave recent CCP developments into a success story about the Communists coming to power, the gallantry of the People's Liberation Army, the staunch support of the Chinese people, the correct Party leadership, and a bright socialist future for the country. This story was conveyed in three important musical performances involving song and dance that were staged from mid-1949 to early 1950: *The Great Yangge of the Celebration of the Liberation* (*Qingzhu jiefang dayangge*); *The Great Musical of Long Live the People's Victory* (*Renmin shengli wansui dagewu*); and *The Great Yangge of Building the Motherland* (*Jianshe zuguo dayangge*). Each of the three

productions told a different story, but together they could be viewed as an inte-grated paean to the Chinese Communist Party and its leadership.

The first major yangge production occurred in June 1949 at the first meeting of the Preparatory Committee of the new Chinese People's Political Consultative Conference. At the invitation of the Communists, the CPPCC, nominally representing twenty-three political groups, gathered in Beiping to discuss the future of China. At the conclusion of the five-day conference on the night of June 19, at Huairen Hall (Huairentang) in Zhongnanhai, the Communist leadership compound, a musical performance was staged to celebrate the historic gathering as well as to entertain the participants, which included Mao Zedong and Zhou Enlai.

The program began with two performances: first, a victory waist drum dance, which paid tribute to the Preparatory Committee of the CPPCC for its role in setting up a new political regime in China, and, second, the yangge dance, *The Great Yangge of the Celebration of the Liberation* (hereafter, *The Celebration of the Liberation*)—a combination of Shaanxi, Dongbei, and central Henan yangge dances—which sang the praises of the war of liberation. Students from Huada's cultural troupe performed the dance. *The Celebration of the Liberation* was, in fact, a joint product of Huada students and teachers. It began with the traditional New Year greetings, similar to those of the old Shaanbei Yangge but now endowed with a contemporary ring, commemorating the liberation of Beiping and the demise of the Guomindang. The musical performance included a host of traditional musical instruments (such as the war drum) to generate a buoyant mood, depicting, as one student dancer recalled, "a city immersed in endless rounds of uninhibited jubilation."[26]

Huada's yangge troupe was not the only performing group on the program—others included the drama troupe from the Political Section of the North China Military Region—but the yangge drew the loudest applause. A newspaper article entitled "The people's recreation has entered the palace; Huairen Hall saw the yangge dance" clearly spoke to the popularity now enjoyed by this formerly humble art. The show was a resounding success, the paper reported, and of particular value was the performance of *The Celebration of the Liberation*, which was a revelation for those delegates who "never before had visited the [Communist-] liberated areas."[27]

A second, more elaborate show, *The Great Musical of Long Live the People's Victory* (hereafter, *The People's Victory*) was staged in the same hall in late September, when the CPPCC reconvened to prepare for the founding of the PRC. Responsibility for the show was placed in the hands of Guang Weiran (Zhang Guangnian [1913–2002]) and Hu Sha (b. 1922), two teachers associated with Huada's famed Department of Literature and Art, with the assistance of the dancer Dai Ailian.

All three were experienced artists with distinguished careers. Influenced early on by socialist ideals, Guang Weiran, a noted poet and literary scholar,

joined the CCP in 1937 and went to Yan'an in 1938. In 1939 he wrote the lyrics for the *Yellow River Cantata*, an emotionally charged song calling for guerrilla warfare against the Japanese invaders during the War of Resistance. The cantata, later set to music by Xian Xinghai (1905–45), quickly became one of the most influential songs of the war.[28] Hu Sha had an equally illustrious career in the Communist camp. He was a choreographer and an anti-Japanese war drama veteran. Hu joined the Party in 1938 and went to Yan'an two years later, where he continued to be active in drama circles. When the new yangge movement was launched in 1942, Hu became one of its vocal promoters, choreographing a number of dances, his best known being "Production Dance," a yangge glorifying the merits of labor.[29]

Dai Ailian's career as a legendary dancer followed an entirely different route. Born in Trinidad to overseas Chinese parents, Dai exhibited remarkable dancing ability when young. In 1931 she went to London to study ballet. In the late 1930s, during the Japanese invasion, Dai was increasingly drawn to Chinese nationalistic appeals. At the same time, she developed a keen interest in Chinese dance. In 1940 Dai went to China for the first time, "with deep feelings about the motherland," to quote her own words.[30] One of the few Chinese dancers with a firm grasp of Western dance both in practice and theory, she was widely respected by native Chinese artists. Dai was not a Communist but was sympathetic to the socialist cause, so predictably she was one of the prominent figures the Communists tried to entice. That she was invited to watch the yangge show by the *New China Daily* in 1945 and that Zhou Enlai personally taught her the dance were indications of her considerable prestige. In 1949 Huada recruited Dai as a dance instructor.

The People's Victory was performed on a grand scale. It had a cast of 250 dancers, mostly students from Huada, and was one of the largest musical spectacles the Communists had produced up to that time. The show, with yangge as its principal element, was important not only because it commemorated the opening of the CPPCC meeting and was attended by top CCP leaders such as Mao Zedong, Zhou Enlai, and Zhu De (1886–1976); it also had symbolic significance. It was intended, in Hu Sha's words, "to display a comprehensive view of the people's victory [in the revolution]."[31]

Although the show was a joint project between producers, directors, dancers, singers, and folk artists, its directive came clearly from the top. The purpose of the show, according to the instruction the Party presented to the organizers, was "to demonstrate the idea of the people's democratic dictatorship, the leadership of the proletariat, the importance of workers and peasants as the foundation [of the nation], and the great unity of the various national minorities."[32] This instruction was clearly in line with the official CCP policy, as expounded by Mao in his 1949 article, "On the People's Democratic Dictatorship," cited earlier.

Compared to the earlier *Celebration of the Liberation*, *The People's Victory* was a more ambitious, better coordinated, and lengthier production. Whereas

the former underscored the liberation of Beiping and the bravery of the Red Army, the new dance focused on the importance of the masses in the revolution and stressed its political significance, reaffirming the Maoist mass line.[33]

The People's Victory was a song and dance musical arranged in ten parts, each touching on an aspect of the people's revolution.[34] As if to demonstrate that it was intended as a continuation of the earlier *Celebration of the Liberation*, the show opened with a tribute to the remarkable achievements of the PLA's war of liberation against the reactionary Guomindang and the people's joy at the ultimate success of the CCP. A war drum dance, in the Hebei folk style, followed as an introduction to the show. Accompanied by a drum and two gongs, a dozen male dancers, each holding cymbals in both hands, moved about the stage, dancing at a feverish pitch while striking the two cymbals, creating a thunderous roar. Wang Yi, a virtuoso folk dancer from Hebei, performed a solo. In spectacular, fluid motion Wang repeatedly swung his two cymbals swiftly around his body, "forming two golden butterflies soaring in circles," according to one viewer who watched in awe.[35]

The third part, titled "A Song-and-Dance Overture," was a jubilant combination of songs and dances, designed to celebrate the historic convening of the CPPCC in preparation for the founding of a new nation. The flower drum dance, accompanied by a combination of drums and gongs, formed the fourth part and was intended to express the people's joy in welcoming the news of liberation. Audiences were reminded of the bygone Guomindang era when chaos reigned and corruption was rampant. "The Red Flag Is Fluttering," a marching song, was the fifth part of the program, and depicted the gallantry and high spirits of the Red Army. Raising red flags and brandishing swords, the performers danced "across" the Yellow and Yangzi rivers to liberate the country.

This was followed by a yangge play titled *Four Sisters Brag about Their Husbands*. In the play four female dancers sang boastful tunes about the achievements of their respective husbands, each of whom was either a worker, a peasant, or a soldier. The message was clear: were it not for the generous work of workers, peasants, and soldiers, the Communist victory would never have materialized— another reaffirmation of the Party line regarding the masses. "Celebration of Victory," a waist drum dance, constituted the seventh segment of the program. With native drummers from Ansai county in Shaanxi beating the drums, the dance communicated the people's joy of victory and lent power to the show.

Younger dancers performed the eighth part, a "Lotus Dance," another popular folk dance that originated in northern Shaanxi. The dance was particularly appealing to the audience because of the performers' skillful moves and handsome costumes designed in the shape of a lotus, a symbol of joy and festivity. In the end, dancers used ribbons to form a five-pointed star to symbolize the victory of the Party (figure 17).[36]

Ninth on the program was a variety of national minority dances, including

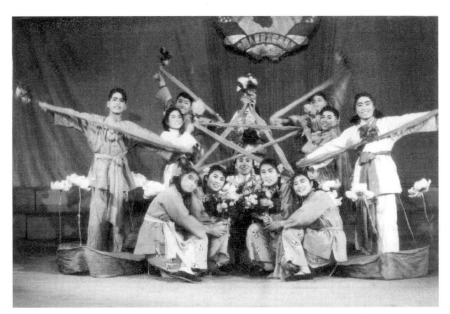

Figure 17. Dancers form a five-pointed star with ribbons, in *The Great Musical of Long Live the People's Victory* (September 1949). *Source*: Courtesy of Dong Xijiu.

those of Mongolians, Muslims, Tibetans, and Miao, as well as the mountain peoples of Taiwan. The colorful display of ethnic musical pieces portrayed China as harmoniously united toward a common goal, led by the CCP. Dramatic effects were carefully choreographed. In the Mongolian piece, for instance, the dancers impersonated equestrian local populace, "riding" from the steppes to Beiping to pay tribute to the new leaders.

"Let Us Triumphantly March under Mao Zedong's Banner" was the finale of the show. In this concluding piece, with the chairman's portrait in the background, dancers, performing as workers, peasants, soldiers, and national minorities, marched in unison with determined steps, singing loudly:

> Under the banner of Mao Zedong,
> We march victoriously forward!
> No mountain can block our zeal,
> And no ocean can subdue our will.
> Our strength is boundless,
> And our wisdom is as tall as a mountain.
> The long march poses no difficulty,
> We will forever follow him,
> Forward! Forward! Forward![37]

The People's Victory was not an artistic performance per se. Each part was carefully designed to follow a preestablished political script. The narrative was

simple, but the political message rang loud and clear. The production, invested with political symbols (red flags and a five-pointed star), was intended both to recapitulate and reaffirm the meaning of the Communist Revolution. Emotionally the participants could relive the revolutionary impulse and enjoy the fruits of victory. Though the capture of Beiping was a mere few months old and the civil war against the Nationalists still raged in the south, it was precisely at this critical juncture when revolutionary passion needed to be rekindled and ideals reaffirmed. The show succeeded in delivering several themes: the significance of folk traditions; the splendor of the Red Army; the wisdom of the leadership; and the glory of the national minorities joining hands, united under a new regime.

The People's Victory had strong rural roots; it was a musical "with pronounced nationalistic characteristics," as director Hu Sha proudly reminded his audiences.[38] In addition to yangge dances—the popular Shaanbei version being the principal one—the musical was an assemblage of a host of folk art forms, including the flower drum dance and the waist drum dance.[39] "The entire production, including its melodies and dance movements," one yangge dancer pointed out during an interview, "was modelled on Shaanbei Yangge."[40] Folk artists (for example, Wang Yi from Hebei) were also brought in to show how the dance was actually performed in local villages, thus adding a sense of authenticity to the performance. This effort toward authenticity demonstrated that the producers continued to hold native dances in high regard. However, convenience and political reasoning were additional motivations. In dance circles, veterans from Yan'an (such as Guang Weiran) assumed the lead in setting the agenda. It was not surprising, therefore, to see them relying on comfortable genres that had earlier proven effective in rural Shaanbei. More important was the political impetus accounting for the decision to incorporate a large portion of folk art forms into the musical, for it continued to demonstrate the correctness of the Maoist line of "learning from the masses."

Another dominant feature in the dance was the military theme. The spectacle of military force was clearly necessary during the early days of the PRC, a period when the country was not yet unified and when enemies, both the Guomindang from within and the Americans from the outside, remained a deadly threat to the young socialist regime. This glorification of armed struggle was of paramount importance in stressing the invincibility of the Red Army.

The dance, moreover, was intended as a tribute to the Communist leaders, especially Mao Zedong. The charismatic aura of Mao's manufactured persona was already quite visible during the Yan'an era, and the fostering of Mao's cult of personality continued in the early days of the PRC. For the CCP, this effort to promote Mao was essential, as it filled the political void left by the demise of the old Guomindang institutions and provided a rapidly changing society with a stable symbolic center. Having Mao shake hands with the performers after the show was also helpful in this regard. As one dancer recalled years later, with a mixture of wonder and excitement: "When we saw Chairman Mao, met

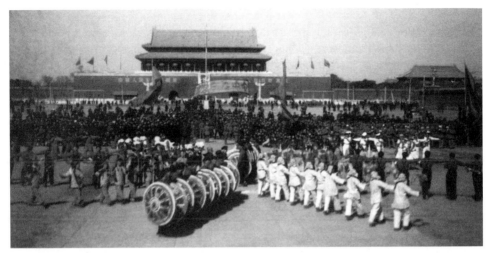

Figure 18. The performance of the *yangge* musical, *The Great Yangge of Building the Motherland*, Tiananmen Square, February 1950. *Source*: Courtesy of Dong Xijiu.

him face to face, we were speechless. After a brief silence, we uttered in unison, 'Long Live Chairman Mao!'"[41]

The dances also bespoke great national unity, where minority nationalities came together on equal footing and with mutual respect as members of one family in a new era. The inclusion of Taiwan's mountain peoples was no doubt deliberate, signaling the Communists' determination to "liberate" Taiwan, occupied at the time by the retreating Guomindang troops, and reunify China.

The third musical, *The Great Yangge of Building the Motherland* (hereafter, *Building the Motherland*), as one of its producers described, was "another major collective effort mounted immediately after *The People's Victory*."[42] This musical was staged during the Spring Festival of 1950, the first Lunar New Year after the founding of the PRC (figure 18). The show therefore symbolized rebirth, signaling the beginning of a new year and drawing its energy from the renewed cycle of the seasons.

Like *The People's Victory*, *Building the Motherland* was a government-promoted project, this time sponsored by the Ministry of Culture and the Central Drama Academy. Supervising the musical were Zhang Geng (1911–2003) and Cao Yu (1910–96), two influential figures in literary circles.[43] Of the two, Zhang was more closely tied to the Party line. Like Guang Weiran and Hu Sha, Zhang was active in staging anti-Japanese plays during the War of Resistance. And, like them, Zhang also went to Yan'an as a devoted Marxist. He became a pivotal figure in Yan'an's new yangge movement, responsible especially for promoting the dance in remote areas, particularly in the Suide region, northeast of Yan'an.[44] After the founding of the PRC, Zhang assumed the post of vice president of the Central Drama Academy, again in charge of drama reform. Cao Yu

was a celebrated dramatist, perhaps the single most influential figure in introducing Western-style drama (*huaju*) techniques into his plays. His ability to skillfully weave Western techniques into his work is aptly illustrated in his best-known drama, *The Thunderstorm* (*Leiyu*) (1933), a play critical of the old oppressive family system and archaic traditional values. As a writer who supported the leftist cause, Cao Yu was appointed director of the People's Art Theater in 1950. Dai Ailian was again invited to direct the entire production. Her gifted student Peng Song (b. 1916) was responsible for coordinating the show.[45]

With 135 students recruited from the Central Drama Academy—an offshoot of Huada's Literature and Art Department—the musical was an open-air group dance with the avowed intention of "elevating the level of art of the old yangge."[46] It was divided into four segments: soldiers, peasants, workers, and a final group dance, each accompanied by music composed specifically for the occasion. The focus of the musical was new: building a socialist nation.

The soldiers' dance opened the show on the theme of defending the nation. Male dancers, in different formations with various military props, portrayed the valor and will of the soldiers. A peasant dance followed, performed by forty female students, who projected positive images of raising fat livestock and tilling land at a collective farm. They waved the yields of their harvest (such as wheat), proudly announcing a bumper crop. Next came the workers' dance, in which male performers represented the workers' determination to lay a solid foundation of heavy industry in the nation. With the use of props such as wheels in gear, their movements reflected a factory in full motion. Forming a human pyramid, the dancers represented a bustling industrial plant. The finale of the musical was an impressive group dance, in which all three groups participated. It took the form of concentric circles, with soldiers at the outer circle, peasants in the middle, and workers at the core. The configuration was both spatial and symbolic: the PLA guarding the nation's borders, the peasants cultivating the land in the vast countryside, and the workers laboring in the newly developed urban industrial centers. Having the workers occupy center stage reinforced their leading position in the Marxist framework.[47] This cheerful climax was directed by Peng Song, accompanied by the theme song written by the famous musician Ma Ke (1918–76), a teacher at the Central Drama Academy. The performance as a whole, Peng Song told audiences, celebrated, through song and dance, the noble idea of "building a free and prosperous motherland in the future."[48]

Building the Motherland was staged nine times in Beijing, primarily at Tiananmen Square, during the Spring Festival. Drawing a total audience of eighty-five thousand spectators, the production seemed to be well received by the general public.[49] For the setting of the musical, the organizers had experimented with various novel approaches, for example, performing in the open air of a public square. No longer confined to Huairen Hall, where the seating capacity accommodated only a few hundred, the show moved outdoors, with the hope

of drawing more viewers and enabling the audience to become more personally involved. Such creative devices, the *People's Daily* wrote, "had moved beyond those of the old yangge . . . and would serve as a model for the new yangge movement."[50]

The Value of New Yangge

Revolutions tend to have hugely significant historic sites that become powerful political symbols. For Michelet, the Bastille personified evil in France; for Russians, the Winter Palace symbolized a detested world. Thus the two spectacles, "The Storming of the Bastille" and "The Storming of the Winter Palace" represented the people's rebellion in their respective nations.[51] Unlike the presentations memorializing the Bastille and the Winter Palace, however, the three yangge musicals lacked an individual event that could distill the Chinese Communist Revolution into a singular moment. Instead, they presented a variety of significant points: the war of liberation, the heroism of the PLA, the wise leadership of Mao Zedong, and the genuine support of the people.

To achieve maximum impact, the Communist propagandists placed the three productions in chronological order—the war of liberation (*Celebration of the Liberation*), the commemoration of the people's victory (*The People's Victory*), and the construction of a new socialist country (*Building the Motherland*)—each delivered through the familiar technique of storytelling. Like an old-fashioned village storyteller, or "a singer of tales," to borrow Albert Lord's noted phrase,[52] the events in the three musicals were woven together to tell a vivid story. It should also be noted, however, that the three productions were not tightly structured nor were their plots clearly defined. But their portrayal of the CCP as the correct leadership linked them closely together, forming what one participant called "an epic story."[53] It would later reappear in an elaborate production of *The East Is Red* (*Dongfang hong*), a 1964 musical of mammoth proportions about the glory of the Chinese Communist Revolution, enacted by Communist artists to celebrate the fifteenth anniversary of the founding of the PRC.

The three musical productions, however, were not without their problems. Artistically, according to the influential writer Tian Han (1898–1968), who had seen the show, *The People's Victory* remained primitive and paled in comparison with its more sophisticated Soviet counterparts. More important, he said, the dance lacked depth. Although the spectacle may generate excitement at the beginning, Tian opined, such passion would soon fade since the show merely scratches the surface of the revolution. Tian was particularly critical of the national minority dances, especially those of the mountain peoples of Taiwan, which, for him, appeared superficial, devoid of any "realistic touches."[54] The directors of the musicals candidly acknowledged their inexperience in mounting a major show. For instance, the producer of *Building the Motherland* openly

admitted that accurately depicting the life of the working class was a major headache.[55] Clearly the rural yangge did not translate well into portrayals of workers in an urban setting.

Decline

Yangge was both a captivating dance and a compelling political symbol during the early days of the PRC. Indeed, it was ubiquitous, showing up regularly in parades, in exhibitions, and on university campuses. But was the Communists' new yangge movement a success? Did this rural art form thrive in the city? And, more important, did the Communists effectively use it as a means of fostering national spirit and conveying socialist messages as originally planned?

After a period of fervent activities from 1949 to 1951, urban yangge seemed to have lost its popularity. After 1951 no major yangge musicals were staged, and writings about it declined drastically. In an interview in the fall of 2002, one of the original yangge dancers in Beijing admitted that the dance seemed to have lost its appeal. "Few performed yangge in 1951," she sadly reported.[56] In fact, contrary to the government's optimistic reports, the yangge campaign encountered many obstacles from the very beginning. Some of the difficulties were technical, but more serious were the political problems, a result of the government's unyielding control of its art policy.

The first problem may be traced to the art form itself. The version of yangge that Yan'an cadres had chosen to popularize in the cities was less sophisticated, characterized by simple moves and predictable patterns. To many urbanites, after seeing yangge for the first time, the dance appeared unrefined and not worth learning. Surely Derk Bodde was not the only critic to characterize yangge as "simple." Some Beijing residents ridiculed it as "vulgar country dancing."[57] Many believed it was "monotonous and dull" and did not warrant much attention.[58] A similar criticism came from Asian professional dancers as well. The celebrated Korean dancer Choi Seung-hee, who was visiting China from North Korea during the Korean War, saw yangge and commented critically that the dance, though presenting a healthy image, was "technically simple and crude." In her view, the dance would earn the respect of those in professional dance circles only if it underwent substantial reform.[59] Such criticism from an internationally renowned dancer who had successfully blended traditional Korean dances with Western techniques (as in her famous bodhisattva dance), would certainly have caught the attention of her Chinese hosts.

The changing political strategy of the CCP also contributed to the decline of yangge in the early years of the PRC. In September 1949 the CPPCC adopted the Common Program, officially announcing that the People's Republic of China "carries out the people's democratic dictatorship led by the working class, based on the alliance of workers and peasants."[60] This shift in emphasis to the workers clearly impacted the workers' view of yangge. In fact, not all workers embraced

the dance with enthusiasm. To some, the art of yangge had a distinctly rural flavor and could not easily be transferred to an urban environment. To gain acceptance among the working class, one worker suggested, yangge "must reflect workers' ideas and sentiments."[61] While this view may well have indicated a rising chauvinism among workers, it did point to the core of the problem: the potential incompatibility between a rural art and an urban industrial workforce.

The Party-sponsored urban form of yangge also faced new institutional challenges. "With the establishment of the People's Republic," two noted drama critics wrote in a recent book, "the former multi-purpose cultural troupes moved toward specialization and professionalization." One example was the famed cultural troupe from Huada that was soon incorporated into the dance unit of the newly established Central Drama Academy, established in 1950. In June 1951 the Ministry of Culture called for a meeting to map out the next phase of propaganda strategies. In December 1952 the ministry issued a directive, "On the Reorganization and Strengthening of the Work of the National Drama Team," transforming the formerly flexible, amateurish cultural troupes into a more specialized dance company.[62] While this directive ensured stronger institutional support (and hence funding) for artistic activities, it also called on the art troupes to become more professional. Inevitably, this undermined the original spontaneous nature and spirit of the yangge troupes.

In December 1952 the Central Song and Dance Ensemble was formed, followed two years later by the National Ethnic Song and Dance Ensemble. This institutionalization of art meant that future performances would increasingly demand professionally trained dancers and singers. Moreover, the presentation of large-scale musicals would challenge the limitations of traditional yangge, which was an open-air dance without the capacity for a lengthy, complex production. When choreographing *Building the Motherland*, Peng Song recognized the shortcomings of yangge. And, indeed, the musical he crafted turned out to be quite unlike the original simple yangge style; in Peng's production, for example, the dancers in the roles of worker, peasant, and soldier, in coordinated movements, formed intricate circular patterns.[63]

In the early 1950s the increasing presence in China of foreign dancers, especially those from the socialist countries, opened the eyes of Chinese artists to new artistic presentations from abroad. Not surprisingly the visits of Soviet dance delegations, ranging from the Red Army Song and Dance Ensemble in 1949 to the celebrated ballerina Galina Ulanova in 1952, received a great deal of attention.[64] Dai Ailian's praise of Ulanova as "the world's greatest ballerina"[65] carried an implicit message to Chinese dancers, since the Russian ballet interpreted dance techniques in ways significantly different from the native performances. In fact, Dai was never preoccupied exclusively with yangge. Her original training as a ballerina and her more cosmopolitan outlook prompted her repeatedly to introduce Western techniques into Chinese dance. This was evidenced in her performance of a ballet in *Peace Dove*, a 1950

song-and-dance musical in praise of world peace as well as a protest against foreign imperialism. The inevitable result was to cause tension between native forms of dance and foreign models.[66] When Dai was named the first principal of the newly established Beijing Dance School in November 1954, she turned her energy increasingly toward training a new generation of professional dancers and was determined to introduce non-Chinese dances, including Russian ballet and Indian dance, into the school curriculum.[67]

Still, the most serious challenge to yangge was political, not artistic. Since the Yan'an days, the CCP unquestionably played a decisive role in directing art and literature in the service of the Party. In so doing, it allowed little room for artistic freedom or improvisation. After the Party seized power it tightened its control even more. In June 1949 the Beiping Municipal General Labor Association issued four specific rules for yangge: male performers were forbidden to dress as women, and any flirtatious or erotic moves were to be eliminated; the portrayal of ghosts, deities, Buddhist monks, and Daoist priests, common elements in the traditional dance, was prohibited; there was to be no vulgarity in the performance, as in the case of ridiculing Chiang Kai-shek as a tortoise, for, according to the association, such derision "does not accurately reflect the true face of the enemy of the people"; and the dancers were not permitted to use excessive makeup in the performance.[68] These directives were not the only imposition from above. The government also explicitly stated that any negative portrayal of the working class in yangge was strictly forbidden.[69] In the words of Zhou Yang, "Anything at all that humiliates the appearance of the working people is unacceptable."[70]

The Communists also frowned on the inclusion of foreign enemies in yangge. When a county in Hebei portrayed Harry Truman and Douglas MacArthur in the National Day yangge celebration, the People's Daily responded with harsh criticism: "In yangge, reactionary characters and laboring people should not intermingle. When do we ever see reactionaries such as Harry Truman, Chiang Kai-shek, Syngman Rhee, and Yoshida [Shigeru] dancing happily together with the working people?"[71]

There is no question that the Communists' new yangge movement was a political endeavor, without any intention of enhancing aesthetic appreciation or encouraging cultural pluralism. Yangge was viewed as an efficient and appropriate medium for communicating socialist ideals to the people. Its reformed performances had to accurately reflect the government's positions. Thus the new urban yangge dances no longer resembled the original spontaneous rural art at the grassroots level. Instead, they represented an art that had been transformed and reinvented from the top. When art is politicized and monopolized by a regime, it is clearly an art under duress. Not only did yangge lose its autonomy, it lost its ability to grow. The reformed urban yangge now spoke with one voice and was performed with one prescribed step. Rapidly the dance became a political

cliché, mere rhetoric. Thus the fate of the new yangge was the dissipation of its initial euphoria.[72]

As an official art form actively promoted by government propagandists, yangge undoubtedly enjoyed great popularity in urban China in the early days of the PRC. Although less popular in urban areas later on, it continued to be widely enjoyed in the countryside and was practiced there with greater freedom. To determine whether the new yangge movement succeeded or failed, we must view this propaganda campaign as part of the government's overall plan to use state spectacles to celebrate the myriad achievements of the new regime, especially the grandest spectacles of all: the National Day and Labor Day parades. Yangge was but one of many components of these nationwide ceremonies to glorify the new regime. Viewed as a whole, these state-sponsored festivities had a considerable impact on the population in the 1950s.

4. Parades

On the morning of February 3, 1949, three days after the seizure of Beiping, the People's Liberation Army marched into the fabled city with great fanfare, signaling an official changeover of power and the beginning of a new era in modern Chinese history. Commanders Lin Biao (1907–71) and Luo Ronghuan (1902–63), positioned atop Zhengyang Gate, inspected the troops as they passed through the gate; the troops then immediately turned eastward into the heart of the legation quarter (Dongjiaominxiang), and then moved on to other parts of the city. Again, the American Fulbright scholar Derk Bodde has provided a valuable eyewitness account of this spectacular display of military might, noting in his diary:

> I missed the first contingents of infantry and cavalry, as well as part of the motorized units. But in what I did see, lasting about an hour, I counted over 250 heavy motor vehicles of all kinds—tanks, armored cars, truck loads of soldiers, trucks mounted with machine guns, trucks towing heavy artillery. Behind them followed innumerable ambulances, jeeps, and other smaller vehicles. As probably the greatest demonstration of Chinese military might in history, the spectacle was enormously impressive. But what made it especially memorable to Americans was the fact that it was primarily a display of *American* military equipment, virtually all of it captured or obtained by bribe from Kuomintang [Guomindang] forces in the short space of two and one half years.[1]

But unknown to Bodde and many Beiping residents on that memorable day, this military parade was by no means casually put together. From the start, the Chinese Communist Party carefully orchestrated and meticulously planned the event. On January 29 Beiping's underground Communist radio stations received a secret telegram from Liu Ren, an organizer of the parade and, as mentioned earlier, a future Beijing municipal party leader, with the instruction, "Line up the people in the streets to welcome [our troops]!"[2] Planners calculated the route to generate the most dramatic and symbolic effect. By entering Beiping through Zhengyang Gate—the main southern entrance into the inner city, formerly reserved for emperors—and then marching into the legation quarter where foreigners had been prominent in bygone days, the Red Army was forcefully stating

that it intended to demolish two evils of China's past: feudalism and imperialism. The Communist army, envisaging a bright new world ahead, would now "liberate" China.

The rich cultural and political context of parades affords historians a deeper understanding of the nature of societies. This is clearly illustrated by the community celebrations (*shehuo*) in traditional China, popular village parades held at the beginning of the lunar year when peasants paid tribute to local deities in the hope of reaping a bumper harvest.[3] The military procession of the CCP was rather different, however, with broad geographical antecedents and major political implications. Historically, parades and processions have been central to politics. In his study of three different societies—Elizabethan England, fourteenth-century Java, and nineteenth-century Morocco—Clifford Geertz has argued that the rulers used royal processions to "justify their existence and order their actions in terms of a collection of stories, ceremonies, insignia, formalities, and appurtenances that they have either inherited or, in more revolutionary situations, invented."[4] During the French Revolution, as Mona Ozouf has contended, festivals and parades marked by popular participation and held in open fields were vital parts of a new revolutionary culture that emphasized the openness and equality of a modern, secular world.[5] Nazi culture thrived on mass rallies. Hitler was a master at emotionally manipulating crowds through coordinated marches and mammoth sports events. Elaborately choreographed parades and arousing processions in Nuremberg awed spectators into fearful obedience.[6] In the Soviet Union, celebrations in Red Square during May Day and on the anniversary of the October Revolution were affirmations of Soviet authority and the supremacy of a socialist system.[7] In the United States, parades such as those celebrating America's independence on July 4 are civic dramas and communal festivals, which, in the words of Mary Ryan, represent "an exercise in popular sovereignty."[8] How did the Chinese Communist parades compare to these?

Like studies of yangge, analyses of Chinese state spectacles have significantly advanced our understanding of how ritual and symbolism influenced the development of nationalism. Recent works on the National Day (October 10) celebrations to honor the anniversary of the 1911 Revolution have shed light on the development of a new national community in early Republican China.[9] One art historian's study of state parades on October 1 in socialist China offers some insights into Communist political ritual and symbolism.[10] But few have examined how these state spectacles were organized institutionally or identified the key planners; even fewer have looked into the influence of Western state ceremonies on Chinese parades (in the case of socialist China, it was the Soviet model). This chapter attempts to fill these gaps by examining both the official agencies responsible for staging state parades in China in the 1950s and the Soviet influence on the staging process. More important, it seeks to understand the nature of Chinese state spectacles, focusing not only on the National Day (October 1) parades but also on the May Day celebrations held in Tiananmen Square in the

1950s. I argue that the parades of the CCP were well-organized political rituals with multiple purposes: they were festivals to highlight the demolition of the old order and to embrace the new socialism; a legitimation of the CCP's authority; a display of myriad achievements under Communism; an affirmation of the centrality of the role of Mao Zedong in modern Chinese revolutionary history (hence promoting the cult of Mao); and an announcement of China's presence in the international socialist camp. The parades also reflected a nation undergoing political and economic changes at the time. Although celebrations and parades were also staged in major cities such as Shanghai, the ones in the capital were the most memorable and significant, and provided a model for others to follow. Local observers were often sent to the capital to learn from the Beijing experience.[11]

City Decorations and Mass Celebrations

Because of political and social uncertainties, the October 10 National Day celebrations in the early Republican era were held intermittently by the warlord government in Beijing, and later by the Guomindang in Nanjing. In the first two decades of the twentieth century military processions on National Day were occasionally staged by warlords in Tiananmen Square and Nanyuan, a military base south of Beijing, but in the late 1920s the Guomindang regime held them at Nanjing's airfield.[12] Few large-scale parades, however, were organized by the state, and festivities often displayed an impromptu spirit.[13] A typical celebration of National Day in this period was described by Shanghai's influential newspaper *Shanghai News* (*Shenbao*) as the public's enthusiastic decoration of the cities with national flags and lanterns.[14]

In December 1949, soon after the founding of the People's Republic, the government officially announced a list of new public holidays and festivals to signal the end of the feudal past and the beginning of a novel era—a pronouncement resembling those of the French Revolution and the October Revolution.[15] These festivals included May Day (May 1), the Youth Festival (May 4), the founding of the PLA (August 1), and National Day (October 1). The most memorable and politically significant of these festivals were the May Day and National Day, to be marked by massive parades and great revelry.

Like the Soviet festivals,[16] the CCP's state celebrations consisted of three basic components: ceremonial decoration of the city, mass spectacles, and, most important, processions conveying visually stunning scenes and compelling political messages. Decoration of the city of Beijing began weeks before May Day and National Day. Red banners and posters were displayed on buildings and at roadsides; shop windows and street signs were decorated with slogans and red stars. Displays varied in different parts of the city. Areas around Tiananmen Square, the symbolic center, received the lion's share, as evidenced in the streets fronting Zhengyang Gate, known also as Qianmen, or Front Gate. Similarly, the

People's Square (Renmin guangchang) in central Shanghai drew the most attention. For the 1951 National Day celebrations, Shanghai's Municipal Communist Party ordered that the main roads leading to the People's Square, especially Nanjing Road and Tibet Road, the two key parade routes, should be "the focus of honor."[17] Park Hotel (Guoji fandian), directly facing the square and one of the tallest buildings in Asia at the time, was to be draped with gigantic festoons of red cloth bearing slogans such as "Long Live Chairman Mao Zedong, the Great Leader of the Chinese People!"[18]

Mass spectacles consisted of a series of public celebrations closely directed by the government. In Beijing free garden parties were held in the Working People's Cultural Palace (formerly the Imperial Ancestral Temple) and Zhongshan Park to the east and west of Tiananmen Gate, respectively, as well as in the Summer Palace and other locations, with thousands of citizens participating. Dancing revelries were held in Tiananmen Square at night, as were displays of fireworks.[19] Citizens set off firecrackers and watched patriotic movies in open-air theaters in Dongdan and Xidan.[20] In these events, the people, according to the *China Pictorial* (*Renmin huabao*), were all "warmly applauding a new China."[21]

The Parades

The greatest public and international attention was focused on the annual May Day and National Day processions in Tiananmen Square and, in Shanghai, in the People's Square (figure 19). The first procession was on October 1, 1949, immediately after Mao proclaimed, atop Tiananmen Gate, the founding of the People's Republic. The procession began with a military parade, followed by thousands of cheerful civilians marching across Tiananmen Square. Mao attached great importance to this founding day military parade, remarking that "since this is the first such parade of our new nation, it must be a great success!"[22] The paraders—holding huge portraits of national leaders such as Mao—swayed rhythmically to the beat of their waist drums and danced yangge, as they passed through the East Sanzuomen into the still enclosed Tiananmen Square and filed past Tiananmen Gate to be reviewed by the nation's new rulers, exited through the West Sanzuomen, and finally dispersed to nearby streets.

In 1951 the municipal government set up two committees: the Capital's Preparatory Committee for the Celebration of the Founding of the People's Republic of China (Shoudu qingzhu Zhonghua renmin gongheguo guoqingjie choubei weiyuanhui) and the Beijing Preparatory Committee for the Celebration of International Labor Day (Beijing qingzhu Wuyi guoji laodongjie choubei weiyuanhui). Each committee resembled the Soviet Union's Central Staff for the Conducting of Holidays,[23] and was responsible for coordinating activities during the parade. But whereas the Soviet counterpart was not created until 1930–31, almost a decade and a half after the Bolshevik Revolution, the two Beijing

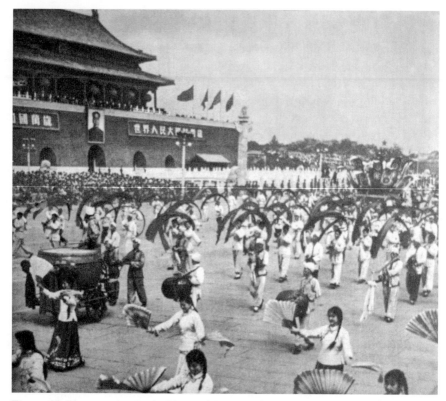

Figure 19. The art group in the National Day parade, October 1, 1954, Tiananmen Square. *Source*: *RMHB*, no. 10 (October 1954): 3.

committees were established in the early days of the PRC, attesting to the Communists' urgency for control. They were nominally under Beijing's municipal government, with the mayor, Peng Zhen overseeing their organization of the parades.[24] Their directives, however, came from the top.

Every year, on the early mornings of May 1 and October 1, the paraders assembled at designated places at Tiananmen Square, usually at the eastern, southern, and northern sides such as Wangfujing and Dongdan.[25] Some gathered as early as three o'clock in preparation for the procession that would start at ten o'clock.[26] The parades had been well rehearsed, usually at night, beginning at least three months earlier. As at the first procession in October 1949, they had two components, one military and the other civilian, the latter commonly known as "the people's parade" (*qunzhong youxing*). The military component headed the ceremony, with detachments of various PLA divisions marching in different formations, accompanied by a weaponry show. Then came the civilian part, involving hundreds of thousands of workers, peasants, students, and artists.[27] After 1952, however, May Day parades eliminated the military portion,

retaining only the civilian part.[28] The performance of this political ritual was never simple. Contrary to the optimistic official reports, the organizers encountered many problems.

In the first two years of the PRC, the Young Pioneers, representing the future of the nation, led the procession immediately following the military parade. The Young Pioneers were mostly primary school students drawn from schools near Tiananmen Square so as to reduce the inconvenience of long-distance travel for the youngsters during rehearsals and the actual performance.[29] For many participants, this assignment carried much honor. "When I found out that I was the only one selected from my primary school to take part in the National Day parade, I felt truly blessed," recalled one female former Young Pioneer, who came from a devoted Communist family. "My grandmother even made me a bright red dress for this exhilarating occasion. But during the ceremony," she added, "I had to wear a white uniform over the dress."[30] The Young Pioneers were followed by workers, peasants, government employees, students, and literary and art groups.[31] In subsequent years other contingents were added, including honor guards, athletes, urban residents from different districts, and representatives from industrial and commercial sectors, who were included because they had, according to official records, "vowed to smash capitalism and help establish socialism."[32] By 1951 a more or less standard pattern was established, with ten groups representing different constituents in the following order: honor guards, Young Pioneers, workers, peasants, government employees, urbanites, representatives from industrial and commercial sectors, students, artists and performers, and athletes.[33] The art group performed colorful dances, and at the end of the parade there were mass gymnastic displays to illustrate controlled and well-coordinated body movements, a sign of discipline and order. Other cities followed this pattern, though slight regional variations did occur, as in the case of Shanghai, where a lively torch relay was added to the National Day parade in 1959.[34]

The marchers generally formed nine columns, with 110 people lined up side by side. That number increased to 150 in 1959, when Tiananmen Square and East and West Chang'an Avenues were greatly enlarged in time for the celebration of the tenth anniversary of the founding of the PRC.[35] The total number of people participating in the processions ranged from 300,000 to 450,000.[36] An additional 50,000 to 100,000 people, some holding banners and others involved in choreographed performances, also assembled in the square, creating an impressive political symbol.[37] "It was a massive gathering of people, filled with pride and joy," reported one marcher who participated in three National Day spectacles in the 1950s.[38] The entire parade, including both the military and civilian components, usually lasted less than three hours, with the civilian part occupying three-quarters of the time.[39]

Common to all the parades were multicolored floats, red banners, decorated models, huge balloons, loud music, lively dancing, bright costumes, and finally,

as a symbol of peace, the releasing of doves. Replicas of industrial machinery and agricultural tools helped to enhance the procession.[40] In the lead the honor guards carried huge national flags, displaying the national emblem and portraits of Communist leaders, with Mao's photo predominating. Portraits of Mao and Sun Yat-sen (1866–1925) led the way in the 1951 National Day celebration. Then followed, in the second row, photos of Zhou Enlai, Liu Shaoqi (1898–1969), Zhu De; the faces of Marx, Engels, Lenin, and Stalin appeared in the third row, followed by pictures of foreign socialist leaders, commonly known as "people's leaders," such as Kim Il-sung, Ho Chi Minh, Lazar M. Kaganovich, and Nikita Khrushchev.[41]

The sequence of these photos varied somewhat, but the dominance of Mao was clearly evident. Scholars have long suggested the importance of the Mao cult in the formation of Chinese political culture,[42] and the state spectacles in the 1950s no doubt added another dimension to the growing deification of Mao since the founding of the PRC. Indeed, Mao's image was central to state parades. In the 1955 National Day celebration, for example, Sun's portrait was relegated to the second row, behind photos of Mao, Liu Shaoqi, Zhou Enlai, Zhu De, and Chen Yun (1905–95). The third row displayed portraits of Marx, Engels, Lenin, and Stalin, followed by those of other foreign socialist leaders.[43] In the 1950s Mao's portrait was sometimes mixed in with those of other senior CCP members, but still the chairman's preeminence was without question, for his image was always closest to Tiananmen Gate, the place deemed most sacred in the entire procession. Even when, in the earlier history of the parade, Mao's portrait appeared with Sun Yat-sen's, Mao's was displayed closer to Tiananmen Gate and hence seen as more important.[44] The only time when Mao's portrait was not in the front was during the annual May Day parade, in which the front row featured portraits of foreign Communist leaders such as Marx, Engels, Lenin, and Stalin.[45] However, the May Day celebration was to commemorate the triumph of the proletariat worldwide, not just in China, and universal symbols such as the hammer and sickle were visible everywhere.[46]

As noted earlier, political rhetoric, like Mao's use of the words "Stood Up!" was integral to socialist China's new political culture. Such propagandizing was clearly evident in the Chinese parades, as it had been in the French and Bolshevik revolutions.[47] "In politics," writes Pierre Bourdieu, "'to say is to do,' that is, it is to get people to believe that you can do what you say and, in particular, to get them to know and recognize the principles of division of the social world, the *slogans*, which produce their own verification by producing groups and, thereby, a social order."[48] Two kinds of political rhetoric were generally evident in the parades: placards (*biaoyu*) carried by marchers bearing political sayings and slogans (*kouhao*) or catchphrases shouted in unison during the processions. "Long Live the People's Republic of China!" and "We Must Liberate Taiwan!" were recurrent slogans.[49] The Mao cult gained fresh impetus because of the numerous

slogans uttered in his name. "We had to repeat the slogan 'Long Live Chairman Mao!' many times," said one Young Pioneer woman, fondly recalling her memorable moments in Tiananmen Square.[50] Although this glorification of Mao was carefully engineered by the CCP, the marchers I interviewed all expressed their reverence for the chairman, indicating the supreme authority Mao enjoyed in the Party at the time.[51] Other slogans were related to individual events. In the 1951 National Day parade, for instance, the unfolding conflicts in Korea were evident in the military nature of the slogans, such as "Salute the People's Liberation Army!" "Salute the People's Volunteer Army!" "Celebrate the Victory of the People of China and Korea!"[52] Watchwords in the May Day parades communicated similar themes but with an emphasis on internationalism. Those in the 1957 May Day procession declared, for example, "Long Live the Great Unity of the Proletariat Worldwide!" "Long Live Marxism-Leninism!" "Long Live the Socialist Camp led by the Soviet Union!"[53]

Another major theme of the processions was the unity of different nationalities, underscoring China as a harmonious nation where people lived peacefully together. The issue of nationalities was a sensitive matter given the tense situation in Tibet, for example, in the early 1950s, where Chinese Communist troops completed the CCP's unification campaign. Not surprisingly, the "Unity of Nationalities" theme was choreographed as a popular dance and also appeared in slogans.[54]

Paraders were told to show "passionate spirit" when entering Tiananmen Square and to wave to the spectators on the reviewing stands as they approached from the east.[55] The high point came when the columns filed past Tiananmen Gate to be reviewed by the nation's leaders. This element of the parade closely resembled the design of Soviet parades, where paraders marched past Lenin's mausoleum and were greeted by leaders from an elevated platform on top of the mausoleum.[56] The organizers invented a new tradition, however. Immediately after all the columns had passed Tiananmen Gate, the assembled crowd, made up largely of workers and Young Pioneers who were responsible for forming various artistic patterns during the parades, rushed to Gold Water Bridge (Jinshuiqiao) in front of Tiananmen Gate, a move popularly known as Advancing to Gold Water Bridge (*Yongxiang Jinshuiqiao*), to cheer and greet the national leaders. This was accompanied by singing uplifting tunes such as "Unity is the Strength" to signal the close bond between the people and their leaders.[57]

Especially memorable was the parade in 1959 celebrating the tenth anniversary of the founding of the PRC. A spectacular procession was staged in the capital and also in major cities such as Shanghai.[58] More than forty foreign government dignitaries, including Khrushchev, were invited to Beijing to attend the ceremony,[59] and a new segment of local militia joined the marching columns.[60] The number of participants in the columns was also increased from 110 to 150, forming one of the largest parades in the history of contemporary China.[61]

Themes

Political and economic themes dominated the two parades each year, expressed in floats, banners, and slogans printed on huge placards. Nowhere were these themes more prominently and succinctly demonstrated than in the slogans, which could be interpreted both as rousing calls for a collective effort to build a strong nation as well as chronicles of changing political movements at the time. As discussed above, slogans such as "Salute the People's Volunteer Army!" were militant and patriotic catchphrases during the Korean War, and other slogans reflected pressing issues at different periods. In the early 1950s the Three Antis and Five Antis campaigns formed the core of other official slogans.[62] Then, in subsequent parades, exhortations such as "Support the First Five-Year Plan!" and "Strive to Enhance Production, Practice Economy, and Accomplish the Goal of the Five-Year Plan!" were frequently used to promulgate China's drive toward industrial and agricultural modernization.[63] In 1958, as the government announced the Great Leap Forward, parade slogans such as "More, Faster, Better, Cheaper" emerged with an emphasis on Mao's three red banners: the general line of socialist construction, the Great Leap Forward, and the people's communes.[64] Hyperbole notwithstanding, these political phrases underscored the relationship between revolutionary language and the state's political aspirations and economic drives. Through a barrage of inspiring words, the CCP intended to forge an image of a new government making resolute political decisions while launching promising economic programs. The Party expected that stirring rhetoric in the mass gatherings could engender a sense of common identity and thus unite the participants both socially and politically.

The honor guards and Young Pioneers were the first ceremonial groups to open the show representing, respectively, the start of the celebration and the successors to the Communist revolution. That the workers marched directly behind these two groups was evidence of their commanding presence in the socialist regime. The workers' key role had been enshrined first in the Common Program adopted by the CPPCC in 1949 and then reiterated in the first Constitution of the PRC in 1954, which declared that workers were the leading force in the new republic. This view, of course, was squarely in line with the Marxist-Leninism orthodoxy underlying the Chinese Communist Revolution.

Immediately following the workers were the peasants, symbolic of the bond between the two classes and a familiar theme in socialist rhetoric that was reinforced by the hammer-and-sickle icon displayed everywhere. Close bond notwithstanding, the hegemonic status of the proletariat was unmistakable, as even the honor guards were mostly workers.[65] Indeed, workers were by far one of the largest groups in the marching columns, numbering several times more than the peasants. In the 1952 National Day parade, for example, 85,000 workers participated compared to only 20,000 peasants.[66] Moreover, the parade organizers gave workers the most important placards and signs to carry. In the 1953

National Day celebration, workers held the key banner, "Celebrating the Successful Opening of the Eighth Party Congress!"[67] Thus the workers' symbolic leading role in the new socialist state was explicit. Also evident in the parades was the workers' pride. "I felt particularly honored when Chairman Mao reviewed the workers," one worker marcher who had participated many times in both the biannual parades from 1949 to the early 1960s reported.[68]

The parades staged were not meant to be nationalistic. In fact, the Chinese Communists had proclaimed that the revolution was part of the international socialist movement, and parade organizers actively promoted a global spirit, as shown by the inclusion of the ubiquitous icon of the hammer and sickle and portraits of Marx, Engels, Lenin, and Stalin.[69] The friendship between China and the Soviet Union, and the leading role of the Soviet Union in world communism, were underscored in placards and slogans, a sign of China's gratitude to Moscow for its economic and technological aid during the 1950s.

The spirit of internationalism was especially accentuated by organizers of May Day, the international labor day that was a foreign-inspired festival and a worldwide event to commemorate the workers' struggle against capitalism and oppression. During a preparatory session for the 1956 May Day parade, when discussing whether Mao's portrait would be the only one displayed, Peng Zhen responded: "Holding only the portrait of Chairman Mao will make foreigners uncertain about our real stance on internationalism."[70] To highlight international friendship, foreign dignitaries were also frequently invited to participate in the two national spectacles.[71] Even so, national themes often overwhelmed the international spirit of the celebrations. Although foreign music was played during the ceremonies, "it should be used only when appropriate," one official document stated, "with the main focus remaining the Chinese pieces."[72] This directive probably came directly from Mao, for he had ordered that the celebrations must "center on China" (yi wo weizhu).[73]

The emphasis on indigenous products was particularly apparent in the use of many native art forms. Revolutions, of course, entail the creation of new symbols antithetical to those of the past, but the Communist revolutionaries often drew models and visual signs with popular resonance. As noted, the lively yangge dance and the playing of waist drums were two of the most dazzling folk performances in line with Mao's instructions. The Chinese lotus dance was another perennial favorite,[74] and equally appealing were the dragon dance, especially the Sichuan version, and the lion dance.[75] Native color was included through a rich variety of local performance art, such as Shandong's umbrella dance, which was adopted in the 1956 National Day festivities.[76] The emphasis on Chinese forms was partly for practical reasons, for they readily appealed to Chinese audiences, but even more important was their ability to demonstrate the value of a national art, a spirit of the new nation's independence. In fact, the more internationally oriented May Day parade paled in comparison with the National Day parade in both scale and symbolic significance. Unlike National

Day parades, May Day parades lacked a military procession. Moreover, Party leaders often saw the May Day marches as mere preparation for the more significant event to come, the National Day celebration in October. This proved to be the case on the tenth anniversary of the National Day parade in 1959. That year's May Day celebrations were pronounced as a "grand rehearsal" for the upcoming National Day festivities.[77]

The significance of the grand parades can also be seen from the perspective of the role played by the politics of space; that is, the cult of Mao Zedong as a supreme leader was developed by positioning him in the center of concentric rings of marchers, making him the symbolic center of the new PRC. Here, Tiananmen Square represented the outermost ring. The inner rings were formed first by the paraders who entered the square from Dongdan. The preselected participants stationed there formed the next ring and advanced to Gold Water Bridge to cheer for the Party leaders. Atop Tiananmen Gate, senior Party leaders including Zhu De and Zhou Enlai formed the innermost circle. And Mao, the new nation incarnate, stood symbolically in the center, completing the spatial hierarchy.

In his study of the symbolics of power, Clifford Geertz contends that centrality and sacredness are closely linked. Political centers, therefore, often form the most sacred, charged space.[78] The preeminence of Mao's status in the holiday celebrations was unambiguous, as were his supreme authority and sacred stance in the Party and the nation. It was the chairman who officially announced the founding of a new nation on October 1, 1949; his giant portrait graced the front of Tiananmen Gate; he was the only leader to receive bouquets from the two representatives of the Young Pioneers during the National Day parades;[79] his portrait was always carried first among all Chinese leaders, and the newly invented tradition of the crowd Advancing to Gold Water Bridge centered on him as China's supreme leader. At the core of that symbolic world, Mao stood supreme.

Organization and Control

One of the most distinctive features of the state spectacles was, without question, the CCP's tight organization and careful monitoring system. As a Leninist organization, the Party naturally demanded that all decisions be carried out unquestioningly and efficiently. Uncertainties and instabilities during the early years of the PRC also required the government to be extremely cautious in critical security matters. Despite the festive spirit, the state parades were planned under close supervision, partly for safety reasons. On May 4, 1949, for example, the Guomindang air attacks against the southern Beijing airport caused great alarm.[80] On February 6, 1950, Shanghai was hit, and Guomindang bombers destroyed the city's power plants and disrupted its water supply systems.[81] In 1950 Chinese security police uncovered a plot allegedly engineered by American

spies who planned to kill Mao and other senior officials by firing a mortar shell at Tiananmen Gate during the National Day parades. Several involved were imprisoned, and two of them, an Italian, Antonio Riva, and a Japanese, Yamaguchi Ryuichi, were executed a year later (see chapter 7).[82]

Careful organization was needed not only for safety reasons. The immense scale of the state spectacles demanded that everything must be coordinated meticulously, for they were state functions that were expected to run smoothly with no mistakes. Therefore the entire undertaking often required many months of planning. I contend, however, that tight control was prompted more by the CCP's anxiety about its very existence, especially in the early years of the PRC. The parades were always carefully and closely directed by Party leaders and government organizers, with little room for grassroots initiatives or unprompted actions. Even dancing revelries and nighttime communal celebrations, intended as spontaneous festivities, were carefully monitored to make sure that the events would not deviate from the Party's plan. In particular, the joyful activities in Tiananmen Square had to be strictly monitored, even to the point where the organizers dictated where specific groups of participants should be positioned in that vast open space. In 1957 May Day evening celebrations, for example, the area in front of Gold Water Bridge was assigned as the "higher-education location," allowing only university students to participate there.[83] The spectacles were mounted through a series of controls, some by visible institutional means, others by personal influence and higher-level directions. The control came in roughly three forms: a central committee responsible for overall management, supervision by Party and government officials, and the influence of senior Party members.

Organizationally, the two parades were planned in Beijing by the Capital's Preparatory Committee for the Celebration of the Founding of the People's Republic of China and the Beijing Preparatory Committee for the Celebration of International Labor Day. Other departments, municipal and central, also participated in overseeing the planning. In 1950, as the archival sources reveal, the Cultural Bureau of the Municipal Party and the State Department's Ministry of Culture also took part in the planning processes.[84] Most important, the Propaganda Department of the CCP Central Committee monitored all decisions regarding the parades.[85] Parade slogans were, of course, strictly regulated, as in a 1955 central Party directive stipulating that "no single unit is allowed to come up with its own slogans."[86] This directive was issued in other cities besides Beijing. In the 1951 National Day celebrations, Shanghai Municipal Party officials ordered that all posters in the vicinity of the People's Square "must be centrally organized."[87] Clearly, the Party disallowed dissension, demanding, instead, obedience and conformity to the prescribed agenda.

High-level institutional control was only part of the story. Senior Party leaders never failed to keep a close eye on the entire planning of the state celebrations. The active involvement of Politburo member and mayor Peng Zhen in the

preparation of the parades was well known. In one of the preparatory sessions for the 1955 May Day parades, for instance, when a dispute arose concerning whether to use the portrait of Sun Yat-sen, the mayor gave his affirmation, saying: "To leave out Sun Yat-sen's portrait would be a mistake, for he contributed to the democratic revolution."[88]

Peng was not the only senior Party member to be involved. Others included Vice Premier Chen Yi (1901–72), Vice Minister of Culture Qian Junrui (1908–85), and Municipal Party Vice Secretary Liu Ren.[89] Premier Zhou Enlai, although not known for his direct role, took a personal interest in the events, especially cultural affairs. It was said, in 1955, that the premier "personally reviewed the art programs."[90] This was no surprise, as Zhou's interest in literary and artistic activities was well known, as were his close ties with many influential artists and intellectuals sympathetic to the Communist cause. Documents also reveal that in later years, especially during the Cultural Revolution, the premier's endorsement was needed for the parade events to take place.[91] To many Party loyalists, firm discipline and tight control were signs that the CCP was in charge. After observing the parade in the capital, a Shanghai municipal delegate reported, with admiration, that "the Beijing Municipal Party surely had a tight grip on the contents of the parade."[92]

Chinese Compared to Soviet Spectacles

Were the Chinese spectacles influenced by the Soviet Union? Although information on this issue is sketchy, evidence indicates that Soviet patterns were admired, studied, and to some extent followed. Early CCP leaders clearly were awed by the Soviet parades. During his stay in Moscow in the early 1920s, Qu Qiubai (1899–1935) watched with great admiration the workers and peasants dancing in Red Square during the May Day parade. "This is a joyous festival," praised Qu.[93] In the early years of the PRC, Chinese organizers sought advice from Soviet military advisers regarding military parades, and also consulted with senior Chinese Party leaders, including General Liu Bocheng (1892–1986), who earlier had been trained at the military institute in Moscow and were familiar with the Soviet parades.[94] In 1954 a Beijing municipal officer was sent to the Soviet capital to study the processions. He reported that Soviet parades, as in China, saw workers and students as the key representative groups in the parade, although the Russians made less of a distinction in their group formations and their processions were marked by a freer spirit.[95]

Surely there are many parallels between the two countries in their respective state festivals. Like the Soviets, who regarded May Day and the anniversary of the October Revolution as their two most important holidays, the Chinese considered the May Day and National Day parades as their two foremost public celebrations. As in the early history of the Soviet Union, a high degree of revolutionary enthusiasm prevailed in the early Chinese parades. However,

clear differences also existed between the two. The early Bolshevik festivals, as pointed out by James von Geldern, were influenced by a pre-1917 avant-garde spirit, and festivities were spontaneous and creative, with talented artists and playwrights drawing freely from artistic traditions.[96] Many voluntary participants took part in the early Russian state events, as in the May Day celebration in Leningrad in 1925.[97] Nevertheless, the increasing dominance of Stalinism and the expansion of political control in the 1930s resulted in fewer popular initiatives and a stale uniformity in the mass public holidays in later years.

In contrast, the CCP exercised a firm grip on every element of the events from the very beginning. Marchers were carefully selected and audiences along procession routes vigilantly monitored, especially those on the main thoroughfares such as East and West Chang'an Avenues. Those who were summoned to stay in the square as part of the overall ceremony, numbering from 50,000 to 100,000 on different occasions, were even more painstakingly screened.[98] These mammoth events were state managed down to the most minute details.

Early Soviet parades also witnessed a carnivalesque spirit that often enlivened popular revelries. This was particularly evident in the attack against enemies through ridicules in the parades, as in the burning of effigies of the kulak on Red Square and the presentation of enemies as zoo animals in the procession.[99] The Chinese Communists, however, like in the yangge dance, prohibited negative symbols of enemies, such as American imperialists, in the celebrations,[100] denouncing these enemies as oppressive and exploitative.[101]

Problems with the Processions

The CCP clearly attached great significance to the two major political spectacles. And, indeed, the sheer volume of the parades, the colorful floats, the marchers' elegant precision, and the festive spirit made the events truly impressive, winning them accolades from foreign observers. "In the future, China will become the strongest nation in the world," reportedly praised one foreign guest after viewing the 1955 National Day celebrations. Another commented, "Chiang Kai-shek would cry if he had seen such a parade."[102]

But despite meticulous planning and tight control, the spectacles never went as smoothly as officials would like the public to believe. Not surprisingly, the major headache came from the effort to coordinate hundreds of thousands of marchers before, during, and after the processions. Complaints were often heard that participants were not marching in unison and were sometimes running to make up for missing steps. The ritual Advancing to Gold Water Bridge, with countless people pushing toward Tiananmen Gate, often resulted in accidents, sometimes serious ones. In the 1955 May Day celebrations, for example, many people were injured. "It could leave a bad impression on foreign guests," one reporter warned.[103]

The nighttime display of fireworks was another concern. In April 1955, in

a preparatory meeting for the upcoming May Day parade, some recalled that wooden buildings in the old imperial palace were burned down a number of times in the Ming and Qing dynasties. As a precautionary measure, Peng Zhen ordered the palace to shut down for three days prior to May 1.[104]

Ironically, festivities notwithstanding, the two major celebrations were operated under extremely tight security. The military and subversive threat from the Guomindang both inside and outside mainland China was always in the organizers' minds. The air attacks against Shanghai's power plant in February 1950, mentioned earlier, were fresh in everyone's memory. Air drills were mounted and air defense system activated in each parade.[105] Every year, as a 1956 archival document reveals, "[antigovernment] reactionary slogans are discovered," although the source gives no specific details.[106] What if enemy planes did attack during the procession? Marchers were instructed by the organizers to obey commands issued by the parade command centers. In the words of Peng Zhen, "Whether it is air raids, the dropping of atomic bombs, hydrogen bombs, rain or hailstones, we must carry on as planned. People must remain in place!"[107] Hyperbolic tone notwithstanding, Peng's instruction reflected his concern about the deadly consequences that could have ensued had chaotic conditions erupted. During the 1954 National Day procession, rain caused confusion and resulted in several people being trampled and killed in a stampede at the exit.[108]

Following the ancient Greek festivals that were held under the open sky, Rousseau saw public celebrations as an expression of the general will of the people and a means for reducing social barriers and reinforcing the people's national character. He proposed to the Polish government that civic festivals be created to imbue the public with the virtue of patriotism.[109] Leaders in the French Revolution did the same. The planners of the Parisian festivals purposely purged old festivals and created new ones that were then manipulated for political gains.[110] Parades and festivals in China may be understood in a similar vein but with a much greater emphasis on tight control of the events than was exercised by their French and Soviet counterparts. In a preparatory session, Mayor Peng Zhen delineated what he regarded as the main goals of the state spectacles: "Parades are a grand demonstration against imperialism. They display our strength and can have an influence on capitalist countries."[111] To achieve this, he instructed, the processions must be staged in "the most overwhelming way."[112] But Peng's terse comment touched only on the most general aspects of the parades. In reality, China's parades were more than theatrical performances or strictly organized ventures painstakingly worked out by the Party; they were a complicated political text that functioned as a means of glorification, legitimation, hero worship, and nationalism. The two annual state spectacles could be read, on the surface, as self-congratulatory parties thrown by the CCP. But essentially they were a calculated measure by the CCP to remake its own image every year, as well as to relive the revolution. Parades in Tiananmen Square, with their highly

flamboyant pageantry, were meant to be seen in their grandest manner. They were intended to propagate the Party's political agenda by imposing a uniform socialist vision on a young nation, to draw popular support for the regime's legitimacy, to underscore the centrality of Mao, and to imbue national pride. The military parade and the civilian processions were designed to demonstrate the harmony between the people and a beloved Party, and to awe opponents into submission. True, Chinese spectacles were influenced by their Soviet counterparts, but the foreign model was adapted to meet China's needs and never followed blindly. Clearly the victory of the CCP in 1949 was propelled largely by its nationalistic appeal to establish China as an independent nation. A parade based entirely on a foreign model, even the Soviet one, without distinct indigenous characteristics, would surely undermine the government's popular support and ultimately its legitimacy.

The issue of control was one of the most salient aspects of these parades. Indeed, the two public celebrations enabled the Party to mount a grand ritual through its multilayered state machinery. The uncertainties of the time (the Korean War) and the real and imagined threats from internal enemies (capitalists and spies) and external ones (the Guomindang and American imperialists) no doubt required the government to be extremely vigilant. The Campaign to Suppress Counterrevolutionaries in the early 1950s is only one of many examples of the effort to stamp out possible opposition. But, more important, the very nature of the CCP called for firm control of the populace and demanded political and artistic conformity. Unlike the pluralistic character of early Soviet parades, the CCP's tight control of the mass holidays occurred right from the early days of the People's Republic. Initial popular elation about the new regime notwithstanding, little audience participation was allowed in the parades. The subsequent standardization of the planning also resulted in increased conformity of all aspects of the mass holidays. True, standardization is an essential feature of all rituals, for it provides a sense of permanence.[113] But it also can easily degenerate into ossification, and that was precisely the case in China. Before long the Chinese state spectacles became uniform, repetitive, predictable, and devoid of creativity.

The Chinese marchers and the prescreened attendants in Tiananmen Square were carefully chosen to take part in the state spectacles. In the processions, marchers were not simply actors but were also members of the audience, wanting both to see and to be seen. Advancing to Gold Water Bridge was a ritualistic finale during which marchers as actors turned quickly into an audience, eager to see the real actors, that is, Mao and his senior leaders, on the sacred stage of Tiananmen Gate. In my interviews with a number of those who marched in the processions in the early days of the PRC, many still spoke with great excitement of rushing to Gold Water Bridge to see their admired leaders, especially Chairman Mao. "Immediately after the procession," one parader reminisced, "we advanced to Gold Water Bridge, standing beneath Tiananmen Gate. Chairman

Mao walked toward us on top of the gate, holding his hat, saying, in a Hunanese accent, 'Long Live the Chinese People!'"[114] It was a magical moment when the chairman and the masses united, affirming the Party's right to represent and speak for the people. In the end, Mao and other senior Party members were not only the actors, but, more significant, they were the directors commanding every move of the marchers—the audience—in the ceremonies. The Party was always at the helm, directing the preselected audience, carefully choreographing and herding them into the vast square, the ritual stage, to heap praise on the Party and its godlike chairman.

III. History

5. The Red Line

The Museum of the Chinese Revolution

Wang Yeqiu (1909–87), a literary historian and devoted Communist, was jubilant when, on January 31, 1949, Communist troops, after a two-month campaign of military encirclement, finally occupied Beiping. Wang was concerned, however, that the Guomindang would destroy much of the trappings of the Chinese Communist Party as they retreated. He was particularly anxious that an important historical artifact would be lost: the scaffold used by warlord Zhang Zuolin (1875–1928) to execute by hanging Li Dazhao (1899–1927), cofounder of the CCP. "The scaffold was uppermost in my mind when I entered Beiping. I was determined to recover it despite all obstacles," he said. "If found," he added, "it will be displayed in a future museum of the revolution so that viewers may know about the heroic death of Comrade Li Dazhao—one of the founders of our Party." To his great relief, Wang ultimately tracked down the scaffold in the Guomindang's No. 2 Prison outside Desheng Gate.[1] And, indeed, it became the first item collected by the future Museum of the Chinese Revolution (Zhongguo geming bowuguan; MCR), which would later open its doors in Tiananmen Square on July 1, 1961, the fortieth anniversary of the founding of the CCP.

Wang's recovery of Li Dazhao's scaffold was part of a large, concerted effort mounted by Communist officials, with the enthusiastic support of intellectuals such as Wang, to create a museum honoring the Communist martyrs and, more important, chronicling the grueling but, in their view, assured path of the CCP's final victory in 1949. But Wang's determination to collect Communist artifacts to build a museum raises complicated questions regarding the exact nature of a museum in Communist China. How might a museum present the history of modern China in general, and the history of the Chinese Communist Party in particular? If creating a museum was largely an ideological undertaking, what sorts of artifacts should it include? What images did the Communists intend to convey through the museum's displays, and by what means?

The significance of the building of a revolutionary museum must be placed in

the larger context of the Communists' political-cultural campaigns launched in the 1950s. In the early days of the People's Republic, Chinese Communists were eager to find ways to establish the legitimacy of their newly created party-state. One of their principal concerns was how China's immediate past, especially the history of the CCP, should be properly chronicled and represented. The narration and representation of the past thus became burning political issues in this critical transition period. As it turned out, the Communists were quick to establish the hegemony of the interpretation of history by controlling both the retelling of the past and the means of representation. This was done through the creation of a national museum in the capital. In this chapter, I argue that a Chinese revolutionary museum was constructed for two specific purposes: to legitimize the CCP's rule by carefully re-creating, through exhibitions, a desirable image of the Party that would impress the public, and to highlight the pivotal role that Mao Zedong played in guiding the Party to its final victory. But although the exhibits were to be under the exclusive control of the Party, there was a long and difficult journey before an acceptable format was finally reached. There were years of debates and compromises, with the participation of many different departments, both of the Party and of the government, and myriad Party officials; all this at a time of frenzied economic change (including the Great Leap Forward) and deteriorating relations between China and the Soviet Union in the late 1950s.

Early History

The idea of building a museum to document the history of the CCP and to house its artifacts and artwork was first raised in 1933 during the Jiangxi Soviet period (1931–34), and perhaps even earlier.[2] But the plan never materialized because of the military and social uncertainties at the time. A similar notion was reiterated during the Yan'an era when, in 1946, the Party established a preparatory committee for the Shaan-Gan-Ning Border Region Museum of the Revolution to formulate a concrete plan, but the ideas were never enacted. Once again, the escalating tensions between the Communists and the Nationalists interrupted preparations.[3] The concept did not receive formal attention again until after the establishment of the PRC in 1949.

Immediately after Beiping was liberated in January 1949, the CCP established the Committee to Control Cultural Affairs, which acted swiftly to place universities, media, and cultural institutions such as museums and libraries under Party control, among them the Palace Museum and the Beiping Historical Museum, the two major museums in Beijing. Wang Yeqiu was in charge of redefining the missions of the museums and planning their future.[4] In May 1950 the State Council issued an order forbidding any smuggling of "precious cultural relics" out of the country, including architectural structures, paintings, sculptures, and rare books.[5]

The new government's policies bore a close resemblance to those of the So-viets. After the Bolsheviks seized power in 1917, they moved swiftly to national-ize the tsar's palaces and all works of art, and to set up a special Board for Mu-seums and the Protection of Art Monuments and Antiques to protect cultural relics. In September 1918 the new Soviet government issued a decree forbidding the sale of valuable cultural and artistic objects to foreign countries.[6] The Chi-nese undertaking, however, was more elaborate, better coordinated, and more tightly controlled.

In May 1949 the Committee to Control Cultural Affairs issued an announce-ment to collect revolutionary documents and artifacts. It focused on two ar-eas: first, all documents related to the Communist Party's clandestine or openly published newspapers, pictorials, proclamations, slogans, photographs, and woodcuts; and, second, artifacts such as the relics of Communist martyrs, flags, official seals, and stamps.[7] This was the first step toward the eventual establish-ment of a museum of the Chinese revolution.

The tempo of assembling memorable artifacts was increased when the Cul-tural Relics Bureau (Wenwuju) was established within the new Ministry of Cul-ture in late 1949 to oversee the entire construction plan for the museum and to improve the coordination of resources. The renowned cultural historian Zheng Zhenduo (1898–1958) was appointed its first director, with Wang Yeqiu as his deputy, responsible for the bureau's daily operations. The new bureau also launched a journal entitled *Research Materials on Cultural Relics* (*Wenwu can-kao ziliao*), later renamed *Cultural Relics* (*Wenwu*).

The Communists were planning a museum of an entirely different nature from museums of the past. After the founding of the PRC, the Ministry of Cul-ture took control of twenty-one major museums in China. Wang Yeqiu was crit-ical of these old-style museums, dividing them into two types: those founded by "foreign imperialists," which bore a clear imprint of aggression, and "antique display places" founded by native Chinese.[8] In Wang's view they were products of a bygone era, ill suited to the needs of a modern socialist society. In March 1950 the Preparatory Committee for the National Museum of the Revolution was formed. It was renamed the Preparatory Committee for the Central Mu-seum of the Revolution (Zhongyang geming bowuguan choubeichu; PCCMR) in July 1950. This was the first time since the establishment of the PRC that the term "museum of the revolution" was officially used.[9]

Soviet Influence

How does one build a museum of the revolution? Which model and guidelines should one follow? No one involved, including Zheng Zhenduo and Wang Yeqiu, was a trained museologist. They were amateurs venturing into new territory. As the new PRC government adopted an increasingly anti-imperialist and anti-American policy, it looked to the friendly socialist Soviet Union for assistance.

The opportunity for the planners of the Chinese museum to observe Soviet museums firsthand came in the fall of 1950 when Wang Yeqiu, as head of a Chinese delegation, went to Moscow to stage a large-scale exhibition of more than one thousand Chinese works of art at the renowned Tretyakov Gallery.[10] Wang found the trip exhilarating. Not only was he greeted by Aleksandr Gerasimov, president of the USSR Academy of Arts and one of the most influential figures in Soviet art circles, he was also invited to visit a number of major museums in Moscow, including the National Museum of the Revolution on Gorky Street. The rich collections he saw there left him awestruck.[11]

For Wang, the displays at the National Museum of the Revolution chronicled the glorious path of the history of the Bolshevik Revolution. Lenin's central role in the revolution was naturally highlighted and his artifacts prominently exhibited, including such influential publications as the first edition of *What Is to Be Done?* The museum also extensively covered Stalin. The history of the Bolshevik Revolution was divided chronologically into four periods, with the October Revolution serving as the defining event: the first stage explored Russian society before the October Revolution; the second, the prelude to the October Revolution; the third, the revolution itself; and the fourth, the construction of socialism following the revolution.[12] Wang also noted that the Soviet museums were part of a larger design of proletarian education, an essential element of a careful plan to enlighten the masses and disseminate socialist information. Soviet museums, in his words, "are inextricably linked with the people, serving as classrooms for the schools."[13]

Wang's visit was the first of many study trips by Chinese pilgrims to the Soviet capital as cultural exchanges between the PRC and the Soviet Union increased. In an article on the Soviet museums, the historian Jian Bozan (1898–1968) classified them into three categories: comprehensive, which included the State History Museum; specialized, which included the Museum of Ethnography; and memorial, which included the Central Lenin Museum and the Gorky Museum. It was the memorial museums, Jian observed, that were predominant after the Bolshevik Revolution, as the new government honored the heroes and martyrs who distinguished themselves in the revolution.[14]

To gain a better look into the Soviet museum system, Russian museologists were invited to China to deliver lectures and to hold discussions with the Chinese.[15] *Research Materials on Cultural Relics* devoted ample pages to the introduction of Soviet museums, and Russian books on museology were also translated into Chinese. One example is *Osnovy Sovetskogo muzeevedeniia* (Principles of Soviet museum management) (1955), a detailed survey of the methods of running a museum but couched in familiar Marxist rhetoric.[16]

Clearly it was the history of the Bolshevik Revolution that preoccupied the minds of Chinese visitors, and, as a result, the Museum of the Revolution, the Central Lenin Museum, and the Red Army Museum attracted the most attention. They found Lenin museums to be ubiquitous in the Soviet Union, turning

up in Leningrad, Kiev, and Tbilisi.[17] These museums were a paean to the architect of the Bolshevik Revolution and became popular sites for people to visit.[18] Memorial museums dedicated to individual Communist heroes and martyrs also attracted the Chinese, such as the Nikolai Ostrovsky Museum on Gorky Street in Moscow. Ostrovsky was a socialist-realist writer whose novel *How the Steel Was Tempered* (1932–34), a tale about a Komsomol member, Pavel Korchagin, who dedicates his life entirely to the Communist cause, had been translated into Chinese in the 1940s and became extremely popular among leftist youth. In his visit to this museum, Wang praised Ostrovsky as a writer "who used art and literature to serve the people."[19]

Building a Museum of the Chinese Revolution

The Western idea that the primary goal of a public museum is to educate and enlighten morally and socially dates back to when the Louvre was opened in Paris in 1793 as a public museum. There is a famous saying by Jacques-Louis David that the French museum should not be "a vain assemblage of frivolous luxury objects that serve only to satisfy idle curiosity" but rather should serve as "an imposing school."[20] The Louvre, which Carol Duncan and Alan Wallach labeled a "universal survey museum," was restricted at the start to royal visitors but was later transformed into an institution accessible to all. Designed to reflect a novel set of social relations, the museum's artwork was grouped by national schools and art-historical periods in the service of a democratic citizenry. Its visitors were considered "shareholders" of the state.[21] In contrast, the Soviet museums in Moscow embraced the entirely different goal of serving the state's interest.[22]

Should the future Museum of the Chinese Revolution be modeled on its Soviet counterpart, or should it strive to be unique? Although Wang Yeqiu was extremely impressed by the Soviet museums, particularly that their basic foundation rested on two distinct themes—the success of the October Revolution and the pivotal role played by Lenin and his close associates,[23] he nevertheless remained determined to build a museum in China that would be distinctly Chinese. This future museum would serve as a place both to preserve and to reconstruct an indigenous political memory. Wang insisted that a future Chinese revolutionary museum would be unique in its dissemination not only of Marxism, but also of "the thought of Mao Zedong."[24]

In February 1950 the Cultural Relics Bureau issued a second, more detailed notice announcing a nationwide collection campaign. Drafted by Wang Yeqiu, this new statement spelled out for the first time the period that interested the bureau: the collection should closely follow the development of modern Chinese history, encompassing the time since the Opium War (1840–42), but should center on "the period of the New Democratic Revolution after the May Fourth Movement when the CCP assumed the nation's leadership role."[25]

The fact that more than thirteen hundred items were assembled by the end of 1950 attests to the initial success of the campaign to build the museum.[26] Among the items subsequently collected were the government bonds issued by the Jiangxi Soviet and the hay cutter used by warlord soldiers in 1947 in Shanxi to execute Liu Hulan (1932–47), a young Communist girl whom Mao Zedong personally eulogized as a martyr.[27]

Revolutionary artifacts were by no means the only items collected by the museum organizers. They also created visual representations with the purpose of producing a specific view of recent Chinese history, especially regarding the development of the Party. This was most evident when certain painters were commissioned with the precise goal of recapturing critical moments in the history of the CCP (see chapter 6).

Essential to the creation of a museum of the revolution was to find the museum a new home. Wang Yeqiu knew without question that the current office of the PCCMR, which occupied just three rooms in a dilapidated building in the western part of the old palace, was clearly inadequate. His idea to relocate the museum received strong support from high Party officials such as Dong Biwu (1886–1975) and Lu Dingyi.[28]

The first proposal to build the new museum in Tiananmen Square was made by Beijing's Municipal Planning Committee in early 1953.[29] Locating the museum in the capital's symbolic center, Wang and his associates believed, would surely affirm its centrality and increase its visibility among the Chinese people. But the government took no further action until August 1958, when the CCP Politburo met in Beidaihe and announced the construction of the Ten Monumental Buildings, among them the Museum of the Chinese Revolution. A preparatory committee on the Construction of the Museum of the Chinese Revolution and the Museum of Chinese History was formed, headed by Qian Junrui, the Vice Minister of Culture, with Wang Yeqiu as the managing director.[30] The person responsible for the design was Zhang Kaiji, an architect trained at Nanjing's Central University.[31] The building was completed in 1959 but did not officially open until 1961. As noted in chapter 2, the museum complex, the second largest of the Ten Monumental Buildings, actually houses two buildings: the northern wing features the Museum of the Chinese Revolution, which chronicles Chinese history from the Opium War to the Communist victory in 1949, and at the southern wing is the Museum of Chinese History, covering Chinese history from its earliest beginnings to the end of the Qing dynasty.

The front entrance of the compound boasts two rows of giant columns, twelve in each row. The top of the entrance, in the center, is decorated with a giant five-pointed star encircled by ears of wheat, a common Communist symbol of a bumper harvest. Flanking the star are sixteen red flags, eight on each side, which represent the supremacy of the CCP and the triumph of the revolution. Guarding the two sides of the entrance are two pylons. They rise 40 meters at the highest point of the building and are in the shape of a burning torch,

signifying Mao's famous 1930 saying, "A single spark can start a prairie fire," intended to exude confidence about the inevitability of a Communist victory in China.[32] The eaves, which are designed with a combination of traditional green and yellow glazed tiles, project another distinct Chinese image. The museum exudes a strong sense of nationalism. Zhang Kaiji proudly stated that the building was designed and built only by the Chinese, with no assistance from any foreign countries, including the Soviet Union.[33] The "miraculous construction," in the words of Zhang and his design team, "is primarily the result of the Party's leadership but also the assistance of the entire nation."[34] Of the two buildings, there is no question that in the eyes of the Chinese Communists the Museum of the Chinese Revolution occupied a far more important position than the Museum of Chinese History.[35] It was in the former that the history of the CCP was to be constructed and reinvented through exhibitions of carefully selected objects and artifacts.

The CCP Propaganda Department

From the initial planning stage in the early 1950s to the eventual opening of the MCR in 1961, the CCP was clearly in full control of both the structure and contents of the museum. The specific objects to display was a major concern of Party officials, for at the heart of the museum was the effort to chronicle the triumphant march of the Chinese Communist Revolution.

Since the second half of the nineteenth century the sphere of culture and art, in both Europe and America, had fallen increasingly under governmental control. However, state involvement in museums and art galleries in those countries was, for the most part, indirectly exercised via boards of trustees, leaving room for individual institutions to make autonomous decisions.[36] This was not so in China, where the Party was ubiquitous in the monitoring of cultural policies and in exercising tight control by means of strict institutional measures. In the case of the MCR, the Party made its presence known both through the Propaganda Department of the CCP's Central Committee and through the many Party committees that had been set up to oversee the museum's construction.

Institutionally, museums were placed under the jurisdiction of the Ministry of Culture. But, in reality, that ministry played only a subordinate role to the more powerful Propaganda Department of the Party's Central Committee. Deciding on how to present the history of the CCP to the public, correctly and forcefully, was too critical a task to be left to anyone other than those most trusted in the Party. This clearly indicated the Party's primacy over the state in both ideological and cultural matters, visible proof of their unequal power relationship. The Propaganda Department controlled not only the slogans used in national parades, as mentioned earlier, but also oversaw the operation of the MCR and stipulated the items for exhibit.

One of the earliest exhibitions mounted by the PCCMR was a commemoration

of the thirtieth anniversary of the founding of the Chinese Communist Party—
the "July 1 Anniversary Exhibition"—held in July 1951 in Martial Hall (Wuying-
dian) in the old imperial palace. "Before the exhibition, I remember vividly that
Chen Boda [1904–89; deputy director of the Propaganda Department] arrived
early to inspect the show," a former museum staff told me.[37] Other key members
of the department also showed up to inspect the exhibit, including the veteran
propagandist and influential director of the department Lu Dingyi. Playing a
supporting role in all this was the minister of culture Shen Yanbing.[38]

The influence asserted by the Propaganda Department was to increase signif-
icantly as the building of a permanent museum progressed. Immediately after
the July 1951 Exhibition, which had been for internal viewing only, the CCP Cen-
tral Committee issued a "Circular concerning the collection of the materials re-
lated to the Party's history," stating that the Propaganda Department would be
in charge of collecting materials from inside the Party and that the Ministry of
Culture would be responsible for collecting display items outside the Party.[39] In
April 1953 the Propaganda Department issued another directive, "An exhibition
outline," specifying the rules for any future revisions of the exhibits.[40]

Senior party members looked on the Propaganda Department as the gate-
keeper of the Party's official image. For example, after reviewing a preliminary
museum exhibition in 1957, Deng Xiaoping, at the time the General Secretary
of the CCP Secretariat, instructed that, whenever the Ministry of Culture had
completed its inspection, "the Propaganda Department must examine every-
thing one more time,"[41] a recommendation with which Premier Zhou Enlai
readily concurred.[42]

In addition to supervision by the Propaganda Department, the Party set up
many committees to ensure the smooth functioning of the entire operation. In
October 1958, two months after the Beidaihe announcement, the Propaganda
Department and the Ministry of Culture jointly formed "A Preparatory Task
Force for the Construction of the Revolutionary Museum and the Historical
Museum," with Qian Junrui as its leader and Wang Yeqiu as its bureau chief.[43]
To ensure the suitability of the exhibits, in September 1959 the CCP Secretariat
established an even higher-level committee, the Central Leadership Prepara-
tory Committee of the Construction of the Museum of the Chinese Revolution.
Headed by propaganda chief Lu Dingyi and Kang Sheng (1898–1975), the com-
mittee comprised such influential members as Hu Qiaomu and Zhou Yang, two
deputy directors of the Propaganda Department; Tian Jiaying (1922–66), Mao's
secretary; and Qian Junrui.[44]

The direct participation of senior Party members Zhou Enlai and Deng Xiao-
ping in the decision-making process of the future museum, noted above, was
further evidence that the Party attached great importance to the museum. As
two museum staff members proudly pointed out: "All senior Party leaders, with
the exception of Chairman Mao and Lin Biao, had visited the museum during
its construction period."[45] Indeed, the list of top Party leaders who inspected

the many rounds of preliminary exhibitions before the museum's official open-
ing in 1961 comprises a veritable Who's Who. For instance, Dong Biwu, Peng
Zhen, Nie Rongzhen, and Bo Yibo (1908–2007) all visited the "July 1 Anniver-
sary Exhibition" in 1951.[46]

Zhou Yang was a frequent visitor at the preliminary exhibits. As deputy di-
rector of the Propaganda Department and a noted Party literary ideologue,
Zhou was the principal official responsible for the supervision of the museum
exhibits.[47] But for young staff members like Yu Jian (b. 1925), the most memo-
rable moment came on the morning of September 20, 1959, several days before
the scheduled opening of the new museum on the National Day of October 1,
Premier Zhou Enlai came to inspect the exhibition.[48] Even though Zhou did not
authorize the museum's official opening on the appointed date, having found
fault with the exhibition (discussed in greater detail below), still his appearance
added to the museum's prestige.

Deng Xiaoping's assessment of the exhibits on May 16, 1961 was equally sig-
nificant, for he, as the General Secretary of the CCP Secretariat, was responsi-
ble for giving the final approval for the opening of the Museum on July 1. Deng
arrived to examine the final preparations of the exhibition, accompanied by a
large contingent of senior leaders, including such members of the Leadership
Preparatory Committee as Lu Dingyi, Kang Sheng, and Zhou Yang. As one mu-
seum staffer recalled years later, "Deng was happy with what he saw," and finally
the opening of the museum received Deng's official endorsement.[49]

Despite Mao's absence from the overseers who had inspected the museum,
his influence loomed large, mainly through his two secretaries, Tian Jiaying
and especially Hu Qiaomu, who had served as Mao's principal writer since the
Yan'an days.[50] Hu later became the chief editor of the four volumes of Mao's *Se-
lected Works* and, as mentioned earlier, in 1951 he authored the authoritative
chronicle of the Party history, titled *Thirty Years of the Communist Party of
China*.[51] His proximity to power brought Hu enormous influence. Years later Lu
Dingyi complained that, as the director of the Propaganda Department, he was
often overshadowed by Hu. In Lu's words: "[Hu] Qiaomu was Chairman Mao's
secretary. He often relayed the chairman's instructions, saying that the chair-
man talked about so and so. I cannot but listen to him."[52]

Affirming the Red Line

The difficulty in arriving at an agreeable exhibit with which to present the his-
tory of the Party in the MCR is evinced by the many committees set up to
oversee the construction of the museum and the repeated inspections by senior
Party officials. Another clear sign of the complex issues involved is the delay in
the opening of the museum for almost two years (from October 1, 1959 to July
1, 1961), eleven months later than the opening of the Chinese Military Museum
on August 1, 1960.[53] How should the history of the CCP be represented? What

exactly was the role of the Party compared to that of other parties, such as the Democratic League? Should the Nationalists, considered an opponent of the regime, be depicted at all in the exhibition?

It is true that the "July 1 Anniversary Exhibition" was deemed a success by Party officials and was a much-needed strategy to legitimize the establishment of a new Communist regime in China. But many in the Party thought its scope far too narrow, falling short of presenting the full and brilliant accomplishments of the Party in a broad historical and political milieu. Therefore, in January 1955 a decision was made by the Propaganda Department to extend the range of the exhibition from "July 1 anniversary" to "CCP history" in general.[54] Two years later, in September 1957, the department issued a new directive to expand the time frame even further, gradually extending the exhibition "from present CCP history to include the New Democratic Revolution, the socialist revolution, and the Old Democratic Revolution."[55]

Nevertheless, the question of how exactly this should be properly handled in an exhibition remained. In 1959 the CCP Central Committee spelled out six rules for the display:

- the exhibition should include the three periods mentioned above;
- the significance of historical events and individual achievements should be judged on the principle of a correct political stance and on concrete situations;
- the exhibition should be an accurate reflection of revolutionary struggles in different regions, especially those led by the CCP;
- in accordance with the principle of internationalism, assistance from the Soviet Union and other socialist countries should be demonstrated;
- the exhibit should accurately reflect the Party's nationalities policy; and
- sizable portraits of Party leaders may be displayed but must be limited to the members of the Politburo Standing Committee, and only the sculpture of Chairman Mao may be mounted.[56]

The museum organizers agreed that the seven major events making up the Old Democratic Revolution (1840–1919) would be included in the exhibition: the Opium War, the Taiping Rebellion, the Sino-French War, the First Sino-Japanese War of 1894, the Reform Movement of 1898, the Boxer Uprising, and the Revolution of 1911. Representing the succeeding New Democratic Revolution (1919–49) would be five specific episodes: the founding of the CCP (1921), the First Revolutionary Civil War (January 1924 to July 1927), the Second Revolutionary Civil War (August 1927 to July 1937), the War of Resistance against the Japanese (July 1937 to August 1945), and the Third Revolutionary Civil War (August 1945 to October 1949). And, finally, the socialist period (since 1949) would chronicle the unparalleled accomplishments of the new People's Republic.[57]

Such a periodization of revolutionary history, based originally on Mao's idea of modern history contained in his 1940 essay, "On New Democracy," was now developed even more specifically by Hu Qiaomu in his *Thirty Years of the Communist Party of China*.[58] On the surface, the division seemed fairly

straightforward. But in practice it was never easy, as museum staff quickly discovered. Among the three historical periods—the Old Democratic Revolution, the New Democratic Revolution, and the socialist period—the second phase was of major concern. "What worried us most was the part dealing with the New Democratic Revolution," confessed Yu Jian years later. "This is contemporary history. [In this period] it is difficult to correctly treat issues related to the events inside and outside the Party, national and international affairs, . . . Many people are still living, and a mishandling of the situation can become a political problem. . . . No one is quite sure how to do it properly."[59]

Zhou Enlai's inspection of the exhibition on September 20, 1959, raised a thorny question. As the premier was about to depart, Wang Yeqiu asked for his reaction. Zhou, recalled one young museum staff member who was present, made one succinct comment, "Not enough prominence is given to the Red Line (hongxian) after the May Fourth Movement."[60] But what exactly was the Red Line? In the expanded 159th meeting of the CCP Secretariat two days later, which Wang Yeqiu was asked to attend, Zhou explicitly outlined his meaning: "In the exhibition of the New Democratic Revolution," he stated, "the Red Line of Mao Zedong Thought was inconspicuously displayed." And he continued: "The Red Line is the fundamental and most critical issue, and we must use it to unite different parties and to mobilize our actions."[61] The meeting concluded with a clear directive: "The exhibitions in the two museums [the Museum of the Chinese Revolution and the Military Museum] must show that politics is in command, using Chairman Mao's correct thought and revolutionary line as the guiding principle."[62] Since the exhibition in the MCR had failed to meet this goal, the official opening was postponed until revisions were satisfactorily accomplished.

On October 8, 1959, the Ministry of Culture, led by Qian Junrui, proposed the following principles as a guide for future revisions: "Underscore the Red Line, omit no major historical events, shorten the battle line, and enhance the aura."[63] It was evident by now to many senior officials that reaching a consensus on an exhibit of the New Democratic Revolution would be difficult, at best, and that therefore they should refrain from even attempting to tackle the third and even more controversial socialist period. Indeed, in 1960, the CCP Central Committee ordered the museum to "temporarily shelve the socialist period."[64]

Thus the central issue remained the question of how the Red Line could be properly delineated. The museum staff made another attempt to revise the exhibit in 1960. This time, however, they seemed to have gone too far. To Zhou Yang's chagrin, artifacts associated with Mao now appeared in great abundance. The chairman's photos and quotations, for example, were everywhere. Moreover, instead of Mao's original publications, such as his "Report on an Investigation of the Peasant Movement in Hunan," replicas were used instead. They were also doubled in size from the original scheme of one-sixteenth of a sheet of paper to one-eighth.[65] Zhou Yang, on revisiting the museum in February 1961,

underscored the importance of presenting the audience with genuine objects, and he charged that the presentation of Mao's publications was too excessive. "The result," he said, "was that it was not the 'Red Line' that was being displayed in the museum but rather the 'Red Silk Fabric.'"[66] Kang Sheng disagreed, however, contending that Mao's items were not overly prominent and arguing that it was necessary that Mao's preeminence be singularly demonstrated. To him, displaying the artifacts of many other leaders was tantamount to others "making rival claims as an equal" (*fenting kangli*) to the chairman, which, Kang insisted, was a bad idea.[67] Unfortunately, no archival records exist to how this conflict was ultimately resolved. We do know, however, that when Deng Xiaoping came to inspect the exhibition on May 16 before the museum's official opening one-and-a-half months later, his opinion reflected the broader view of Zhou Yang. Noticing that only one picture of Li Dazhao was on display, Deng objected, saying, "Li was a founding member of the Party, and to have just one picture of him is totally unacceptable."[68]

The Opening Exhibition

Objects and specimens in a museum, Susan Pearce maintains, are "at the heart of the museum operation."[69] Exactly what were the items exhibited at the grand opening of the MCR on July 1, 1961, the fortieth anniversary of the founding of the CCP? Unfortunately, the archives of the museum remain closed to outsiders, and a full inventory of the displayed artifacts is currently unavailable. However, photographs, articles, and newspaper reports of the exhibition do exist. The following is a partial reconstruction of the exhibition based on these materials and on memoirs and interviews.[70]

At its commencement the museum included displays on only two periods, the Old and the New Democratic Revolutions, eliminating the socialist era. The first period, from the Opium War to the 1911 Revolution, was characterized by what Mao described as a series of fierce struggles against foreign aggression abroad and feudal forces at home. A primary display was a huge cannon guarding the Bogue forts on the Pearl River estuary near the southern city of Guangzhou, defending the nation against British naval attacks in the Opium War. Also on display was Commissioner Lin Zexu's famous memorial to Emperor Daoguang about the dangers of the opium trade and his determination to stop drug trafficking. The Taiping Rebellion occupied an equally prominent place, with Hong Xiuquan's imperial seal and the anti-Manchu declarations by the Taiping rebels on view, demonstrating the importance of this controversial episode in Communist historiography. In another hall of the museum, one could view the swords and spears used by the Boxers to battle the Allied forces during the Boxer Uprising in 1900. Details of the 1911 Revolution were also exhibited.

The museum's emphasis, however, was unquestionably on the New Democratic Revolution. Of the 4,152 square meters devoted to the entire exhibition,

three-quarters of the space, about 3,000 square meters, was allotted to this second period; and of the 3,600 items exhibited, the majority also belonged to this second period.[71] Predictably, the central focus was on the inevitable rise of the CCP in China. A huge bust of Mao Zedong graced the entrance hall leading to the exhibition on this period. The first artifacts on display centered on the introduction of Marxism to China from the Soviet Union. Mao Zedong's famous saying, "The salvoes of the October Revolution brought us Marxism-Leninism" (1949),[72] was placed above a model of the cruiser *Aurora* along with one of its shells, a gift from the Soviet Union, that had been used in an attack on the Winter Palace in 1917. A replica of Vladimir Serov's oil painting, *Lenin Declares Soviet Power* (1947), hung on another wall. An original copy of the Chinese translation of *The Communist Manifesto*, published in Shanghai in 1920, was also on view.[73]

But items regarding the early Soviet influence on China formed merely a prelude to the more important subject, the founding of the CCP in China, and thereafter the Soviet element of the exhibition diminished drastically. A replica of the site of the First Party Congress was on display. But the emphasis was on the leading role played by Mao Zedong. Occupying center stage of the hall were five huge photos of the participants of the First Party Congress: Mao Zedong in the middle, flanked on his left by Dong Biwu and Chen Tanqiu (1896–1943) and on his right by He Shuheng (1876–1935) and Wang Jinmei (1898–1925). Above these hung another of Mao's famous saying, "In China, the Communist Party was born, an epoch-making event" (1949).[74] The key position of Mao's portrait and his authoritative saying served to reinforce his centrality in Party history dating back to the beginning of the communist movement in China.

Li Dazhao was given more prominent treatment than he had received in the preliminary exhibitions, where only one photograph of him was on display. Now, not only were his influential writings being shown, including "The Victory of the Masses," but his pictures also occupied a more elevated place in the Communist pantheon of heroes. While the exhibition clearly followed a Marxist script by underlining the importance of the proletariat in the Chinese revolution, displaying weapons such as axes and knives used by workers during urban uprisings (as in the Shanghai strikes in 1926 and 1927), equal weight was devoted to the rising peasant movement in rural China. Visitors could view an original copy of Mao Zedong's "Report on an Investigation of the Peasant Movement in Hunan," printed in Hankou in April 1927, as well as makeshift flags used by peasant associations to rally support in their attacks against local tyrants and evil gentry.

The artifacts in the Second Revolutionary Civil War were clearly militaristic in nature, beginning with a display illustrating the birth of the Red Army in the Nanchang Uprising in August 1927. Not unexpectedly, the legendary Long March was given detailed and heroic treatment, with a soldier's straw sandals displayed to demonstrate the hardship the troops endured during the ordeal.[75]

A model of Zunyi Conference Hall, where Mao assumed the top posts in the Party in 1935, was placed in the middle of the hall to signify the beginning of a new era of correct leadership in the CCP.

The hall chronicling the War of Resistance illustrated the Communists' activities on two fronts: resisting the Japanese invasion and building a socialist base in Yan'an. Armbands of the Eighth Route Army and the New Fourth Army were displayed, as was the weaponry captured during the victorious battle against the Japanese troops at Pingxing Pass in northeast Shanxi in September 1937. The specific mention of the campaign, led by forces commanded by Lin Biao, who had replaced Marshal Peng Dehuai (1898–1974) as China's minister of defense after the Lushan Conference in 1959, was an obvious indication of Lin's rising influence. But the Rectification Campaign in Yan'an was given even more conspicuous treatment. On the wall, for example, was Luo Gongliu's (1916–2004) oil painting, *The Rectification Report* (1951), which shows Mao in a simple hall, his left hand raised in the air, standing before portraits of Marx and Lenin, passionately delivering his famous speech on thought reform to a rapt audience in Yan'an in 1942.[76]

On display in the final episodic theme, the Third Revolutionary Civil War, were details, including maps and weaponry, of the three military campaigns launched by the Communists during the civil war against the Nationalists, in Manchuria, North China, and Central China. In an exhibition of the Second Plenum of the Seventh Central Committee of the CCP, held in March 1949, Mao is seen laying down the foundation for a future socialist China by convening the Political Consultative Conference and forming a future "democratic coalition government." The room adjacent to this display showed the triumphant conclusion of the Communists' victory in the civil war and the founding of the PRC. Dong Xiwen's (1914–73) oil painting *Founding Ceremony of the Nation* (discussed in chapter 6), gracing a huge wall, symbolizes the historic moment.

After its inauguration in 1961, the MCR would undergo several transformations. During the Cultural Revolution in November 1966 radicals closed down the museum. It was reopened in 1969 but this time merged with the Museum of Chinese History to form the Chinese Revolutionary Historical Museum. Fourteen years later, in 1983, the museum reclaimed its original name.[77] In February 2003 yet another incarnation took place: the government ordered that the museum be merged once again with the Museum of Chinese History, forming a new Chinese National Museum (Zhongguo guojia bowuguan), under the supervision of the Ministry of Culture.

The MCR was a political arena where the Chinese Communists narrated and presented their own story. Although portraits and paintings of Marx and Lenin were displayed in the museum in the spirit of Communist internationalism, the museum's focus was unmistakably domestic. The aim was primarily to tell a carefully scripted tale of the inevitable rise of the CCP, led by Mao Zedong, as

he directed the populace in a fight against the oppressive Guomindang at home and the callous imperialists abroad (particularly the Japanese and the Americans), ultimately liberating his people. "In essence," one museum worker reminded me, "the entire history of modern China should be read solely as a revolutionary history led by the CCP."[78]

The formative period of the museum in the late 1950s must be examined within the larger context of Chinese politics and international relations during this time, an era characterized by a growing rift between China and the Soviet Union and marked by the tumultuous Great Leap Forward. Of course, from 1959 to 1961 China also suffered from severe natural calamities—extensive floods and droughts—and, moreover, with the fiasco of the Great Leap Forward, China was retreating from the radical stance of Maoism. Nevertheless Mao's position in the Party remained unchallenged. In fact, the ouster of Peng Dehuai after the Lushan Conference rekindled Mao's conviction in his revolutionary vision. The publication of the fourth volume of his *Selected Works* in October 1960 may be seen as Mao's way of reaffirming his supreme position in the Party. Indeed, Mao did make a form of self-criticism concerning the Leap at the Party Central Work Conference in Beijing in June 1961. But, as Kenneth Lieberthal points out, this criticism was "never circulated to lower levels of the Party," and the chairman's "own responsibility was shielded to protect his legitimacy."[79] Many museum staff members whom I interviewed in China reiterated a similar view: that the Lushan Conference might have tarnished Mao's prestige at a later date, when details became more publicly known, but at the time it actually further consolidated Mao's personal dominance in the Party.[80] Mao's unparalleled position remained relatively intact after the Great Leap. A principal reason may be that, as Roderick MacFarquhar suggests, "the men who could have made political capital about the failure of the leap—Chou En-lai [Zhou Enlai], Ch'en Yun [Chen Yun], Li Fu-ch'un [Li Fuchun]—had never shown any disposition to challenge his personal position or authority."[81]

Did the 1961 exhibition reflect the shifting political tide at that time? Soviet influence was surely played down. Peng Dehuai's pictures were removed from the 1961 exhibition.[82] But Lin Biao's achievements, especially his Pingxing Pass victory against the Japanese in 1937, were highlighted and hence glorified. Was Mao's Red Line too excessively presented in the opening exhibition, as Zhou Yang once criticized? Because no information is available on the details of the prior trial exhibitions (inventories and catalogues), we do not know for certain. But judging from the items being shown in the 1961 exhibition, Mao's Red Line was systematically and prominently displayed. While it is true that other senior leaders such as Liu Shaoqi (in his role as organizer of the Anyuan workers) and Zhou Enlai (for his part in the Nanchang Uprising) were duly mentioned, Mao unquestionably took center stage, even as he was being lionized in the larger social and political context of modern Chinese history. This broader context had been recommended by Zhou Yang.

Duncan and Wallach, in their study of "universal survey museums"—the Louvre in Paris and the Metropolitan Museum of Art in New York—argue that the architecture, the layout of rooms, and the sequence of collections of these museums create "an experience that resembles traditional religious experiences." In walking through the museum, the visitor "moves through a programmed experience that casts him in the role of an ideal citizen," thus affirming and legitimizing the concept of the modern state.[83] Although the MCR succeeds in producing such an experience, it was built to serve a very different purpose. The successive historical periods, Chairman Mao's sacred texts, and the carefully selected battle scenes all form a coherent iconographic program to be imparted to museum visitors. And the Party, reflecting its exclusive and monopolistic nature, controlled the means of representing the past. The museum space was never intended to reveal history in all its diversity, complexity, and contradiction. Instead, its orientation was toward a singular interpretation in line with the political reality in China.

6. Oil Paintings and History

"I did not produce a single painting in my entire life that met my expectations of what I most wanted to create," the celebrated painter Dong Xiwen reportedly lamented on his deathbed.[1] Dong may not have produced the dream piece that he would truly cherish, but he did create, albeit unwillingly, a deeply controversial work of art in his 1953 oil painting, *The Founding Ceremony of the Nation* (*Kaiguo dadian*) (figures 20 and 21), for it epitomizes the tension between art and politics in the People's Republic. In this famous piece, Dong portrays Mao Zedong in Tiananmen Square on October 1, 1949, with his senior associates in attendance—Liu Shaoqi, Zhu De, Zhou Enlai, Gao Gang, Lin Boqu (1886–1960), and others. They are surrounded by huge lanterns, a Chinese symbol of prosperity, and a sea of red banners that declare the founding of a new nation. When first unveiled in 1953, the painting was widely hailed as one of the greatest oil paintings ever produced by a native artist.[2] In just three months more than half-a-million reproductions of the painting were sold.[3] But the fate of this work soon took an ominous turn, and the artist was requested to make three major revisions during his lifetime. In 1954 Dong was instructed to excise Gao Gang from the scene when Gao was purged by the Party for allegedly plotting to seize power and create an "independent kingdom" in Manchuria. During the Cultural Revolution in the mid-1960s Liu Shaoqi was accused of advocating a "bourgeois reactionary line" and subsequently was purged, and Dong was ordered in 1967 to redo his painting again and to erase Liu from the inauguration scene. Then, in 1972, also during the Cultural Revolution, the radicals, commonly labeled the Gang of Four, ordered a third revision, namely, that Lin Boqu be eliminated from the painting for allegedly opposing the marriage of Mao and Jiang Qing (1914–91) during the Yan'an days. By this time Dong was dying of cancer and was too ill to pick up the brush, so his student Jin Shangyi (b. 1934) and another artist, Zhao Yu (1926–80), were assigned the task. These two artists, afraid of doing further damage to the original piece, eventually produced a replica of the painting with the ailing Dong brought from the hospital for consultation on his embattled work. Though Dong died the following year,[4] the ill-fated story of *The Founding Ceremony of the Nation* did not end: in 1979, with the demise of the

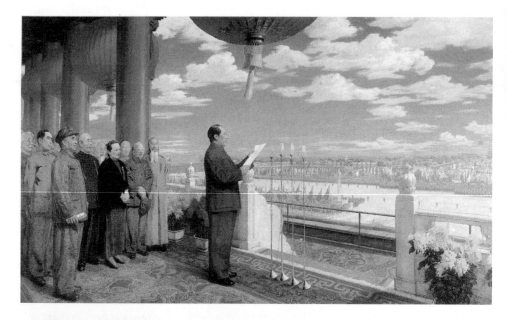

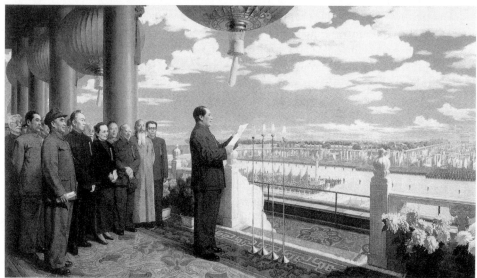

Figure 20. Dong Xiwen, *The Founding Ceremony of the Nation*, ca. 1967, oil on canvas, 230 × 405 cm. *Source*: Courtesy of the National Museum of China (formerly the Museum of the Chinese Revolution), Beijing.

Figure 21. Reproduction by Jin Shangyi, Zhao Yu, and Yan Zhenduo of Dong Xiwen, *The Founding Ceremony of the Nation*, ca. 1979, oil on canvas, 230 × 405 cm. *Source*: Courtesy of the National Museum of China, Beijing.

Gang of Four and the Party's official rehabilitation of Liu Shaoqi, the images of Liu, Gao Gang, and Lin Boqu were restored in the painting. Because Jin Shangyi was on a foreign tour, Yan Zhenduo (b. 1940), a graduate of the Department of Oil Painting at the Central Academy of Fine Arts (CAFA), was called upon to help reinstall the three leaders.

Chinese artists were not the first to be ordered by authorities to revise their paintings and hence rewrite history in order to accommodate the political reality, for this was a long tradition among their Soviet counterparts as well. In 1949, for instance, Sergei Gerasimov repainted his famous 1943 oil painting, *The Mother of a Partisan*, to give the heroine a more courageous appearance, in conformity with the theory of socialist realism then in vogue in the country.[5] But few Russian works suffered the fate that befell Dong's painting. Compared to the role of the Soviet Communist Party in rewriting its nation's modern history, the Chinese Communist Party was even more decisive in revising modern Chinese history, especially in its use of paintings as a key means of persuasion.

The use of oil paintings as a political tool is apparent at various times in the history of art. Velázquez's portraits of Philip IV and David's paintings of Napoleon, especially the French artist's rendering of Bonaparte's coronation, are well-known examples that project the majesty and supreme authority of a monarch to his people. In America, John Trumbull's four murals of the American Revolution, which now grace the Capitol Rotunda in Washington, D.C., affirmed the establishment of a new nation. In the PRC, however, the Communists' use of artworks reached far beyond the mere tension between politics and art to include the influence of the Soviet Union, and the nationalization of oil painting—a medium, after all, introduced from the West. By examining what the Chinese Communists called "revolutionary history painting" (*geming lishihua*),[6] I will analyze the CCP's propaganda effort to reconstruct an official visual narrative of the nation's history. The analysis focuses on the paintings commissioned by the Museum of the Chinese Revolution in the 1950s and early 1960s. Julia Andrews and Kirk Denton have each discussed these paintings,[7] but few studies have addressed the historical contexts and institutional settings within which these paintings evolved. Nor have these efforts probed deeply the external factors, especially Soviet socialist realism, that had a substantial impact on Chinese oil paintings in the 1950s. Like the controversial issue of the Red Line in the MCR's exhibits, the choice of historical themes in oil paintings emerged from debates and infighting among Party leaders as they tried to produce an acceptable master narrative of CCP history.

Soviet Influence

Chinese Communists took firm control over art immediately after the founding of the PRC. One of the government's plans was to suggest a series of history paintings, especially in oil, to depict the CCP's accomplishments and its final

victory in 1949. When the July 1 Anniversary Exhibition was mounted in 1951 to commemorate the thirtieth anniversary of the founding of the CCP, it was Wang Yeqiu's idea to incorporate history paintings and sculptures depicting the Party's history into the exhibition.[8]

Wang Yeqiu's suggestion was likely inspired by what he had observed in the Soviet Union. As head of a Chinese delegation to exhibit Chinese art in the Soviet capital in late 1950, he was greatly impressed by the artworks in the Moscow museums. In the National Museum of the Revolution, for instance, Wang admired how Lenin's political career had been carefully highlighted by oil paintings and maps. These paintings, according to Wang, forcefully chronicled the Bolshevik leader's path of struggle and triumph. Wang wrote admiringly in his report that the items were visually attractive and could be effective educational tools for the public.[9] As a result of that experience, he proposed to bring art, especially oil paintings, into the construction of the MCR.

Wang's proposal received preliminary approval in March 1951, when the Art Bureau of the Ministry of Culture officially approved a plan to realize this task by establishing the Leadership Group of the Production of Revolutionary History Painting (Geming lishihua chuangzuo lingdao xiaozu; LPRHP). This group was made up of veteran Communist artists such as the cartoonist Cai Ruohong (1910–2002), the art critic Jiang Feng (1910–82), the sculptor Wang Zhaowen (1909–2004), and the woodcut artist Yan Han (b. 1916). They were asked to assemble a team of talented artists to create a series of oil paintings for future museum exhibits.[10] One person the LPRHP approached was Luo Gongliu, a veteran Yan'an woodcut artist and at the time an instructor at CAFA. Years later, Luo recalled, "In 1951, when the Museum of the Chinese Revolution first commissioned history paintings, they came up with an outline of topics. Yan Han, who coordinated the task, assigned me to work on *The Rectification Report*. He insisted that it had to be done in oil."[11]

Why was the Party so focused on oil paintings? The LPRHP's decision to commission oil paintings seemed surprising, since in its early years the government was committed to producing accessible, popular art forms, especially nianhua (New Year prints) and lianhuanhua (serial picture stories) to disseminate socialist ideas to the population (see chapters 7 and 8).[12] Compared to the New Year prints, the Western medium of oil painting seemed marginal to the government's needs. On closer examination, however, such art had significant value. In the early 1950s both the artistic and the political climate was receptive to oil painting, and the public responded with enthusiasm to the realistic technique of the genre. Academically, the French-trained Xu Beihong, a renowned oil painter and the director of CAFA, was an advocate of this Western medium. Xu, one of the most influential artists in China, was noted for his vivid portrayals of galloping horses and historical paintings such as *Tian Heng and His Five Hundred Retainers* (1928–30). Oil painting also received important official endorsement in 1953 when the Party shifted its art policy from popularization to

professionalism, with a goal of raising artistic standards by giving young artists systematic and rigorous academic training. The reorganization of art education began in earnest in that same year when CAFA established an oil painting department. This official approval gave the medium proper recognition and an elevated status.

The rising prestige of oil painting also stemmed from the growing influence of Soviet socialist realism, publicly embraced by the Chinese government in the early 1950s when it announced an unequivocal pro-Soviet policy. Socialist realism, promoted by Stalin since the early 1930s, stipulated that art had to be socially relevant to the masses, with all subjects depicted from the viewpoint of the glorious future promised by socialism. Inherent optimism but aesthetic conservativism, along with the interests of the oppressed classes and the ideals of collectivism, were key traits of this Soviet model.[13] Oil painting was a visual medium well suited to accentuating these traits.

Soviet influence was by no means confined to socialist realism. When, in the early 1950s, American and European art publications were deemed politically degenerate and ceased to be available, imported Soviet magazines became the only venue where art students could get a glimpse of Western art.[14] Among the Russian oil painters enthusiastically promoted by Chinese art circles were Ilya Repin and Vasily Surikov, two pillars of the Peredvizhniki (Itinerants) school of nineteenth-century Russian painting, whom Xu Beihong had lauded as "two of the greatest painters in the world."[15] Repin and Surikov were renowned not only for their large, sweeping historical canvases but also for their criticism of autocratic rule and their commitment to social commentary (as in Repin's *Barge Haulers on the Volga* [1870–73]). This style was in marked contrast to that of the Imperial Academy, which produced neoclassical works on biblical and mythological themes. Stalin's fondness for Repin was well known, and by his direction the Peredvizhniki were resurrected to provide a historical basis for socialist realism, with a stress on art as a vehicle to raise class consciousness.[16] In China, Repin was praised as a "people's artist,"[17] and Surikov was equally honored as a "genius" realist history painter.[18] Russian artists were not the only ones singled out as models; the French neoclassical painter David was lauded for his realistic portrayal of revolutionary scenes during the French Revolution.[19] But Russian artists were granted center stage.

For Chinese artists a golden opportunity came in October 1954 when a large-scale exhibition of the Soviet Union's economic and cultural achievements was mounted in the newly constructed Soviet Union Exhibition Hall (now Beijing Exhibition Hall). This major event also displayed key Soviet works in Beijing, including oil paintings such as Boris Ioganson's *In an Old Urals Factory* (1937) and Fedor Shurpin's *The Morning of Our Motherland* (1948).[20] The art show proved memorable and stimulating for young Chinese artists. "This was the first time that I saw the original European oil paintings," recalled Jin Shangyi.[21]

An even more important event was the arrival of Soviet oil painter Konstantin

Maksimov in Beijing in February 1955 to offer a class to the students at CAFA. About twenty students were carefully selected nationwide to attend the Soviet master's class. It was the first time that a noted Russian painter had appeared before Chinese students to offer professional instruction.[22] Maksimov was viewed as a skilled practitioner of Soviet socialist realism, as in his painting *Sashka the Tractor Driver* (1954), an inspiring image of farm life. "He taught us the basic techniques of sketching as well as the concept of structure in oil painting," his student Jin Shangyi recalled.[23] His class, commonly known in Chinese art circles as Maxunban (Maksimov Training Class), lasted for two years and trained a host of talented young painters, including Jin Shangyi, Hou Yimin (b. 1930), and Zhan Jianjun (b. 1931). Many of them went on to assume key positions in art circles. In the mid-1950s a number of young Chinese artists were also sent by the Chinese government to the famed Repin Institute of Art in Leningrad to learn painting and other techniques, including etching. Among those sent were Luo Gongliu and Wu Biduan (b. 1926), the latter a young instructor at CAFA.[24]

Ultimately, the rise of oil painting was largely the result of its special appeal as a medium. Its flexibility in the use of colors, its wide range from lights to darks, and its ability to achieve a multiple blending of tones all differed markedly from traditional Chinese ink-and-brush painting, and provided a refreshing alternative to aspiring Chinese artists. "The principal characteristic of oil painting is its realistic touch. Its volume, space, colors, and light are all real. The works are attractive; they draw people's attention," Jin Shangyi recalled in an interview about why he was drawn to this genre as a young artist.[25] The capacity of oil painting to depict minute details and blend different tones also was ideal, in the words of Cai Ruohong, "in presenting historical themes and delineating heroic personalities."[26]

Phases of Commission

Major oil paintings in the Soviet Union were commissioned by official agencies like the Red Army and the People's Commissariat of Heavy Industry.[27] This became even more frequent after the publication of the authoritative *A Short Course in the History of the All-Union Communist Party (of Bolsheviks)* (hereafter *Short Course*) in 1938, which presented a glowing view of the accomplishments of the Bolsheviks in the Russian Revolution. The establishment of the LPRHP by the Ministry of Culture in 1951 to commission oil paintings for the future MCR bore a close resemblance to the Soviet experience.

The significance of the LPRHP must be understood within the larger context of the CCP's organization and institutional control. Institutionally, the LPRHP was the museum's lowest-ranking body in commissioning art. Above that committee was the Ministry of Culture, which was directly responsible for the planning and execution of the museum's exhibits. Again, the Propaganda Department played an even more critical role, as it oversaw the policies and displays

involved in the entire construction process. As mentioned in chapter 5, to ensure the building's successful completion, the CCP Secretariat, in September 1959, set up yet a higher-level committee to oversee the work—the Central Leadership Preparatory Committee of the Construction of the Museum of the Chinese Revolution. During the first half of the 1950s the commission's undertakings were limited, because for many years the future museum existed only on the drawing board. Once the government clearly decided to build a new museum as one of the Ten Monumental Buildings, the museum planners raced against time to commission new artworks for the opening ceremony in October 1959. But in 1957, Yan Han, the key coordinator in the initial 1951 commission campaign, was purged as a rightist during the Anti-Rightist Campaign. Luo Gongliu was then quickly summoned to Beijing from Leningrad and charged with completing the task of commissioning artists for the new museum.[28]

In the eyes of Party officials, three issues had to be addressed regarding how to proceed: Which historical topics should be featured in the oil paintings? Which artists should be commissioned? How should these paintings emphasize Mao's role in Party history, and should the roles played by his key associates be included? An official view of CCP history, as noted earlier, was reached in 1951 with the publication of Hu Qiaomu's *Thirty Years of the Communist Party of China*. This authoritative text, resembling the Soviets' *Short Course*, set the tone for commissioning oil paintings for the MCR.

Now, armed with a general guideline of CCP history, the LPRHP initiated several attempts to commission artists to produce works on approved topics. First, politically reliable painters were approached. In the early 1950s the first group of commissioned artists included Dong Xiwen, who joined the CCP in December 1949, Luo Gongliu, and Wang Shikuo (1911–73), a veteran Party member since 1942. But Communist sympathizers such as Xu Beihong were also recruited. A second consideration was whether these artists were technically competent to undertake the task. Dong Xiwen was an accomplished painter and a professor at CAFA, and clearly a good candidate. Moreover, because the focus was on historical subjects, those artists who had actually participated in the historical events to be depicted would have an edge. Thus Luo Gongliu's participation in the 1942 Rectification Campaign in Yan'an made him an ideal candidate to paint this important episode in CCP history. This resulted in his famous *Rectification Report*, mentioned earlier.

Because the projects were widely regarded as, in the words of painters Hou Yimin and Zhan Jianjun, "state assignments" (*guojia renwu*), those recruited felt "extremely honored."[29] No doubt they appreciated, too, the added benefit of garnering nationwide attention. In my interviews with the participating artists, almost half-a-century later, many still evinced pride and enthusiasm for this important mission.[30] Officials facilitated the project by providing the artists with all sorts of support, including on-site visits, and encouraged them to conduct historical research, examine old photos, read memoirs, dig up archival

materials, and interview eyewitnesses to arrive at faithful renditions of their chosen subjects.[31] In 1961 the government also furnished artists food and lodging, arranging stays at the Oriental Hotel (Dongfang fandian) to paint their works. "We were well housed and better fed at a time of great turmoil after the Great Leap Forward when food was scarce and supplies woefully limited," said Zhan Jianjun.[32] The artists' sense of involvement was strong, and many perceived this as a rare opportunity to help create a new nation through their artistic skills. Indeed, the artists were enthusiastic in joining the chorus of those who wished to build a new socialist state in China. They played a role in establishing, not simply conforming to, the Maoist view of history.

The third issue—the proper assessment of Mao's role in Party history—was a much thornier subject. In fact, the reason the scheduled opening of the MCR on the October 1 tenth anniversary did not materialize was that senior Party members were still debating whether Mao should be the focus of an exhibition of Party history. These debates, described in chapter 5, were known as the issue of the Red Line, and pitted Kang Sheng's position that Mao's preeminence must be singularly highlighted against Zhou Yang's proposal of a more balanced treatment of the Party's history that would include reasonable coverage of other senior leaders' achievements. By the time the museum officially opened in July 1961, an approach closer to Zhou Yang's view had been adopted, but Mao was still depicted as head and shoulders above his closest associates.

The Red Line was not the only issue that troubled the artists. A more immediate concern was that of the themes of the visual representations. Under the strong influence of Soviet socialist realism, Chinese artists in the 1950s were expected to create works emphasizing historic "thematic art" (zhuti), which, according to Igor Golomstock, meant, in Soviet aesthetics, that they were to depict, in glowing terms, "the leadership and their colleagues, revolutionary events, [and] heroics in work and war."[33] The artists' works were to be "representative" (dianxinghua) of these themes;[34] that is, they were required to capture the essence and unique characteristics of important historical events. Cai Ruohong explained this official line when he wrote that historical themes must exhibit two major characteristics: they must "reflect the revolutionary movement of workers, peasants, and soldiers and their revolutionary wars [against imperialism and capitalism], and portray the determination and integrity of revolutionary heroes."[35] But it was never easy to implement these ideas on canvas.

Between 1958 and 1961 senior officials carried out many rounds of internal investigations to arrive at an acceptable chronicle of Party history. Although we have no inventory of how many paintings were actually produced—museum archives remain closed to outsiders—we do know that many were deemed questionable and abandoned.[36] The rejected artwork tells us as much about the Party's views as do those that were eventually approved.

Jin Shangyi's *Farewell* (*Songbie*) (figure 22) was one of the rejected pieces. A gifted student of Maksimov, Jin, like others, was sent to on-site visits in Jiangxi

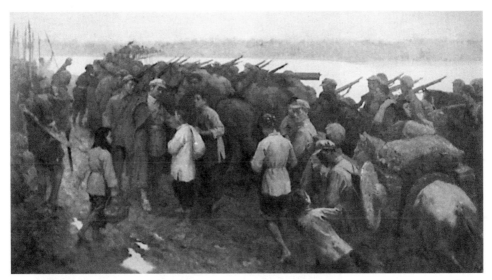

Figure 22. Jin Shangyi, *Farewell*, 1959, oil on canvas, 137 × 242 cm. *Source*: Courtesy of the National Museum of China, Beijing.

in 1959 to work on a piece about the legendary Long March.[37] Inspired by a popular song, "Ten Farewells to the Red Army" ("Shisong Hongjun"), which describes the pain of separation between soldiers and their families and fellow villagers at the start of the Long March in late 1934, Jin painted the Red Army's departure with a great deal of emotion. Soldiers in the painting leave at dawn, against a gray sky; their teary wives watch them depart; parents with heavy hearts bid their sons farewell—the entire scene exudes the sadness of separation.[38] "Mine is a realistic portrayal of the difficulty of parting," Jin declared in an interview.[39] "My intention was to support the correct decision of a strategic military shift, but I also knew that I could not portray despondency. Overall, I think the entire piece is upbeat."[40] But this was not what some Party leaders saw in the painting. During an inspection of the exhibits, Kang Sheng criticized Jin's *Farewell* as too gloomy. In his view, the painting "does not fully demonstrate the Red Line of Mao Zedong thought";[41] that is, the despondent mood in Jin's work contradicted revolutionary optimism, an essential requirement of socialist realism.

Coordinator Luo Gongliu ran into trouble himself. In 1959 he unveiled his painting, *Behind the Fallen Are Endless Successors* (*Qianpu houji*) (figure 23), depicting the sacrifice of the revolutionaries during the Guomindang's purge of the Communists in 1927. A martyr's body lies on the floor beneath a cloth, surrounded by three grieving family members—two girls and one young man—all in white mourning clothes. The young man, standing tall and gazing into the distance, appears defiant and determined. A dark background conveys a sense of terrible loss. Influenced by Rembrandt, Luo was unique among his peers in his skill at rendering light and shade in his works.[42] By contrasting the white apparel

Figure 23. Luo Gongliu, *Behind the Fallen Are Endless Successors*, 1959, oil on canvas, 181 × 152 cm. *Source*: Courtesy of the National Museum of China, Beijing.

with the sober setting and using the living and dead to form a reverse "T" shape, Luo presents in his painting what one art critic calls a memorable "jade monument" (*yubei*), one that symbolizes the selfless sacrifice of the Communists.[43] The painting's original title, *The Seed of Fire* (*Huozhong*), evokes a similar hope for the future.[44] But, like Jin's *Farewell*, Luo's painting was criticized for its serious deviation from the approved aesthetic vocabulary, that is, for "portraying too miserable a scene," and therefore his picture was removed.[45]

The Approved

When the Museum of the Chinese Revolution received official authorization to open its doors on July 1, 1961, all of its approved commissioned paintings, in addition to the revolutionary artifacts, were finally on view. But the MCR was not the only institution to commission oil paintings in the 1950s, as others such as the Chinese Military Museum followed suit. Moreover, in addition to oil paintings, the Party sought other art forms to document its history. Among the best

known were Wang Shikuo's *Bloodstained Garment* (*Xueyi*) (1959), a black-and-white charcoal drawing about peasants during land reform testifying against landlord brutalities. Shi Lu's (1919–82) *Shifting Military Strategy in Northern Shaanxi* (*Zhuan zhan Shaanbei*) (1959), a traditional Chinese ink painting, depicts Mao's military maneuver when the Nationalist forces attacked Yan'an in 1947. Gu Yuan's (1919–96) *Liu Zhidan and the Red Brigades* (*Liu Zhidan he chiwei duiyuan*) (1957) is a woodcut of an early Communist leader in Shaanxi province. Still, few media matched the emotions elicited by oil paintings. An examination of these paintings reveals the emergence of various themes; the most prominent being the martyr, the military, the leader, the worker, and the founding of the new nation.

The Martyr

An icon in Chinese Communist oil paintings was the image of a fallen comrade, and one of the most celebrated works on this topic, an example of Soviet socialist realism, was Quan Shanshi's (b. 1930) *Unyielding Heroism* (*Yingyong buqu*; 1961) (figure 24). Quan, an oil painter who had studied at the Repin Institute of Art in Leningrad, claimed to have been inspired by Mao's influential 1945 essay "On Coalition Government," in which the chairman wrote about the "White Terror" unleashed by the Nationalists to annihilate the Communists in April 1927. In that essay Mao wrote, "The Chinese Communist Party and the Chinese people were neither cowed nor conquered nor exterminated. They picked themselves up, wiped off the blood, buried their fallen comrades and went into battle again."[46]

Quan's painting depicts the body of a martyr lying in a lush field and covered by a red cloth, an indication of his revolutionary spirit. Surrounding the body are peasants who look both indignant and defiant, many of them having been wounded in the battle. In their hands are long spears, pitchforks, and guns in preparation for the next skirmish to defend their territories. Red banners, signifying the group's political nature, flutter in the background. In the middle stands a leader, hands on hips, his gaze reflecting the glorious future made possible only by the sacrifice of such martyrs. Others mourn silently. In the foreground, a young boy, fists clenched, a sword strapped to his back, stands before the fallen martyr to pay his respects. While the group appears to display extraordinary restraint, their postures portray fierce resistance and a readiness for self-sacrifice. The individuals in the painting reflect a new realism in art that differed markedly from traditional Chinese painting in which artists emphasized the inner lives of individuals, and not their formal appearance, by means of their surroundings and various attributes.

Andrei Sinyavsky, in his noted essay "On Socialist Realism," contends that a basic quality of socialist realism is the image of self-sacrifice, one that artists used to raise the heroes of socialism "ever higher and higher on the ladder of political morality."[47] Clearly Quan Shanshi intended to honor this noble spirit

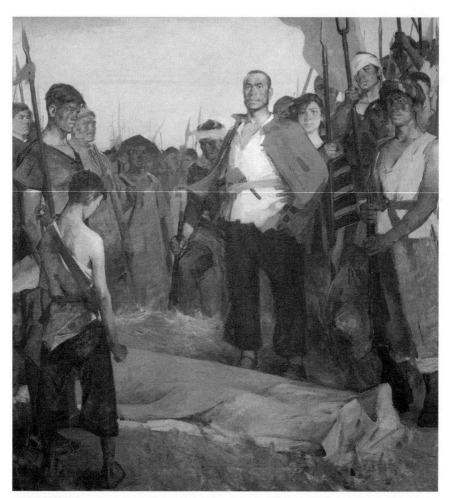

Figure 24. Quan Shanshi, *Unyielding Heroism*, 1961, oil on canvas, 231 × 216 cm. *Source*: Courtesy of the National Museum of China, Beijing.

by monumentalizing the martyrs. "Using symbolic representations to communicate my themes," the painter noted, "I monumentalize martyrs as a way to express the people's grief and hatred as well as their confidence in their strength to endure future struggles."[48] Displaying the martyr's body, Quan affirmed, "is critical to the entire setting of the painting. . . . Without that, the painting does not achieve the intended effect."[49] And the young boy in the foreground, a symbol of the future, conveys, according to the artist, "the idea of the continuing struggle [for the revolution]."[50] The sun's first glow as it rises in the background announces the dawning of a new era.

The design of the painting, ironically, resembles that of Luo Gongliu's rejected piece, *Behind the Fallen Are Endless Successors*. But the reason Quan's piece was endorsed and Luo's rejected was that, for the inspectors, the two

paintings reflect a very different spirit: whereas the latter appeared pessimistic, the former captured the promise of a successful Communist revolution.

The Military

Another central theme in socialist art was the portrayal of the great battles in the history of the CCP. One such theme was reflected in paintings that glorified the Red Army's military tradition and justified the continuing armed struggle against the enemy. Two military topics addressed by such paintings were the War of Resistance against Japan, exemplified by Zhan Jianjun's *Five Heroes of Mount Langya* (*Langyashan wu zhuangshi*; 1959) and the civil war against the Nationalists, depicted in Bao Jia (b. 1933) and Zhang Fagen's (b. 1930) *Great Victory in Huai-Hai* (*Huai-Hai dajie*; 1961).

Zhan Jianjun's *Five Heroes of Mount Langya* (figure 25) combines careful research and superb craftsmanship. Based on a true story, the painting portrays five Communist soldiers who fought against Japanese troops at Mount Langya in Yi county, Hebei province, in September 1941. Refusing to surrender when their ammunition ran out, they jumped off the cliff to demonstrate their

Figure 25. Zhan Jianjun, *Five Heroes of Mount Langya*, 1959, oil on canvas, 186 × 203 cm. *Source*: Courtesy of the National Museum of China, Beijing.

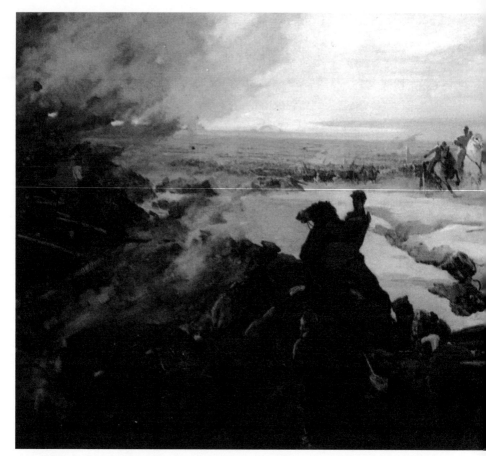

Figure 26. Bao Jia and Zhang Fagen, *A Great Victory in Huai-Hai*, 1959, oil on canvas, 150 × 320 cm. *Source*: Courtesy of the National Museum of China, Beijing.

unyielding spirit, but two eventually were rescued. Like other commissioned artists, Zhan Jianjun researched the event he would portray; he visited the original site and interviewed the two survivors to acquire a sense of historical accuracy and to imagine the trauma of loss.

The artist's portrayal of the scene was imaginative. Instead of depicting conventional combat, Zhan painted five heroes with guns in their hands standing atop a cliff preparing to jump. "To create a memorable effect I wanted to capture the soldiers' indomitable spirit just before their sacrifice," Zhan wrote in an article soon after he had completed the painting.[51] Zhan's painting stresses the coherence of the group, but their distinct expressions also highlight their individuality. The human pyramid shaped by the five soldiers reflects the artist's long-standing interest in geometric form, an element highlighting many of his works. This pyramidal arrangement is also seen in the ordering of the mountain

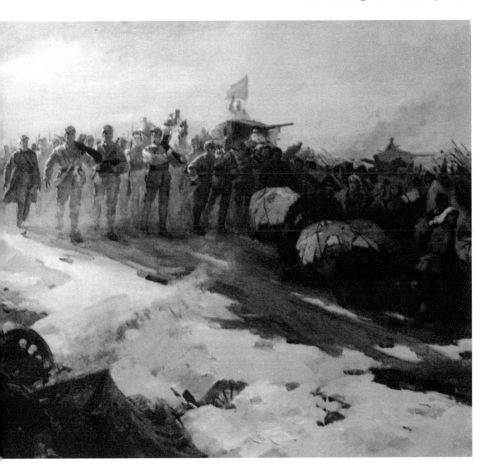

ranges in the background upper right, which conveys a kind of solemnity for those viewing the scene from below. The pyramidal design, in the words of the artist, was intended "to create the effect of a monument."[52] Zhan's efforts were clearly successful, as one art critic commented: "The soldiers appear not to be standing on the top of a hill but to be growing out of it."[53]

Bao Jia and Zhang Fagen's *Great Victory in Huai-Hai* (figure 26) illustrates a different type of military conflict: it is a panoramic view of the Red Army on its invincible march in central China during the civil war between the Communists and the Nationalists. Painted in the customary horizontal format in oil history painting, *A Great Victory in Huai-Hai* shows the Communists' victorious conclusion of the Huai-Hai campaign that was waged in southern Shandong and northern Jiangsu from late 1948 to early 1949. With red flags waving and tanks rolling, countless soldiers, some on horseback but most on foot, move

in a grand procession across the battlefield. Following them on the right, at the upper part of the painting, are the commoners pushing carts carrying their belongings, forming a bond between commoners and soldiers. Relegated to the lower left of the painting are wounded Guomindang soldiers and what remains of their damaged trucks. Thus the design of the painting marks a clear diagonal division between the victors and the defeated. The contrasting colors are sharp and distinctive. At the upper section of the painting the PLA marches under a bright, dawning sky, the sign of a promising future, whereas the vanquished are depicted in blue and dark colors, reflecting derision and defeat. The color variation in the painting, both "bright versus dark, cold versus warm," Bao Jia explained, were intended to reflect "the power of the people's revolutionary forces surging ahead with great momentum."[54]

Soviet military canvases often depict two principal features of war—the confrontation of adversaries and the prospect of violent death—as in Aleksandr Deineka's *Defense of Sebastopol* (1942). This is not the case in Chinese revolutionary history paintings. *A Great Victory in Huai-Hai* pictures neither the mayhem nor madness of real battle. Instead, it portrays a strong political message: the outcome of the campaign is assured and the socialist future is bright. The marching troops are intended to show, in the words of Bao Jia, that the Communists "will carry the revolution through to the very end."[55]

The Leader

At the heart of socialist realism is the subject of the supreme leader, an image clearly evident in the Soviet Union in the 1930s and 1940s when portraits of Stalin occupied center stage in the government's visual propaganda. The same can be said of China, where Mao's dominance was unparalleled. Nowhere was this shown more visibly than in Jin Shangyi's *Chairman Mao at the December Conference* (*Mao zhuxi zai shieryue huiyi shang*; 1961) (figures 27 and 28).

Jin Shangyi's painting, a tribute to Mao's leadership, portrays the chairman's role in a crucial conference of the CCP Central Committee held in Mizhi, Shaanxi province, in December 1947, which charted a new course for the Party in China's civil war with the Nationalists. The new direction spelled out by Mao in his report, "The Present Situation and Our Tasks," was to destroy Chiang Kai-shek and, in Mao's words, send the Nationalists "down the road to destruction" as well as to "establish a democratic coalition government." Mao then concluded, "The dawn is ahead, we must exert ourselves."[56]

When Jin was assigned to capture this historic meeting on canvas, he was keenly aware of what was expected of him. His mission, in his own words, was to demonstrate the chairman's "brilliance, wisdom, determination, steadfastness, foresight, and ability to anticipate the imminent victory of the nationwide revolution" at a critical junction in CCP history. But unlike Aleksandr Gerasimov, the Soviet court painter who had personally met Stalin and painted a number of the Soviet leader's portraits, including the famous *Stalin and Voroshilov*

in the Kremlin (1938),[57] Jin had never met Mao and had to rely on "photos and documentaries, as well as descriptions from those who had seen him."[58] Jin realized that when portraying a towering figure like Mao, he was required not just to arrive at an acceptable likeness but to create an icon. He first worked on Mao's hands, believing that they spoke with the same eloquence as the leader's facial appearance. "Without a forceful hand gesture," Jin told us, "it would be difficult to demonstrate the chairman's bold vision in brilliantly arriving at correct decisions." With a huge frame dominating the entire picture, the final work shows a confident leader forcefully extending his right arm to deliver a point. Mao's facial expression is one of certainty and decisiveness, bespeaking total control of any situation. Mao is speaking to his senior associates at the meeting, but they are not shown in the painting. By leaving out the audience, Jin Shangyi generates tension between the chairman and his followers and provokes the viewer's curiosity regarding the expressions on his listeners' faces, which can only be imagined.

The chairman is viewed from below to make him appear taller and more majestic. His posture suggests demonstrative authority, underscoring his masterful command of the situation. The original background was a white wall, but Jin made it dark red, not only to produce a sharper visual contrast with Mao's gray dress but also, in the artist's words, "to present a revolutionary flavor,"[59]

Figure 27. Jin Shangyi, preliminary study for *Chairman Mao at the December Conference*, 1961. *Source*: Jin Shangyi, "Chuangzuo *Mao zhuxi zai shieryue huiyi shang* de tihui" (My reflections on painting *Chairman Mao at the December Conference*), in *Geming lishihua chuangzuo jingyan tan* (On the creation of revolutionary history paintings) (Beijing: Renmin meishu chubanshe, 1963), 41.

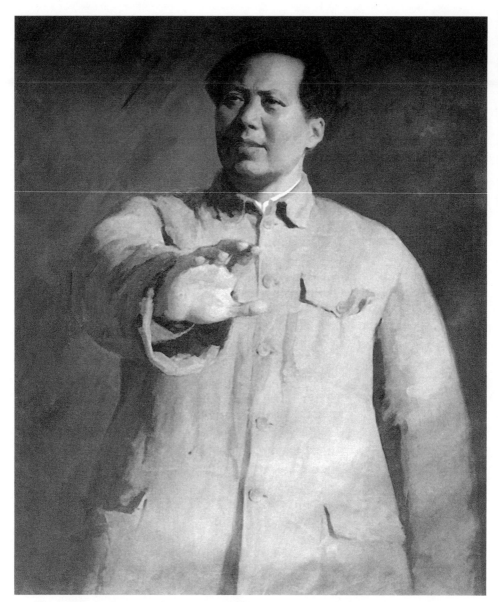

Figure 28. Jin Shangyi, *Chairman Mao at the December Conference*, 1961, oil on canvas, 158 × 134 cm. *Source*: Courtesy of the National Museum of China, Beijing.

as red was the revolutionary color. The singular focus on Mao speaks loudly of the chairman's unparalleled position in the Party. It also conveys the sanguine view that he will lead the country to a bright future. Jin's piece was clearly influenced by Soviet art. Like his teacher Maksimov, Jin is a distinguished portrait artist who captures the leader's imposing character with great sensitivity. His conception of the hand gesture may have been influenced by his Soviet

counterparts, who often portrayed Lenin and Stalin with their arms raised, presumably pointing toward the future, as in Vladimir Serov's *Lenin Declares Soviet Power* (1947)[60] and Viktor Tsyplakov's *V. I. Lenin* (1947).

The Worker

Whereas Jin Shangyi's *Chairman Mao at the December Conference* focuses on Mao, the painting *Comrade Liu Shaoqi and the Anyuan Miners* (*Liu Shaoqi tongzhi he Anyuan kuanggong*; 1961) (figure 29), by Hou Yimin, another student of Maksimov's, tells the story of another Communist leader in a different kind of struggle: the role played by Liu Shaoqi in a coal miners' strike against an exploitative social system in Anyuan, Jiangxi province, in September 1922.

In Marxist rhetoric, workers play a most critical role in forging a socialist revolution. They are credited as the chosen people who brought the Bolsheviks to power. Sanctification of the proletariat had long been exploited by Soviet painters, as in the case of Boris Ioganson, whose famous *In an Old Urals Factory* depicts grim working conditions and the awakening of class consciousness among the proletariat. Ioganson's piece was one of the most influential among young Chinese artists in the 1950s,[61] but whereas the Russian artist's work dwelt only on the gathering storm between the two opposing classes, Hou's *Comrade Liu Shaoqi and the Anyuan Miners* describes an organized strike in full action.

To ensure that his painting was highly realistic, Hou made three trips to Anyuan coal mines to absorb all the details. He wanted to faithfully portray this pivotal event in the history of the CCP.[62] In Hou's painting, Liu Shaoqi is a young labor leader directing the fight against the exploiters, an episode officially canonized in the 1950s as an early attempt by the CCP to launch the trade union movement in the country. How would Liu Shaoqi as a leader be portrayed on canvas? Early on, Hou confessed that he had difficulty portraying Liu as simply "one of the workers" as well as the organizer of the strike who acted with "determination and farsightedness."[63] But the finished product reveals no such conflict. Liu is clearly the leader directing a multitude of workers advancing along the road to demolish an unjust system. Situated at the top of the triangular design of the painting, he radiates an unstoppable energy. But the strike is never a solitary struggle—with arms raised in protest and pickaxes on their shoulders, the workers "are on the offensive," as one art critic described this combative scene.[64]

To add a more realistic touch, Hou arms the miners with lamps and winnowing baskets, along with their pickaxes. The miners are not undifferentiated followers of a charismatic organizer, nor are they a faceless crowd. The artist's depiction of distinct personalities is a unique feature of the painting. Many workers were modeled after real people, the artist pointed out. The wounded worker to the left of Liu was modeled after Zhou Huaide, a worker who died as a martyr in a subsequent labor strike. To the right is a white-bearded old man, whose crooked back is the result of lifelong hardship under an oppressive

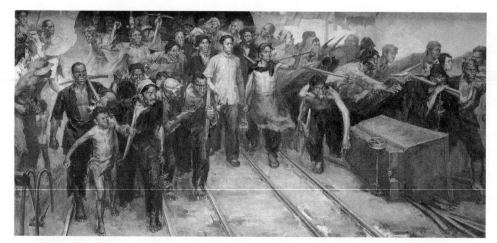

Figure 29. Hou Yimin, *Comrade Liu Shaoqi and the Anyuan Miners*, 1961, oil on canvas, 160 × 330 cm. *Source*: Courtesy of the National Museum of China, Beijing.

mining system. But now, with pickaxe in hand, he is fighting back. Moreover, a child laborer, at the front of the painting, symbolizes both the cruelty of the child labor system and a successor to the revolution. The child's clothes are tattered, but he wears a red necklace, a local emblem of longevity, thus adding a local element to the scene.[65] The faces of these ordinary miners, which Hou dignified by giving them unity and purpose, show the force of collective action and, most important, in the words of Hou Yimin, "the awakening of class consciousness."[66]

The Founding of the New Nation

Dong Xiwen's *Founding Ceremony of the Nation* triumphantly concludes the visual narrative of CCP history on canvas in the new museum.[67] In documenting a historic event in contemporary China, Dong's work is highly authentic. The painting was done in the style of the popular nianhua, which lent an indigenous flavor to the art because of the prints' traditional technique of using sharp contrasting colors, in this case bright red pillars and lanterns, a blue sky, and white clouds. While the chrysanthemums are a familiar symbol of longevity, the white doves released into the sky signal the return of peace in a land long ravaged by chaos and war. In the middle of Tiananmen Square, a new national flag has been raised, while crowds of hundreds of thousands, surrounded by colorful banners, stand in formation both admiring the chairman and engrossed in his declaration.

Despite his training in Western oil painting, Dong's work was undoubtedly influenced by the traditional nianhua that the government actively promoted as a popular folk art in the 1950s. "The Chinese people like bright, intense colors," Dong wrote in 1953. "This convention is in line with the theme of *The Founding*

Ceremony of the Nation. In my choice of colors I did not hesitate to put aside the complex colors commonly adopted in Western painting as well as the conventional rules for oil painting." "If this painting is rich in national styles," he continued, "it is largely because I adopted these [native] approaches."[68] In 1953 the government publication houses widely distributed Dong's celebrated painting, which enjoyed great popularity.[69]

Dong was also innovative and imaginative. In *The Founding Ceremony of the Nation* Mao is depicted standing on a carpet. Its surface texture is enhanced by the addition of sawdust.[70] The confined setting of Tiananmen Gate, enclosed by ancient walls and gates in the early 1950s, also led Dong to adopt more imaginative interpretations. He eliminated a few pillars in front of Mao to open up the space before him and forge a direct link between the chairman and the adoring crowds assembled in the square. Mao is also directly facing Zhengyang Gate, the main southern entrance into the inner city of the former imperial palace, along the traditional sacred north-south axis, a symbolic representation of his authority.

Concentric circles are a dominant pattern in Dong's painting, and Mao's centrality in this pattern is unmistakable. No longer a man of action as in the civil war period, Mao appears in a stately manner with an imposing presence. But unlike the real event, where he made the historic announcement surrounded by his closest comrades including Zhu De and Zhou Enlai, in the painting he stands alone, almost in the center, separate from everyone else. His closest comrades, standing to his left, form the innermost circle. The next circle is the assembled audience lined up in the vast square and enclosed by the old city walls that would be demolished in the mid-1950s, greatly enlarging the square. Outside the walls is the distant age-old city, and at the outermost edge the nation beyond shines under a blue sky and bright clouds, promising a glorious future. Without question, Mao is the heart of this symbolic world, and his vision stretches far beyond the capital into the new world. Celebratory National Day and May Day parades, as noted earlier, communicated this same message that Mao was the paramount leader in the new nation.

When *The Founding Ceremony of the Nation* was first unveiled in 1953, it was enthusiastically received. But it also had its detractors. Xu Beihong, for example, registered disapproval. According to Xu, although the painting did accomplish its political mission by accurately depicting an important historic moment in China, artistically it barely resembled an oil painting because of the predominance of typically rich Chinese colors, with no gradations of warm and cool hues as in the West.[71] Senior Party leaders, however, viewed the painting approvingly, seeing it as a testament to the young nation's evolving identity and growing confidence. When the painting was exhibited in Zhongnanhai, the Chinese leaders' compound, in April 1953, Mao was quoted as saying, "[The painting shows] a great country, which is China. Our paintings are unsurpassed if measured against others internationally, for we have our own unique national

form."[72] Hyperbole notwithstanding, Mao's statement points to an important reason why historical paintings were commissioned in the first place: they were forceful vehicles to demonstrate national pride. This issue became more pronounced in the late 1950s and early 1960s when the Sino-Soviet split prompted Chinese art circles to adopt a more nationalistic stand.

Differences between Chinese and Soviet Paintings

It is commonly assumed that Chinese history oil paintings closely resembled their Soviet counterparts, but few scholars have analyzed the differences. Certainly the creation of a series of political images in oil paintings was nothing new, as all twentieth-century authoritarian systems, including China and the Soviet Union, promoted art as a means of directly expressing their political ideals.[73] But distinguishing Chinese paintings from the others were the institutional settings under which they were produced and the ways they were closely monitored by the Party. Their increasingly nationalistic tenor also distinguished them from the Soviet model.

Throughout the 1920s the Russian authorities gave no clear direction for the desired form of art under the dictatorship of the proletariat. Only in 1932 did the Soviet Central Committee disband all artistic groups and place all cultural activities under Party control.[74] In contrast, the CCP exercised tight control over the Museum of the Chinese Revolution from the very first stage of its construction. The commissioning of paintings took several steps; throughout the process, the Chinese authorities carefully monitored each phase, and the Propaganda Department supervised all operations.

Negative themes were common on Soviet canvases and were generally regarded as a way to depict historical dialectic struggles in which the socialist camp was eventually triumphant. Two notable examples are Grigori Shegal's *The Flight of Kerenski from Gatchina in 1917* (1937–38), which depicts the ousting of the prime minister of the provisional government by the Bolsheviks, and *The End* (1948) by the Kukryniksy (a collective name derived from the acclaimed art team of Mikhail Kupriyanov, Porfiri Krylov, and Nikolai Sokolov), which shows Hitler's death by self-administered poison. Chinese revolutionary history paintings, however, seldom presented enemies as primary subjects. The scene of the defeated Guomindang troops in Bao Jia and Zhang Fagen's *Great Victory in Huai-Hai* is a rarity. Even there, the enemy serves only as a backdrop to the Red Army's victory. Revolutionary paintings generally conveyed positive images, showing major historical events in the most glowing light. This type of commissioned work was meant, in the words of Wang Zhaowen, to extol "revolutionary optimism." It would "distort the revolutionary ideal," Wang added, if the works were visualized in the language of "horror and brutality."[75] In depicting leaders, therefore, Jin Shangyi echoed, "we must do everything we can to avoid making them appear unsightly."[76] Wang's and Jin's comments are clearly in line with the

doctrines of socialist realism, but by stressing positive interpretations almost exclusively, Chinese paintings went a step further than their Soviet counterparts in giving socialist realism a far more dogmatic and restrictive expression.

In addition to ceremonial portraits of leaders and historical revolutionary themes, oil paintings in the Stalinist era included landscapes glorifying the motherland, as well as still lifes, although these occupied the lower rung of revolutionary socialist art. One example is Vasily Baksheev's *Blue Spring* (1930), a painting of silver birch trees as a symbol of Russia. Chinese painters, on the other hand, focused primarily on leaders and revolutionary themes, and they deemed landscape and still life painting insignificant forms of revolutionary art. As such, paintings depicting Chinese history had a much narrower scope than their Russian counterparts. Moreover, Soviet portraits of leaders were heavily influenced by the Russian Orthodox Church and religious icons; as Victoria Bonnell has pointed out, leaders often were portrayed with a worker and peasant at their side, similar to the apostles standing beside Christ, as in A. L. Sokolov's 1922 poster, *Let the Ruling Classes Shudder before the Communist Revolution.*[77] Paintings representing Chinese revolutionary history, of course, lacked a religious component.

The most significant difference between the two countries may have been the conscious attempt by Chinese artists to instill native colors in their works. They did so in order to produce a national style of oil painting, known collectively as the nationalization (*minzuhua*) of painting. This attempt was most eloquently described by Dong Xiwen, when he argued in 1957 that Western oil painting had to be nationalized for it to take root in China. Dong warned that if oil painting was not assimilated so that it becomes "part of our blood," the genre will forever remain a "foreign product."[78] But in the 1950s nationalization was a nebulous concept with numerous meanings—artistic, technical, and political. Artistically, nationalization meant creating a Chinese style of painting by blending indigenous and Western techniques. Dong's adoption of bright colors and ornamental designs following the convention of New Year prints in *The Founding Ceremony of the Nation* is one example.[79] Dong was proud of his work, and in his painting, as he stated, he purposely "lessened the contrast between warm and cool colors" and "simplified the extensive gradation of light and dark"—common oil painting techniques—giving his piece a strong "ornamental effect," typical of traditional Chinese painting.[80] Others, however, in order to lend their work a more distinctive Chinese look, proposed accentuating the principles of "generality and concentration," ideals long cherished in traditional ink painting.[81]

Technically the concept of nationalization, according to Zhou Enlai, was "tantamount to popularization," meaning that art could be made accessible to the widest possible audience, especially to "workers, peasants, and soldiers."[82] This line of reasoning, of course, closely followed Mao's directive in his "Yan'an Talks," which called for the use of art as a political device to serve the people.

Perhaps even more important, nationalization, politically, reflected the official policy of finding an independent artistic road different from that of the Soviet Union. This became more urgent in the late 1950s, when the relationship between China and the USSR turned antagonistic, and Mao's policy of self-reliance became a guiding principle in the nation's campaign to distance itself from Moscow. In the end, neither art nor technique but politics was at the heart of the nationalization of oil painting. China's search for a distinctive art clearly reflected an affirmation of its independence.

The idea that art can be dangerous and hence must be strictly controlled has been understood since the time of Plato's *Republic.* Stalin's attack against the avant-garde in the 1930s and Hitler's denunciation of "degenerate art" in 1937 were prompted by the fear of free artistic expression. But throughout history art has been used to serve the interests of those in power. In the case of the PRC, the paintings depicting revolutionary history commissioned by the MCR were the Party's attempt to tell its own victorious history through a medium introduced from the West, and to assert its independence from foreign countries. The museum was a highly controlled political arena, and the paintings were the Party's hegemonic representations of the nation's memory.

Chinese painters were commissioned in successive stages by Party officials to produce works on predetermined subjects, and many of these artists did so with the utmost devotion and flair. But how much autonomy did the artists enjoy? Despite the dominance of the state, there is no denying that painters retained a modicum of freedom in the use of colors and brushwork in executing their art. Zhan Jianjun, for instance, was heavily influenced by European Impressionists in his experiments with color and light. Similarly, Luo Gongliu praised the achievements of Monet, van Gogh, and Matisse.[83] But notwithstanding their personal tastes and individual styles, their works ultimately had to be subservient to ideological ends or face rejection, as in the case of Jin Shangyi's *Farewell.* With its rigid doctrines, socialist art could only speak one official language, dictated from the top.

In China, revolutionary history paintings were tailored to accommodate the political goals of the national leaders, and thus artistry was stifled. Although little information is available about how Chinese citizens actually viewed the paintings in the MCR, there is little doubt regarding the precise way in which the CCP wanted its history recorded. But the subjects the leaders wanted the public to see were constantly in flux, reflecting the perpetual power struggle among the leaders. Paintings in the museum thus enjoyed only a precarious and often fleeting existence. Dong Xiwen's *Founding Ceremony of the Nation* was not the only casualty of Party infighting. Hou Yimin's *Comrade Liu Shaoqi and the Anyuan Miners* suffered a similar fate. Hou's painting had enjoyed rave reviews when it was first presented in 1961, when Liu Shaoqi's position was affirmed. But during the Cultural Revolution in the mid-1960s, when Liu was attacked by the

radicals as a "capitalist roader" and removed from power, Hou received criticism and his painting was removed from the MCR exhibits. It was replaced by another oil painting, *Chairman Mao Goes to Anyuan* (*Mao zhuxi qu Anyuan*; 1967), by a Red Guard, Liu Chunhua (b. 1944), in which Mao, not Liu, is glorified and depicted as the undisputed leader of the miners' strikes. Although revolutionary history paintings were visual tales designed to chronicle the achievements of the CCP, the script was in no way fixed; rather, the story was continually reinterpreted according to shifting political tides.

IV. Visual Images

7. Devils in the Drawings

On July 2, 1949, the All-China Congress of Writers and Artists was held in Beiping. The conference, reminiscent of the First Congress of Soviet Writers in 1934, was orchestrated by the CCP to emphasize the importance of literature and art in nation building under socialism. But for the CCP the congress had an even more immediate goal: rallying the support of writers and artists for the impending founding of the People's Republic on October 1 and mapping out a cultural strategy for building a new socialist nation. With 753 noted writers and artists in attendance, the meeting was a truly momentous event.

In an important report, the art critic and woodcut artist Jiang Feng, a vocal advocate of the official art policy, assessed the CCP's past achievements in art and proposed a plan for its future development. In the years just prior to the Communist takeover, Jiang asserted, the art policy in the Communist liberated regions "changed fundamentally after the unequivocal acceptance of Chairman Mao's call to use art as a tool to serve workers, peasants, and soldiers." The result, according to Jiang, was that art forms had since been thoroughly popularized in order to meet the needs of the general public, "turning them into something that belonged to the people." Jiang underscored the effectiveness of a host of popular art forms—namely, posters, cartoons, woodcuts, lianhuanhua (serial picture stories), and nianhua—in conveying the socialist messages to the masses and in promoting the Party's agenda. These art forms, according to Jiang, were readily comprehensible, simple in form, and easy to produce, giving them "a strong hold over the masses."[1]

Jiang's speech was by no means a simple statement on art. In reality it reflected the urgency with which the Chinese Communist Party, after seizing power, sought to establish an effective art policy to help rule and disseminate socialist ideas in the vast country of China, a country populated largely by illiterate peasants. For a quick answer, the CCP turned to popular visual forms of propaganda. The Chinese Communists understood that to seize power they must first capture the hearts and minds of the Chinese people, and to do so they knew they had to first create or refashion appealing political images. The popular art forms such as cartoons, lianhuanhua, and nianhua, mentioned in

Jiang Feng's speech, became ideal tools to reach out to the majority of the people and to win their support for the new government. To be sure, these three art forms were by no means the only devices used by the Communists to circulate their intended images among the public, but both the artists and the Party officials discovered that they were the most effective vehicles for creating the desired effects. In his book about European art, Francis Haskell maintained that visual images are historically conditioned and cannot be divorced from the social factors that produce them. In the words of Haskell, images can be seen as "an index of society."[2] In the Chinese case, images were more than historically conditioned; they were also politically confined. They chronicled and reflected the political realities that shaped them. Furthermore, the Chinese Communist visual lexicon in the 1950s had a strong nationalistic appeal, a deliberate departure from foreign models. Oil painters, including Dong Xiwen, painted in a very similar style.

Visual Tools

The Communists' use of cartoons, especially political ones, had a long history.[3] During the Yan'an years, satirical works attacking the Guomindang by young cartoonists such as Hua Junwu (1915–2010) and Zhang E (1910–95) appeared regularly in Party-run newspapers like the *Liberation Daily* (*Jiefang ribao*) and were a distinguished feature in Communist visual propaganda art.[4] A number of advantages in adopting this artistic device were obvious. Cartoonists often produced direct, simple, and easily recognizable images that make this art form ideally suited for conveying a compelling viewpoint. Artistically, the cartoonists' technique of distortion and exaggeration, coupled with their ability to make complex subjects appear simple and to the point, succeed in making a sharp, sometimes shocking, impression on their viewers. Most important, political cartoons especially are characterized by the essential ingredients of timeliness and topicality, according to the British cartoonist David Low.[5] Political cartoons, known as "current affairs cartoons" (*shishi manhua*) in the 1950s, indeed generated a sense of immediacy and functioned as ideal tools to reflect government policies.[6] Cartoons then became a regular feature in Party-run newspapers, such as Beijing's *People's Daily* and Shanghai's *Liberation Daily* (*Jiefang ribao*).[7] News cartoons were created almost instantly in response to current events and were designed primarily to project official viewpoints. "As soon as the news reports from the New China News Agency arrived on our desks," Fang Cheng (b. 1918) of the *People's Daily* recalled during a recent interview, "we followed up on the stories and quickly came out with a cartoon for the next day's edition."[8]

Chinese cartoons, like oil paintings, were influenced by Soviet art, an impact already visible during the Yan'an years when Russian artworks were reprinted in key newspapers like the *Liberation Daily*.[9] By the early 1950s Russian artistic styles were viewed as official models to be systematically emulated by

Chinese artists. The acceptance of Soviet socialist realism was illustrated by the increased reprinting of Soviet cartoons in the Chinese press.[10] Chinese newspapers regularly printed works by Boris Efimov and the Kukryniksy.[11]

If political cartoons, mostly printed in single frames, excelled in commentary on specific political events of the day and carried a sense of immediacy, lianhuanhua, by using successive pictorial frames, were considered ideal by Chinese Communist artists to relate a coherent story to viewers. Indeed, Communist artists took lianhuanhua seriously. A primary reason was that lianhuanhua had a long history in Chinese art, dating as far back as the Han dynasty, if not earlier, so it was deeply rooted in Chinese tradition.[12] In the Republican era lianhuanhua continued to enjoy great popularity in urban China, especially in major cities such as Shanghai and Tianjin.[13] "Small bookstalls," observed Mao Dun in 1932, "renting out inexpensive serial picture stories dotted the Shanghai city landscape."[14] Not surprisingly, the huge popularity of lianhuanhua drew the attention of Communist artists even before 1949. Yan Han's *Five Heroes of Mount Langya* (1944), for example, was a lianhuanhua about a group of Communist soldiers' heroic resistance against the Japanese incursion in 1941; the same theme would later be created on canvas in 1961 by painter Zhan Jianjun, as noted in the previous chapter.[15]

Concerted efforts to utilize this popular art form for political indoctrination did not occur, however, until after 1949. One Shanghai official described the city's more than three thousand bookstalls renting out lianhuanhua booklets and drawing two hundred thousand readers a day as a "stunning" phenomenon. Of those renting the booklets, 50 percent were children, 20 percent were women, 20 percent were workers, and the remaining 10 percent were people in other categories.[16] Because of their popularity, one critic added, lianhuanhua could become "an indispensable educational tool, especially for those who are less educated."[17] In December 1949, immediately after the founding of the PRC, the Mass Pictorial Press (Dazhong tushu chubanshe), under the supervision of the Ministry of Culture, was established to oversee the production of new lianhuanhua with socialist messages.[18] A new national semimonthly magazine, *Serial Pictures (Lianhuanhua bao)*, was also launched in 1951 to facilitate the cause. New young artists were trained, and exhibitions were mounted.[19] Like cartoons, lianhuanhua appeared regularly in major Chinese newspapers.[20] In 1952 more than 670 different kinds of new serial picture booklets were printed, with a combined print run of 21.7 million. In 1954 the number increased to 900 new titles with a total print run of 35.8 million.[21]

On the surface, Chinese lianhuanhua resemble American comic strips, which count continuous narration as one of their key features and characters appear repeatedly from frame to frame. But unlike their American counterpart, Chinese lianhuanhua were not conceived as "a medium of entertainment," a core feature of the American comic strip, as argued by Judith O'Sullivan.[22] Lianhuanhua in socialist China served primarily a political purpose. On that

ground, Chinese lianhuanhua more closely resembled Soviet Rosta Windows, which, issued in the 1920s by the Russian Telegraph Agency ("Rosta"), used four to twelve different frames to create a story of the latest political events.[23] But the two were also different in several ways. Although Rosta Windows were stories of mostly four to twelve frames, the length of a single piece of lianhuanhua varied and could be as long as several hundred frames, and they regularly appeared as booklets. Unlike the Rosta Windows that were about current events, the subject of lianhuanhua went beyond news alone. And in terms of popularity, the Rosta style fell out of favor at the end of the Russian civil war, whereas lianhuanhua enjoyed increasing popularity after 1949.

In addition to cartoons and lianhuanhua, three other popular art forms—nianhua, woodcuts, and posters—were also a prominent element in the Communist propaganda arsenal. Nianhua and woodcuts were typically used in the 1950s to glorify the achievements of the new regime and rarely for the purpose of demonizing the enemy, whereas posters were used for both purposes. This chapter centers on cartoons and lianhuanhua, the two forms of popular art commonly used by the Communists to attack their perceived enemies. The third form, the celebratory nianhua prints, is examined in the next chapter.

U.S. Imperialists and Their Allies

In December 1948, on the eve of the Communists' capture of Beiping, the CCP issued a secret memorandum entitled "Guiding Principles after the Occupation of the City," which instructed the Communists to seize control of the mass media, especially newspapers and radios, after capturing Beiping. The document stated unequivocally, "We must explain clearly both the general and specific positions, principles, policies, and methods of our Party and our army concerning [the governing] of the city." And, the document went on, "we must also thoroughly expose the political, economical, intellectual, and social crimes of the reactionaries."[24]

Like the Soviet political representations,[25] a familiar technique Chinese artists used in attacking their enemies was a sharp distinction between "us" and "them," between friends and foes, heroes and villains. Such a clear contrast comes primarily from the Marxist conception of class struggle, which, in theory, divides the world into two antagonistic camps: oppressed versus oppressors, socialism versus capitalism, and proletariat versus capitalist. In the Chinese case, however, the disposition to view the world in a bipolar framework was also dictated by the specific time and context, when in the early days of the PRC the new regime had to draw an unmistakable boundary between those who sided with socialism and those who stood against it, as Mao Zedong clearly stated in his 1949 article, "On the People's Democratic Dictatorship." Chinese Communists and their foes, in Mao's view, were therefore locked in a deadly battle.

But who were the "reactionaries," also later known as "counterrevolutionaries"

or, collectively, as "enemies"? What types of "political, economical, intellectual, and social crimes" did they commit, and how should these enemies' "crimes" be "thoroughly exposed" to the public? The list of enemies depicted in Communist propaganda art was long and could be roughly divided into external and internal threats. Enemies abroad were U.S. imperialists, represented by politicians and generals such as Presidents Harry Truman and Dwight Eisenhower, and Generals Douglas MacArthur and George Marshall; European allies of the United States, including British prime minister Winston Churchill and chancellor of the Federal Republic of Germany Konrad Adenauer; and Asian friends of the United States, primarily Japanese prime minister Yoshida Shigeru and South Korean president Syngman Rhee. Domestic enemies were diverse and could be grouped into two categories: political opponents, such as Chiang Kai-shek and his associates, foreign spies, and domestic saboteurs; and economic, social, and religious villains, such as capitalists, landlords, members of popular religious groups such as the Unity Sect (Yiguandao), priests, and bourgeois intellectuals such as Hu Feng (1902–85). The enemies were denounced for their crimes either because of their anti-Communist stand or their social and economic wrongdoings, including exploitation and corruption. Although an attempt was made to distinguish between external and domestic foes, in reality the two groups were often depicted as close allies, interlocked in many ways, linked by a malevolent conspiracy; those wreaking havoc at home were supported by evil forces outside the country.

The United States was widely recognized by Chinese Communists as the newly established PRC's most implacable enemy. CCP media perceived the United States as a rapacious predator and quintessential representative of the twin evils of capitalism and imperialism. In his famous article, "Farewell, Leighton Stuart!" written in August 1949, Mao denounced the U.S. role in recent Chinese history, namely, its part in China's ruinous civil war when the United States and the U.S. ambassador to China John Leighton Stuart supported the corrupt Guomindang regime. "The war to turn China into a U.S. colony, a war in which the United States of America supplies the money and guns and Chiang Kai-shek the men to fight for the United States and slaughter the Chinese people, has been an important component of the U.S. imperialist policy of worldwide aggression since World War II," wrote Mao.[26] Chinese propaganda artists faithfully echoed this official anti-American line. One of the most common techniques used was allegorical representation, which was a key component in propaganda art for a number of reasons. Such representations clearly distinguish between the good and the bad; they are often rich in association; they dehumanize as well as humiliate foes, especially when bestial images are used; and when the representations are familiar past symbols, they are readily understood by the masses.

The snake and the wolf, often used in the West as symbols of ruthlessness and brutality,[27] were the two most common allegorical figures that Chinese artists used to characterize Americans negatively. According to folklorist Wolfram

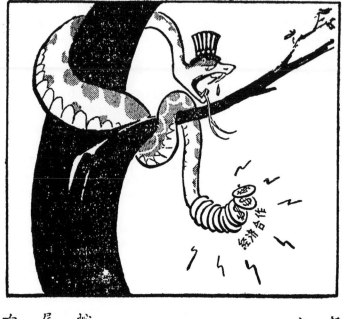

响　尾　蛇　　　　　　　　　　江　帆

Eberhard, snakes are a "clever but wicked" creature in Chinese folk belief: "treacherous people," for example, are said to have a "snake heart."[28] Already adopted earlier in the Yan'an era to symbolize destructive forces in Chinese society as in the civil war,[29] the snake was one of the most reviled images in Communist propaganda art against the United States in the early days of the PRC. Jiang Fan's (b. 1924) *The Rattlesnake* (figure 30), which appeared in the *People's Daily*, portrays the United States as a snake that uses the ruse of "economic cooperation" to achieve its goals of Asian domination. In this cartoon the United States reveals its malicious plan not only for China but also for Asia as a whole. Here Jiang Fan depicts the United States as a coercive, expansionistic power. In his cartoon, a rattlesnake wearing an American hat is a symbol of evil, epitomized in its huge jaws, forked tongue, white fangs, and rattling tail in the shape of a dollar sign.

The wolf was another common symbol used by Chinese artists to ridicule the American government. C. A. S. Williams described the wolf in Chinese folklore as an "emblem of cupidity and rapaciousness."[30] In the 1950s Hua Junwu followed this line of thought but directed his attack against Americans. In his cartoon, *Wolf's Disguise*, Hua depicts Washington as a wolf masquerading as a gentleman who lies in order to promote his scheme to dominate the world.[31] Likewise, Fang Cheng's *The Singing Performance of the Wolf* (figure 31) also aims to uncover this sinister imperialist design. In this cartoon Fang portrays the United States as a wolf that devours a chicken by disguising itself as the very

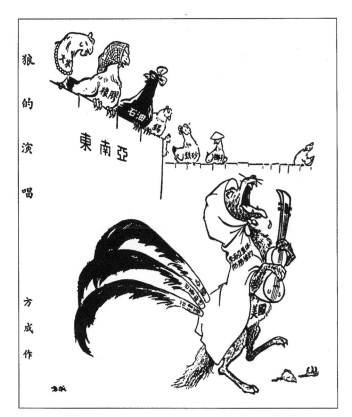

Figure 31. Fang Cheng, *The Singing Performance of the Wolf.* Source: *RMRB,* October 22, 1954, 4.

victim of its own assault. Fang criticized that the United States, with Thailand, Pakistan, and the Philippines already under its domination, continued to promote the idea of a collective defense treaty for Southeast Asia in 1954. Obviously the wolf is not driven by an altruistic motive. Rather, as the cartoonist tells us, it has its eyes on the region's rich natural resources: rice, rubber, oil, tin, and iron ore.

Snakes and wolves were only two of the many allegorical images Chinese artists used to condemn U.S. policies. Others included dogs, rats, weasels, octopuses, and moths.[32] In one cartoon the U.S. government is depicted as a giant octopus with tentacles marked with swastikas, skulls, and dollar signs, and each holding a gun, a sword, or an atomic bomb, menacing the Pacific region, an indication of America's appetite for imperialistic expansion.[33]

The common practice of portraying political opponents in subhuman or nonhuman form, such as animals, reptiles, and insects, to demonize the enemy allows propagandists to insult their adversaries without guilt and implies that the elimination of enemies would bring about a safer society. Exaggeration of the enemy's dreadful acts also justifies trust in the authorities to repel the common threat. The Bolshevik artists excelled in this type of art when using it to

attack capitalism and imperialism. Viktor Deni's famous civil war cartoon *Antanta* (Entente), for example, portrays three White Army generals as vicious dogs, each restrained on a leash held by three foreign officials: Uncle Sam and an English and French official, signaling the White Army's slavish acquiescence to evil external powers.

Allegory was by no means the only method the Chinese propagandists used to denounce the archenemy. Another familiar method employed was satire, and the images were equally savage. This was fully evident in the artists' depictions of the Korean War, which broke out in June 1950. In China's highly publicized Resist America, Aid Korea Campaign, General Douglas MacArthur, the commander of the U.S. forces, was, predictably, the main target of Chinese anger. Dubbed routinely as "Mac the Devil" and "Mac the Madman" in Chinese cartoons, MacArthur was criticized as an insane general who cared nothing about the lives of Asian peoples but only about his country's interest in Asia. In *MacArthur's "Distinguished War Record" in Korea* (figure 32) by the celebrated cartoonist Ye Qianyu (1907–95), the general is portrayed as an evildoer using Taiwan as a base to unleash aggression on the Korean Peninsula. The aggressor, however, is met with determined resistance from the heroic Korean people and, his hand battered and bloody, suffers a humiliating defeat. Chiang Kai-shek is shown hiding behind the general, an obvious demonstration of Chiang's cowardice, while the South Korean leader Syngman Rhee, in an obvious state of

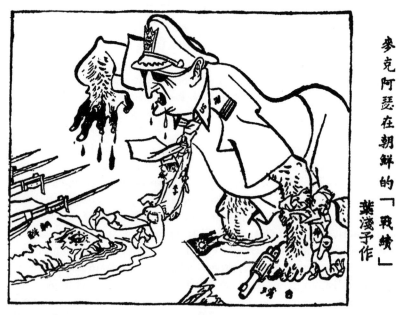

Figure 32. Ye Qianyu, *MacArthur's "Distinguished War Record" in Korea.*
Source: *RMRB*, July 19, 1950, 1.

panic, clings desperately to the American general's tie so as not to fall down. The cartoonist's position was clear: eventually the Americans will suffer an ignominious defeat.

Although MacArthur symbolized American imperialism in Asia, he was not the only American leader to be singled out for attack. In another cartoon, President Harry Truman was portrayed as the Statue of Liberty, but, instead of holding up a torch of light he is about to drop an atomic bomb on innocent people.[34] Two secretaries of state—Dean Acheson (under President Truman) and John Foster Dulles (under President Eisenhower)—were pictured as villains as well, depicted as fervent advocates and implementers of their country's cold war policies: manipulation of the United Nations; turning Taiwan into a U.S. puppet state as well as a military outpost in Asia with the signing of a mutual defense pact with Taiwan; and rearming Japan as a U.S. foothold in Asia. All these factors invoke an image of an imperialist nation whose aggression must be roundly condemned and swiftly checked.[35] American allies in Europe and Asia fell under similar attack. Winston Churchill, for example, was disparaged in Chinese art as another warmonger, executing orders originating from Washington.[36] Yoshida Shigeru fared no better. He was condemned as a U.S. lackey in Asia and a traitor to his own country.[37]

Death was another satirical image used by Chinese artists to attack U.S. foreign policy. The U.S. government was often painted as death incarnate, a reflection of the cold war ethos in the early 1950s when the CCP regarded the confrontation between socialism and capitalism as a battle between light and darkness. A battle against America, therefore, was a just war against an evil power that had caused untold sufferings to other peoples. Fang Cheng and Zhong Ling's (1921–2007) *The "Traveler" Has Returned!* (figure 33) is a cartoon about the homecoming of a wounded American sailor from Korea. His face is skeletal, and he is pulling a shipload of downed planes and tattered flags, a sign of his country's humiliating defeat in the Korean War. The sailor's return in defeat mocks the U.S. government's deceitful recruiting poster that entices young people to enlist by dramatizing an overseas assignment to war-torn Korea as a vacation.

In Chinese Communist propaganda art the United States was also satirized as a nation plagued by incessant class struggle, controlled by Wall Street capitalists and big corporations such as Standard Oil. Capitalists were often represented as corpulent males with puffed up froglike bodies and sinister smiles. They were heartless bosses whose monopolistic control of the nation's wealth bitterly divided social classes and generated conflicts. These images were undoubtedly inspired by Chinese Communists' perceptions of the West. But they were doubly reaffirmed later by the introduction of Soviet propaganda art, such as Viktor Deni's famous *Kapital* (Capital), in which a plump, smug capitalist is surrounded by a sea of gold coins. These American bankers and businessmen, Chinese artists contended, actually controlled America. Ding Cong's

「旅行」的人們回來了！ 方成　鍾靈作

木牌上是美國的杜魯門政府在國內到處張貼的徵兵「廣告」，他們用「旅行」來欺騙人民去充當砲
灰。隨著美國侵略者在朝鮮戰場上所謂「海空軍優勢」的破產，大批「旅行」的人們回來了。

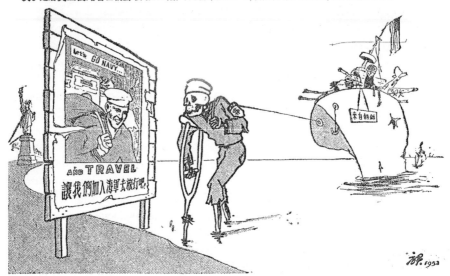

Figure 33. Fang Cheng and Zhong Ling, *The "Traveler" Has Returned! Source: RMRB,*
September 5, 1952, 4.

(1916–2009) cartoon, *The Manipulator of the War of Aggression*, illustrates this
reality: a Wall Street boss grasping in his right hand a blood-stained sword with
the phrase "war of aggression" and in his left hand a whip, sitting atop an an-
guished American worker and beating him in an effort to make him move for-
ward (figure 34).

Chinese propagandists often used a tone of contempt for America's vaunted
military power, an attitude Mao clearly expounded when, in his 1946 celebrated
"Talk with the American Correspondent Anna Louise Strong," he compared the
United States to a paper tiger. Mao told the reporter that "the atom bomb is a pa-
per tiger which the U.S. reactionaries use to scare people." "All reactionaries are
paper tigers," added Mao.[38] Mao's picture of the United States as a "paper tiger"
was a curious mixture of disrespect for American technological capabilities, a
supreme and naive confidence in Communist China's own destiny, and a daring
bluff. Such a simplistic impression of the enemy could have disastrous conse-
quences for the PRC in the real world, but it was a potent stimulus to the propa-
gandists' imagination in formulating their ideas. Zhang Ding's (b. 1917) cartoon,
Paper Tiger (figure 35), which denounces Truman's belligerent posture toward
the Korean Peninsula as a futile bluff, is a faithful articulation of Mao's view. The
cartoon implies that if U.S. troops were to cross the 38th Parallel, they would be
humiliatingly routed by the Communist forces. In the artist's view, Truman's

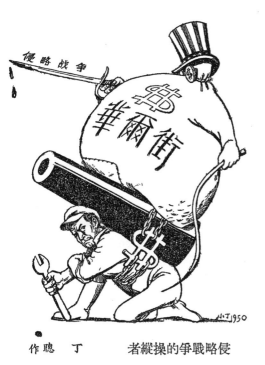

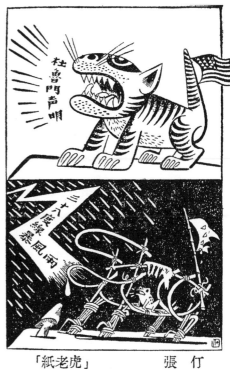

Figure 34. Ding Cong, *The Manipulator of the War of Aggression. Source: XGC* 1, no. 11 (November 25, 1950): 8.

Figure 35. Zhang Ding, *Paper Tiger. Source: RMRB,* July 20, 1950, 1.

decision to intervene militarily in the Korean War in his fight against Communism resembles not the roar of a tiger but merely the feeble croak of a toad.

In ridiculing American imperialists, Chinese visual representations were clearly influenced by the Soviet Union. In the early years of the PRC, in addition to cartoons of the Kukryniksy and Efimov mentioned earlier, political drawings by Dmitrii Moor and Viktor Deni were widely introduced.[39] Soviet cartoons and posters were regularly reprinted not only in major official newspapers, such as Beijing's *People's Daily* and Tianjin's *Progressive Daily,*[40] but also in regional papers such as Jinan's *Popular Daily (Dazhong ribao).*[41] "The works of the Kukryniksy were my favorite," Fang Cheng reminisced in a recent interview. "We zealously emulated Russian artists' works published in *Crocodile (Krokodil),* and very soon our style changed," he recalled.[42] Indeed, the sense of immediacy in Soviet graphic art derived from its focus on current events, especially issues related to the cold war. This emphasis on current events, together with anti-American sentiments, had a strong impact on Chinese art. This influence on Chinese artists in the mid-1950s, as noted earlier, was followed by an interest in Soviet oil painting.

But to say that Chinese artists actively borrowed from their Soviet mentors is not to indicate that they lacked originality or imagination. From the very beginning Hua Junwu decried slavish imitation of foreign models, including those of the Soviet Union. The veteran cartoonist called on his fellow artists to weave native idioms, including traditional proverbs, into their works.[43] Chinese artists frequently used proverbial sayings, folk tales, and native painting styles, such as brush painting on Chinese papers (*xuanzhi*), which provided a distinct indigenous flavor and signaled the artists' conscious effort to establish their own identity, separate from foreign models.[44]

Chiang Kai-shek and the Guomindang

If the United States was regarded as a personification of the foreign devil, then Chiang Kai-shek was the foremost symbol of the domestic devil in Chinese Communist propaganda art, a demon that should be held responsible for China's past and current troubles. Before 1949 Chiang Kai-shek had already become a favorite target of Chinese Communist propagandists. In a well-known 1947 cartoon, *Sharpening the Knife to Continue Killing* (figure 36), Hua Junwu satirizes the Guomindang leader as a bloodthirsty tyrant who talks peace with the Communists merely as a smokescreen to rekindle a civil war in order to annihilate his opponents and further his own interests.[45] Hua was a virtuoso in the art of ridiculing Chiang Kai-shek, who was often depicted as an emaciated, sickly old man (signs of weak-mindedness and incompetence), with a headache patch on his forehead. This trademark figure of Chiang covered with bandages became one of Hua's most memorable artistic creations.[46]

After 1949 Chiang Kai-shek's image deteriorated. At this time cartoonists, in addition to their usual satirical approach, were increasingly adopting allegory as a way to ridicule their subjects. Thus visual media now pictured Chiang as a beast engaging in despicable acts, fated to be condemned by the Chinese people as a corrupt oppressor. Hua Junwu, now the principal cartoonist for the *People's Daily*, again took the lead in scorning Chiang. In *Each Attends to His Own*

Figure 36. Hua Junwu, *Sharpening the Knife to Continue Killing.* The characters on the shield read, "peace plan." *Source:* Hua Junwu, *Hua Junwu zhengzhi fengcihua xuanji* (Selected satirical cartoons about politics by Hua Junwu) (Beijing: Renmin meishu chubanshe, 1954), 4.

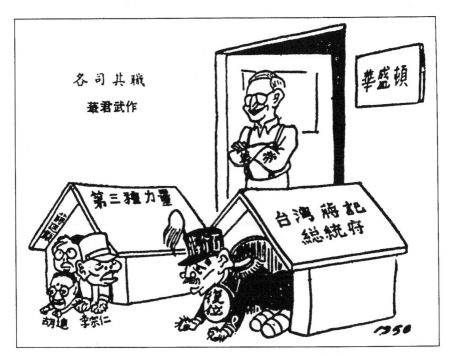

Figure 37. Hua Junwu, *Each Attends to His Own Duties. Source: RMRB*, March 9, 1950, 6.

Duties (figure 37), Hua derides Chiang as a "running dog" who obsequiously follows the orders of his foreign American master. The two doghouses in this cartoon, labeled "Chiang Kai-shek's Presidential Palace in Taiwan" and "The Third Force," represent America's imperialistic interest in China. "The Third Force" housed three dogs who made up a rival third force against Chiang: General Li Zongren (1891–1969), scholar Hu Shi (1891–1962), and historian Jiang Tingfu (1895–1965). In the other doghouse is Chiang himself, portrayed as a dog and wearing a tag that reads "Restoration," indicating Chiang's wish and intention to be reinstated, in all his former glory, as China's supreme dictator. Behind these two doghouses stands the smiling master, a foreigner, "American imperialist" inscribed on his sleeves, at the entrance of a room labeled "Washington." The confidence the American exudes suggests that his dogs will perform faithfully in carrying out his plan.

Representing the enemy as a dog is a common motif in political cartoons. One recalls, for example, Viktor Deni's *Antanta* mentioned earlier. This dog image reappeared in the early days of the PRC, with an obvious intention to humiliate Chiang as a spineless leader. The novelty, however, was not the allegory of the bestial image, but the repetition, intensity, systematic denigration, and concerted effort that Chinese artists mounted to attack Chiang. Repetition, as Jacques Ellul points out, is one of the most common propagandistic devices.[47]

The image of Chiang as a running dog parallels that of the United States as a wolf. Both bestial representations provide convenient and familiar symbols that political artists can target, but they also validate the use of violence since the annihilation of beasts is justified.

Dogs, of course, were by no means the only symbol used by the Communist artists to demean Chiang Kai-shek allegorically. Like the United States, Chiang was also portrayed as a rat. In a cartoon titled *Rats Moving Their Houses*, Hua Junwu depicts Chiang as a large rat. Chiang and his close associates are fleeing in panic to South America bringing with them bags of money stolen from the people, as the Red Army advances.[48] Both these images—the "running dog" and the large rat—call to mind repulsive creatures that inflict damage on the nation.

The swastika was another familiar image propagandists used in attacking Chiang Kai-shek, identifying him with the evil of Nazism. In Communist songs before 1949 Chiang Kai-shek was already dubbed "China's Hitler and the Present-Day First Emperor of Qin."[49] In pictorial art he was often depicted with a swastika, implying that his intentions were similar to the Nazi's plan to destroy Communism at home and abroad.[50]

Chiang's association with Hitler's anti-Communist policy was given renewed emphasis in the 1950s. Chiang Kai-shek and the Führer were portrayed in Chinese cartoons as belonging to "a similar group of evildoers."[51] Here the swastika was used with even greater intensity and frequency. Zhang Ding's *Marching toward Death* (figure 38), for example, shows Chiang and other Western leaders

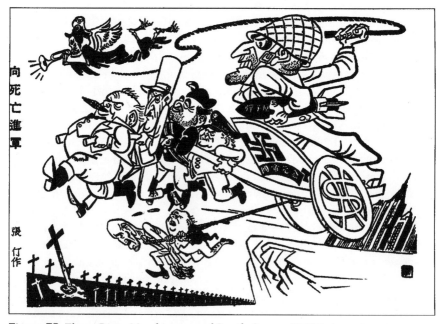

Figure 38. Zhang Ding, *Marching toward Death*. *Source*: *RMRB*, August 11, 1950, 4.

pulling a chariot with a swastika depicted on the front that is about to fall off a cliff, with an American soldier driving the chariot and holding an atomic bomb. The outcome, of course, is predictable, for, as the title tells us, the group is in a headlong dash toward their own destruction. The repetition of fascist insignia, such as a swastika, in post-1949 Chinese propaganda art was intended primarily to attack Western anti-Communist policies. Absent in these pictures, however, was the National Socialists' message of racial supremacy and anti-Semitism.

Counterrevolutionaries at Home: Spies, Saboteurs, and Others

Like the Soviet Union, which had a nationwide campaign to combat counterrevolutionaries that resulted in the death of more than half a million people from 1921 to 1954,[52] the CCP launched the nationwide Campaign to Suppress Counterrevolutionaries in the early 1950s. But who were the counterrevolutionaries? Article 7 of the Common Program issued by the CPPCC in September 1949 referred to "Kuomintang [Guomindang] counterrevolutionary war criminals and other leading incorrigible counterrevolutionary elements who collaborate with imperialism, commit treason against the fatherland and oppose the cause of people's democracy."[53] Despite this, the term was never given a precise legal definition. In general, the government regarded any anti-Communist activity as counterrevolutionary. In March 1950 the CCP issued a directive stating that the suppression of any anti-Communist activity "must be harsh and swift." The document stated unmistakably: "We cannot be too lenient, allowing counterrevolutionary activities to run rampant."[54] By late 1953 a total of 712,000 perceived counterrevolutionaries were executed, and 1,290,000 were incarcerated.[55] It was a ruthless and decisive move by the Party to consolidate its power.

The Campaign to Suppress Counterrevolutionaries, as expected, took center stage in the official media in the early 1950s, and government presses abounded in stories of how concealed Guomindang spies and saboteurs were exposed by conscientious citizens or reported to the authorities by their own kin.[56] As in Soviet political representations, where the struggle against spies and saboteurs was an important theme,[57] Chinese propaganda art faithfully chronicled the campaign's developments and reflected the government's position. Cartoons with titles like *Never Relax One's Vigilance against Counterrevolution*, in which the counterrevolutionary is rendered as a poisonous snake,[58] appeared repeatedly in print media.

In addition to cartoons, lianhuanhua provided still another device to satirize the domestic enemy. The narrative style of lianhuanhua, a storytelling format, proved ideal for publicizing official views. Shanghai, the foremost center of lianhuanhua production in China, saw the increasing popularity of this propaganda art. The city's leading newspaper, the *Liberation Daily*, openly labeled lianhuanhua a "potent weapon" in the battle against counterrevolutionaries.[59] Hua Junwu admitted that lianhuanhua were superior to cartoons as a propaganda device, as

cartoons were limited to only one frame whereas lianhuanhua presented a more comprehensive pictorial analysis through a sequence of images, which was especially appealing to the public.[60]

Liu Jiyou's (1918–83) *Little Heroes Arrest a Spy* (figure 39) is an apt illustration of the benefit of this narrative format. It is a six-frame lianhuanhua about two Suzhou primary school students who are also Young Pioneers and who arrest a Guomindang spy with the help of the People's Liberation Army. The Guomindang spy had offered the two students a large sum of money to cause chaos at their school and disrupt education in the early days of the Communist rule. The boys resist, and a scuffle ensues in which one of the boys is hurt and the spy is finally subdued. The students are praised by their teacher and classmates for their bravery. That they are Young Pioneers assisted by the PLA in uncovering the

(5) 恰巧遇到幾個解放軍同志遠遠走來，陳永康把手中東西放下，｜把特務抱住，拼命大喊：『解放軍同志捉特務啊！』

(6) 特務被捉。但是英勇的陳永康卻在捉住特務的時候被特務打傷了。老師和同學們都來慰問他。

Figure 39. Liu Jiyou, *Little Heroes Arrest a Spy*. Two Young Pioneers are grappling with the spy. In the end, one of the wounded little heroes is congratulated and comforted by his teachers and classmates as he lies in bed recuperating. *Source: XGC* 2, no. 11 (June 10, 1951): 35.

spy's scheme reaffirms the pivotal role of the CCP played in providing correct leadership in times of crisis. Liu, a veteran lianhuanhua artist, noted for his traditional line drawing (*xianmiao*) technique and meticulous rendering of classical portraits, presented his characters with vivid details. His theme, pitting young students against a spy, new versus old, was a common technique Communist artists used to depict a novel era in which children were growing up as new socialist men and women with increasing confidence in the future.

Li Hanzhang's *Seven Little Heroes Use Ingenuity to Apprehend Spies* takes up a similar subject. Here seven primary school students in Tianjin use wit and courage to capture two counterrevolutionaries planning on committing arson and wrecking havoc in nearby villages.[61] The evocation of vigorous youth is at the core of the two lianhuanhua. The students' brave and laudable action is not prompted by their simple, uncorrupted hearts, as romanticists perhaps would suggest but rather by their heightened political consciousness inspired by the new socialist regime.

Not only did young people become dedicated citizens under the new Communist rule, but commoners, women in particular, also played equally constructive roles. Miao Di (b. 1926) and Zhao Zhifang's (b. 1928) serial picture *Aunt Yao Apprehends the Spy* is an example (figure 40). Here, near Tianjin, a peasant woman with small bound feet acts wisely in the name of socialism to detain a spy who intends to escape justice by taking flight. Once again, the spy has a Guomindang connection, having belonged to the brutal police force before 1949. Now he has concealed his past identity but continues to engage in subversive acts. Nonetheless, his identity is finally revealed and he is imprisoned.

The Guomindang spies are everywhere, propaganda art tells us. In another serial story, *Shijingshan Power Plant Workers Arrest Spies*, the spy is a former hooligan who has infiltrated a power plant in Shijingshan, the key industrial area west of Beijing. He destroys machines and disrupts power production. But at the end he is caught red-handed with a gun by the plant's security forces. This time, the proletariat, the chosen class in Marxist ideology, plays a heroic role in rooting out the counterrevolutionary.[62]

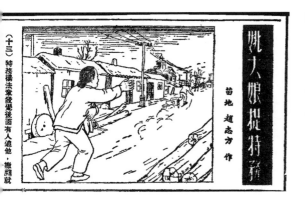

Figure 40. Miao Di and Zhao Zhifang, *Aunt Yao Apprehends the Spy*. Aunt Yao, with feet bound, chases after the spy and catches him. She is commended by her fellow villagers and friends for her wise and courageous act. *Source*: *RMRB*, April 17, 1951, 3.

In the CCP's visual lexicon, spies, of course, are not confined to those who serve the Guomindang masters but also include foreign agents. Miao Di and Zhao Zhifang's serial story, *Smashing the Espionage of American Imperialism*, depicts the alleged plot to kill Mao atop Tiananmen Gate, noted in chapter 4, in pictorial form (figure 41).[63] The ringleader is portrayed as Colonel David Barrett, one-time U.S. military attaché to the U.S. Embassy in Beiping, who organized an intricate scheme to eliminate the top CCP leadership before the fall of the city. By 1950 Barrett had already left China, but he continued to communicate with several collaborators in Beijing, including Antonio Riva, a wealthy Italian trader, and Yamaguchi Ryuichi, a Japanese bookseller. The plot, as pictured, is to kill Mao and his senior associates atop Tiananmen Gate by attacking them with a mortar on October 1, 1950, during the National Day celebration. But the scheme is exposed. Several men are arrested and quickly convicted. Two of them—Riva and Yamaguchi—are eventually executed. "These American spies," as portrayed in the lianhuanhua, "collapse before the Chinese who have now stood up [against Western imperialism]."[64] The wide range of spy stories clearly demonstrates that domestic enemies and foreign foes did not work independently. Instead, they were closely intertwined with one another, forging a conspiratorial scheme and seeking the ultimate destruction of the new government.

In addition to the Guomindang agents and American spies, other types of counterrevolutionaries were the members of quasi-religious societies and priests. The popularity of folk millenarian religions had long invited suspicion from the Communists. The Party believed that these sects not only encouraged superstition but also hindered political mobilization among rural inhabitants. The attack against religious sects was leveled especially against the influential Unity Sect, a sect popular in North China. A 1951 report issued by the Beijing Municipal Party claimed that 15 percent of the peasant population in the rural vicinity of Beijing were members of the sect. It was "running rampant," according to the report.[65] That the Unity Sect had an early history of collaboration with the Guomindang against the Communists made it a logical target of the new government. In 1949 Mao angrily reminded people of the link between the Unity Sect and the Guomindang, and called on his followers to eliminate all

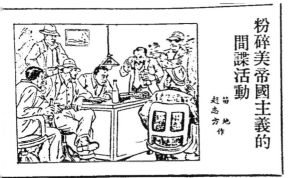

Figure 41. Miao Di and Zhao Zhifang, *Smashing the Espionage of American Imperialism.* American spies in China attempt to carry out their goal of killing the highest-level Communist leaders atop Tiananmen Gate by firing a mortar at them during National Day celebrations. *Source:* RMRB, September 4, 1951, 3.

Figure 42. Fang Cheng, *The High Priest. Source*: RMRB, August 4, 1955, 2.

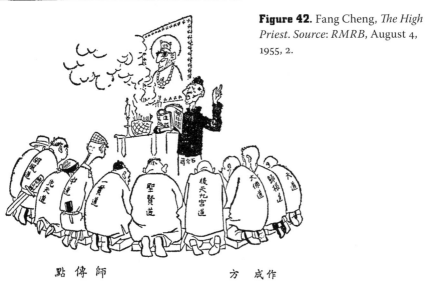

these "reactionary forces."[66] Official campaigns to eradicate the Unity Sect and other religious sects, such as the Xiantiandao (Way of Former Heaven), were thus launched in earnest in the early 1950s, particularly in the Beijing and Tianjin areas, and these campaigns included visual assaults. Tian Zuoliang was noted for devoting a number of his works to this theme. His *The Class of the Immortals* is an eleven-frame lianhuanhua said to be based on a true story about the secret life of Zhang Falun, a leader of the Unity Sect. Zhang, an unmarried landlord, was known to have sexually abused his female followers, cheated people out of money, and beaten poor peasants to death. The lianhuanhua shows that when the news of the Communist victory reaches the village, Zhang panics; he plans a quick escape, but he is arrested by local police and put on trial. During the trial he is revealed to have disseminated anti-Communist pamphlets, and is finally "punished according to law."[67]

Fang Cheng's *The High Priest* (figure 42) places the Unity Sect and other religious sects in a larger conspiratorial scheme. Pictured in the cartoon is an assemblage of different sects—the Unity Sect, the Way of Former Heaven, and

Shengxiandao (Sage Way)—all kneeling before the high priest Chiang Kai-shek. In a portrait on the wall, a deity wears sunglasses and a U.S. hat, a pointed implication that the various sects are undeniably tied to imperialists abroad.

Western churches were, of course, included in the assaults against religion. Clergies were also labeled as part of America's design to dominate China. In one cartoon a priest secretly passes intelligence to the U.S. agent outside the church.[68] Christian faithful were attacked as close allies of the Guomindang and surrogates for U.S. interests in China.[69]

Class Enemies: Capitalists and Landlords

Capitalists occupied a special place in Chinese Communist demonology. Like Bolshevik propaganda art, Chinese visual images identified capitalists as the most deplorable of enemies, faithfully reflecting the official Marxist-Leninist line. Historically, the pictorial assault against the capitalists, mostly in the form of cartoons, appeared long before the founding of the PRC,[70] although the attacks were modest compared to those against American imperialists and Chiang Kai-shek.

By 1949 the negative image of greedy traders and crafty speculators was firmly established. The capitalists were viewed as symbols of the depravity of the West. After launching the Three Antis Campaign in the fall of 1951, which was directed against corruption, waste, and bureaucracy, the Party immediately followed with the Five Antis Campaign in January 1952 to "cure" the bourgeoisie of their five vices: bribery, tax evasion, theft of state assets, cheating on government contracts, and stealing state economic secrets. Once again, Chinese political art reflected the battle against the businessmen and bankers.

Whereas Bolshevik visual propaganda occasionally represented capitalists as a female monster (as in Aleksandr Apsit's poster *International*), Chinese political art seemed always to picture the capitalists as selfish, egoistic corpulent males, often dressed in long gowns. *Five Steps of Bribery*, a 1952 lianhuanhua, tells the story of a merchant who bribes a government official by wining and dining him. At the end, the official gratefully asks, "Comrade, do you need help?"[71] Zhang Wenyuan's *Bribery* touches on a similar subject, a story of a businessman showering government officers with money and pricey cigarettes.[72] In *Who Is Murdering Our Beloved People?* (figure 43) capitalists are portrayed as war profiteers, sending spoiled food to the front. "They are secretly murdering our most beloved people," the story declares, a reference to the Chinese People's Volunteer Army at the front during the Korean War.

Another key class of villain was the landlord. Like the Soviet kulaks who became one of the three most hated symbols in Bolshevik visual demonology dating back to the early days of Soviet rule (the other two were tsars and priests),[73] Chinese landlords came under visual attack in the early 1950s. The CCP certainly realized that the stability of rural areas was vital to its regime, so a

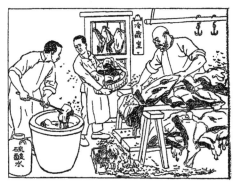

（四）他們喪盡天良，把發綠的臭牛肉先用刀把一層髒臭的綠色刮去，放在硫酸水裡浸過，擱在冷藏庫裡冰過以後，就夾在好肉中賣去。

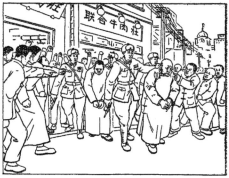

（八）人民是決不容許這種傷天害理的野獸在人類社會裡橫行的。反盜竊運動展開後，在職工們的檢舉下，上海人民政府已將張、徐兩汜逮捕起來了，全國人民都一致要求嚴厲懲辦這兩個祖國的叛徒。

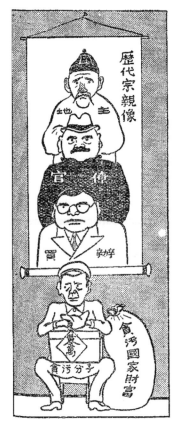

貪污世家　　　華君武作

(left) **Figure 43.** Zhongyang meishu xueyuan (Central Academy of Fine Arts), *Who Is Secretly Murdering Our Beloved People?* Profiteers prepare rotten food for Chinese soldiers at the front during the Korean War by mixing foul beef with good meat, but they are eventually caught by Communist security forces. *Source: XGC,* no. 5 (March 16, 1952): 18.

(right) **Figure 44.** Hua Junwu, *Pedigree of Corruption. Source: XGC,* no. 2 (January 16, 1952): 24.

sweeping Agrarian Reform Law was implemented in 1950 to cement the Party's support among the peasants. Under the new law, massive land redistribution took place and poor peasants were encouraged to vent grievances against the landlords. Chinese political art reflected this Party-sponsored violence. Many pictures appeared of tenants holding a public forum to recount the past sins of local landlords.[74]

A common method propagandists used was guilt by association, for example, connecting landlords to other villains of similar class backgrounds. Hua Junwu's *Pedigree of Corruption* (figure 44) implies that the modern-day embezzler

descends from a line of dishonest folk: the father is pictured as a comprador; the grandfather, a bureaucrat; and the great grandfather, a landlord. The message is clear: evil runs through successive generations of a corrupt family tree, a tree that must then be uprooted.

Bourgeois Intellectuals

Intellectuals did not cause major concern among senior officials until the resurgence of the thought reform campaigns in 1953–54, which the Party launched to gain support of intellectuals for the First Five-Year Plan announced at the beginning of 1953. Winning over the intellectuals, however, turned out to be difficult. The Party allowed a modicum of freedom in 1953 in order to secure intellectuals' allegiance as well as their participation in industrialization and modernization programs, but the policy backfired. In 1954 Hu Feng, a friend of Lu Xun (1881–1936) and a member of the executive board of the Writers' Union, spoke critically of the Party's policies. Hu criticized the CCP's imposed political indoctrination and demanded that intellectuals be given a greater degree of freedom of expression and publication. The Party, seeing Hu's opposition as a grave challenge to the government, reacted swiftly and harshly. The leadership mounted a nationwide campaign to discredit Hu and quickly turned it into an all-out assault against so-called bourgeois thinking, intending to clamp down on dissension and force intellectuals into submission. Hu was denounced as a counterrevolutionary, and was arrested and incarcerated in May 1955. Many of those accused by the Party of forming a clique with Hu were also jailed. Twenty-three years later, in 1978, the Party rehabilitated Hu and acknowledged it had made a mistake.

Predictably the coordinated nationwide attack against Hu Feng in 1955 was not just verbal but was also apparent in cartoons and lianhuanhua. Beijing's Municipal Party mounted an anti–Hu Feng cartoon show in the city's Working People's Cultural Palace and Beihai Park.[75] Hu Feng, his crimes myriad and vicious, was one of the most notorious intellectual demons in China, as illustrated in the relentless art crusades against him during the mid-1950s, in which he was drawn as a true bourgeois liberal with heinous intentions against the CCP and as an agent of the Guomindang regime in Taiwan. He was denounced not simply as an individual but as the ringleader of a well-organized "counterrevolutionary clique."[76] Ye Qianyu's cartoon *Fake Surrender* and Hua Junwu's *Pickpocket* depict Hu Feng as having lied about his ignoble history of liberalism when, in truth, he had been a Guomindang spy all along.[77]

Ying Tao's (b. 1925) *Counterrevolutionary Special Detachment* demonstrates Hu's wider dreadful scheme against the government (figure 45). In this cartoon Hu Feng is drawn as the leader of an underground counterrevolutionary organization. A portrait of Chiang Kai-shek hangs on the wall with an inscription ordering a counteroffensive against the mainland and predicting victory

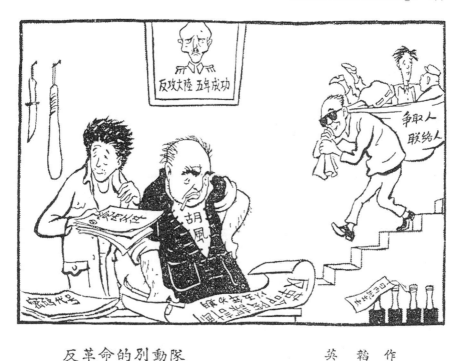

Figure 45. Ying Tao, *Counterrevolutionary Special Detachment. Source*: *RMRB*, June 8, 1955, 3.

in five years. As Hu studies the subversive plan, an associate hands him stolen classified CCP information and another cajoles people to join their endeavor. Fang Cheng and Zhong Ling's *Memorial Service across the Strait* illustrates how Chiang Kai-shek in Taiwan is deeply grieved by the uncovering of Hu's clique and Hu's eventual incarceration.[78] This alleged connection between Hu Feng and the Guomindang was a key motif in Communist propaganda art used in defaming intellectuals.

Hu Feng, as a reactionary, was linked to still another evil notion about the West, namely, liberalism. Hua Junwu's *Masquerade Party* depicts a masked tiger wearing a fur coat with the inscription "The Hu Feng Counterrevolutionary Clique" and dancing intimately with a man wearing a hat bearing the label "liberalism."[79] Liberalism was commonly associated with Western decadence but also more broadly with an objectionable political attitude. In Mao Zedong's 1937 essay, "Combat Liberalism," he states, "Liberalism stems from petty-bourgeois selfishness, it places personal interests first and the interests of the revolution second."[80] By linking Hu Feng with this hated Western value, the propagandists were sending a stern warning to writers and scholars who still harbored Western ideals, liberalism in particular.

Native Colors

It is true that in political propaganda, Soviet art exercised a strong impact on China. The Kukryniksy, for instance, could count on Fang Cheng as their faithful follower. And as far as motifs are concerned, the image of a greedy Chinese landlord bore a close resemblance to the kulak in the Bolshevik graphic lexicon. Likewise, a corpulent Chinese capitalist had much in common with the Soviet portrayals of *burzhui*—a pejorative rendering of the Russian word for bourgeoisie (*burzhuaziia*). But to say that Chinese art fell under the strong sway of the Soviet Union does not mean that it lacked its own distinct characteristics. One sees both obvious and subtle distinctions between the two countries in visual propaganda. In religious matters, for example, both countries attacked religion in their art. As in Soviet political art, which identified *pop* (priest) as a key devilish figure in Bolshevik demonology,[81] Chinese visual representations similarly denounced religious groups such as the Unity Sect and Christianity as a pernicious force in society. Yet there is a key difference between the two; in the Soviet case, the Russian Orthodox Church and religious icons continued to exercise a strong impact on the art, which was particularly evident in the Russian artists' extensive use of the color red, a holy hue in traditional icons associated with figures worthy of reverence. In contrast, Chinese propaganda art was usually devoid of any religious connotations.

Both countries, in producing their art, drew on a rich repertoire of traditional designs. Soviet poster artists such as Aleksei Radakov proposed to use the simple narrative style of traditional prints (*lubki*; sing. *lubok*) to convey desired socialist messages, intended especially for the peasants.[82] But not everyone welcomed this idea, and in the 1930s the *lubok* style came under attack. Dmitrii Moor, the famed Soviet graphic artist, for instance, saw it as detrimental to the development of a proletarian style of political art and called for artists to abandon the style.[83] In contrast, although Chinese propaganda artists earlier in the Yan'an years had called for the elimination of religious elements in folk forms,[84] they embraced native folk styles with enthusiasm, viewing them as an embodiment of folk wisdom and a manifestation of national pride.

Among key artists, Hua Junwu was uncomfortable with foreign models. Like many others, he sought inspiration from China's native traditions, especially folk art, calling for both nationalization and popularization of art.[85] Hua became a seasoned practitioner of the craft. His titles were often vivid and pointed, especially with his use of proverbs and *xiehouyu*, allegorical sayings with obvious hidden messages that people understood instantly. "After Japan's surrender, in 1945," Hua recalled years later, "I drew many cartoons incorporating proverbs, such as '*Huangshulang gei ji bainian—buan haoxin*' [The weasel goes to pay his respects to the hen, clearly without the best of intentions]."[86] A fellow cartoonist, Liao Bingxiong (1915–2006) from Guangdong, not only joined Hua in championing the use of folk sayings, but he also adopted an ingenious approach of weaving local Cantonese dialect into his works.[87]

Chinese propagandists also tapped folk tales to evoke familiar images. A notable example is Liu Jiyou's *Master Dongguo* in the lianhuanhua format printed in 1951. That they made use of native art forms was also evident in their drawing techniques. Chinese artists were never quite at ease using "balloons" for dialogue, a device commonly employed in foreign cartoons. Instead, they preferred to express their views in captions, a more traditional technique that was also more familiar to the Chinese. Although the mode of pen-and-ink drawings was adopted from the West and from the Soviet Union, as Fang Cheng acknowledged, many artists, including Fang, returned to painting with brushes on traditional *xuanzhi* papers to produce their works.[88] In fact, Liu Jiyou frowned upon the pen-and-ink technique; he achieved fame by perfecting line drawing, the traditional style of painting.[89]

The portrayal and demonization of enemies in Chinese propaganda art, especially in cartoons and lianhuanhua, clearly demonstrate that political images are an integral source of historical evidence and that their significance must be considered alongside literary texts and oral testimonies. The importance of Chinese art as propaganda is evident in three areas: propaganda art campaigns as a chronicle of the history of the CCP in the 1950s, reflecting the Party's changing policies and ideologies; the use of certain folk art forms by Chinese artists to assert a distinct Chinese identity and hence a departure from foreign models; and the campaigns, like many CCP's policies, as political exercises serving the Party's interests with dictatorial directions coming from the top.

Chinese propaganda art expressed the voice of the nation. Peter Burke argues that nationalism can be expressed relatively easily through images of folk art, as shown in the "home style" (*Heimatstil*) of early twentieth-century German and Swiss painters.[90] One finds a parallel in the Chinese case. Although Soviet art came to be viewed as a model to be emulated by Chinese artists after the founding of the PRC, it was never embraced unreservedly by the Chinese. Hua Junwu, for one, called for the sinification of foreign art along the Maoist line.[91] Even Lu Dingyi, the head of the Propaganda Department, said "it is important to learn from the Soviet Union but we cannot copy indiscriminately from them."[92] Chinese artists, in their search for a style reflecting their own characteristics, borrowed from their native folk traditions. That approach fell comfortably in place with the correct Maoist "mass line." It encouraged propagandists to speak the language of the commoners, making their works more comprehensible to viewers. But perhaps more important, it was essentially a nationalistic pronouncement by artists affirming their own identity.

As already indicated, in the early 1950s lianhuanhua were generally well received by the public. Less clear, however, is whether these art forms helped to shape public perceptions of contemporary events. This is a challenging question in the study of art and cultural history, for despite many theories on the reception and diffusion of art, Pierre Bourdieu's among them,[93] we have little

evidence of how an audience actually receives and interprets these represen-
tations. Images, of course, are often interpreted differently by people of differ-
ent backgrounds. For example, pictorial representations of General MacArthur
were surely not targeted at rural audiences. Indeed, Hua Junwu admitted that
many political cartoons "were incomprehensible to the peasants."[94] Cartoons
depicting current events were also directed more toward urban than rural read-
ers. The cartoonist Fang Cheng revealed, in an interview, that political cartoons
in the 1950s were a common feature of political campaigns. "These cartoons
were enlarged and posted on walls at public meetings during the Resist Amer-
ica, Aid Korea Campaign," he recalled.[95] But if cartoons of news events were
created more for urban consumption, then lianhuanhua such as *Aunt Yao Ap-
prehends the Spy*, with peasant women as protagonists, were intended to reach
a broader audience, appealing both to peasants and urbanites alike. In the 1950s
lianhuanhua enjoyed a publication boom. As noted, more than 900 lianhuan-
hua titles were printed in 1954, with a total print run of 35.8 million, and by
1958 close to 3,000 titles were printed, increasing the print run to as high as 122
million[96]—figures that would surely have delighted Party propaganda officials.
And in the early 1960s a national book award was established to honor the best
serial picture books, thus elevating the status of this art form.[97]

The demonization of enemies in Chinese propaganda art ultimately must
be viewed in the context of the Party's total control of art. Boris Groys con-
tends that "for the totalitarian state, all of society represents a single vast, uni-
fied, homogeneous field of operation."[98] Groys argues with reference to the So-
viet Union, but his point applies equally to China, where, as in the Soviet Union,
art and literature were crafted to conform to an authoritarian vision. Art, as
described in the *People's Daily*, must be utilized "to coordinate closely with the
campaign to eliminate all counterrevolutionaries."[99] In the early 1950s the CCP's
two key propaganda arms, the Propaganda Department and the Ministry of Cul-
ture, monitored and directed the official artistic line to ensure that Party policies
were closely followed. Artists had to stay in line. Cartoonist Ye Qianyu recalls in
his memoirs that, in the 1950s, when official policies dictated that past villains
such as "Huizhong of the Song must be labeled as a [feudal] emperor, and Dong
Qichang [of the Ming] a big landlord," no one dared deviate from these rules, for
doing so would have dire consequences.[100] In a recent interview Fang Cheng was
candid about his role: "We were 'hack writers for the government'; I worked for
the *People's Daily* then, and my job was to serve that newspaper."[101] In the end,
political agendas outweighed other considerations, including artistic ones.

The Party's tight control of art was detrimental to artistic creativity, as art-
ists had to operate within prescribed boundaries. Moreover, limitations on ap-
proved topics meant that tired subjects like the United States as an evil force and
Chiang Kai-shek as a "running dog" were endlessly repackaged and recycled. As
a result, visual representations were "simplistic and formulaic, and many works
appear to be a cliché," one art critic admitted.[102]

The demonization of enemies could exert a terrible human toll. In 1978 the disgraced writer Hu Feng was rehabilitated, and the Party finally admitted that he had been mistakenly accused. But what were the reactions of those who had engaged in frantic denunciation of Hu? Hua Junwu now expressed remorse for incorrectly reproaching Hu Feng during the 1955 campaign against him.[103] Fang Cheng, too, confessed that he had created "bad products to slander good people."[104] Cartoonist Zhong Ling, who once associated with Hu Feng in the 1930s, admitted ruefully in an interview that his criticism of the writer in 1955 was a way to "dissociate himself from Hu." "That period of the anti–Hu Feng campaign was an extremely perilous time," he said. "If you were labeled a member of the Hu Feng clique, you were finished and your entire family was doomed."[105] The case of Hu Feng clearly reveals not only the Party's tight control over the outpouring of devilish images in attacking its enemies but also, and more important, the deadly outcome that accrues when a political party manipulates art as a propaganda tool to advance its own interests, despite the dire consequences.

8. New Year Prints and Peasant Resistance

On November 26, 1949, less than two months after the founding of the People's Republic, the Ministry of Culture issued a directive to artists and writers about the importance and possible use in a new era of nianhua (New Year prints), a simple and inexpensive Chinese folk medium used to decorate homes in celebration of the New Year:

> Nianhua are one of the most popular types of Chinese folk art. Under the feudal rule in the past, it was employed as a vehicle to spread archaic ideas. After Chairman Mao delivered his "Talks at the Yan'an Forum on Literature and Art" in 1942, in which he called on writers and artists to use old artistic forms to promote popularization of literature and art, artists in various old liberated areas began to use reformed nianhua with considerable success to disseminate the idea of people's democracy. New nianhua prints have proven to be a beloved art medium, rich in educational value. With Chinese Lunar New Year fast approaching—the first since the founding of the PRC—local cultural and educational organizations should look on the development and spread of nianhua as one of their most essential tasks during this New Year's propaganda activities. The new prints should convey the following messages: the grand victory of the Chinese people's war for liberation and the people's great revolution, the establishment of the People's Republic, the Common Program, and the recovery and progress of industrial and agricultural production. . . . To launch a widespread nianhua movement, regional cultural and educational agencies, and art organizations, should mobilize artists to produce new prints, letting them know that this is an important artistic undertaking with wide impact.[1]

The directive was significant in a number of ways. It was one of the earliest documents on cultural policy issued by the newly established government, an indication of its importance and urgency. Delivered in the name of the Ministry of Culture and in unmistakable language, it instructed local governmental agencies to spread specific official messages through a popular print medium. How successful was the nianhua campaign? This chapter examines the Communists'

use of this third popular form of visual propaganda to mobilize the masses for nationalistic and socialist causes.

A study of nianhua in post-1949 China raises two sets of broader issues: the production and dissemination of a cultural artifact by the state and its reception by the masses. The Chinese populace was thought by the elite to consist of passive receivers who submissively accepted the state's political teachings. Contrary to this familiar image, this chapter will show that they were a majority who, through active consumption, picked and chose from the official menu, and often mounted a vocal resistance that thwarted the government's conversion effort.

A Distinct Cultural Artifact

It came as no surprise that the Communists viewed the nianhua prints as an ideal propaganda tool, for the prints contained the key cultural and political ingredients that they needed at a critical time in the nation-building effort. The prints were made with woodblocks, a folk art rooted in antiquity. Usually simple in design, brightly colored, inexpensive (only a few cents each), and extremely popular, they provided an ideologically correct framework through which Mao could instruct his cadres and writers to study and eventually embrace the medium as a means for bridging the gap between intellectuals and the masses. Perhaps most important, they were among the most effective means for arousing powerful nationalistic feelings in the populace.

Indeed, nianhua have a long history in China. Although their origins remain unclear, the practice of pasting images of deities on the doors of homes on New Year's Eve was known as early as the Eastern Han dynasty in the second century B.C.[2] The Ming and Qing dynasties saw the emergence of several major nianhua-producing centers in the country—Yangliuqing near Tianjin in Hebei province, Yangjiabu in Shandong, Taohuawu in the city of Suzhou in Jiangsu, and Mianzhu, north of Chengdu, in Sichuan—all enjoyed nationwide reputations, although each center had its own distinct local characteristics.[3]

Many nianhua prints were designed by illiterate peasant artists and printed in village homes (especially in Yangjiabu).[4] They were popular in all walks of life, but more so among villagers than urbanites. Their popularity stemmed not only from their bold, sometimes outrageous designs and dazzling colors (representing an optimistic view of life) but also from their ability to reflect the life of the common people. Although the exact meanings embedded in the folk prints are not always obvious, the recurrent motifs of benevolent deities, a bumper harvest, and rosy-cheeked children reveal a rural population, who, despite their precarious existence, work the land, marry, and give birth according to venerable custom, and continue to hope for a better life in the future. The themes in the prints can be roughly divided into several categories: protective deities who

bring good fortune and drive away malicious spirits (door deities and the Stove God); the everyday lives of the peasants (Yangjiabu's *Ten Labors of Men*); deities and spirits connected with the agrarian world (*The Ox King*); propitious emblems (Yangliuqing's *Bearing Many Sons*); popular historical personages (heroes from such famous novels as *The Romance of the Three Kingdoms*); flowers and birds; and current events. Thousands of prints were sold each year. In Yangjiabu alone, for example, based on more than four hundred different types of prints, the annual sales figure exceeded ten million copies in the early 1950s.[5]

Indeed, the popularity of the nianhua prints had caught the attention of Communist propagandists even before they came to power. Earlier in the Yan'an days, Communist artists had already successfully used nianhua to inspire nationalism and socialism. That this propaganda tool was a people's art both delighted and comforted the Communists, for art, according to Mao Zedong in his 1942 "Yan'an Talks," should serve the masses and depict the heroic deeds of workers and peasants. Cadres and intellectuals must learn from the people, Mao instructed, for the masses are the fountainhead of correct policies. Thus New Year prints were a perfect medium to bring artists and the masses together to build a new socialist regime. Nianhua as an art form, of course, did not in itself prove useful for the Communists as an ideological tool. The propagandists carefully filled the prints with nationalistic designs by portraying the Communists as the sole supporters of China's sovereignty, on the one hand, and the valorous resisters against foreign aggression (especially the Japanese invasion), on the other. They also illustrated a life of joy and cooperation under Communist rule, juxtaposing it with portrayals of dreadful misery and chaos under the Nationalists.[6] In brief, the CCP was promoted as China's only hope to reunify a dividing nation and to save it from foreign aggression, thereby restoring its lost glory. Unlike Marx, Mao's primary political instincts were nationalistic. He understood that nationalistic feelings could be fostered by invoking the nation's pride as well as by appealing to the public's outcry against imperialist incursions. New Year prints were a handy tool to achieve these goals. By endorsing this unique Chinese art, the Communists not only championed a cultural heritage and showed their due respect for folk art, they also used it to advance their ideological agenda.

Production and Dissemination

In one sense the new nianhua campaign initiated by the Ministry of Culture in November 1949 was a continuation of the Yan'an practice; it also differed in a number of ways. Technically, the new prints, which differed from traditional peasant woodblock nianhua, were painted by artists and then produced by an offset machine to allow for greater flexibility in production and more freedom in design and color variation. Politically, the campaign would now be conducted systematically and supervised by the government; it would be mounted nationwide; and, most important, it now had a sense of legitimacy.

Indeed, the nianhua reform was one of the largest art campaigns ever mounted by the CCP to create a shared ideological universe. It was a crusade conducted from the top down, and proceeded simultaneously on several fronts: through extensive publicity in official publications; the open support of celebrated artists; exhibitions; conferences; a search for and reforming of traditional folk artists; and award presentations in open competitions for the best new print designers. From the outset the *People's Daily*, the official Party newspaper, gave the new nianhua prints extensive coverage, parading the latest products and reminding its readers of their immense value. Coverage became even more noticeable with the approach of the Chinese Lunar New Year.[7] Major art journals also printed nianhua, often devoting entire issues to them.[8] Enthusiastic support came from many corners, especially art circles. Cheng Yanqiu (1904–58), a renowned actor in the Beijing opera, traveled to Yangjiabu in 1950 to support the drive.[9] In line with the Party's policy of "serving the people," the Party reformers sought out folk artists (*minjian yiren*). They praised the folk artists' plebeian roots and then attempted to reeducate them, turning them into advocates of a new society. A certain Yang Wandong, a folk nianhua artist from Yangjiabu, for instance, was lauded for his ardent support of the government's endeavor.[10] Frequent exhibitions were held in both the capital and provinces to showcase the genre.[11] Perhaps the most prestigious recognition came in April 1950 when the Ministry of Culture, in the first national competition, presented awards to twenty-five artists for the best new nianhua prints. Their names and award-winning pieces were proudly announced in the national media.[12] Such competitions continued in subsequent years.[13] The nianhua campaign reached a crescendo when Premier Zhou Enlai made a well-publicized visit to Yangliuqing during the Chinese Lunar New Year of 1960, adding his enormous prestige to the cause.[14]

The nianhua reform epitomized the complete but uneasy merger of art and politics in the new regime. Although the reformers found many merits in the traditional nianhua prints, they were not entirely comfortable with the rural art form. Their ambivalence was perhaps understandable. The CCP, a Leninist vanguard party, was inherently condescending toward the lower classes, despite Mao's repeated calls to serve the people. Like the Bolsheviks,[15] the Chinese Communists were apprehensive about mass initiative. Activities at the grassroots had to be kept under the Party's watchful eye or they could get out of control. The Communists also realized early on that uncontrolled art could be politically dangerous to the regime.[16] Finally, Chinese intellectuals and artists held the traditional view that peasants were ignorant and superstitious, living in a world inhabited by strange deities and grotesque spirits. The fact that many of the traditional nianhua prints were religious drawings reinforced this negative impression. Of course, as faithful Marxists, Chinese Communists had long conducted campaigns against various forms of religious activities.[17] This time they were especially appalled by the abundance of what they called "superstitious

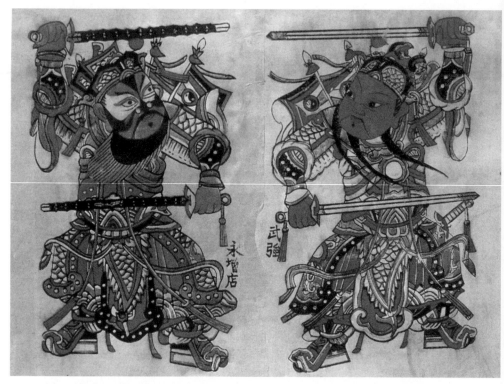

(above) **Figure 46**. *Generals Yuchi Gong and Qin Qiong.* Wuqiang county, Hebei province. 24.5 × 14.5 cm. "Yongzengdian" on the left is the name of the print shop, and "Wuqiang" on the right is the county where the print was produced. *Source*: Wang Shucun, *Paper Joss: Deity Worship through Folk Prints* (Beijing: New World Press, 1992), 134.

(facing top left) **Figure 47**. *The Stove God.* Fengxiang county, Shaanxi province. 27.5 × 19.3 cm. At the top of the print is a 1987 calendar (a reprint of a traditional version). The couplet reads, "The master of the people / The surveillance official [literally, "ear and eye"] of heaven." *Source*: Author's collection.

(facing top right) **Figure 48**. *Zhong Kui* (Qing dynasty). Wuqiang county, Hebei province. 73 × 52 cm. The bat in the upper right corner is an auspicious symbol. (The Chinese character for "bat" is homophonous with another character meaning "blessings.") The square is a Daoist emblem of exorcism. *Source*: Bo Songnian, *Chinese New Year Pictures* (Beijing: Cultural Relics Publishing House, 1995), plate 104.

products" in the New Year prints: the door deities (figure 46); the Stove God (figure 47); Zhong Kui, an exorcist who expels demons (figure 48); and *zhima*—papers printed with images of deities, such as *The Ox King* (*Niuwang*) (figure 49) that were burned at the end of the ritual. These religious prints, charged the art critic Wang Zhaowen, were nothing more than the reflections of people's "feudal thoughts."[18] "They were poisonous old-style prints," another artist echoed,

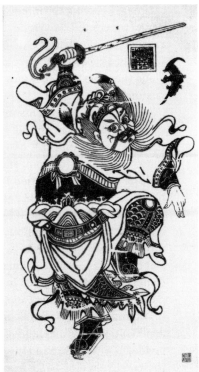

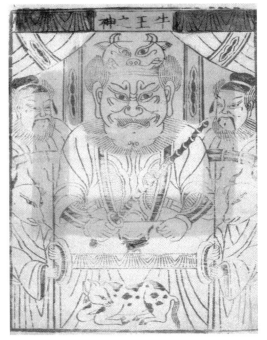

Figure 49. *The Ox King.* Beijing. 31 × 25 cm. With a fierce expression, the Ox King is shown wearing an ox headgear. Date unknown. *Source:* Wang Shucun, *Paper Joss,* 21.

"primarily serving the interests of the landlord class." A novel type of New Year print (*xin nianhua*) must be created to replace the old style, he suggested.[19] The reform was clearly more than an artistic exercise: it was a socialist campaign intended to weed out what the Communists considered the peasants' pernicious thoughts. Hence it was an assault against their behavior as well as their customs.

True, alarm had been sounded over the nianhua prints' "feudal elements" earlier in the Yan'an period, but no concerted effort had yet been mounted to deal with the problem.[20] Now the same issue had resurfaced, but with a new sense of urgency. In a joint statement issued in October 1951 by the Ministry of Culture and the Publication Bureau, the government ordered that "publication of any New Year prints that are reactionary and harmful be stopped," referring in particular to the religious prints. They warned, however, that the undertaking had to be carried out cautiously so as not to provoke public resentment or open protest.[21] Similar prudence was reiterated in the statements issued by provincial cultural bureaus.[22] A flurry of reform activities soon took place in nianhua centers in the early 1950s.[23] In the early 1950s, for example, a reform team, composed of a dozen printers and art students, was sent to Yangjiabu by the Ministry of Culture of East China and the Bureau of Culture of Shandong province to conduct on-site visits, hold conferences, and suggest changes.[24] The reformers divided traditional Shandong prints into four categories: "acceptable and can be preserved"; "requiring changes"; "reactionary"; and "superstitious."[25] Religious prints, which were assigned to the last category (especially images of the Stove God and door deities), were the first to be criticized.

Traditionally, the Stove God (Zaojun) was one of the most widely worshiped deities in the Chinese folk pantheon. Not surprisingly, he appeared as a central figure in the New Year prints. Although ranked relatively low in the celestial hierarchy, the Stove God was considered extremely important because of his close link to people's everyday lives. Woodblock images of the Stove God—usually accompanied by his wife (or flanked by two wives)—are placed above the kitchen stove. At the top of such prints was included a lunar calendar, which was vital in giving peasants a sense of time and the rhythm of agricultural production. It is believed that the Stove God is responsible for protecting the home and bringing fortune to family members; hence he is also known as "the master of the household." According to custom, on the evening of the twenty-third day of the twelfth lunar month, the god's image is burned and he returns to heaven to report to the Jade Emperor about the family he watched over in the past year. He returns to earth seven days later on New Year's Eve. The family then puts up a new print to mark the beginning of another annual cycle.[26] To ensure that the god makes as many good comments as possible (and preferably no bad ones) about the family in front of the supreme deity, sugared melons or other sweets are offered to "sweeten" his mouth. Thus the Stove God plays a double role: as both protector of the family and trusted servant of the Celestial Emperor,

he forms a critical link between heaven and earth. The annual dispatch of the Stove God to heaven, observed Arthur Smith, a Protestant missionary in late nineteenth-century China, was one of the most important ceremonies of the "New Year worship."[27]

The government saw the Stove God print as a problem precisely because of its popularity and perceived influence. The print was gradually banned from circulation. Reformers devised two new designs to replace the old ones: a *Martyr Memorial Pagoda* (*Lieshi jinianta*) and a novel agricultural calendar (*Nonglitu*).[28] Both prints had been purged of religious connotations; they now told the story of socialism, as carefully scripted by the state. The piece *Be Diligent and Frugal in Managing Your Home* (*Qinjian chijia*), a new agricultural calendar, is one telling example (figure 50).[29] Appearing in the 1950s, the scene portrays a family celebrating the New Year. It is a bumper year, with abundant food and ample supplies; the house is filled with cheerful family members who have

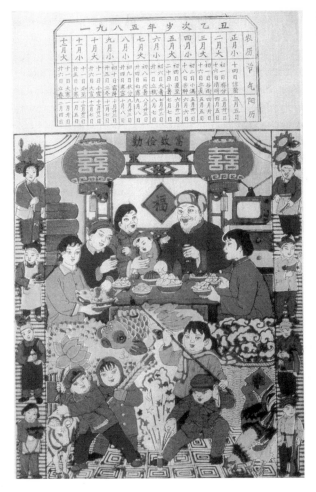

Figure 50. *Be Diligent and Frugal in Managing Your Home.* Yangjiabu, Shandong province. 53 × 37 cm. The calendar is for 1985, a reprint of a version issued in the 1950s. *Source*: *Yangjiabu nianhua* (Yangjiabu's New Year prints), ed. Shandongsheng Weifangshi bowuguan and Yangjiabu muban nianhua yanjiusuo (Beijing: Wenwu chubanshe, 1990), plate 134.

gathered together to enjoy a nice meal. In front of the table another scene bursts with excitement and activity: children are symbolically enacting the activities of farming, forestry, animal husbandry, and fishing, all yielding bountiful results. The print's setting and atmosphere are familiar: a time-honored lunar calendar coupled with a joyful scene vibrating with rich hues and life; but its meaning is distinctly different. Flanking the family is a group of supporters and protectors: devoted cadres, selfless soldiers, and other good-hearted souls. The occasion is definitely not a remembrance of the past, but a paean to the present. The Stove God is nowhere to be seen; instead, common people are charting their own future. What makes this delightful scene possible, the print tells us, is not just the hard work and unflagging energy of the masses, but, more important, the favorable environment that has been brought about by the new government.

The door deities (Menshen), another staple of nianhua, met a similar fate to that of the Stove God. In several print-producing areas (for example, in Zhuxianzhen, Henan province) door deities topped the list in sales.[30] Posted on front gates and inner doors, the door gods' images were believed to ward off evil spirits. Shen Shu and Yu Lu were the initial guardians of the gates, mentioned as early as the second century A.D.[31] Later, two equally famous generals—Qin Qiong and Yuchi Gong (see figure 46) of the Tang dynasty—were added to the illustrious list. Dressed in full armor and holding swords or axes, they are warriors with an imposing presence. The multicolored prints appear in pairs and in symmetry, adopting the face-to-face pose (thus creating a sense of harmony). Although the size of the warriors varies, their images are sometimes life-size in appearance. Their majestic and fear-inspiring presence guards the main entrance to the house, therefore assuming a most important task of protecting the home against malign forces. Besides their widely accepted magical power, the popularity of door god prints also stemmed from their dramatic patterns: vivid colors, bold contours, exaggerated features, and rich narratives, as in the print of Generals Qin Qiong and Yuchi Gong, which tells the story of how these two warriors of the Tang guarded the palace gates, protecting Emperor Taizhong from evil forces. Other types of door god prints illustrated the deities either as a pair or as lone figure. While Qin Qiong and Yuchi Gong guarded the front gates, prints of other door deities—such as paired civil officials and the solitary Zhong Kui—were pasted on the interior doors of the home.[32] Zhong Kui, the exorcist who captures and devours demons, was especially admired, for he was believed to bring forth happiness and good fortune.

Similar to the Stove God prints, the door god prints underwent dramatic changes at the hands of the reformers in the 1950s. A new series of socialist designs and themes began to appear, closely following the ideological rules dictated by the state. Luo Cheng's 1955 piece, *Defend Our Motherland! Protect Peace! (Baowei zuguo! hanwei heping!)* speaks a new political language through the conventional framework (figure 51). The print represents a pair of well-decorated PLA soldiers (one navy, one army) standing tall at the center and

Figure 51. Luo Cheng, *Defend Our Motherland! Protect Peace!* (1955).
Place of printing and size unknown. *Source: Nianhua xuanbian,
1949–1959* (Selected New Year prints, 1949–1959), ed. Renmin meishu
chubanshe (Beijing: Renmin meishu chubanshe, 1961), plate 34.

looking straight ahead, each holding a happy child in his arms. With toy war-
ships and fighter planes surrounding the figures, the image connotes military
strength and vigilance, a nation guarded against invaders. Yet another child
holds a dove about to take flight, conveying a different message: China is also a
peace-loving country. The soldiers are surrounded by five children representing
five major ethnic groups (Han, Manchu, Mongolian, Hui, and Tibetan). They are
now living in a land of abundance as well as ethnic harmony. Similar to the old
door gods, the soldiers are in a pair, tall and Herculean; like the old deities, they
exude an air of confidence and dignity. But instead of assuming the traditional
face-to-face pose, they now gaze right at us, conveying an added sense of deter-
mination; instead of depicting children holding traditional emblems of peonies
and lotuses, respectively symbolizing wealth and noble sons born in succession,
these new children are shown with symbols of military might (battleships) and
peace (doves, lambs); instead of the soldiers being surrounded only by boys, girls
are now included as well, reflecting the new government policy of sexual equal-
ity (as proclaimed in the new 1950 Marriage Law); and, finally, instead of pic-
turing only Han children, the five youngsters are from different major ethnic

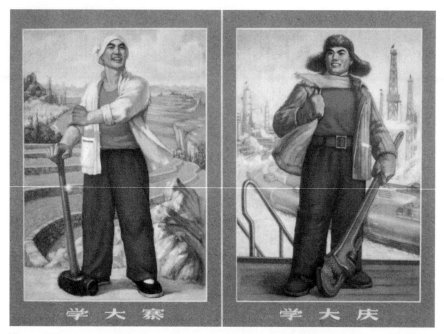

Figure 52. Yu Xing, *Learn from Daqing! Learn from Dazhai!* (1967). Place of printing and size unknown. *Source*: Minisize sale sample; author's collection.

groups, representing a country of great ethnic harmony. The new print's realistic portrayal was no doubt intended to strike a more authentic resonance among the audience. Ironically, however, the playfulness and imagination of the old prints has vanished, making the new images appear forced, uninspired.

Besides soldiers, common people also took the place of the discredited deities. Workers and peasants—the other two proclaimed pillars of the proletarian state—began to figure prominently and abundantly in the new prints produced in the 1950s.[33] They also assumed the role of door guards. A print of the later period in the 1970s—*Learn from Daqing! Learn from Dazhai!* (*Xue Daqing! Xue Dazhai!*; figure 52)—is a celebrated example. Again in frontal pose and standing upright, a worker and a peasant join the chorus in celebrating the Communist regime's achievements. Their backgrounds, respectively, are an oil industrial complex in full production and lush, sprawling fields. The picture is based on a real life story: the worker, modeled on Wang Jinxi (1923–70), leader of the Daqing oilfields in Heilongjiang, and the peasant, based on Chen Yonggui (1914–86), head of the Dazhai model commune in Shanxi province, were the Communists' models of ordinary people, who, with little help from the government but through hard work and determination, could turn forbidding production conditions and impoverished fields into a success story.[34] This was another

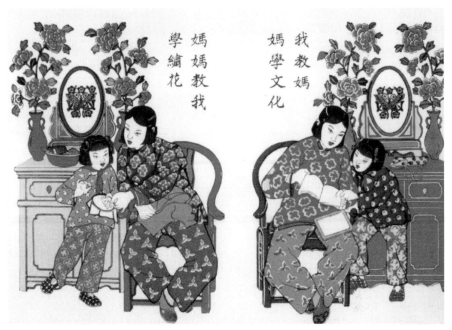

Figure 53. Ye Zhenxing, *Mother Teaches Me How to Do Embroidery; I Teach Mother How to Read* (1956). Shandong province. Size unknown. *Source*: *Nianhua xuanbian, 1949–1959*, plate 41. This 1956 version is a reprint of the original 1954 piece.

shining case of the Maoist virtue of self-reliance, local initiative, and devotion to a collective goal.

Not all new door prints, of course, were about soldiers and workers. Another type conveyed no overt official message, yet was perhaps even more effective in propagating socialist ideas precisely because of its nonpolitical nature. In 1954 Ye Zhenxing, a member of the nianhua reform team in Shandong, came out with a pair of inner door prints known as *Mother Teaches Me How to Do Embroidery; I Teach Mother How to Read* (*Mama jiao wo xue xiuhua; wo jiao mama xue wenhua*). The prints drew instant attention (figure 53).[35] In customary bright colors (especially red), the print tells a simple story: one scene depicts a mother teaching her daughter, a Young Communist Pioneer, the traditional craft of embroidering; the other scene portrays the daughter, in return, teaching her mother how to read and write. On the surface, the relationship between mother and daughter is not unusual, but the portrayal of their bond is fresh. The mother-daughter tie is no longer based on the archaic hierarchy of domination; rather, it is based on a new spirit of mutual help and care, each benefiting the other in a different way. The mother, who is illiterate, is now a student under her daughter's tutelage in a new society. Having been denied education in the old days, she now has a chance to learn, and the promise of a bright future,

and she has taken up the opportunity with glee. At the same time she is passing on a venerable skill to her daughter, signaling the continuation of a traditional craft. The image of a daughter learning embroidery is not exactly a sign of sexual equality,[36] but it seems that the artist's intention is to present the importance of parental love and family bonds, both of which are enriched by new meaning: the significance of learning both the traditional and the new. The power of this new print lies not in its didactic message but in its calm reflection. Here is a cheerful family enlivened by a personal touch; it speaks a political language without appearing forced or contrived. The picture suggests that such a scene would not be possible without the wise leadership of the CCP.

The Stove God and the door deities were not the only two religious motifs that underwent forced transformation; the condemned list included God of Wealth (Caishen), Zhong Kui, *zhima* such as the Ox King, and others. They were, as one Communist supporter put it, "sheer nonsense."[37] In brief, the attack against religious prints was a battle against folk beliefs as well as rural backwardness. The great socialist transformation could be accomplished, many reformers insisted, only when the villages were rid of these sorts of pernicious thoughts and practices.

The Chinese Communists' attack on religious nianhua bore a close resemblance to what had transpired earlier in the Soviet Union, but also differed in a number of ways. The Russians were equally determined to remove rural ignorance and backwardness (Gorky once described Russian peasants as "half-savage, stupid, ponderous people"). The assault on peasants' beliefs began in the early days of the Bolshevik Revolution and culminated in Stalin's policy of forced collectivization during the 1930s. Also in the 1930s, the Komsomol activists and party reformers arrested priests, closed down churches, seized icons (sometimes for mass burnings), and silenced rural elites for holding dissenting views.[38] They also eliminated *lubki* and religious tales, with a clear intention to instill a new revolutionary culture of atheism and socialism in the countryside.[39] Moreover, similar to the Chinese, the Soviets did not completely abandon the old artistic forms. They also recognized the enormous potential of traditional art and folk idioms in the service of the revolution. Indeed, the widespread influence of icons was appropriated by some artists to promote the interests of the state. Dmitrii Moor, for example, used images drawn from icons to pour scorn on religion in antireligious journals such as *Bezbozhnik* (The godless) in the 1920s.[40] But although their political goals were similar, the Chinese nianhua reform was conducted on a bigger scale, was implemented more systematically, and was placed under tighter government control than its Soviet counterpart. No sustained art reform was mounted by the Soviet government on a national basis. The Soviet war against religious prints was largely subsumed under Stalin's general policy of "liquidating kulaks as a class."

To be sure, China's nianhua reform was never confined to an attack on folk religions; indeed, it was intended to reshape the minds of the populace according

to socialist goals. Through the new prints, collective visions were carefully disseminated and enforced. Among these, three themes stood out distinctly: the glory of production, the younger generation's contributions to the cause of socialism, and selfless leaders who cared about the people and guided the nation to a brighter future.

Labor was central to the Maoist vision of a good society, and its importance was emphasized in the reformed prints. This can be seen in the transformation of yet another folk genre. Traditionally a type of nianhua known as the money tree (*yaoqianshu*), which depicts a tree decorated with coins and gold, was among the villages' favorites (figure 54). The print portrays a fantasy of growing wealth and prosperity. A Yangjiabu song reflected the lively imagination envisioned in the print:

> With a money tree at home,
> I am richer than a millionaire.
> Once a day I shake it,
> Coins rain down like a storm.
> Together we harvest them,
> A pile of gold stands taller than my home.[41]

Such an idea did not sit well with the Communists, for it represented, as one critic promptly decried, the harmful and erroneous notion of "reaping without sowing."[42] In 1952 Shi Banghua, a young artist of the Yangjiabu reform team, came out with a new print, *This Is the Real Money Tree* (*Zheshi zhenzheng de yaoqianshu*), to replace the old one (figure 55). Instead of being covered with coins, the new tree is full of apples. The setting is an apple orchard on a collective farm. But the real message lies in the cooperative spirit of the people who work together as a team. The labels on the truck sum up the essence of the picture: "Mutual aid and cooperation form a huge force, and labor and production yield a bumper crop." Only through hard work and communal support, the picture tells us, can we guarantee good results.

The popular image of rosy-cheeked children (pangwawa) had to be repainted too. In the past, images of chubby little boys carried a blessing for the bearing of many sons. It was a genre commonly associated with two symbols, lotuses and pomegranates, both representing fertility because of their many seeds (*zi*, which also means "sons"). *Bearing Many Sons* (*Lian sheng gui zi*), a perennial piece from Yangliuqing dating back to the Qing dynasty, is a good example (figure 56). A child is blowing the *sheng*, a reed woodwind (*sheng* is homophonous with another Chinese word meaning "giving birth"), and is surrounded by lotus seedpods (*lian*, a word also meaning "continuous"), suggesting a large family, with many sons being born in succession. In the early 1950s a new image of children appeared after Zhang Ding became an eager participant in the reform. In his print, *New China's Children* (*Xin Zhongguo de ertong*), which won second prize in the 1950 new nianhua competition, the children are portrayed as

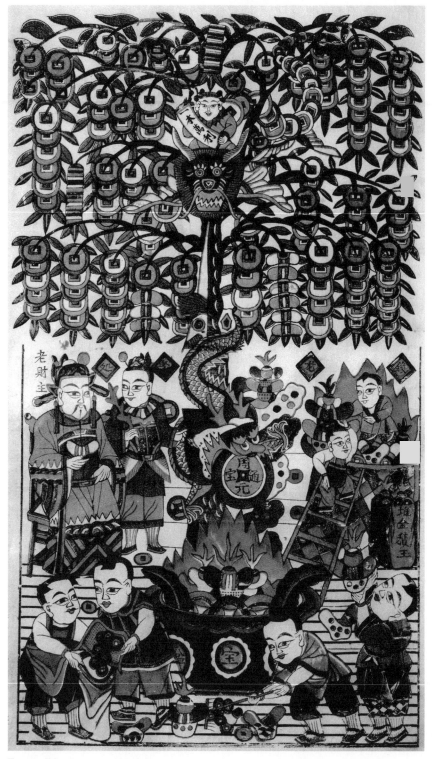

Figure 54. *The Money Tree* (Qing dynasty). Yangjiabu, Shandong province. 68 × 40 cm. The tree is painted like a dragon. A giant bowl is placed under the tree to harvest coins and other treasures. *Source*: Bo Songnian, *Chinese New Year Pictures,* plate 165.

Figure 55. Shi Banghua, *This Is the Real Money Tree*, 1952, Yangjiabu, Shandong province, 72 × 42 cm. *Source: Huadong minjian nianhua* (East China's folk New Year prints), ed. Chen Yanqiao, Chen Qiucao, and Zhu Shiji (Shanghai: Shanghai renmin meishu chubanshe, 1955), 58.

soldiers gallantly fighting U.S. invaders, represented by a single American soldier, and their lackey Chiang Kai-shek, both of whom are defeated and driven off in humiliation (figure 57).[43] The children's former lovable and laughing faces have been replaced with fierce looks as the children bear arms to defend the nation against vicious enemies. The incongruity between the old and new prints could not be more pointed: once innocent and happy children are now armed patriots guarding the nation.

While Soviet activists replaced portraits of Saint Nicholas with posters of

Figure 56. *Bearing Many Sons* (Qing dynasty). Yangliuqing, Tianjin, Hebei province, 34 × 58 cm. *Source*: Bo Songnian, *Chinese New Year Pictures*, plate 45.

Figure 57. Zhang Ding, *New China's Children* (1950). Beijing. Size unknown. *Source*: *Nianhua xuanbian, 1949–1959*, plate 1.

Marx and Lenin on village walls,[44] Chinese reformers substituted images of Mao Zedong and Zhou Enlai for folk deities. Mao and his close associates were praised for their wise leadership and their devotion to improving the lives of the commoners. Gu Yuan's *Chairman Mao Talks to the Peasants* (*Mao zhuxi he nongmin tanhua*; 1951) depicts how deeply the chairman cared for the lives of ordinary people.[45] Perhaps the most famous piece portraying the close relationship between the leaders and the people is Lin Gang's (b. 1925) *Zhao Guilan at the Heroes' Reception* (*Qunyinghui shang de Zhao Guilan*) (figure 58). Winning first prize in the 1951–52 national nianhua competition, Lin's piece was based on the true story of a female chemical worker who repeatedly risked her own life to protect the state-owned factory from disaster.[46] She was received by Mao in 1949 and praised as one of new China's "model workers." In this piece Zhao, whose right hand supports her disabled left hand (in a white glove), is having a friendly chat with the chairman, while premier Zhou Enlai stands nearby, smiling approvingly. Replete with elegant colors and the attendants' vivid facial expressions, this is an impressive propaganda piece. Despite a crowded scene and evidence of lively conversation going on in the hall, nothing in the piece diverts attention away from the principal figure, Zhao Guilan, flanked by the two gratified leaders. The female worker, though small in stature, takes center stage.

Figure 58. Lin Gang, *Zhao Guilan at the Heroes' Reception* (1951). Beijing. Size unknown. *Source: Nianhua xuanbian, 1949–1959*, plate 7.

Other figures are carefully balanced to form a circle around her. This picture glorifies the heroic deeds of the working class, but, more important, it shows the care their leaders bestow on them. Lin Gang's *Zhao Guilan at the Heroes' Reception* and Gu Yuan's *Chairman Mao Talks to the Peasants* were but two images that artists wove into a colorful tapestry of Party hagiography.

The Reception

In the early 1950s millions of new socialist nianhua prints were produced, creating a publication boom. According to a statement issued by the Ministry of Culture and published in the *People's Daily* in 1950, between November 1949, when the new nianhua policy was announced, and April 1950, 412 types of new prints were issued in twenty-six localities, with a distribution of more than seven million copies. "The prints depict the face of a new China, communicate the sentiments of the Chinese people, and have won the wide acceptance of the populace," the Ministry declared.[47] The official assessment was echoed by zealous reformers eager to participate in the exercise. But such governmental data are hard to verify, for independent sources are unavailable. Do we really know the audience's reactions? Do we understand peasants' *mentalités*—the ways in which people's values were shared, how their attitudes were changed, and how their mental world was constructed? An investigation of *mentalités* reveals, in the words of Jacques Le Goff, "the impersonal content of [people's] thought."[48] Such an understanding is important because it examines history at ground zero, rather than from above.

Given that no explicit folk documents (such as interviews) seem to exist, and that questions of popular attitudes are extremely difficult to tackle, can this problem be circumvented? Perhaps. A few reports released by provincial cultural bureaus and reform teams may give us clues into peasants' elusive *mentalités*.[49] Another indication of their reactions are the survey results that were occasionally published in magazines and journals about the nianhua reforms, and which included peasants' comments.[50] True, comments attributed to peasants could very well be tailored to the needs of elite participants in the debate, but the unsophisticated nature of their expressions lends credibility to the idea that their responses are genuine. I also propose to address this issue through an examination of elitist records, especially the writings of the nianhua reformers. Perhaps I risk committing the same error I propose to avoid. Yet certain elitist records can surely be used to explore the mentality of the forgotten peasant. A careful examination of the reformers' writings reveals far more than a slavish repetition of official views. Those sent to the front line were often embroiled in heated debates with respect to the appropriateness of certain techniques and print designs for the implementation of state policy. They reiterated the Party line, of course, but they also expressed frustration in dealing with the peasants. It is the reformers' frustration that proves most revealing, for, in

their investigation, peasants' voices and anger were occasionally reported and, in some instances, directly quoted to support the reformers' disappointment. In other words, reformers' writings on the nianhua campaign are made up of a mosaic of Party policies and popular reactions, providing another channel for us to look into the complicated mental world of the peasantry. This world, contrary to government propaganda, was far from submissive and quiet. The peasants were often blunt in their opposition to the new prints. They found many reformed pieces unacceptable and refused to buy them, frustrating the official nianhua policy and rendering it ineffective. This negative response was clearly reflected in the poor sales of the new prints, which furnishes yet another avenue to examine the peasants' *mentalités.*

What makes a good nianhua? A good print, according to art critic Wang Shucun, contains several essential ingredients: it tells a good story, the caption is written in propitious language, and the people it represents are men and women of great distinction or moral worth.[51] A northern Jiangsu proverb provides a broader definition: "A cherished print has five components: it is beautiful to look at, carries auspicious ideas, relates a good tale, is forceful, and exudes a flamboyant spirit."[52] Measured against these standards, the nianhua reform was a failure.

From the outset, peasants were critical of the new prints. They found it hard to accept a novel kind of nianhua produced on an offset machine, a process dramatically different from that of the traditional woodblock style. The problem, however, lies less in the peasants' unfamiliarity with the new technique and more in their uneasiness with the colors of the new designs. For many peasants, the machine-made prints were aesthetically unappealing and visually problematic. Color, of course, lies at the core of a print, and this is especially so in nianhua. Feng Zhen (b. 1931), a nianhua expert, during her investigation of the sales of New Year prints in rural Hebei, observed, "Chinese peasants are first drawn to a print's colors, and only then to its content."[53] This comment is in accord with the conclusion drawn by sociologists who study people's artistic tastes. Herbert Gans and Pierre Bourdieu, for example, have argued that art appreciation is not an innate predisposition but, rather, is acquired. One learns to understand art through education, and education is differentiated by social class.[54] Bourdieu's theory of social distinction draws attention to the varied tastes expressed by people from different social strata. Those in the lower social classes, according to Bourdieu, tend to favor art that is more colorful, more direct, to demand immediate satisfaction, and stress function over form. Those from the upper classes, on the other hand, are likely to hold a more reflective and discriminating view of art.[55] "This print is sparkling and that one brings prosperity" was a common reaction among Chinese peasants to their favorite prints, noted Feng Zhen.[56] Indeed, the two critical terms for traditional folk prints were "sharp" and "bright," which, according to painter Yu Fei'an, meant hues that were "bright and lively, bold and exaggerated, and completely enchanting

whether viewed from near or far."[57] Bright colors in nianhua, especially red, served more than a decorative and practical function, lightening up the bare, dark rooms inside a peasant's home; they also represented felicity and prosperity. The traditional use in the New Year prints of a limited number of widely available, inexpensive red, green, and yellow pigments was also prompted by economic considerations, contends Yu Fei'an. Folk artists, he argues, with their limited resources, had little choice but to find pigments that were cheap and convenient to use.[58] But vibrant colors in the old prints seemed incongruous to art reformers' academically trained eyes. For many, bright red and sharp green were not only "offensive to the eyes," as one critic quickly dismissed them,[59] but they were also "in poor taste."[60] Nor were the reformers comfortable with what they regarded as the monotonous use of a limited number of bright colors. Instead, they preferred muted tones, with the use of shading, to render volume and mass and to give the picture a more refined appearance.[61] As a result, the new products were less spectacular in color and more subdued in mood. The peasants' rejection was immediate. One spoke candidly: "These new prints are not bright enough (bu huobao)."[62] Another added, "They look stale (bu xinxian)."[63] Prints with muted colors and shading drew particularly harsh criticism. As one peasant woman remarked on the shabby dress of a woman in a print: "It is true that women dress casually for work, but when they appear in a print, they should don more handsome clothing."[64] Bright colors were therefore more than a visual expression; they also ignited the peasants' idealization, providing an escape from their harsh and unpredictable lives.

For many peasants, the new nianhua prints failed to deliver an appealing story. Clearly the government had intended to purge traditional nianhua of unacceptable elements and to fill them with new subjects. In so doing, however, the prints' familiar storylines—one of their most endearing legacies—were eradicated. As indicated earlier, a high-quality nianhua must tell a good story. Moreover, the peasants seemed to hold a deep-rooted belief that much of a print's appeal was in its ability to relate a tale. Familiar images in a traditional print were therefore more than the products of artistic expression; they also provided entertainment, as in the case of the abovementioned depiction of Generals Qin Qiong and Yuchi Gong. What appealed to the peasants in a traditional print was a story with a familiar plot, relating well-known episodes from the past. The embedded story communicated a single coherent narrative. The new socialist prints, with modern heroes and revolutionary themes, now replaced the familiar tales. Widely known traditional figures such as Generals Qin Qiong and Yuchi Gong were now replaced by the unfamiliar face of Zhao Guilan, the government-promoted, modern-day labor heroine with no roots in the peasants' collective memory. As one peasant remarked, "I have no idea what these prints are about; they have no story to tell."[65]

To be sure, the realistic portrayals in the new prints ran counter to the exaggerated and distorted depictions in folk artists' earlier works. In the traditional

prints, the oversized heads, the huge eyes, the towering door guardians, the chubby babies, and the beautiful women were all idealized representations. Contrary to these traditional practices, the reformers, following the official doctrine of socialist realism in vogue at that time, produced new pictures in a stark, realistic fashion. *Defend Our Motherland! Protect Peace!* is a case in point. In this print the People's Liberation Army soldiers are too realistic and straightforward to inspire one's imagination. The striking and exaggerated features commonly associated with the old formula (as in Zhong Kui) have disappeared; so, too, have its dramatic and entertaining effects. Peasants in the 1950s viewed such faithful depictions of human figures as dull. "The new prints are far too realistic (*tai xiang zhen de*)," one criticized.[66] "They are uninteresting (*mei kantou*)!" another concluded.[67]

The new prints also differed from their predecessors in language. The reformers employed a multitude of unfamiliar phrases, words, and neologisms. Gone were such titles as *Stove God, God of Wealth*, and *Bearing Many Sons*. Instead, an unfamiliar array of socialist slogans emerged: *Learn from Our Soviet Elder Brothers* (reflecting China's tribute to its socialist brethren) and *Long Live the Great Friendship between the Chinese and the Koreans!* (voicing support for the Communist forces in the Korean War). The reformers' repeated use of dense and embellished prose posed a further problem. Instead of clear, direct language, one critic complained, some artists used obscure sentences and complicated rhymes in designing their new prints, especially the "Four Hanging Scrolls," a type of nianhua linking together four pictures to construct an overall theme. "Many suffered from a language of bewildering complexity, incomprehension, and pretension," he asserted.[68]

Ye Youxin, a member of the 1952 Yangjiabu reform team, put his finger on this problem of patronizing elitism. In an article published in 1954, Ye criticized the reformers as having a superior urban bias against the old prints, denouncing them as "backward" and unworthy of attention.[69] That the majority of reformers (especially art students) came from the cities blinded them to the rustic nature of folk art, as well as to the peasants' emotions. Beginning in the early 1950s, urban scenes, especially of the capital, Beijing, occupied an increasingly prominent place in the new images. This was, however, a motif unfamiliar to the peasants. The protagonists in the new prints often looked more like city dwellers than country folk, and the images appeared foreign and strange to the villagers. "These are actually rather good pictures, but they are not my cup of tea (*buhe women de daodao*)," one peasant commented on the urban scenes depicted in a print.[70]

This urban bias, as one artist confessed, reflected a fundamental problem of the elite's implicit but widespread condescension toward this traditional art form. "Artists, in general, did not take New Year prints seriously," he observed. "They view the prints as an inferior genre to painting," and many "are compelled to produce them against their will."[71] Such criticism struck a sensitive

chord. In the early years of the People's Republic, elated by the promise of a new socialist regime, many noted artists, including Ye Qianyu, Li Keran (1907–89), and Zhang Leping (1910–92), rallied behind the government's call to support the nianhua drive, giving the endeavor prestige and visibility. The veteran artists eagerly tried their hand at designing new prints. Ye Qianyu's piece on the unity of all nationalities in China (1952) and Li Keran's on labor heroes (1952) even gained accolades by winning prizes in the national nianhua competition in 1952. But such enthusiasm soon diminished as the veteran artists gradually turned their attention elsewhere. The shift largely reflected the change in government policy in 1953. With the beginning of the First Five-Year Plan and the end of the Korean War, the government announced its program for industrialization and technological growth. The art associations also shifted their focus from popularization to specialization and professional training. This spelled trouble for yangge, as mentioned earlier, and also resulted in a greater emphasis on Soviet-style oil painting and traditional Chinese painting (*guohua*), both of which demanded more advanced technical skills and further academic training.[72] Ye Qianyu and Li Keran soon abandoned nianhua and once again embraced their beloved traditional painting, especially when both artists were appointed to the newly revived Department of Traditional Painting at the Central Academy of Fine Arts in 1954. Ye's and Li's brief stints in the nianhua camp therefore reflected a temporary digression from their principal devotion. It also indicated a more widespread phenomenon among artists: their unwillingness to commit time and energy to what they regarded as a minor art form, known neither for its status nor artistic worth. In 1953 nianhua was one of the three principal art forms catering to mass consumption (the other two were serial picture stories and slides), something artists shunned. All three forms were derisively labeled by many artists as the "three don'ts": that is, three types of art that artists avoided.[73] This elitist bent, art critics Bo Songnian and Wang Shucun charge, is evidence of how artists continued to despise the vital task of popularization, which, of course, spelled more trouble for the nianhua campaign.[74]

The reformers' elitist bias, however, was only one of the problems in the campaign, and by no means was it the most serious. The campaign was fundamentally a political crusade and should therefore be analyzed in that vein. The government's attempt to exercise political control over people's lives was nowhere more evident than in its antireligious measures. But to lump together peasants' religious beliefs as mere "superstitions," as government officials and reformers did, is a gross simplification of the peasants' enormously complicated mental and spiritual universe. The government attack against religious prints was essentially an assault against the peasants' traditions, as well as against their psychological bent and artistic imagination. Sociologists and anthropologists studying China have long argued that religion, especially popular religion, plays a critical role in people's lives. Following C. K. Yang, many hold that popular

religion, which is syncretic and less concerned with doctrinal distinctions than elite religions such as Buddhism, has an integrative function in society.[75] Popular religion is closely related to life-cycle rituals (childbirth, weddings, and funerals) and annual festivals (New Year's day, seasonal holidays, and birthdays of deities). It was tied to the well-being of the living and generated a sense of community and harmony in the villages. Chinese peasants worshipped deities who responded to their needs and could provide both psychological and spiritual comfort. Their requests to their trusted gods were downright practical. For example, the Stove God was encouraged (even bribed) to bring good fortune to the home after his favorable report in heaven. Such a practice reflected the hopes and desires of a rural population, who, despite living under conditions of severe material constraint, continued to dream of a better life ahead.

The change from the *Stove God* to the *Martyr Memorial Pagoda* was therefore met with instant disapproval. That the new image was purged of its religious blessings, which meant protection and good fortune, angered the peasants. Worse still, unlike the Stove God image, which represented the festive New Year, the renewal of the seasonal cycle, and hope, the new image was viewed as a symbol of death and mourning. Thus the meaning it conveyed was the exact opposite of the traditional print. "Inauspicious!" was how peasants put it.[76] Indeed, the issue of auspiciousness, an essential ingredient in the traditional prints, came up repeatedly in the peasants' harsh criticism of the new prints.

Negative reactions to prints such as the *Martyr Memorial Pagoda* illustrated the predicament of reformers as the new designs with overt propaganda were often frowned on by consumers. The government's concerted effort to bring nianhua prints under central control caused problems by imposing the primacy of politics and ideology on cultural matters and demanding that the people speak with one voice. Politics now invaded the new prints at every level. The official status of the new nianhua meant that artists were only permitted to operate under prescribed rules and portray approved subjects such as selfless workers, wise leaders, and peasant cooperative society. This, of course, was in sharp contrast to the old prints, which drew inspirations freely from multiple sources, ranging from daily experiences to memorable heroes of the past, and allowed the folk artists a greater degree of freedom in their creations. The poverty of the subject matters and the stilted language in the new works made them predictable and dull, and the images and plots, as one critic wrote, became "formulaic and abstract."[77] Refashioning *The Money Tree* into *An Apple Tree* was yet another indication of the rapid politicization and routinization of folk art. One peasant reacted with sarcasm: "How much is an apple tree worth?"[78]

Despite official propaganda to the contrary, the results of the reform were disappointing. Of course some pieces were well liked, such as *Mother Teaches Me How to Do Embroidery; I Teach Mother How to Read*, but in general peasants were apathetic about the new products and refused to buy them. Statistics issued by the Department of Culture of East China Bureau in 1952 revealed that

new prints occupied only 1 percent of the total sale of 7.8 million copies of nian-hua in Yangjiabu in that year. The department was forced to admit that "feudal, superstitious old products still exercised enormous influence on the masses."[79] According to a later report, 860,000 copies of new prints featuring "workers, peasants, and soldiers" were produced in Shanghai and Tianjin in 1955, amount-ing to 38 percent of the total production, while the rest were devoted to "classi-cal theatrical scenes and chubby boys" and other similar subjects. The follow-ing year, the percentage of "workers, peasants, and soldiers" took a surprising nosedive to 8.8 percent, but the output of "classical theatrical scenes and chubby boys" soared to 56.6 percent. The production of new prints continued to drop in 1958, falling to 2.6 percent, while the manufacture of traditional-themed prints climbed to 72.4 percent. Although the reporter who presented these statistics blamed the disappointing print sales of the socialist heroes on poor distribu-tion and ineffective promotion, the problem undoubtedly lay in the insipid pro-paganda art itself.[80] A report in the early 1980s showed no improvement in the situation:

> It is by now a familiar problem: the traditional prints of chubby babies, ancient costumes, beautiful ladies, and propitious contents [reappear and] sell briskly. They are printed in large quantities, easily in the millions, whereas those new prints that reflect real life and are rich in new ideas and educational value have few takers; sometimes only a few thousands are sold. Others have ceased print-ing altogether."[81]

Worse still, to the astonishment and fear of officials and reformers, many pre-viously condemned religious prints were making a comeback. A report pub-lished in the early 1980s related the alarming news: "In villages, people are once again surreptitiously printing superstitious nianhua such as the door gods."[82] A decade later, in the early 1990s, the situation was completely reversed, as door god prints made a new, public appearance. In 1991 the prestigious People's Art Publishing House in Shanghai sent out catalogues and openly solicited orders for the once-condemned deity prints such as Qin Qiong and Yuchi Gong.[83] The continued strong public interest in door god prints is an indication not only of the powerful hold of tradition but also of the peasants' successful resistance against imposed politicized art.

In brief, the nianhua reform proved to be a failure, as it never achieved the government's original intention of appealing to the masses. Among the rea-sons for its demise was the strong challenge of the calendar posters (*yuefenpai*) that originated in Shanghai and were usually graced by pictures of beautiful women.[84] Most important, however, the peasants, opposed to the government-initiated designs, refused to buy them. Instead, they continued to express their nostalgia for the old style. In resisting state pressure, the peasants let their con-sumption, or lack of it, do the talking.

Resistance

It is true that modern forms of political dictatorship, as Hannah Arendt has argued, have the power and means to invade an individual's private life,[85] but, as this chapter illustrates, they can never completely dominate it. They face a populace that is by no means passive. Similarly, the Gramscian model of cultural hegemony also overestimates the elite's ability to exercise influence over the lower classes, when in fact common people are often quite vocal in thwarting cultural impositions.[86] The Chinese nianhua protest was a reaction against an unprecedented nationwide art campaign mounted by a government that intended to infuse its populace with socialist ideals through the vehicle of folk art. But far from submitting to the ideological constraints imposed on them by the state, the populace stubbornly adhered to their own traditional methods of consumption and refused to purchase the socialist prints. In so doing, not only did they delimit and redefine the publicly perceived relations of domination, they also challenged the common notion that officials have the ability to freely impose cultural hegemony on the lower orders.

The study of peasant resistance has moved forward by leaps and bounds in recent decades, especially through the works of Barrington Moore Jr., Eric Wolf, and James Scott.[87] Although scholars dispute what exactly constitutes resistance, they have reached a consensus that peasants are neither passive nor inert, nor are they hapless victims. Ample evidence shows that peasants take charge of their own lives and create their own social space to protect themselves against external (especially state) oppression. This conclusion is a product of a study of "history from below" (borrowing E. P. Thompson's well-known phrase);[88] it also assumes that an appreciation of peasants' voices is central to our understanding of agrarian protest.

The Chinese peasants' resistance to the new nianhua prints was evident in their decision not to buy them. By emphasizing the role that selective consumption played in the resistance culture, one also shifts the focus from the state's cultural production to popular reception, from producers to consumers, and from officials to peasants. Indeed, the process of consumption, which is of no significant value in orthodox Marxist theory, can be of great use in analyzing Chinese peasants' behavior. The idea that consumerism is a form of activism brings to mind Michel de Certeau's influential work *The Practice of Everyday Life* in which he describes a much-neglected kind of resistance among ordinary individuals. Instead of looking at the producer (writer, landlord), de Certeau studies the active role played by the consumer (reader, renter), and sees active consumers taking charge of their lives.[89] He argues that consumption is a form of production, a process through which consumers in capitalist societies skillfully adjust mass-manufactured artifacts to meet their own needs, as in the case of an audience responding at will to a television drama. By emphasizing cultural consumption and not production, de Certeau not only places the users of

culture at the center of everyday practices, he also challenges the ability of the powerful to impose their will freely and unopposed. The consumers, according to de Certeau, clearly know how to withstand pressure from the top. Through tricks and disguise, they can subvert power and confuse, if not reverse, relations of domination.

That popular taste poses a problem for the Communist regimes has already been demonstrated by Richard Stites, among others. In his book about Russian popular culture, Stites uncovers a vibrant consumer culture in the Soviet Union. Even in the years of harsh control and oppression under Stalin's rule, Stites argues that an element of consumer choice was always available and a strong public desire for entertainment, not politics, persisted.[90] Popular taste often befuddled and frustrated the state's attempt to use mass culture to indoctrinate the masses.

Similarly, in rural China peasants made choices and played an active role in the face of a state-imposed agenda, as was evident in the nianhua reform. In general, peasants viewed the nianhua drive with deep suspicion and disapproval. Most of the new products failed to meet their traditional standards of a good print. The new prints were visually problematic, religiously inauspicious, too realistic, and did not tell a good story. Moreover, the prints were designed by a group of urban reformers who knew little about peasants' lives and certainly seldom considered their views. Worse still, the drive was an ideological campaign initiated by a new Communist state, one that intended not only to indoctrinate the peasants but also to change their customs and common practices. Political prints proved to be suffocating, depriving peasants of artistic imagination and denying them their practical and psychological needs; moreover, the prints denied peasants their traditions and, ultimately, their very sense of worth. Peasants, Samuel Popkin argues, are intelligent calculators who control their own destiny based on self-interest. They view collective goods largely through the lens of self and family. They are "rational," according to Popkin, because "they make the choice which they believe will maximize their expected utility."[91]

The Communist state's domination over its populace is never simply in the arenas of politics or economic life; it is, perhaps even more important, in the area of culture. However, the production of cultural artifacts (in this case, the new nianhua) was a complicated process of creation and reception, over which the state had no absolute control. It was an ideological war between state and society, and between producers and consumers. In the nianhua reform, the state proved unable to impose a new type of political propaganda on a seemingly quiescent public.

Consumerism is quickly spreading in today's China, especially since Deng Xiaoping unleashed market reform in the late 1970s. In fact, the political nianhua prints are available even today,[92] but recent studies indicate that peasants continue to favor traditional visual expressions and familiar auspicious emblems.[93] Many prints have also assumed a different look. In 1984 Liu Xiqi's *China, My*

Figure 59. Liu Xiqi, *China, My Motherland!* (1984). Place of printing and size unknown. *Source:* Bo Songnian, *Zhongguo nianhuashi* (History of Chinese New Year prints) (Shenyang: Liaoning meishu chubanshe, 1986), plate section, 27.

Motherland! (*Zuguo a, Muqin!*) appeared and became an instant hit (figure 59). The print depicts a young Chinese woman returning to Beijing from overseas for a nostalgic visit. With the customary bright colors and familiar doves, she is enjoying a leisurely walk at Tiananmen Square. But why is the print so popular? Is it the capital (with its monumental Great Hall of the People in the background) that evokes the visitor's sense of belonging and patriotism to her motherland, as the title would have us believe? Or is it the beautiful young woman with her sweet smile? We do not know for sure, of course. But given the fact that the country is now awash with consumerism, and that calendars and magazines featuring attractive female movie stars and alluring female models are a hot commodity in the publication industry, it is likely that consumers are drawn to the print less for its patriotic call, and more because of the enchanting woman.

V. Commemoration

9. The Cult of the Red Martyr

Zhang Side (1915–44), a young peasant Red Army soldier who was a veteran of the Long March and once served as Mao Zedong's personal guard, was killed on September 5, 1944, when a charcoal-producing kiln suddenly collapsed in northern Shaanxi province. Shortly thereafter Mao delivered a famous eulogy, "Serve the People," which paid an emotional tribute to the dead soldier:

All men must die, but death can vary in its significance. The ancient Chinese writer Szuma Chien [Sima Qian] said, "Though death befalls all men alike, it may be weightier than Mount Tai or lighter than a feather.". . .

From now on, when anyone in our ranks who has done some useful work dies, be he soldier or cook, we should have a funeral ceremony and a memorial meeting in his honor. This should become the rule. And it should be introduced among the people as well. When someone dies in a village, let a memorial meeting be held. In this way we express our mourning for the dead and unite all the people.[1]

In the following year Mao's eulogy was elevated to an official level and became a political symbol. During the Seventh Congress of the Chinese Communist Party, held in Yan'an from April to June 1945, at a time when China's War of Resistance against Japan was rapidly drawing to a victorious end, congressional delegates held a memorial service on June 17, 1945, commemorating those who had perished in earlier military conflicts. A memorial statement was read, honoring the "martyrs" (*lieshi*):

You who died for the cause of the Chinese people's revolution were distinguished descendants of China. Having long abhorred China's decline, darkness, and backwardness, you valiantly stepped forward to protect the people and fight against the aggressors, tyrants, and oppressive systems. Ultimately you shed your blood . . . and your agony embodied the suffering of the Chinese people. . . . But countless Chinese like you inspired the efforts that saved our nation. . . . Your sacrifice bore fruit . . . and your heroic spirits have continued to inspire us all.[2]

This public statement, together with Mao's earlier memorial for Zhang Side, may be seen as the beginning of what I call the "cult of the red martyr" in the history of the CCP. Obviously this cult was linked to the cause of revolution and

war, which persisted in China throughout the twentieth century. The Party's struggle to establish an independent nation, free of foreign imperialism and native feudalism, would clearly place Communist revolutionaries in mortal danger, and many lives would be lost. Nevertheless, Mao confidently predicted a triumphant outcome, which he later expressed in his poem, "Shaoshan Revisited" (1959): "Bitter sacrifice strengthens bold resolve / Which dares to make sun and moon shine in new skies." During the Yan'an era the CCP faced the pressing question of how to deal with the increasing number of dead among its rank and file, either killed in battle or tortured to death by the enemy. How did the Party deal with the issue of death for the cause of revolution?

The study of death has gained considerable attention among China scholars in recent years,[3] but few have examined in depth political implications of martyrdom in Communist China. To be sure, the concept of martyrs as heroes has a long history in China. Two ancient, well-known examples are Qu Yuan, a patriotic poet from the southern state of Chu in the Warring States period, who was slandered by evil officials and later drowned himself in protest against a corrupt king and an immoral society; and Yue Fei, the loyal Southern Song dynasty general executed by the emperor because, although he successfully resisted the invading nomadic Jurchens, he was viewed with suspicion by the defeatist faction at court. Both Qu Yuan and Yue Fei are long-revered examples of integrity and loyalty to their state.[4]

In the twentieth-century, under the influence of the West, the concept of the martyr acquired new meaning: in addition to honoring the martyr's moral values, a novel and weightier emphasis was placed on the revolution's dead as models for the living to emulate.[5] Examples of this change include the Nationalist government's commemoration of the Seventy-two Martyrs of the Yellow Flower Mound, who perished in an abortive attempt to overthrow the Qing dynasty in the spring of 1911 in Guangzhou, and the celebration of General Zhang Zizhong (1891–1940), who died in May 1940 in Hubei while resisting the invading Japanese.[6] The commemoration of the revolutionary martyrs in the Republican era, as a recent study suggests, was usually initiated by the bereaved and included a strong element of local politics, where regional interests often eclipsed those of the central authorities and reflected the deep political division at the time.[7] What, then, distinguished the Chinese Communists' commemoration of the dead after 1949 from that of their predecessors? The fundamental difference was the development of the cult of the red martyr in the first decade of the People's Republic, which is the focus of this chapter, and the CCP's systematic attempts to monopolize the cult. The CCP imposed its political agenda from the top on an unprecedented scale, with the entire operation doubtless aimed at promoting loyalty to the Communist Party and consolidating its rule in China. The cultivation of the red martyr cult, often mounted by the state with extensive publicity, provides strong testimony about the carefully manipulated politics of commemoration in the 1950s. Although the official cult of the red martyr was an

integral part of the CCP's political culture, the Party soon found that the commemorations were not easily controlled from the top. The commemorations of the revolution's dead were public, official acts, but the issue of violent loss of life was also an intensively private matter among the martyrs' loved ones, and this made the cult a contested terrain that the Party could not monopolize.

Who Were the Martyrs?

Influenced partly by their atheistic approach to death, the Bolsheviks, according to Catherine Merridale, dispensed with religious ceremonies and opposed memorials in the early years of their rule. In 1924 the Old Bolshevik M. S. Ol'minskii famously volunteered to have his body, after his death, converted to industrial fats and fertilizer. Similarly, Lenin opposed all forms of mourning, although this position would soon change as Russian officials began to realize the political value of commemoration and death in affirming their legitimacy and consolidating their rule.[8] Unlike the Soviets, the Chinese Communists, ever since the Yan'an days, had begun to view commemoration as an important ritual with increasingly political significance.

By the end of the fighting that finally established the PRC, in 1949, the Party faced the staggering fact that the War of Resistance against Japan had killed and wounded more than six hundred thousand Red Army soldiers;[9] later, in the civil war against the Guomindang, another 1.31 million soldiers became casualties.[10] Ways had to be found, Party officials believed, to explain the unthinkable cost in human life, and to ease the pain of the bereaved and the survivors. The deaths must be honored, not seen to have been in vain. For Party leaders, this turned out to be an ideal time to merge death with nationalism by transforming wartime sacrifice into political gains. They found the answer in the development of the cult of the red martyr, which was created for a number of purposes: to divert attention from the destruction of war; to legitimize armed conflict as a means of fighting enemies; to comfort the bereaved and help them cope with personal loss; to help heal collective psychic wounds; and, finally, to educate future generations, thus serving, in the words of Zhou Enlai, "to commemorate the dead and inspire the living."[11] The cult of the red martyr was a core element in the CCP's political culture in the 1950s. It was clearly manifested in two related official acts: various commemorative practices to honor the martyrs, and the building of a national cemetery—the Babaoshan Revolutionary Cemetery—in the western part of Beijing, as a place of national pilgrimage.

But who were the martyrs? In 1950 the Ministry of Internal Affairs (later the Ministry of Civil Affairs) issued a statement defining a martyr as someone who died a heroic death in one of the following seven historic conflicts: the 1911 Revolution opposing Manchu rule; the Northern Expedition from 1924 to 1927; the national revolutionary war of 1927–37; the resistance against Japanese aggression in the 1930s; the War of Resistance against Japan from 1937 to 1945,

referring to the dead among the Eighth Route Army and the New Fourth Army; the War of Liberation against the Guomindang; and, finally, all individuals who perished while incarcerated by imperialists and reactionaries during these historical periods.[12]

This classification closely followed a master narrative of modern Chinese history drawn up by Mao Zedong in his 1940 essay "On New Democracy." By tracing its origin to the 1911 Revolution and not to 1921 when the CCP was founded, the statement clearly underscored the primacy of the struggle for national independence as the principal yardstick for determining martyrdom. Moreover, the inclusion of the 1911 Revolution meant that the Communists were themselves legitimate heirs to the revolution led by Sun Yat-sen. After the outbreak of the Korean War in the summer of 1950, the list of martyrs was extended to include those who lost their lives during the Korean conflict, as in the case of Luo Shengjiao (1931–52), who perished while saving a Korean youth from drowning in January 1952. Luo was lauded by Chinese official publications as a perfect example of "internationalism."[13]

The CCP took several steps to systematically construct the image of the martyr. Coordinated largely by the Family Welfare Bureau (Youfuke) and the supervision of the Ministry of Internal Affairs, the government offered various kinds of aid to martyrs' families (lieshu) to ease their financial burdens and help them resume a normal life. The bureau found jobs for family members, subsidized their children's tuition, and assisted families in daily work-related operations, agricultural tasks among them.[14] Even more important, however, the Party initiated measures and used its political monopoly to dictate how the cult should be interpreted; the most significant action included designating a memorial day for the fallen, constructing memorial halls and war cemeteries nationwide, publishing the biographies of martyrs, and holding public trials of those responsible for the death of comrades. However, this top-down approach was never absolute, as sometimes the government had to negotiate with the bereaved and survivors who contested the state's decision, based on their own nonpolitical perspective.

Developing the Cult

Martyrs Memorial Day

Revolutions often involve the rapid dismantling of symbols of the past regime and replacing them with new ones. At the same time, as Mona Ozouf argues in her book about the French Revolution, new festivals are created to announce the commencement of a new era.[15] This was also the case in the Bolshevik Revolution, where, as Richard Stites observes, Lenin and his associates used revolutionary festivals, in the form of songs, symbols, and pageantry, to foster the values of socialist society.[16] New festivals also helped politicians claim legitimacy by promising to reinvent the world anew. An example is the CCP's naming the

Qingming Festival (April 5), which is the lunar grave-sweeping day, as Martyrs Memorial Day (Lieshi jinianjie).

The renaming process began, in fact, even before the establishment of the PRC in October 1949. On March 7, 1949, the Communists' North China People's Government changed the name of the Qingming Festival to Martyrs Memorial Day. It instructed the territories then under Communist control to "commemorate [the martyrs] in earnest in order to heighten people's political consciousness and enable them to learn from martyrs' revolutionary spirit."[17] On April 5, 1949, the city of Baoding in Hebei province held a large memorial service, with six thousand participants, to commemorate the fallen.[18]

Honoring martyrs at the traditional Qingming Festival became an official ritual immediately after the founding of the PRC. In early April 1950, for instance, the Ministry of Internal Affairs ordered officials nationwide to honor fallen heroes at the Qingming Festival as a memorial day for the martyrs.[19] On this date of the first Qingming Festival after the founding of the new republic, Beijing's municipal government held a memorial service to honor Li Dazhao, cofounder of the CCP, who, as noted earlier, was hanged in 1927 by warlord Zhang Zuolin. Presided over by Wu Han (1909–69), the vice mayor of Beijing and a historian, and attended by officials from the municipal government, the service was held at Li's grave in Wan'an Public Cemetery, west of Beijing. Wu Han led the party in observing a moment of silence, and then wine was offered to the deceased and wreaths were laid at Li's grave.[20] The practice of honoring martyrs was repeated in many locations, including Shanghai, Lanzhou, and Nanchang.[21]

The appropriation of the Qingming Festival as Martyrs Memorial Day was a familiar Communist tactic of "pouring new wine into an old bottle," a practice the Communists used to great effect during the Yan'an days. This practice should not be regarded merely as a ploy, however. In declaring the Qingming Festival as Martyrs Memorial Day, the Communists essentially gave this traditional event an emotional moral appeal, equating the fallen with China's forebears. Like ancestors, martyrs were the "founders" of the new People's Republic, and they deserved the people's eternal gratitude. Whereas ancestors were related to their descendants by blood, martyrs were related to the Chinese people by their political commitment and loyalty to the Party. Their sacrifice would inspire others to follow in their footsteps.

In Communist nations, public memory remains largely a product of official manipulation. In his book about the social framework of memory, Maurice Halbwachs argues that memories are socially constructed, meaning that social groups, not individuals, determine what is remembered.[22] Unlike history, which aims at comprehending the multiplicities of the past, collective memory simplifies complexities and sees events from a predetermined perspective. Memories, Pierre Nora also reminds us, are malleable and can be easily manipulated by opposing forces.[23] To serve their interest, authoritarian leaders often impose a hegemonic interpretation on how traditions should be read, using memories to

exploit the past. In China, group memories of martyrs did not appear independently but were organized and shaped by the powerful state machine, which not only controlled the means of remembering but also prescribed rules for how the past should be remembered. The renaming of the Qingming Festival as Martyrs Memorial Day is just one of many examples.

The declaration of a special day honoring dead soldiers is, of course, not unique to China but is widely observed in other nations as well. Memorial Day in the United States and Heroes Memorial Day in Hitler's Third Reich both carry similar messages.[24] But China's Martyrs Memorial Day was a unique combination of these two: the government's deliberate appropriation of a time-honored festival to suit its ideological needs and its total imposition of how the past should properly be remembered. In the 1950s, under close supervision by the CCP's Propaganda Department and through the Ministry of Internal Affairs, Chinese Communists explicitly shaped public memory as they saw fit. The Qingming Festival was thereafter highly politically charged. Citizens were encouraged to visit martyrs' tombs to elevate their own "political consciousness," as stated in one circular issued by the Ministry of Internal Affairs.[25]

War Memorials

Public memorials for dead heroes, however, called for more than a visceral response such as declaring a special Martyrs Memorial Day; the ritual also had to be observed physically by means of tangible structures in actual locations. Seeing, even touching memorials is a way of connecting with the dead and also a gesture that may lessen mourners' pain of loss. Indeed, war memorials such as military cemeteries, commemorative monuments, and martyrs' shrines—or, to borrow a term from Pierre Nora, "sites of memory" (*lieux de mémoire*)[26]—allow mourners to actually feel, see, and touch physical objects in their remembrance of the dead. More important, perhaps, is that people can actually visit physical sites, and hence these locations are ideal locations for political indoctrination. Thus war memorials play a role of exceptional significance in Communist politics of commemoration.

Monuments to the war dead are certainly common in many nations. From the Acropolis to the Arc de Triomphe, as Jay Winter points out, war memorials have occupied a central place in the history of European architecture.[27] Nor were memorials unique to the Communists in China. Those who perished in the Northern Expedition and in military conflicts against Japan were honored in the Public Cemetery of the Commanders and Soldiers of the Nationalist Revolutionary Army, a war memorial complex constructed by the Guomindang in 1923 in Nanjing's Purple Mountains, adjacent to the Sun Yat-sen Mausoleum.[28] But factors distinguishing the Chinese Communist memorials were the vast number that were built after the founding of the PRC, the frequency of commemorative events honoring the dead, and the multiple channels the authorities used to dictate the events.

The first official monument built by the CCP was the Red Army Martyrs Memorial Pagoda; more than ten meters in height, the monument was erected in Ruijin, Jiangxi, in February 1934, to commemorate the fallen, but it was later demolished by Guomindang troops.[29] The effort to build war memorials gained momentum after the PRC was established. The first major monument erected in the new capital to honor the dead is, unquestionably, the Monument to the People's Heroes in Tiananmen Square. Situated at China's most sacred center and aligned with Beijing's traditional north-south axis, the monument is a dominant presence in the capital. Its symbolic significance is analyzed in the next chapter.

In addition to those in the capital, a huge number of war cemeteries, memorial halls, monuments, temples, and pavilions were built throughout the country in the 1950s to honor fallen heroes, with the Ministry of Internal Affairs acting as the supervising agency. By the 1990s the number of martyrs memorials exceeded five thousand.[30] The two that are considered the most important are the Jin-Ji-Lu-Yu (Shanxi-Hebei-Shandong-Henan) Martyrs Memorial Cemetery in Handan, Hebei province, and the Yuhuatai Martyrs Cemetery in Nanjing. Construction of the Jin-Ji-Lu-Yu Cemetery started in 1946, during the civil war, and was not completed until 1950.[31] The site contains the bodies of more than 260 Communists commanders and soldiers from northern China who lost their lives during the War of Resistance and the civil war; the area is 213,000 square meters and includes a pagoda, a memorial hall, an exhibition room, and a pavilion. Mao viewed the construction as an important tribute to the dead soldiers, and he paid a rare personal visit to the site in November 1952.[32]

An even more important memorial is Nanjing's Yuhuatai Martyrs Cemetery, which is imbued with political symbolism not only because of its mammoth size of 113 hectares but, more important, because it is located at Yuhuatai, south of Nanjing, where the Guomindang used it as the execution ground for many Communists, among them the labor leader Deng Zhongxia (1894–1933). The groundbreaking for the cemetery was on July 1, 1950, which was the twenty-ninth anniversary of the founding of the CCP, but the entire complex was not completed until 1989. The memorial compound now comprises various structures: a memorial hall, sculptures, a pavilion, tablet corridors engraved with writings by Lenin and Mao, and, most important, a soaring monument situated at the highest point of the cemetery that represents the martyrs' noble ideals; at a height of 42.3 meters, the monument also stands for the date of April 23, 1949, when the People's Liberation Army liberated this former Guomindang capital.[33]

Biographies

The cult of the red martyr was also created through printed materials and mass media propaganda issued by the government. Among the numerous books published, the most influential may have been Hua Yingshen's *Biographies of the Chinese Communist Martyrs* (*Zhongguo gongchandang lieshi zhuan*), which was

first published in December 1949, two months after the founding of the PRC, and contains the biographies of twenty-three martyrs, including such well-known figures as Li Dazhao, Cai Hesen (1895–1931), and Qu Qiubai.[34] The book was arranged chronologically so that the names chronicled the history of the CCP in modern China. The first group were pioneers, including Li Dazhao, Cai Hesen, and Qu Qiubai, who, according to a glowing book review published in the *People's Daily*, realized the flaws of Sun Yat-sen's democratic revolution and instead pursued the path of proletariat revolution to save China by "following the Soviet road."[35] Peng Pai (1896–1929) led the second group in introducing the peasant movement into the revolution—"a major turning point in achieving the final victory," the review notes. The final group, including Liu Zhidan (1903–36), Fang Zhimin (1899–1935), Zuo Quan (1905–42), and others, was, the book reviewer points out, "a distinguished group of strategists and gallant warriors," characterized by their selfless devotion to the revolutionary cause. The review ends with an admonishment:

> Today's victory in the Chinese revolution stems from the sweat and blood of these martyrs. After reading this book we should cherish the memories of the martyrs and remember that our victory did not come easily. We must therefore strive even harder to carry out the martyrs' unfulfilled dreams.[36]

An equally important book about a martyr was *My Beloved China* (*Ke'ai de Zhongguo*), a collection of autobiographical essays by Fang Zhimin. A founder of the Chinese Red Army and an influential peasant movement organizer in Jiangxi in the 1930s, Fang was captured by the Nationalists and executed in Nanchang, Jiangxi, in August 1935. In his hagiography, it was said that before his execution, the hero faced death with defiance and valor, loudly denouncing the Nationalists as "a group of vicious bandits, shameless traitors, and butchers of workers and peasants."[37]

Fang's essays, written during his incarceration, were smuggled out before his execution; they were published as a photo-lithograph edition in 1951, and then, with great fanfare, in type the following year.[38] To show the Party's deep respect for the martyr and his family, Minister of Interior Xie Juezai (1884–1971) paid a special visit, in August 1951, to the hero's mother in Nanchang during his tour of South China as the head of the Central Government Delegation to revisit the former Communist-controlled bases. According to an article in the *People's Daily*, Fang's mother, though illiterate, showed "immense concern for state affairs," especially the Korean War, which had been launched by "American imperialists." "[This time]," she declared, "we must not let imperialists invade us again!" The newspaper article ended with the news that the martyr's mother would soon accept an invitation to travel to Beijing "to see her beloved leader, Chairman Mao."[39]

The Party's creation of a list of martyrs was meant to generate and affirm a genealogy of dead heroes in the Communist pantheon. A close reading of these

biographies reveals, however, that they tell little about the martyrs' lives. The dead heroes were portrayed in a formulaic manner: they were all devoted to the Party, kindhearted to their comrades, extremely brave on the battlefield, and intensely bitter over the foreign imperialists. The effusive, repeated use of key words—"duty," "devotion," and "sacrifice"—in official biographies was, of course, common in the language of Chinese Communist propaganda. For contemporary readers, these words have a hollow ring, but their repetition in the 1950s was designed, after years of chaos and social dislocation, to bring forth a sense of shared value to the masses during an uncertain time in the early PRC. Honoring the martyrs' sacrifice and affirming the road they had taken was tantamount to joining the new socialist community.

Public Trials

A great deal of theatricality was added to the cult of the red martyr in the form of public trials of "counterrevolutionaries" that were mounted in the early 1950s during the Campaign to Suppress Counterrevolutionaries. The counterrevolutionaries publicly tried were those responsible for the deaths of Communists even before 1949. A notable case was Zhao Jixian, who was accused of suppressing the Communist-led Beijing-Hankou Railway Strike on February 7, 1923, and causing the deaths of many Communists, including the worker leader Lin Xiangqian (1892–1923). The trial was extensively covered in the national press and highly publicized. The *People's Daily*, for example, chronicled the trial with a front-page article titled "The Public Trial of the Main Culprit of the February 7 Massacre."[40]

On the morning of February 16, 1951, Zhao Jixian was actually put on trial on open ground near the Hankou Railway Station, where the incident had occurred twenty-eight years earlier. With five thousand people attending, the trial was presided over by the head of Wuhan's People's Court, and the prosecutor read aloud the list of indictments to the defendant. The martyrs' families and the many former workers who were Zhao's alleged victims were in the audience.

According to the *People's Daily*, scores of witnesses came forward to support the state's indictment of Zhao Jixian for his crimes. Among them was an old worker, Zheng, who testified that Zhao Jixian had related the news that a railway union had been formed to warlord Wu Peifu (1874–1939), who had promptly dispatched troops to brutally suppress the labor movement. Zheng charged that the troops "carried out a bloody suppression, killing and wounding several hundreds of workers." Zheng called Zhao "a most sinister fellow" and then, pointing his finger at the defendant, said, "Today you are finished. We demand the people's government to execute a ruthless criminal like you, to avenge the death of the February 7 martyrs!" The widow of Lin Xiangqian, who had traveled all the way from Fuzhou, Fujian province, made an emotional speech, declaring, "My husband's blood will not have spilled in vain. Under the leadership of Chairman

Mao and the Chinese Communist Party, our motherland has been liberated, and we have now stood up. Now I wanted to see with my own eyes how this murderer of my husband is executed in front of the people." Zhao Jixian was surrounded by angry denouncers, all shouting, in unison, "Execute Zhao Jixian and avenge the death of the martyrs!" Zhao, described by the national press as "an executioner whose hands were soaked in blood," was sentenced to death. Tied up, he was immediately brought to the location where Lin Xiangqian was killed, and there he was shot. On the same afternoon the representatives attended a ceremony for the February 7 martyrs.[41]

Show trials, like that of Zhao Jixian, abounded in the 1950s and were, unquestionably, well orchestrated and similar to the show trials in the mid-1930s in the Soviet Union, where disgraced officials were charged with cruel extortion and indifference to peasant suffering.[42] Show trials in China in the 1950s were, without question, well-planned events. Before throngs of people, the defendant's alleged crimes were often read aloud by court officials. The victims usually had a chance to vent their rage at the defendants, and the attendants generally participated collectively to denounce the defendants for their wrongdoings, making the trial a public event under the sway of a frenzied crowd.

The trial of Zhao Jixian was clearly based on the belief that justice could be served by public denunciation and open humiliation. The open court turned into a people's tribunal for the dispensation of communal justice. With high drama and sweet revenge, this was a collective verdict intended to touch millions. The full coverage in newspapers clearly showed that the Communist officials meant to offer this trial as a model, implicitly encouraging local authorities to organize similar ones in their own districts. The execution of a former criminal thus conformed with the government's policy of suppressing counterrevolutionaries at a critical time, in the early 1950s, when it was consolidating its power.

The Hidden Stories

The highly stylized report of Zhao Jixian's trial by the government-controlled press was partly a collective myth about the red martyr, in which the voices of the bereaved, if they existed at all, remained faint and stereotypical. We know woefully little about the world of private experience, or the painful process by which the bereaved came to terms with their grief.

The creation of the cult of the red martyr uses death both to achieve maximum political power and to reaffirm socialist values. Through the martyrs' fight against foreign imperialists and domestic capitalists and their sacrifice, the CCP sought to invent and reinforce the solidarity of a Chinese nation as a shared community with common goals and collective experience. This underscored coherence rather than difference, consensus rather than discord. But, despite the Party's many means of controlling publicity, including creating Martyrs Memorial Day and building war memorials, its control sometimes proved limited for the reasons noted above: the public nature of the official commemorations

could not dismiss their intensely private relevance to those who mourned the dead, and thus the ceremonies could never be entirely manipulated by state hegemony.

Commemorations, as Jay Winter convincingly argues in his book about World War I, are also an existential response to bereavement.[43] The visceral reaction of widows and orphans often outweigh the hyperbolic political rhetoric of loss. Herein lies the tension between the government and the public. Even in the official press, problems can be detected in the most carefully screened reports. Indeed, the early days of the PRC did not go as well as the government wanted the public to believe. For example, the proper recognition of the status of the martyrs did not always come in a timely fashion, thereby incurring the anger of the bereaved families. In 1951 a young man in Ru'nan county, Henan province, complained that his father, a Communist, was killed in the civil war against the Nationalists but received no official recognition, despite the family's repeated petitions to the local government to honor the dead man with the title of martyr. "How could the Ru'nan County People's Government show so little concern about the martyrs' families?" was the son's angry reproach.[44] Some family members were equally distraught about their futile requests, often stalled by bureaucratic hurdles, to transfer the remains of their revolutionary dead from where they were killed to their hometowns.[45] The martyrs' families also suffered social discrimination, as revealed by archival sources that indicated that they faced obstacles when looking for jobs, because their misfortune was seen as a social stigma.[46] This cruelty, which they were unprepared and disheartened to face, made the agony of their loss even more difficult to accept.

The martyrs' lives were not always as glowing as the government wanted to present to the public, prompting the writers of their biographies to move into the dubious domain of exaggeration and fabricated interpretations. Biographers later admitted that partial facts were intentionally included and sometimes distorted to make the martyr's family background appear more humble than it actually was.[47] These contrived lower-class origins were clearly intended to establish closer bonds between the dead heroes and the oppressed, in keeping with Marxist ideology.

In the process of creating the red martyr cult, the government often made careless mistakes, as in failing to relate the sad news to the widows or parents. In September 1952, during the Korean War, the People's Volunteer Army headquarters received a letter from the wife of an enlisted soldier, Wang Jincai. In a desperate tone, the wife wrote:

Jincai:

Your mission in Korea is an honorable act. You must be extremely preoccupied, for since your departure more than a year ago we have heard not even a word from you. After you left home, I myself and our two children were immediately placed in a dire economic situation. To this day, we have not received

even a penny from you, and staying with others or resorting to borrowing barely help us survive. . . . Write to us as soon as you see this letter, and think of a way to help solve our plight. Otherwise, we three will certainly freeze to death or die of starvation.[48]

The office soon discovered that the wife's letter could not be delivered to the soldier, for he had died the year before. Wang Jincai, a factory worker from Tangshan, Hebei province, who had joined the Chinese People's Volunteer Army in 1951, had been killed by an American bomber shortly after entering Korea with his battalion in June of that year. In December, the army issued a death certificate, titled "The Certificate of the Heroic Sacrifice of the Revolutionary Soldier," promising that a pension would be paid to the bereaved in accordance with established rules. But, for unknown reasons, the certificate was never delivered to Wang's widow, so when Wang's widow wrote her letter to her husband in 1952, she did not know that her husband was dead.

An army officer, realizing a terrible mistake had been made in communication, ordered an immediate investigation into the incident. He ordered that the undelivered certificate be sent to Wang's widow without delay, and instructed: "In addition to receiving regular condolence visits from a government official, the family should be included among those entitled to long-term relief help."[49]

Babaoshan Revolutionary Cemetery

The Building of a National Cemetery: Removal of Eunuchs' Tombs

In the early years of the PRC, the Babaoshan Revolutionary Cemetery (Babaoshan geming gongmu) (figure 60), a national cemetery west of Beijing, was constructed as another important means of creating the cult of the red martyr. The idea of having a national cemetery in the new capital was first suggested by Premier Zhou Enlai. It is said that after the PRC was founded, Zhou instructed Wu Han of the Beijing Municipal Government to find "an idyllic, easily accessible setting" to build a "permanent resting place for the revolutionary martyrs for the purpose of conducting revolutionary education."[50] This was not entirely a novel idea. As mentioned earlier, as early as 1946 the CCP had ordered the building of the Jin-Ji-Lu-Yu Martyrs Memorial Cemetery in the city of Handan, Hebei province. But the Babaoshan Revolutionary Cemetery was distinct in at least two ways: it would be built in the new capital and thus occupy a unique place in the nation's psyche; and it would be more inclusive, serving as the burial ground not only for martyrs but also for high officials, leaders of the Democratic parties who were sympathetic to the Communist cause, and distinguished foreigners who championed socialist ideals.[51]

After looking at a number of possible sites, the government finally decided on the Honored Nation-Protecting Temple (Baozhong huguosi) in Babao Hill (Babaoshan) as an ideal place for the future cemetery. The temple was soon

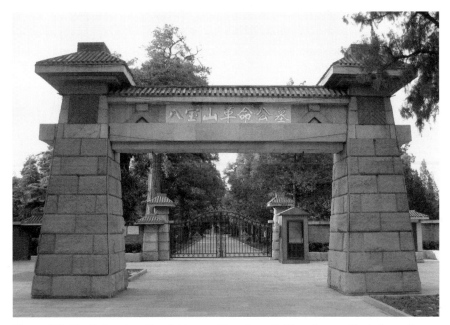

Figure 60. The Babaoshan Revolutionary Cemetery, Beijing. *Source*: Photo by author, July 21, 2006.

renamed the Babaoshan Revolutionary Cemetery. But the story of constructing a national cemetery was a long and complicated one, requiring the removal of the remains of eunuchs in the original temple's burial ground, the proper naming of the cemetery, the purchase of additional land as the number of burials mounted, and, most controversial of all, determining who were qualified to be interred in this sacred shrine.

The Honored Nation-Protecting Temple was built in the early Ming dynasty to pay tribute to the eunuch-general Gang Bing, who died in the Prince of Yan's (later Emperor Yongle) northern campaign against the Mongols, and was buried in Babaoshan.[52] The temple was subsequently used as a retirement home for the aging eunuchs, and a graveyard was created to bury those who died. In 1949 dozens of former eunuchs were still living in the temple, including the eighty-year-old Xin Xiuming, who represented the group.[53] When the temple was converted to a national cemetery, the eunuchs were transferred to other temples in the city. But there remained the problem of the existing 156 eunuchs buried in the temple,[54] as the juxtaposition of dead eunuchs and revolutionary martyrs in the same compound was incongruous, and, for many, utterly unacceptable. Complaints like the following by the Communists abounded: "It is inconceivable to see that the government still allows the tombs of these feudal palace servants to be placed together with the revolutionaries."[55] Negotiations between the government and Xin Xiuming ensued. Under repeated pressure, Xin finally

relented in 1956. In a letter to the government, Xin declared himself to be a person "who has followed socialism with confidence,"[56] and he signed the agreement to transfer the remains of the deceased eunuchs to a public eunuch cemetery in the Haidian area.

Rules for Burial

A thorny issue was how to determine who was qualified to be buried in this exalted shrine. In December 1951 officials provided guidelines in the document "Temporary Rules for Burial in the Revolutionary Cemetery." The guidelines state that the purpose of the national cemetery is to allow future generations to "pay their respect to revolutionary soldiers or personnel who had made distinguished contribution to the revolution and had been killed in some form of revolutionary activity or passed away later as a result of illness."[57] The cemetery was to be divided into three sections, burying high-ranking cadres above rank 15 as well as distinguished individuals such as scholars and artists.[58] The size of the tomb would depend on official or military rank. The first section, the most prestigious and located at the upper part of Babaoshan, was for those who "had made exceptional contributions to the revolution," referring largely to senior Party officials and eminent scholars and artists; the second was for provincial officials; and the third for county officials.[59] The size of the grave varied: whereas those in the first section had no size restrictions, each provincial official was allowed a plot of six square meters or eight square meters; and county officials were allowed an area four meters in length and either two or four meters in width.[60] In the early 1950s, among the 640 graves in the Babaoshan Revolutionary Cemetery that had already been built, 20 were at the provincial level and 620 at the county level.[61]

Before interment in the national cemetery, the identity of the deceased had to be verified, first by confirmation from the individual's work unit and then from the Bureau of Civil Affairs of the municipal government.[62] At its early conception, it was clear that the government allowed interment not only for martyrs but also for those who had "made distinguished contributions to the revolution." Those who qualified were individuals whom the CCP called "foreign friends," including Anna Louise Strong and Agnes Smedley.[63] The original name, the Revolutionary Martyrs Cemetery (Geming lieshi gongmu), was therefore too restrictive. In 1951 the government dropped the term "martyrs" and renamed the burial ground simply the "Revolutionary Cemetery" (Geming gongmu), allowing more flexibility in burial and accommodating different types of death.[64] In 1970 Zhou Enlai ordered the name to be changed again to the Babaoshan Revolutionary Cemetery (Babaoshan geming gongmu).[65]

The national cemetery drew nationwide attention, and the site instantly became the most honored place for eternal rest. The tranquil setting and dignified tombstones also seemed to create a sense of peace for the bereaved and perhaps even made the pain of death more acceptable. As a result, demands for burial in

the cemetery mounted, and the original land set aside was rapidly exhausted. The municipal government reacted by purchasing more land, restricting the size of individual graves, and encouraging cremation. In November 1954, to expand the number of gravesites, the municipal government purchased an additional 74,000 square meters of nearby land.[66] In 1955, to accommodate more burials, officials ruled that a body could occupy only one burial plot, and each tomb had to be no more than four meters long and two meters wide. Once the body was buried, it could not be transferred to another site.[67] Although the new standard size implied uniformity and equality, senior leaders were never bound by it. Finally, in the mid-1950s, cremation for deceased high Party officials was encouraged. "To save land and money, and for the purpose of hygiene, the government encouraged cremation rather than burial [for the dead]," a report of the Ministry of Interior Affairs stated.[68] Four crematories were bought from Czechoslovakia and England for this purpose.[69] In 1958 the main hall of the former temple was converted to a columbarium for the placement of cinerary urns.[70]

As a garden cemetery, with shade trees symbolizing eternal sleep and an orderly landscape of plants and shrubs, the Babaoshan Revolutionary Cemetery is, in fact, not unique. A similar idea had, of course, been developed in Europe and America in the nineteenth century.[71] But as "the nation's most renowned, highest standard burial ground," as one official publication called it,[72] the Chinese cemetery exhibited a number of distinct characteristics in its arrangement. The tombs, generally uniform in size, were clearly laid out according to rows and numbers. In section 1, for example, twenty tombs were generally arranged for each row. Also, the Babaoshan Revolutionary Cemetery is devoid of religious connotations, whereas military cemeteries in the West are often adorned with Christian crosses and sculptures of soldiers resting in the arms of Christ (as in the wall painting *The Apotheosis of the Fallen* at the Italian war cemetery at Redipuglia), thus likening death in battle to Christ's sacrifice and resurrection. Instead of religious symbols, the red star (as in the tomb of Ren Bishi and Qu Qiubai) and the hammer and sickle (as in the tombs in the section 2 of the cemetery) project a secular image of nationalism and socialism.

Burials and Reburials

Burials in the Babaoshan Revolutionary Cemetery generally took two forms: interments, especially state funerals, and reburials. State funerals, as in the French and the Bolshevik revolutions, were often manipulated by individual regimes as a venue for open pronouncements about their core beliefs and to draw broad support through elaborate displays of pageantry. At the funeral of the French revolutionary Marat, immortalized by the artist David, Marat's compatriots used the martyr's exposed corpse as a forceful indictment against the conspirators, thereby affirming the ideals of the Revolution.[73] Similarly, Lenin's funeral in 1924 and his eventual burial in Red Square, the heart of the Soviet capital, were carefully designed by the Bolsheviks to reinforce the Party line.[74]

The first senior Party leader to be buried in the Babaoshan Revolutionary Cemetery was Ren Bishi (1904–50), following a well-publicized state funeral in the capital. One of the most influential figures in the Chinese Communist Party, Ren died of a severe cerebral hemorrhage at the age of forty-six at his home in Beijing in late October 1950. In a black-bordered statement, the news of Ren's death was announced the following day on the front page of the major official newspapers, including the *People's Daily* and the *Enlightenment Daily* (*Guangming ribao*),[75] and the Central Committee of the CCP immediately formed a commission to organize Ren's funeral. Led by Mao, commission members were almost all top Party and government leaders.[76]

Ren's casket was moved the next day to the Working People's Cultural Palace, formerly the Imperial Ancestral Temple. It was the first time in the history of the PRC that the newly converted Working People's Cultural Palace was the site of a state funeral. Ren lay in state in the mourning hall—the palace's main hall—a solemn place in bygone days when it was reserved only for emperors and their offerings to their ancestors, thus symbolically placing the deceased Communist leader in the pantheon of the Communist heroes as one of the new nation's founding fathers.

The state funeral was solemn and moving. Hanging on the wall of the mourning hall was a giant PRC flag, and Ren's portrait was right below it. Many funeral wreaths surrounded the bier, which was flanked by four military honor guards as well as four members of the New Democratic Youth Corps, of which Ren had been the chairman.[77] For the next two days thousands of mourners filed through the mourning hall to pay their last respects to Ren. On October 30 a memorial service, chaired by Peng Zhen, was held at the main courtyard. The government ordered flags to fly at half-mast and cancelled recreational activities for one day. Liu Shaoqi's eulogy called on others to "learn from Comrade Ren Bishi in order to complete the final liberation of the Chinese people."[78]

Ren was finally interred in the Babaoshan Revolutionary Cemetery. Located on the slope of the northeastern corner of the hill in section 1, Ren's tomb is the grandest of all, overlooking the entire cemetery with an open vista. Designed by the architect Liang Sicheng, the tomb is a two-part structure, with a photograph of Ren placed at the front, and, behind it, a tombstone decorated with a five-point star, and an inscription in Mao's calligraphy: "The Tomb of Comrade Ren Bishi" (figure 61).[79] Ren's gravesite was later flanked by those of two equally prominent figures: on its left was the tomb of Qu Qiubai, the early Communist leader executed by the Guomindang in 1935, whose remains were transferred to the national cemetery in 1955, and on its right was the tomb of Zhang Lan (1872–1955), the leader of the China Democratic League, who served as vice-chairman of the new Central People's Government. One outcome of Ren Bishi's burial in the national cemetery was the creation of a pantheon. The Party had clearly asserted its control in determining every aspect of the funeral process. The final purpose of the state funeral was to perpetuate the memory of a great son of the

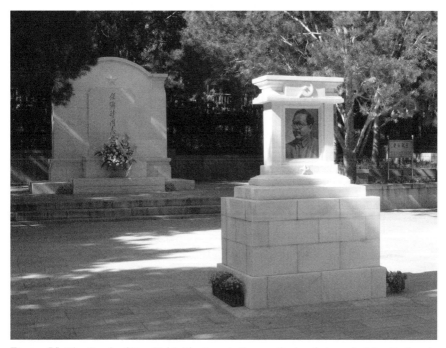

Figure 61. The Tomb of Ren Bishi. The inscription on the tombstone, in Mao Zedong's calligraphy, reads: "The Tomb of Comrade Ren Bishi." *Source*: Photo by author, July 21, 2006.

Party. At the same time it turned the burial ground into an educational space, designed to teach youngsters about Ren's sacrifice for his country.

Ren's burial rituals closely resemble what Catherine Merridale calls the "red funerals" in the Soviet Union. After 1917 these spectacles began with announcements of the death of important revolutionaries by issuing black-bordered statements in the press, followed by burials with giant wreaths and honor guards flanking the bier.[80] As was made clear by Ren's burial, state funerals were never a simple mourning exercise. Avner Ben-Amos argues that they exhibited "the dual character of the ceremony, a political event and the final rite of passage in a man's life,"[81] though the emphasis was often on the political dimensions of the event. The funeral arrangements for Lenin in 1924, for example, turned into a fierce political fight among senior Soviet leaders over the succession issue.[82] Ren's state funeral also presented a political message, calling on his followers to carry his banner forward. The huge publicity surrounding his funeral was designed to spur national unity, reinforce the Party line, and crush any potential threats to the new regime in the early days of the PRC. The usual outpouring of emotion at Ren's death no doubt also projected a strong image of unity between the Party and the people.

Reburials at the Babaoshan Revolutionary Cemetery were just as important

as interments and may even have had greater political symbolism, especially in the early days of the PRC. Again, reburial was not a new practice. One of the most highly publicized cases was the reburial of General Zuo Quan, Vice Chief of Staff of the Eighth Route Army, who died in Shanxi in the resistance against Japan in 1942, at the age of thirty-seven. Zuo's remains were moved from an old burial site in western Hebei to Handan's Jin-Ji-Lu-Yu Martyrs Memorial Cemetery after it was completed in 1950.[83]

The first reburial at the Babaoshan Revolutionary Cemetery took place in December 1949, when the remains of Wang Hebo (1882–1927) and seventeen others were reburied in Babaoshan. Wang, a Communist workers' leader, and his associates were killed by Manchurian warlords in November 1927.[84] But the most famous reburial took place in 1955, when Qu Qiubai's remains were transferred to the Babaoshan Revolutionary Cemetery from Changting, Fujian province, where the Nationalists had executed him in June 1935.

Qu's remains were officially reinterred in Babaoshan on June 18, 1955, the twentieth anniversary of his execution. The CCP staged a grand reburial ceremony to honor this early Communist leader. It was a solemn ceremony with deep political implications: officiating was Zhou Enlai, as a member of the CCP Central Secretariat, accompanied by senior Party leaders such as Dong Biwu, Kang Sheng, Peng Zhen, Lu Dingyi, as well as Qu's widow, Yang Zhihua (1901–73). Pines and cypresses, traditional symbols of longevity, surrounded the new grave, which is situated on the left side of Ren Bishi's tomb, in the most revered section of the cemetery. A portrait of Qu was placed in front of the tomb, encircled with flowers. As part of the service Lu Dingyi presented a brief biography of Qu Qiubai, and delegates laid flowers at the new gravesite. After the interment Zhou laid a wreath of white peonies, a conventional symbol of distinction and honor, in front of Qu's grave. A band struck up "The Internationale," a tribute to Qu's role as a leader in China's proletariat revolution. The mourners, according to the *People's Daily*, gathered around Qu's new grave to commemorate "this great warrior of the Chinese working class."[85] Mao wrote the inscription for Ren Bishi's tombstone, and Zhou Enlai graced Qu's tombstone with his elegant calligraphy: "The Tomb of Comrade Qu Qiubai."[86]

Obviously, Qu Qiubai's reburial was initiated by the government to generate maximum publicity and create the greatest educational impact. Reburials also had their private side, however, as grieving parents and relatives often made a strong emotional appeal to the government to include their loved ones in the Babaoshan Revolutionary Cemetery. Although these reburials had an element of privacy and were less spectacular, they were no less significant, for the revelations of the mourners' memories of the deceased, often different from the official platitudes. Two famous reburials, both the result of family petitions to the municipal government, involved Fan Hongjie (1897–1927) and Fang Bowu (1896–1927). Both were followers of Li Dazhao in the early years of the CCP. But whereas Fan was a Peking University student and an active member in the early

Communist movement, Fang organized the rickshaw workers. The two young Communists, together with Li Dazhao, were executed by the warlords in April 1927. Fan's body was buried outside Xuanwu Gate in Beijing, and Fang's remains were interred in a Hunanese charity graveyard outside the city.[87] After the founding of the PRC, Fan Hongjie's elder brother petitioned the government to rebury Fan at Babaoshan. Independently, Fang Bowu's younger brother made a similar request to the Beijing Municipal Government. In his letter, the younger Fang expressed his concern that the charity graveyard might soon be removed to make room for the city's rapid redevelopment. "I longed for the transfer of my elder brother's remains to the Revolutionary Martyrs Cemetery," he wrote, "but I could barely raise enough money to do so. I could only hope that the Party and government would think about my brother's loyal deeds and find a way to transfer his remains."[88]

We know, from historical documents, that Fang Bowu was survived by his mother, who lived in his native Hunan, his son, who worked in Guangxi, and his widow. This information was useful to verify that Fang actually had died a martyr's death. After the government concluded that Fang "indeed had sacrificed his life for the revolution, and had not divulged any Party secrets, [the government] recommended that he be posthumously conferred the title of 'martyr.'"[89] Both petitions were quickly approved, especially Fan's, which was authorized by none other than Party elder Dong Biwu, who testified that Fan had "died for the CCP" and unquestionably deserved to be buried at Babaoshan.[90] The remains of the two martyrs were subsequently reinterred in section 2 of the cemetery. For the Party, including the two martyrs in Babaoshan was yet another fitting recognition of the revolutionary dead, but for the family it played a significant role in their long and painful healing process.

Controversies

The burials at Babaoshan were not without controversies. Although formal burial required two steps of confirmation, mistakes did occur that were sometimes serious. In a 1952 internal document, the municipal government admitted that, among 126 interred up to that point, some were erroneously buried at a higher-ranking site than they deserved, and some mistakenly occupied two burial plots.[91] Even worse, a certain air force officer, Chen Youren, whose burial record surprisingly did not show the cause of death, was later found to have been shot after he was discovered "committing adultery with a female comrade."[92] Such a belated discovery was embarrassing, and potentially disastrous if made public. Investigations were immediately mounted to find out how this had happened, and, presumably, Chen's body was quickly removed. However, the municipal government decided not to find out who was responsible for this serious error, apparently fearing that matters might get out of hand.

Although the Bureau of Civil Affairs had stipulated the sizes of different tombs according to rank, not everyone followed the rules. Government

documents revealed that some members of the democratic parties, whose support the government was eagerly courting in the early years of the PRC, made excessive demands for what they wanted, insisting, for example, that they be given bigger plots to bury their loved ones. These were "difficult questions to handle," admitted officials at the Bureau of Civil Affairs.[93]

Several tombs were painted with "serious feudalistic and superstitious colors," government officials complained.[94] No specific details of these "feudalistic and superstitious" elements were revealed, but the government was not entirely innocent, as officials referred to the tombs of Ren Bishi and Qu Qiubai as *lingmu*, a description used in bygone days exclusively for a tomb of the imperial family. This conflicted with the denunciation of privilege and inequality by secular Communist leaders.[95]

In October 1986 the State Council announced the first list of the nation's key national martyrs memorials. Among the thirty-two listed, the Tomb of Martyr Li Dazhao, in Beijing, ranks first, followed by Jin-Ji-Lu-Yu Martyrs Cemetery and Martyrs Cemetery of the North China Military Region, both in Hebei.[96] A second list of thirty-six additional martyrs memorials was announced three years later and included the Tomb of Martyr Lin Xiangqian in Minhou, Fujian province.[97] These sites were part of an official "patriotic education" campaign to instill socialist ideals in the Chinese populace. Not surprisingly, in 1997 the municipal government named the Babaoshan Revolutionary Cemetery a "Patriotic Education Center."[98] These moves were part of the government's continuing efforts to exploit the cult of the martyr to consolidate its power. As a result, memorial structures dotted China's landscape everywhere. By the early 1990s the number of martyrs cemeteries and war memorials under the supervision of the Ministry of Civil Affairs reached a staggering 5,327.[99]

Chinese Communists continued to build on the cult of the red martyr and invoked dead heroes such as Li Dazhao to sanction their cause. In many ways this cult closely resembled what George Mosse calls the "cult of the fallen soldier" that arose with modern European wars and turned dead soldiers into martyrs, making them objects of national worship and transforming sacrifice in battle into a great didactic exercise to forge national cohesion.[100] The CCP similarly used the cult of the red martyr as a political tool, never as a civic commemoration, to advance its socialist agenda.

A major distinction needs to be made here: although martyrs in the West are almost universally portrayed as national heroes to mask or transcend the brutality of war, the West, in contrast to China, has a conspicuous number of famous antiwar monuments. Examples of such monuments include the Kaiser-Wilhelm-Gedächtniskirche in Berlin, which testifies to the horrors of war, not its glory, and Edwin Lutyens's Monument to the Missing of the Battle of the Somme, in Thiepval, France, which expresses the impossibility of triumphalism in war. These monuments point up the bitter experience of loss and

bereavement, not exhilaration of victory. China's war memorials, in contrast, often lack the anguish of loss and, instead, tell a politically optimistic story.

The cult of the red martyr in Communist China is seldom a story of bereavement. Instead of placing a human face on wars and highlighting their cruelty in terms of the wounded, the widows, and the orphans, it extols war's glory and warriors' sacrifice to the lofty political goal of socialism. True, in recent years a few war monuments have been dedicated to loss and suffering, for example, the Museum of the Nanjing Massacre in Nanjing was erected in 1985 to commemorate the more than 250,000 Chinese brutally killed by the invading Japanese troops in the Guomindang's capital in December 1937. Most of these museums, however, are couched in nationalistic language and celebrated as sites of patriotic education for the nation's youth. In China, only public mournings are staged by the state, and rarely are the bereaved seen publicly expressing their grief.

The relationship between states and memorials in the modern West, argues James Young, is never one-dimensional. It is true that official agencies are in a position to shape public memory, but once memorials are created they "take on lives of their own, often stubbornly resistant to the state's original intentions."[101] The relationship in China is quite different. The Ministry of Civil Affairs, under the influence of the Propaganda Department, exercised a great deal of manipulation and direct control by allowing only certain monuments to be built, and it dictated how these monuments should be presented to the public.

Notwithstanding the CCP's tight control, problems arose. A 1963 Interior Ministry's confidential report to Premier Zhou Enlai discussed a number of difficulties, including "the serious problem of waste and extravagance. . . . In some locations many memorials dedicated to the martyrs have already been built, but [local authorities] continued to request additional construction or expansion of the existing memorials." An unresolved problem was whether, besides the martyrs, deceased Communist veterans and senior cadres would be allowed to be buried in the martyrs cemeteries, and whether a cemetery dedicated to specific martyrs should permit other martyrs to be buried there. Often memorial sites were not properly managed, and some memorial buildings rapidly deteriorated. At some sites, the report noted, activities "unrelated to martyrs" were conducted, such as "the development of factories, warehouses, offices, or even entertainment centers, or for raising pigs and sheep."[102]

It is unclear whether Zhou or other government officials took any measures to address these problems. But since the 1980s, as China has changed to become an open-market system and the populace has increasingly succumbed to materialist values and eagerly pursued personal gains rather than collective socialist goals, the cult of the red martyr seems to have lost steam. Reports tell of the continuing neglect of the martyrs memorials. In March 1980, for example, an article in the *People's Daily* reported that a local martyrs memorial pagoda was "covered with wild grass, with garbage lying everywhere."[103] Even worse, in

1994 the Yuhuatai Martyrs Cemetery was leased for a dog show.[104] Calling the situation "alarming," *Party History News* (*Dangshi xinxibao*), an official publication of the Propaganda Department of Shanghai's Municipal Communist Party, appealed to its readers to "save revolutionary museums!"[105] What does the future hold for the cult of the red martyr? It appears that market forces will likely continue to overwhelm every aspect of Chinese life and erode the ability of the authorities to control the Chinese people, including the way to honor and remember dead Communist heroes.

10. The Monument to the People's Heroes

The Monument to the People's Heroes in Tiananmen Square was one of the most important new political symbols created in the early days of the People's Republic (figure 62). The huge granite obelisk, situated along Beijing's most sacred central north-south axis, commands the vast and austere square—the ritual center of China's capital—not only by its imposing presence but also by its centrality.[1] On the surface, the monument was constructed to commemorate those who had sacrificed their lives for the building of a new Communist state, echoing what Philippe Ariès once argued, "Without a monument to the dead, the victory could not be celebrated."[2] For the Chinese Communists, however, the building of a giant memorial in the capital's most sacred location was more than an act of commemoration; it was a cultural production serving the political need to establish the regime's control over the nation's collective memory.

As pointed out earlier, a close relationship exists between collective memories and commemorative landscapes. "Space is a reality that endures," writes Maurice Halbwachs. "We recapture the past only by understanding how it is, in effect, preserved by our physical surroundings."[3] Pierre Nora argues along the same line, but although his "sites of memory" cover an array of collective memories in France, including the tricolor flag, the Louvre, and "La Marseillaise," he especially emphasizes the country's monuments, where, he contends, "the heart of France beats loudest."[4] Perhaps nothing is more emotionally powerful than a public memorial on which collective memory is firmly anchored. A public monument, by implication, embodies the beliefs and aspirations of its patron. As the most notable piece of public art created by the PRC, the Monument to the People's Heroes is essentially a CCP manifesto carved in stone. In this chapter I argue that the monument, more than any other memorials and war cemeteries, the Babaoshan Revolutionary Cemetery included, lay at the heart of the Chinese Communists' creation of the cult of the red martyr. This structure was unique not only because of its centrality in the capital's ceremonial space (and hence in people's psyches) but also because, along with its political message, it exhibited an intricate interplay between architecture, history, art, and politics.

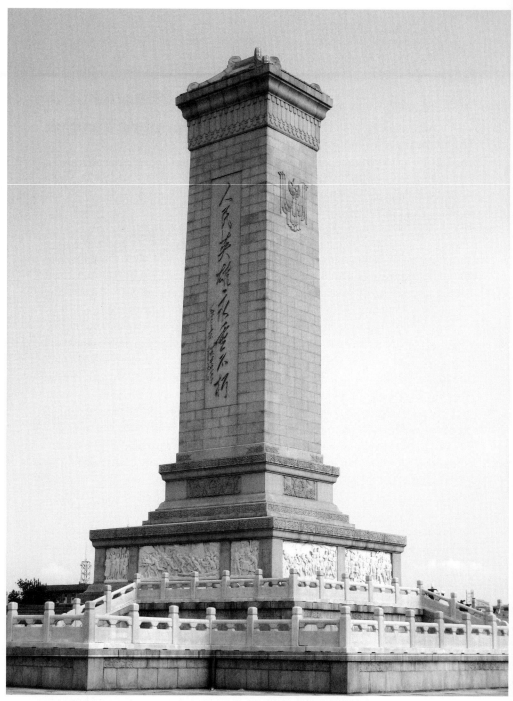

Figure 62. The Monument to the People's Heroes, Tiananmen Square. *Source*: Photo by author, July 31, 2004.

Architecture

The CCP's decision to build a war monument in the nation's capital was not without controversy, for the act of commemoration inevitably raises the question of the nature of remembering. Which past events should be recalled? Should the memorial be celebratory, emphasizing victory, or admonitory, focusing instead on the brutality of war and loss of human lives? What type of structure would best represent the exhilarating sense of the rebirth of China after many decades of foreign invasion and civil wars?

Officially, the decision to build a monument in the capital to honor those who sacrificed their lives for the founding of a new republic was made by the Chinese People's Political Consultative Conference on September 30, 1949, the last day of its ten-day meeting in Beijing. The date was critical, for it was the eve of the historic founding of the PRC. Nominally, then, the idea of building a monument was not initiated by the CCP but by the CPPCC, a group of delegates representing twenty-three political groups convened by Mao to represent a broad popular base and, more important, to lend much-needed support to the new regime's legitimacy.

In fact, the proposal to construct a memorial to commemorate the dead was conceived much earlier. Although the exact date of the CCP's decision to build the monument remains unclear, according to Wu Liangyong, a Tsinghua University architect, "to prepare for the opening of the founding of the People's Republic, the Central Committee of the Chinese Communist Party had for some time organized experts to plan for the construction of a memorial."[5] Such a proposal no doubt reflected the Party's pressing need to justify its mandate to rule. Rousseau's question "What can make authority legitimate?" indeed lies at the heart of politics. A formidable physical structure in a sacred location erected by a new regime is one of the most conspicuous ways for that regime to proclaim its legitimacy.

Before October 1 the question of an appropriate site for the monument, perhaps the most critical aspect of the entire undertaking, was debated among government officials. Several locations were proposed—for example, Dongdan, Babao Hill, Yuanmingyuan—but the majority recommended Tiananmen Square, for it was here, many Communists argued, where China's new revolution made its debut. The recommendation was in keeping with the CCP's general interpretation of China's immediate past history. The Communists contended that it was in Tiananmen Square where student demonstrations on May 4, 1919, crystallized national grievances against foreign imperialism and triggered calls for a rejuvenated China. Mao Zedong openly proclaimed himself a follower of the May Fourth legacy. To him, the May Fourth demonstrations were "a movement of tremendous significance," for it "marked a new stage in China's bourgeois-democratic revolution against imperialism and feudalism."[6] The architectural

relics and the historical importance of Tiananmen Square also made it an ideal place to house the future memorial.[7] Equally important, as argued in chapter 1, the Communist leaders had planned to turn Tiananmen Square into a "people's square" in order to create a new political space in the capital. According to the Communists, the PRC was established to serve the people. Mao wanted to place the monument where people's celebrations of national events could take place. The construction of a monument fell well within this larger political blueprint.[8]

Although the monument site was officially selected in 1949, the unprecedented size of the undertaking and the government's inexperience with such a huge project led the Chinese officials to proceed slowly and cautiously. The government in 1952 sought help from Soviet experts, and at that time Mayor Peng Zhen requested that the Ministry of Culture hire Soviet artists experienced in this kind of work "to provide guidance."[9] Soviet advisers were never brought in, however, perhaps because the central leadership and the majority of the project participants saw the monument as a national symbol, and thus they were loath to call in foreigners. Existing sources so far reveal no evidence of Soviet participation in the monument project, although the city planner A. S. Mukhin was consulted on the possible impact of an earthquake on the structure of the obelisk.[10] In 1952 the state Construction Commission of the Monument to the People's Heroes (Renmin yingxiong jinianbei xingjian weiyuanhui) was created by Peng Zhen, and an assembled team of noted architects, historians, and sculptors set to work on overseeing the design and execution of the entire project. Peng Zhen headed the commission, with Zheng Zhenduo and Liang Sicheng serving as associate directors. Beneath them, several sections were given specific tasks: Liang Sicheng headed the architectural section, as well as being associate director; Zheng Zhenduo directed the art design; and historian Fan Wenlan (1893–1969) was responsible for placing the project in a proper historical context.[11] The new state agency was charged with promoting a new political agenda to affirm a society creating itself anew.

The actual construction of the monument did not begin until August 1, 1952, a date chosen to coincide with the commemoration of the twenty-fifth anniversary of the founding of the People's Liberation Army during the Nanchang Uprising on August 1, 1927.[12] The original plan was to complete the entire project by October 1, 1955, in time to celebrate the sixth anniversary of the founding of the PRC, and to cap the occasion with an unveiling ceremony officiated by Chairman Mao.[13] As it turned out, however, the project was not completed until 1958 because of numerous debates between officials, historians, architects, and sculptors concerning the shape of the stele, the historical events inscribed on it, and the giant reliefs reflecting those events. In the end, according to chief architect Liang Sicheng, all major decisions were made by the "central government."[14] From the beginning, the project was invested with political meanings. But how could a physical structure be used to commemorate the dead and at the same

time evoke feelings that the regime was a legitimate political order? In what way could the promises of a new socialist regime be conveyed through artistic and spatial means? These questions preoccupied Liang Sicheng.

As a patriot excited by the prospects of a new and peaceful China, Liang, with the aid of his wife Lin Huiyin, herself a talented artist, threw himself into the assignment with dedication and energy. Liang wanted a traditional Chinese-style monument. His idea of a nationalist structure no doubt came from the demand of a government-commissioned project that, in the 1950s, was strongly influenced by Soviet socialist realism and by Stalin's controversial directive that architecture must be "national in form and socialist in content."[15] Zhang Bo, Liang's student, argued that Liang's idea may well have been influenced by Mao, for, according to Zhang, Liang was particularly taken by Mao's contention that China's new democratic culture in the early years of the PRC must be "nationalistic, scientific, and popular," an idea that the chairman expounded in his essay "On New Democracy."[16] Mao's idea, of course, is in line with the theory of socialist realism. I would argue, however, that Liang, in designing the monument, paid scant attention to "socialist in content," focusing instead on "national in form."[17] His conception of a nationalistic memorial came more from his own intellectual reflections on the differences between Chinese and Western architectural traditions. As a scholar, Liang valued Chinese architecture greatly. He fervently believed that the future memorial should reflect the capital's architectural grandeur in keeping with its status as the nation's principal monument.

What exactly did Liang have in mind when he talked about a nationalistic memorial? Chinese traditional architecture, according to Liang, observed several fundamental rules of construction (or what he called "grammar" [*wenfa*]) and featured a number of unique aspects compared to Western traditions, among them the three-tiered structure (a raised platform, the main building, and the curved roof), a symmetrical balance, a southern exposure with the building situated along a north-south axis (so as to catch the maximum sunlight), bracket sets (*dougong*), and glazed tiles.[18] These features, he argued, must be carefully examined when designing the new monument. In planning, Liang and his associates sought inspiration from noted Tang dynasty steles (such as the Songyang Academy Stele in Henan and the Filial Piety Stele in Xi'an, Shaanxi).[19] "There is a long tradition in China of using engraved letters (*beiwen*) as the focal point of the stele," wrote Liang. "It is therefore most appropriate to follow this traditional layout [in designing the memorial]."[20] His admiration of traditional steles notwithstanding, Liang was critical of their size and appearance. In his view, "traditional steles were not only short but were also gloomy, lacking heroic spirit."[21] All these elements would have to be changed.

Besides proposing a distinct Chinese style for his project, Liang also wanted height, massive presence, durability, and a sense of harmonious balance. He

realized that monumentality could best be represented by altitude. Liang argued that a tall and imposing structure, which oversees and commands its immediate surroundings, could be used to represent the high aspirations of a young regime and energetically translate the new government's ideals into visible political symbols.[22] The completed monument was expected to be 40.5 meters high, a height that was deemed appropriate given the size originally planned for Tiananmen Square, which was to measure 200 to 250 meters in width.[23] But, as indicated in chapter 1, the final construction of the square, in 1959, measured 880 by 500 meters, much bigger than the initial projection, thus making the monument appear even smaller in this larger landscape.

The monument, Liang insisted, should also fall within the Chinese conception of spatial and architectural harmony and balance. In a 1951 letter to Mayor Peng Zhen, Liang contended that the traditional architectural layout of Tiananmen Square could be left intact. The projected monument, in his view, must be introduced into this preexisting spatial context in the least intrusive way. Instead of becoming a new extension of the square, the monument must be an integral part of it. The most important structure in the square, in the eyes of Liang, was Tiananmen Gate, a magnificent wooden building atop a gigantic horizontal structure. The projected monument should therefore be something quite different, in style as well as structure. It should be a vertical, towering stone construction. A close parallel was the Drum Tower and the Bell Tower on the northern end of the capital's central axis. The Drum Tower, argued Liang, because of its horizontal, wooden form, was in direct proportion to the Bell Tower, which was a vertical, brick building.[24]

Of course size and height go hand in hand in a great structure. Liang and his associates argued that the monument was to be built from the most sturdy natural material—granite—to ensure its durability and immense presence. Massive blocks of granite were harvested and hauled from the famous quarry in the Fushan region in Qingdao, Shandong province.[25] More than 17,000 pieces of granite were eventually used in the project, with a 14.7-meter, 60-ton slab occupying the central position of the monument.[26] At the base of the shaft were eight gigantic historical reliefs, depicting key moments in China's recent history. To emphasize its importance, the entire monument was supported by two Chinese-style *xumizuo* (decorated bases), embellished with the traditional symbols of pines, cypresses, chrysanthemum, and peonies representing longevity and distinction. Originally one terrace was proposed, but Liang and other architects recommended two to add strength and weight to the base. This double terrace served both as a solid and wider foundation and as a way to lift the monument off the ground, into the air, reinforcing its might and commanding position.[27]

Not everything went smoothly, however. The design triggered debates between architects (headed by Liang) and sculptors (headed by Liu Kaiqu [1904–93]). The architects preferred a traditional-style stele; the sculptors, however, felt that a

giant human figure as the center of the monument would best represent the heroic achievements of the Chinese people. After all, they argued, the purpose of the monument was to commemorate the war dead.[28] The two camps also differed on how the top of the monument should be designed. The sculptors again suggested an array of human figures, but the architects disagreed. Such an idea, they contended, was unorthodox and in sharp contrast to the traditional Chinese style. Moreover, the high elevation of the monument, they argued, would render the figures invisible to viewers on the ground. Most problematic of all, such figures would shift the focus away from the engraved letters at the center—the traditional heart of the monument—completely reversing the original intent of the design. It was a heated debate that drew the attention of high Party officials, including Premier Zhou Enlai.[29] In the end, the architects prevailed: the monument would be a Chinese-style stele with a traditional *luding* roof, that is, a flat top with four sliding slopes (what Liang Sicheng called "an architectural top").[30] This decision was prompted not only by the importance of projecting a nationalistic image in the style of a traditional stele but also to allow ample room for Mao's eight huge Chinese characters—"Eternal Glory to the People's Heroes" (*Renmin yingxiong yongchui buxiu*)—to be properly inscribed in the center of the monument.

Designers and government officials confronted yet another controversial issue during the construction of the obelisk, namely, the monument's orientation. Should it face south, in line with China's architectural tradition, which, as noted in the Confucian ritual text, *The Rites of Zhou,* stipulated that major buildings (especially palaces) be constructed along a north-south axis,[31] or should it face another direction? The issue was ultimately settled not by scholarly discussion but by a political decision. According to Wu Liangyong, Premier Zhou Enlai reasoned that once Tiananmen Square was expanded, people would normally enter the square from East and West Chang'an Avenues, which ran in front of Tiananmen Gate. The crowd would therefore gather not at the southern part of the square but at the northern part, precisely where people would have a better view of Mao's inscription in the center of the monument were it facing north. Finally, Mao gave his approval for the monument to face north.[32] On the surface, that decision may simply have been made for convenience and practicality, for it took into account the anticipated gathering of the masses during major celebrations. Yet, I would argue that it was a careful attempt by the Communists to emphasize the monument's revolutionary and antitraditional nature. At a height of 37.94 meters, 4.24 meters taller than Tiananmen Gate, the monument, representing the will of the people, overshadowed the Gate and the old Forbidden City (the monarchical past) both in height and symbolic importance. Whereas the old Forbidden City represented the bygone, often tragic past, the monument symbolized the promise of the future.

To emphasize the importance of this major undertaking, the government recruited the best craftsmen from all over the country, for example, stonemasons

from Quyang county, Hebei province, who were famous for their masonry skills.[33] The officials also steadfastly chronicled every step of the construction process in major newspapers and magazines, especially in the party-run *People's Daily*.[34] Located in the people's square, the government would like people to believe that the monument not only was a dedication to the people's heroes but also was constructed by the people. The term *jitizhuyi* (collectivism) was repeatedly used during the building of the memorial.[35] The *People's Daily* interviewed workers who participated in the project. A sixty-three-year-old stone-cutter named Pang, the paper told us, was tireless in devoting his energy to the project.[36] According to government officials, letters poured in from all over the country, voicing support for this unprecedented plan.[37]

The entire monument complex was completed and unveiled on Labor Day, May 1, 1958, just in time to mark the ninth anniversary of the nation's founding in October of that year. The memorial's three-tiered structure reflected its distinct nationalistic characteristics. Mao's huge characters, "Eternal Glory to the People's Heroes," following the traditional inscription design, graced the frontal part of the monument, facing north. At the back, facing south, was an epitaph drafted by Mao, issued in the name of the CPPCC and written in Premier Zhou Enlai's elegant calligraphy:

> Eternal glory to the people's heroes, who sacrificed their lives in the people's war of liberation and the people's revolution over the past three years!
>
> Eternal glory to the people's heroes, who sacrificed their lives in the people's war of liberation and the people's revolution over the past thirty years!
>
> Eternal glory to the people's heroes, who, from 1840, sacrificed their lives in struggles against domestic and foreign enemies to preserve the nation's independence and the people's freedom and well-being![38]

At 37.94 meters, the monument is one of the tallest structures in the square. "It commands the surrounding buildings," observes Zhang Bo, because it lies in the center of the square, equidistant from Tiananmen Gate in the north and Zhengyang Gate in the south.[39] Its centrality and towering presence announces its dominance and architectural importance. The Communists fully realized that a new political beginning involved a new definition of space, a space that needed to be carefully defined, reshaped and even invented.

History

The creation of a national monument is, of course, more than the construction of a mammoth obelisk in the middle of the capital. It is about something more intangible and powerful: the meaning of history, the correct way of examining the past, and ultimately the proper role of the CCP in a long line of dynastic succession. A decision was made by the Monument Commission to decorate the monument with eight reliefs, each with a different historical theme.

Responsibility for charting the proper course of Chinese history in the project

went to Fan Wenlan. Fan, a prominent Marxist historian, was ideally suited for the job. A veteran Communist since 1926, he was especially noted for his authoritative voice among leftist scholars in interpreting modern Chinese history. He was trained at Peking University, and, like many of his contemporaries, was appalled by the imperialist aggression in China since the nineteenth century. Early on he developed an interest in Marxism. Pursuing his socialist dreams, Fan traveled to Yan'an in 1940.[40] There he expressed his zealous devotion to Marxism and vocalized his often emotional stand on a Marxist interpretation of Chinese history, drawing the attention of Mao Zedong. Fan outdid all others in his ability to take a long and comprehensive view in examining Chinese history, as evidenced in his influential multivolume work, *A Condensed Comprehensive History of China* (*Zhongguo tongshi jianbian*).[41] Mao was also drawn to Fan's writings on modern Chinese history, especially those on the Taiping Rebellion. In his controversial 1943 pamphlet, *The Life of the Traitor-Butcher Zeng Guofan* (*Hanjian guizishou Zeng Guofan de yisheng*), Fan vehemently condemned Han general Zeng Guofan for what he called his "bloodstained" role in suppressing the Taiping Rebellion. The rebellion, many Communist historians believed, was a righteous uprising and a precursor of the CCP-led peasant revolution in the twentieth century.[42]

Echoing Mao's argument that literary creations cannot be dissociated from a proper class perspective (as expounded in Mao's "Yan'an Talks"), Fan Wenlan went a step further to emphasize the close ties between scholarship and politics. "The idea of separating scholarship from politics is erroneous," he asserted. "Scholarship must serve politics."[43] Not all historical periods were equally important, according to Fan. The proper view of historical study was, first and foremost, to "examine the history under the revolutionary leadership of the proletariat, and only then the old democratic revolutionary history led by the bourgeoisie."[44] In studying history, therefore, one must "stress the present and slight the past" (*hou jin bo gu*).[45]

As a historian, Fan Wenlan faithfully repeated official Communist policies, closely following the original historical framework that Mao had delineated in his essay, "On New Democracy," which, as previously stated, his followers later elaborated on, dividing modern Chinese history into two successive periods: the Old Democratic Revolution and the New Democratic Revolution. Given the limited space that the monument allowed, however, the question was which episodes in these two periods should be depicted?

In its initial meeting on July 18, 1952, the Committee on Sculpture, Art, and Historical Materials (Diaohua shiliao bianshen weiyuanhui), chaired by Fan Wenlan, first decided that the episodes selected must depict "a chronicle of nationalist liberation and struggle in modern China." Nine pivotal events were proposed: (1) the Opium War, focusing on both the Sanyuanli Incident against the British troops outside Guangzhou in 1841 and Commissioner Lin Zexu's burning of the opium; (2) the Jintian Uprising of the Taiping Heavenly Kingdom;

(3) the Boxer Uprising of 1900, defined as "a peasant movement against the imperialists"; (4) the Revolution of 1911, using the Wuchang Uprising as its central subject; (5) the May Fourth Movement, centering on the patriotic speeches of students in Tiananmen Square, and thus demonstrating "the link played by the intellectuals in the revolutionary movement"; (6) the First Revolutionary Civil War, emphasizing the worker's anti-imperialist struggle in the May Thirtieth Movement; (7) the Second Revolutionary Civil War, focusing on the Jinggang Mountains, the early rural base of the CCP, and the Long March; (8) the War of Resistance, featuring the Battle of Pingxing Pass against the Japanese invasion in 1937; and (9) the Yangzi Crossing to liberate the Guomindang capital of Nanjing in the War of Liberation.[46]

In the second meeting a week later, the committee, after long deliberation, added one more episode: the February 7, 1923, Beijing-Hankou Railway Workers' Strike. This event would be placed right after the May Fourth Movement, giving additional weight to the role played by the proletariat in the formative period of the CCP. The primary depiction of this episode was to be the execution of the strike leader Lin Xiangqian by the warlord troops.[47] This proposal was later revised to highlight the workers' resistance as a whole, rather than Lin's execution alone, thus making it conform to the other nine episodes, which stressed united action, not individual sacrifice.[48] In the ensuing weeks, the participants were embroiled in heated debates, unable to agree on which episodes were most essential and which might be omitted. Because of limited space, Fan Wenlan even suggested merging the May Fourth Movement and the February 7 Workers' Strike into a single relief.[49] The final decision again rested with the central leaders, from whom the committee sought advice and received final approval.[50] On January 19, 1953, Mao sent the following instructions: the Boxer Uprising was to be replaced by the First Sino-Japanese War of 1894; the Jinggang Mountains was to be replaced by the Nanchang Uprising; and the Battle of Pingxing Pass was to be replaced by Yan'an. Mao also suggested that a better theme than the Sanyuanli Incident could be found.[51] The debates continued for almost two years; not until November 6, 1954, did Mayor Peng Zhen, with the approval of the CCP's Central Committee, finally decide on the eight historical events to be included: the Opium War; the Taiping Rebellion; the 1911 Revolution; the May Fourth Movement; the May Thirtieth Movement of anticolonial demonstrations in 1925; the Nanchang Uprising; the War of Resistance against Japan, with an emphasis on the Communists' guerrilla warfare; and the Yangzi Crossing by the Red Army in the civil war against the Nationalists in South China.[52]

Why these eight? By choosing the Nanchang Uprising of 1927 over the Jinggang Mountains, the Communists wished to emphasize the paramount importance of the founding of the Communist military force, even more so than the first Communist rural base. The War of Resistance against Japan was selected over Yan'an because it stood for a better and far more powerful image of a united China than the latter. Such an image carried special weight in the

early years of the PRC, when the new regime repeatedly stressed the necessity of national unity in building a new nation. Topics such as the Battle of Pingxing Pass and the Long March were eliminated because they were single events, whereas the War of Resistance was comprehensive in scope. Mao's January 1953 instructions unmistakably favored common themes over specific events. An even simpler rationale might have been the lack of space on the monument, requiring that tough choices be made. This might explain why ultimately the Boxer Uprising was not included.

The eight events on the monument are those the Communists consider the major turning points in modern Chinese history.[53] They were, according to the Communists, progressive episodes, moving forward in an irreversible direction and leading eventually to the ultimate triumph of the CCP in 1949. The eight scenes tell the familiar story of the Chinese people's determined and persistent struggle against evil forces. They depict stark contrasts in order to convey a clear, uncomplicated message: good (Chinese) against bad (foreign imperialists), peasants (Taipings) against the corrupt regime, revolutionaries against the reactionary Qing government (the Revolution of 1911), patriots (the May Fourth students) against international injustice, workers against foreign capitalists (May Thirtieth Movement), Chinese defenders against Japanese invaders (War of Resistance), and proletarian forces against Chiang Kai-shek's repressive Nationalist government. These simple contrasts immediately strike a chord in the viewer, which is what the Communists and the designers had in mind.

It seems only natural that the eight selected historical themes are overwhelming military in nature, since the monument was originally conceived to honor the war dead. With the exception of the May Fourth Movement and the May Thirtieth Movement, all were armed conflicts against an identifiable enemy or enemies: the Opium War was against the British imperialists, the Taipings and the 1911 Revolution were against the Qing government, the War of Resistance was against Japanese invaders, and the Yangzi Crossing was against the Nationalists. Although both the May Fourth and the May Thirtieth movements were not military in nature, they were militant in spirit. They were fervent anti-imperialist events with profound repercussions in China. This emphasis on military events largely reflects the Maoist philosophy of war. Mao saw armed conflicts as defining moments in human history, and he viewed these conflicts through a political lens. According to Mao, wars contributed to the progress of history by overthrowing the ruling classes and mobilizing oppressed people at all levels to take justified action. Modern Chinese history, as Mao repeatedly emphasized, advanced through different stages of armed struggle.[54]

The monument clearly emphasizes the present, not the past. Three of the events occurred before 1919—the Opium War, the Taiping Rebellion, and the Revolution of 1911; five—the May Fourth Movement, the May Thirtieth Movement, the Nanchang Uprising, the War of Resistance against Japan, and the Yangzi Crossing by the Red Army—however, took place in the period of

the new revolution during which, the CCP claimed, the Communists took a decisive leadership role. The final decision to devote more space (and thus importance) to the present over the past perhaps also explains why themes such as the First Sino-Japanese War and the Boxer Uprising were excluded at the end. Highlighting the present over the past was obvious and deliberate. Such a view echoed Fan Wenlan's argument that the correct way to study history is to "stress the present and slight the past"; but, more important, it was in line with Mao's own conception of modern Chinese history. To lay stress on the present is of course to accentuate the importance of the CCP's correct leadership in guiding the Chinese revolution to its final victory.

There is also the question of victory over failure. Before the Revolution of 1911, Mao argued, China's struggles against imperialist powers and feudal forces "all ended in failure"; only when they "learned Marxism-Leninism did the Chinese people cease to be passive in spirit and gain the initiative."[55] In short, if past struggles yielded disappointing results, the more recent battles under the leadership of the CCP produced triumphs.

Among the five historical themes reflecting the present, the last one (and hence the most recent), the Yangzi Crossing, is surely the most important. It is depicted in the frontal piece that faces Tiananmen Gate. The weight of the present is in fact spelled out in Mao's emotional inscription on the monument, which begins by commemorating those who died in the most recent liberation wars and then reflects back on those who perished in the Opium War.

Hegemonic manipulation of the past by state, church, or Party is common in history. Rulers selected, simplified, rewrote, or emphasized a certain period or a past event to meet their own political needs. The emphasis is therefore less on what actually happened than on what should have happened in keeping with a set of prescribed political ideals and goals. History is an infinitely malleable text to be reshaped in the hands of politicians in order to meet their urgent needs at the time.

Sculpture

Public art must connect to its audiences to draw life and staying power. It cannot remain abstract or cerebral if it intends to generate an emotional impact. Similarly, monuments cannot simply be described, studied, or discussed; they must be seen, felt, and ultimately experienced. State memorials require a human face to inspire and elicit visceral responses. The task of furnishing an identifiable human face was given to the artists and sculptors who were supervised by an art committee. Headed nominally by Zheng Zhenduo, in reality the committee's two associate directors—the veteran Yan'an woodcut artist Yan Han and the French-trained sculptor Liu Kaiqu—did the actual artwork, which comprised eight gigantic reliefs at the base of the monument corresponding to the eight historical themes dictated by the Party.

The artistic composition proceeded in two steps. Before the sculptors started on the reliefs, a team of artists developed imaginative designs illustrating the eight historical events. Yan Han called for assistance from a group of noted painters, including Ai Zhongxin (1915–2003), Dong Xiwen, and Feng Fasi (1914–2009). Ai was in charge of the initial sketch for *The Opium War*, Dong for *The Revolution of 1911*, and Feng for *The May Fourth Movement*, leaving the most important depiction on the monument, *The Yangzi Crossing* to Yan Han.[56] Several drafts were made and then sent, through the mayor's office, to the CCP's Central Committee for endorsement. According to Yan Han, only after Mao gave his final approval did the sculptors begin working on the reliefs, turning the drawings into intense facial expressions and forceful gestures, and giving the sculpted human bodies the appearance of vivid immediacy and compelling realism.[57]

The sculptor team was headed by Liu Kaiqu, who had a distinguished record as a sculptor, a profession that drew little attention until after 1949.[58] Liu received his early training in art, especially oil painting and sculpture, in Beijing. In 1928 he went to Paris, the mecca of art in Europe, where he enrolled at the École des Beaux-Arts, studying under the noted French sculptor Jean Boucher.[59] Under Boucher, Liu studied the most outstanding works of French sculpture available, especially the masterpieces of Auguste Rodin and Aristide Maillol. Among Western masters, Rodin became his most admired hero. The Manchurian Incident in the autumn of 1931 drew his attention to China. Liu decided to return home in June 1933 to respond, in his own words, to "the call of the motherland."[60] After his return, Liu became a teacher of sculpture at Hangzhou Academy, a renowned center of Chinese art. Appalled by the Japanese aggression, his works were imbued with a strong nationalistic flavor. One of the pieces he created in 1935 was the noted "Monument to the Fallen Soldiers of the Shanghai Campaign [against the Japanese attack] in 1932," widely praised as the first major modern memorial designed by a native artist.[61] With the founding of the PRC, like Liang Sicheng and Fan Wenlan, Liu Kaiqu joined the monument project with enthusiasm. As associate director of the project's artistic team, he was aided by a group of young and talented sculptors, including Hua Tianyou (1901–86), Zeng Zhushao (b. 1908), Wang Bingzhao (1913–86), Fu Tianchou (1920–90), Wang Linyi (1908–97), Xiao Chuanjiu (1914–68), and Zhang Songhe (1912–2005). Of the eight, four were trained in France (the others were Hua, Zeng, and Wang Linyi), indicating the dominant influence of the French school in Chinese sculptural circles.

The design and carving of the huge reliefs took four years to complete. In the end, eight big reliefs and two smaller ones were done on white marble, brought from Fangshan, Hebei: *The Opium War* by Zeng Zhushao and *The Taiping Uprising* by Wang Bingzhao occupy the eastern part of the monument, facing the Museums of Chinese History and of the Chinese Revolution; *The Revolution of 1911* by Fu Tianchou, *The May Fourth Movement* by Hua Tianyou, and *The*

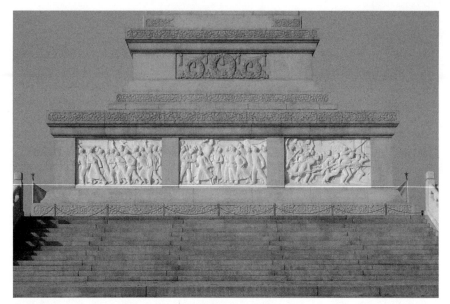

Figure 63. The back of the monument, which faces south toward Zhengyang Gate, displays three historical reliefs: *The Revolution of 1911* (right); *The May Fourth Movement* (center); and *The May Thirtieth Movement* (left). *Source*: Photo by author, October 13, 2002.

May Thirtieth Movement by Wang Linyi face south toward Zhengyang Gate; *The Nanchang Uprising* by Xiao Chuanjiu and the *War of Resistance against Japan* by Zhang Songhe are on the western part of the monument, facing the Great Hall of the People; and Liu's *The Yangzi Crossing*, the center piece, faces north, directly opposite Tiananmen Gate (figure 63).

The eight reliefs were designed on a grand scale. Each at a height of 2 meters and together totaling 40.68 meters in length, they were not meant to be viewed in aesthetic isolation but as a totality, a continuous flow of events stamped with a clear historical destiny. In terms of development, they run clockwise from the east, and reach a triumphant conclusion on the north. In Fu Tianchou's words, "The reliefs are united into a coherent whole." But Fu was also quick to point out that because each of the eight reliefs was designed and carved by an individual artist, each retains its artistic individuality.[62] The notion of artistic individuality was emphasized even more strongly by Liu Kaiqu. Influenced by Boucher, Liu argued in a similar vein that sculpture must be "a creative art, or it will go nowhere."[63] But did the reliefs exhibit distinct personal characteristics, as Fu and Liu suggested? In the end, the final result revealed something quite different, namely, conformity over individuality, politics over art, the result of the increasing role played by Soviet socialist realism, which left little room for artistic creation.

As discussed in chapter 6, the genre of oil painting in China in the 1950s was

strongly influenced by Soviet socialist realism. Likewise, sculpture faithfully adhered to the Soviets' official doctrine. Works by noted Soviet sculptors such as Vera Mukhina were greeted with enthusiasm. Chinese artists were instructed to model their work on that of the Soviet masters, as clearly defined in the writings of Zhou Yang, the influential vice minister of cultural affairs.[64] Now Liu Kaiqu's models were no longer Rodin and Maillol but Mukhina and Nikolai Tomski, especially the former, whose immense sculpture *Worker and Collective Farm Girl*, a celebrated work originally placed atop the USSR Pavilion at the World Exposition in Paris in 1937, had a strong impact on Chinese sculptors. Mukhina's sculpture, a work of dynamic forward movement, depicts a worker and a peasant woman brandishing a hammer and a sickle respectively. It demonstrates an ideal socialist sculpture: the celebration of the achievements of Communism. And there were other salient features of socialist realism in art that Chinese artists would have to study faithfully and attentively: the ideals of collectivism, the joys of production, the wise leader (usually an imposing presence, standing tall and pointing the way to a glorious future), the resolute and selfless spirit of the Red Army, the muscular human body, and the spirit of optimism about an assured bright tomorrow. The exhibit in Beijing in the fall of 1954 of a smaller replica of Mukhina's *Worker and Collective Farm Girl* and Tomski's portrait of Gorky, among others, at a well-publicized, large-scale exhibition of the Soviet Union's economic and cultural achievements brought the Soviet style even closer to home.[65] Liu Kaiqu visited the exhibition and was deeply impressed by Mukhina's masterpiece. "Soviet sculpture," lauded Liu, "represents the superiority of the Soviet social system as well as the diligence and courage of the Soviet people." "Let us learn from Soviet sculpture," Liu emphatically concluded.[66]

The remarkable realism and simplicity of these eight reliefs, exactly the government officials' intention, clearly reflects the strong influence exerted by socialist realism. Art serves politics best when it is straightforward, when the viewer, without ambiguity, readily sees the message behind the image. The reliefs emphasized themes of critical importance to the government: the people's determined will against foreign aggression, the spirit of grassroots collectivism, the indomitable spirit of the People's Liberation Army, and the prevailing nationalistic sentiments. Ultimately, the reliefs conveyed an unmistakable message, namely, that it was the CCP that provided the leadership in China's long and painful quest for independence and national sovereignty.

Zeng Zhushao's *The Opium War* retells a famous episode of Commissioner Lin Zexu's destruction of thousands of trunks of confiscated opium from foreign traders in 1839 (figure 64). The incident triggered the notorious Opium War and forever changed the fate of modern China. The relief is a scene of fierce activity, with dozens of Chinese workers opening trunks of raw opium and dumping them into huge trenches to be destroyed. With rolled-up sleeves and bare chest, one worker is holding an axe in his hand, ready to smash open yet another opium trunk; one of his fellow workers is signaling others to bring more trunks

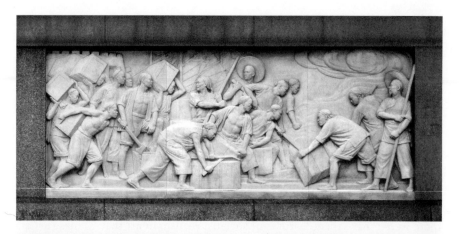

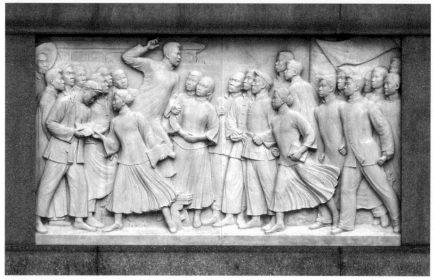

(top) **Figure 64.** Zeng Zhushao, *The Opium War*. *Source*: Photo by Ming-mei Hung and Ming-yang Hung, August 1, 2009.

(bottom) **Figure 65.** Hua Tianyou, *The May Fourth Movement*. *Source*: Photo by Ming-mei Hung and Ming-yang Hung, August 1, 2009.

forward to be discarded. Flames are billowing from the ditches. The figures, in the style of socialist realism, are realistically drawn configurations of muscle and fury. Their carefully delineated faces and hands reflect the intensity of their activities, and their determined look evokes rage as well as struggle against foreign exploitation and immorality.

Hua Tianyou's *The May Fourth Movement* expresses a different kind of action (figure 65). Against the background of Tiananmen Gate, a group of students are assembled to denounce the imperialist aggression in China. Standing on the

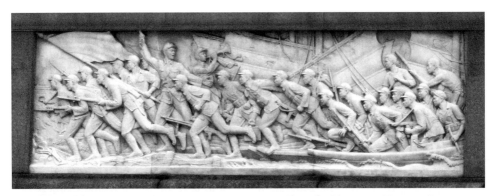

Figure 66. Liu Kaiqu, *The Yangzi Crossing. Source*: Photo by Ming-mei Hung and Ming-yang Hung, August 1, 2009.

bench is a male student in a Chinese long gown making an impassioned speech, his audience in rapt attention. Others are distributing leaflets, calling for support. In this monumental event, women comrades are equal and enthusiastic participants. Wearing pleated skirts, they are working in unison with their male counterparts to spread a patriotic message to the crowd, exhibiting boundless energy and firm commitment. In so doing, they symbolically break away from their traditional role of restrictive and submissive femininity, marking the dawning of women's liberation in China. The artist's careful physiognomic studies and his close attention to details of clothing make this an outstanding piece.

Liu Kaiqu's *The Yangzi Crossing*—the final and the most important of the eight pieces—brings the pictorial narrative to an exhilarating conclusion: the People's Liberation Army successfully crossing the Yangzi River to liberate South China (figure 66). With bugles and red flags, makeshift junks, and the help of ordinary fishermen, Communist troops make a daring crossing of the river in April 1949 to capture Nanjing, the Nationalists' capital. The soldiers' faces exude a combative spirit and determined will. Weapons in hand, they charge intrepidly ahead toward the enemy camp, fighting not only to vanquish their enemies but, more important, to help establish a new nation in China. They are not alone in their noble campaign, for they are enthusiastically supported by the people. *The Yangzi Crossing* is flanked by two smaller reliefs on each side: *Aiding the Front* and *Celebrating the Liberation*. These are scenes of ordinary people supporting their beloved troops, ensuring the CCP's eventual triumph.

The highly realistic reliefs, with touches of symbolism (in *The Wuchang Uprising*, the statue of a lion represents the yamen, or office, of the Qing government), correspond to the eight historical events they portray. Each clearly demonstrates the highly emotional style of socialist realism: a determined tilt of the head, clenched fists, fixed gaze, and militant posture. Together they weave a pictorial, emotional narrative of modern Chinese history from the Opium War to the Communist victory in 1949. But just what do they tell us? "Much

of the world's public art—memorials, monuments, triumphal arches, obelisks, columns, and statues," observes W. J. T. Mitchell, "has a rather direct reference to violence in the form of war or conquest."[67] These reliefs, however, have a different ring. The images do not dwell on the brutality of war—the dead, the orphans, the maimed, the bereaved, or what Otto Dix describes as "the work of the devil." Nowhere is the horror and inhumanity of organized violence explicitly or implicitly depicted. In fact, scenes of combat are conspicuously absent and enemies are merely implied. We find no villains in the reliefs such as Chiang Kai-shek, nor do we find any scenes of atrocities committed by the invading Japanese soldiers. Battle scenes are depicted not to reveal the brutality of war but to portray the courage, honor, and determination of the Chinese people's struggle for a just cause. Death is not mourned; it is suggested, even celebrated. For it is the noble death and the theme of the nation's rebirth that underscore the entire project. Unlike most war memorials (such as the Vietnam Veterans Memorial in Washington, D.C.), which provide a place where people can grieve, the Monument to the People's Heroes is where people celebrate.

Although the eight reliefs are populated with human faces, no one is identified. Among the more than 170 figures portrayed, for example, there is no Lin Zexu, China's hero, in *The Opium War*, nor do we find Communist commanders He Long (1896–1969) and Ye Ting (1896–1946) in *The Nanchang Uprising*. Reflecting on his own piece, *The 1911 Revolution*, Fu Tianchou wrote, "My work depicts no leaders among the revolutionaries; instead, its emphasis is on the consciousness of the participants."[68] The intention of the artists was clear: heroes in the reliefs refer not to the kings and generals who are conventionally described as shapers of history but to the common soldiers and ordinary people who sacrifice their lives for the good of the nation. "Who are the masters of history?" Fan Wenlan asked, and then emphatically answered, "The laboring masses are the masters of history!"[69] In the reliefs peasants, workers, and soldiers occupy center stage. The message of *Aiding the Front* and *Celebrating the Liberation*—the two smaller pieces flanking *The Yangzi Crossing*—is clear: without the wholehearted support of the people, the eventual triumph of the Communist troops cannot be guaranteed. Such a message reinforces Mao's belief that "weapons are an important factor in war, but not the decisive factor; it is people, not things, that are decisive."[70]

Ironically, the effectiveness of the realistic portrayals of human figures and scenes in the reliefs are undermined by their unrealistic nature. The armed conflicts depicted are too one-dimensional and artificial to have any real emotional impact. By emphasizing only the positive facet of armed conflict, the artists deprive war of its most human and terrifying dimensions: the carnage, loss of lives, and enormous emotional toll. As a result, the scenes make war painless and untrue, sanitized and romanticized as they are by the artists and Party officials. The pictorial representations offer the public a chance to be instructed, but not to participate and experience true emotion.

Artistically, the eight reliefs are surprisingly alike and monotonous. The people who make up the crowd in Wang Linyi's *The May Thirtieth Movement*, for instance, display similar emotions and gestures, lacking any psychological substance and depth. One Chinese art critic commented, "All the relief panels look pretty much the same, and it cannot be distinguished who did what."[71] The angry but orderly crowd, the neatness of the charging troops, and the carefully arranged scenes make the reliefs forced and artificial. The Party's demand for a strict political rendering of pictorial images severely restricted the artists. Individuality was discouraged, creativity forbidden. Although Liu Kaiqu and many of his colleagues had been inspired earlier by Rodin's work (Liu once praised Rodin's style as "majestic")[72] and had admired Rodin's ability to give body movements in his sculpture, their pieces, falling under the ultimate sway of Mukhina and Tomski, were political in execution and restrained in spirit, showing little of Rodin's love of anatomical exaggeration (as in *The Thinker* and *Balzac*) and preoccupation with visions of life tormented by death and agony (as in *The Gates of Hell*). The artists' unvarying portrayal of heroic postures and scenes, following Party rules, makes their reliefs artistically inferior.

The Monument to the People's Heroes was the first of hundreds of its kind to be built all over the country after the founding of the PRC,[73] and yet it remains the most important national memorial ever created by the Chinese Communists. Its significance lay primarily in its location in the center of Tiananmen Square, where it dominated a consecrated space at the heart of the nation specifically reserved for dead heroes. Simply by being a war memorial it recalls the huge sacrifices that Chinese martyrs made in their struggle to liberate China from national humiliation. Although the monument was built to commemorate dead heroes, however, death was not explicitly portrayed but only implied. The eight reliefs express not the sadness and agony of loss but the glory of the national struggle in modern Chinese history. The purpose was thus to strike a commemorative and inspiring tone and not a macabre one, using the stele to address noble questions of mortality and the proper way to commemorate it.

As a state-sponsored repository of the national memory, the monument is an instrument of what social scientists call "integration propaganda," an attempt to legitimize the new regime and propagate its socialist gospel.[74] But did the plan work? As I argued in chapter 2, from the outset the Chinese Communists realized that architectural forms were one of the best means to evince their political power, as in the building of the Great Hall of the People. But as a piece of art, the monument suffers from the Party's stilted, inflexible views, so that, with few exceptions (e.g., *The May Fourth Movement*), the figures seem to have sprung from the same monotonous sculptural technique. The immense idealized figures can be admired but not experienced, for they lack emotional depth and sensitivity. The horrors of armed conflict are absent. Instead, they display the valor, sacrifice, duty, and honor of the soldiers, in line with Party

rhetoric. The underlying themes are celebrations of patriotism, nobility of arms, and sacrifice, and thus they are merely exercises in propaganda and hagiography. Ultimately, political art deprives war of its brutalities and hence its human dimension, rendering the historical events abstract and ineffectual. Liu Kaiqu did acknowledge his debt to Rodin and cherished the ideals of artistic freedom, but in the end he echoed the Party dogma.[75] As Yan Han confessed in a recent interview: "We artists created according to the [government's] needs."[76]

Although individual heroes were not depicted in the reliefs, and though the monument was touted officially as a product of the collective contribution of the laboring people, it was in fact an elitist creation, conceived by noted artists such as Yan Han and constructed by prominent architects such as Liang Sicheng and sculptors such as Liu Kaiqu. The craftsmen working in the field, including stonemasons Liu Runfang and Wang Ersheng, both from Hebei's Quyang county, were never mentioned in the official press. Their names remain buried in the archives, long forgotten.[77]

As a political production, the monument is a structure of contested codes and representations. By naming the memorial the Monument to the People's Heroes and by locating it in Tiananmen Square, the Communist regime has unexpectedly created a dangerous memorial space as well as a gigantic gathering place in the nation's capital. Ironically, the state's best interest is to portray itself as the representative of the people while forcefully disallowing them a voice, to uphold the memorial's literal meaning of honoring the common people's sacrifice while simultaneously denying their autonomous power. But the "People's Square" is by nature public, and a public space can never be dominated by a single, dictatorial rule from above; it can only be contested by multiple voices from below. Herein lies the major contradiction between the Party's design and popular demand. In the name of the people, Communist leaders attempted to monopolize the collective memory through the monument and to orchestrate mass events in the square to promote their own interests, for example, the tumultuous Red Guards' gatherings in Tiananmen Square to support Mao's radical causes during the Great Proletarian Cultural Revolution in the mid-1960s. Yet memory is highly elusive. Ordinary citizens often behave differently and unpredictably, not necessarily in line with the Party's will. In April 1976, during the traditional Qingming Festival of homage to ancestors, thousands flocked to the monument to lay wreaths and to write poems commemorating the widely respected, by then deceased premier Zhou Enlai in an act of protest against radical leaders, later known as the Gang of Four. The monument, the only visible structure in Tiananmen Square, served both as a convenient rallying point and a symbol of protest against the Communist officials. Likewise, in April 1989, the death of Hu Yaobang (1915–89), the ousted but respected party secretary-general, brought thousands of students back to the square. Again wreaths and flowers were laid at the monument to mourn the death of Hu, and this time to call for an end to corruption in the Party and to demand economic and democratic reforms. The

ensuing brutal suppression of the democratic movement on June 4 is another instance of the continuing contest between the CCP and the common people in their battle to control the square and the monument.

As a physical structure representing the nation's memory, the monument's symbolism is never fixed; it shifts with the ever-changing political wind. The Chinese Communists are well aware that a complex work of public art such as the Monument to the People's Heroes encompasses a number of contested codes and representations, for example, a government-sponsored project versus a memorial honoring the people; the history of the Communists versus the history of the Nationalists; the present versus the past; the glory versus the brutality of war; architects versus sculptors; the stele in nationalistic design versus the reliefs patterned on Soviet socialist realism. They also fully understand that a memorial placed in an uncertain ceremonial arena must be subject to constant surveillance. To reaffirm their legitimacy to rule, the Communists cannot allow competing ideas to coexist; they must exercise absolute control. But as long as the monument was built to commemorate the sacrifice of the people and to represent the people's interests, the people will always have a right to reclaim it, despite the government's wish. As a result, Tiananmen Square in general and the Monument to the People's Heroes in particular will remain a perpetual political and cultural battleground between those who rule in the name of the people and the people themselves.

Conclusion

The story of the Chinese Communists' consolidation of power in the first decade of the People's Republic is a vast, complex tale. In this book I have examined the CCP's creation and reinvention of myriad political-cultural forms intended to reshape China in terms of new shared values and collective visions. Emphasizing the close interaction between politics and culture, I have argued that Mao and his senior Party members created a new political culture infused with a nationalistic ethos that helped cement their grip on power.

Running through these political-cultural forms are three interrelated themes: Soviet influence, nationalistic appeals, and the authoritarian rule of the CCP. Soviet advisers who arrived in throngs in China in the early 1950s were crucial to the CCP's plans for nation building. These foreign experts were a strong presence in city planning, the expansion of Tiananmen Square, the construction of museums, and the introduction of new art forms. But they also brought along their preconceived ideas of how this disciple nation should be built, patterned on their own Soviet models. Mao and his senior colleagues, however, were never comfortable with the foreigners' presence and influence. They sought a different path by building their legitimacy on nationalistic appeals to China's sovereignty and independence. That approach dated back to the Communist leaders' Yan'an years, when Mao called for the sinification of Marxism to underscore the supreme importance of letting foreign ideologies serve only China's practical and immediate needs.[1] Thus Soviet models were never blindly followed, and, on many occasions, they were either rejected by Chinese officials or appropriated for their own use. This stand was made even more explicit, as mentioned earlier, when Beijing mayor Peng Zhen, in discussing the future city planning of the capital in 1956, uttered his famous remark, "We cannot always follow the actions of others." In standing on their own, the Chinese Communists built a mammoth Tiananmen Square, distinct from Moscow's Red Square, and continued to emphasize indigenous cultural and artistic forms. Nevertheless, the championing of nationalism was merely a means to achieve the clear political goal of consolidating the CCP's rule and developing the best methods to achieve that aim. To this end, the officials transformed the nation into a propaganda state

through carefully planned projects that included constructing massive buildings, writing an orthodox history of the Chinese Communist Revolution, building a memorial in the middle of Tiananmen Square, and staging annual national parades. However, the Party was not a homogeneous group with a single view, and so its strategies did not run as smoothly as the official media claimed at the time. This book reveals the intense debates that arose between senior Party officials, top bureaucrats, intellectuals, and artists over cultural policies as different committees planned and implemented these government-sponsored projects. Meanwhile, the highest authorities regularly intervened in the proceedings, attesting to the importance of these projects to the CCP's central leadership.

The New Political Culture

Throughout the entire gamut of Chinese Communist revolutionary rhetoric, the most compelling and succinct pronouncement was Mao Zedong's declaration in September 1949 at the Chinese People's Political Consultative Conference: "The Chinese people have stood up!" Mao's proclamation brought an end to China's protracted history of war, destruction, social dislocation, and humiliation inflicted by foreign aggressors. This memorable slogan and powerful metaphor became a reality on October 1, 1949, when Mao stood atop Tiananmen Gate and announced the founding of the sovereign People's Republic of China. Scholars have argued that the Bolshevik revolutionaries who seized power in Petrograd in October 1917 did not at first perceive their success as the establishment of a new Russian nation. As Marxist internationalists, however, Lenin and his associates thought in terms of class struggle, imagining that their proletarian revolution would soon spread throughout Europe.[2] In China's case, Mao's slogan spoke to the contrary: the Chinese Communist Revolution, though still seen as part of a world socialist revolution, was predominantly the establishment of a new independent nation.

The creation and expansion of the vast political space of Tiananmen Square at the heart of the new capital was one of the initial steps to confirm the CCP's power in the early 1950s. Once Mao Zedong and his close aides were securely installed in Zhongnanhai in the old Forbidden City, the sacred square adjacent to it immediately acquired the aura of an inevitable Communist victory. Tiananmen Square was expanded to mammoth proportions. Contrary to the advice of Soviet advisers but in line with the original indigenous conception of a rectangular form, the "people's square," as the Chinese Communists called it, ultimately surpassed Moscow's Red Square in size and majesty. Equally important, the Ten Monumental Buildings that were built in the late 1950s were other potent manifestations of the Party's grand vision expressed in colossal architecture. The square and the commanding buildings, vast in scale and dramatic in effect, offered an ideal means to celebrate the glorious achievements of the CCP and to inculcate a sense of national identity.

The new political culture was also played out in theatrical festivals in the form of annual state parades on Labor Day and National Day, in the 1950s, in Tiananmen Square and China's other major cities. There is no denying that the Communists wanted to put on a good show, for annual parades were highly public displays, designed to be viewed by the controlled masses and aimed at impressing them with multicolored floats and red banners. But these parades, tightly monitored and embodying discipline and order, differed markedly from the spontaneous, carnivalesque spirit commonly found in the West. The state festivities were never the celebration of a free people. Instead, they were the key instrument through which the Party remade itself.

History writing was another forceful means to render a reconstructed story of the CCP's eventual triumph in 1949. In addition to the official history texts that state publishing houses issued to tell its own success story, the Party retold the same revolutionary tale through displays of carefully chosen artifacts and the commissioning of oil paintings to be hung in the Museum of the Chinese Revolution. This institutionalization of memory by artifacts in a state institution assured the paramount role of the Communist leaders, Mao in particular, in realizing the socialist dream in China.

Pictorial images were yet another form for linking power with representation in the CCP's new political culture in the 1950s. Early in its history, especially during the Yan'an days, the CCP recognized that pictorial means were the best way to communicate with the masses, particularly in the countryside where there was a high rate of illiteracy. As a result, a host of artistic forms were tied closely to political socialization efforts. In the young PRC, the popular art forms of cartoons and serial picture stories took center stage in the Chinese Communists' anti-Guomindang and anti-imperialist campaigns. The demonization of the enemies in these two genres was closely tied to the government's policies, as seen in the deploring of U.S. military intervention in Korea and the Resist America, Aid Korea Campaign. On the other hand, because nianhua prints were a time-honored way of celebrating congratulatory occasions, they were used to depict the cheerful side of a new society.

Finally, the politics of commemoration were as important a means as the celebrations of National Day in reaching out to the public. For the CCP, acts of remembrance and festivities were two sides of the same coin in reenacting, through group participation, a shared past that would otherwise gradually fade over time. Eulogizing the martyrs, building Babaoshan Revolutionary Cemetery in western Beijing, and erecting the Monument to the People's Heroes in Tiananmen Square were thus viewed as major components of the political education of the masses. These practices employed the rhetoric of heroism, selflessness, and undaunted spirit to reconfirm the subordination of the living to the spirit of the martyrs, the citizens to the state, and the rank and file to the Party leadership.

Organization and Mass Mobilization

My contention in this book is that the new political-cultural campaigns in the early PRC would have been impossible without the Party's organizational networks of propaganda, always with the military at its disposal. Lenin's main contribution to Marxism, as he wrote in 1902, was that a tightly organized party of dedicated activists was absolutely necessary for a revolution. Successful revolutionary activities could only be conducted by a centrally controlled and hierarchically structured organization.[3] Similarly, the CCP's political-cultural activities in the 1950s were mounted through a series of rigidly controlled Party organizations.

As a Leninist organization, the CCP appeared no different from other Communist parties in its use of highly organized activities and calculated tactics to enhance its power. But what distinguished it from others, as many scholars have pointed out, were its flexible strategies and serious efforts to educate the masses politically through myriad channels, including regular group studies or group criticism. The Party used such institutional control to great effect, much more so than its Soviet counterpart.[4] During the War of Resistance against Japan, the CCP responded to the exigencies of the time such as the Second United Front by using its creative and adaptive organization to mobilize the masses and establish its political base in different localities; it did so, for example, by mediating regional military disputes and forming alliances with village elites.[5] This technique also worked efficiently in its military campaigns during the civil war against the Nationalists in Manchuria, which proved vital to their eventual victory in 1949.[6] The organization worked underground as well, even attending to the most minute details. For example, before Communist troops officially entered newly liberated Beiping in early 1949, the CCP's Military Occupation Commission instructed the soldiers: "All along our policy [has been] clandestine and [has] not exposed us. . . . Before entering the city, bring [your own] rice bowls, chopsticks, pans, and kettles. If these are borrowed from the people, it can easily generate ill feelings among them."[7]

In the new political-cultural campaigns examined in this book, two organizational agencies were paramount: the Propaganda Department of the Party's Central Committee and the Ministry of Culture in the State Council. The Propaganda Department, the official ideological gatekeeper, which was headed by Lu Dingyi, set the agenda and gave general instructions. In the construction of the Museum of the Chinese Revolution, the Propaganda Department defined the general ideological framework within which the museum should be set up, specifying the correct display of items. Controls were also precise, as when the department reminded the parade organizers in the Beijing Municipal Party that the authority for creating parade slogans rested with central Party officials. The Ministry of Culture, headed by the renowned novelist Shen Yanbing, played a supporting role in dispensing detailed instructions and overseeing particular

projects, such as the formulation of the nianhua prints policy in late 1949 and the mounting of the cartoon attack against Western imperialists through official print media. The Propaganda Department and the Ministry of Culture imposed vigilant supervision to ensure that decisions were made by top Party officials to prevent deviations from the approved course. Through the creative use of an array of political-cultural forms, the CCP invented its own legitimization by mobilizing the masses, in whose name the Party proposed to rule. This process, in the 1950s, was enthusiastically supported in many ways by revolutionary intellectuals, who were, above all, propagandists working to persuade others to follow the Party line.

The propagandists, whether the chief propagandist Lu Dingyi or party functionaries, played the roles of instructors and supervisors to educate the masses in becoming active agents in the creation of a new socialist system. But who exactly were the "masses"? In her study of twentieth-century totalitarian systems, Hannah Arendt contended that "the totalitarian movements aim at and succeed in organizing masses—not classes" for political gain. Arendt described the masses as "politically indifferent," "atomized," living in "isolation," and lacking "normal social relationships"; cut loose from the safe anchor of traditional institutions, they were vulnerable to the appeals of mass leaders like Stalin and Hitler.[8] The PRC's mobilization campaigns, however, were cast in a more positive light, designed to shape a different kind of populace—a politically active throng whose energy could be harnessed as a revolutionary force to build a new nation. Further, by being allowed to participate in the grand rallies, people derive a sense of involvement and empowerment. The National Day parades were occasions to reenact the Chinese Communist Revolution and relive the glorious experiences of the past. Undoubtedly, the assembling of half a million marchers in Tiananmen Square on National Day was a spectacular sight. Such mass gatherings were highly significant, for, as Arendt observed, "totalitarian movements depend on the sheer force of numbers to such an extent that totalitarian regimes seem impossible, even under otherwise favorable circumstances, in countries with relatively small populations."[9]

The participation of the crowd, however, implies neither a widening of popular representation nor the people's genuine engagement in the decision-making process. Here the theory of French psychologist Gustave Le Bon, and again Lenin's, is helpful. In the late nineteenth century, alarmed by mass politics, Le Bon, whose theory of crowd behavior greatly influenced Hitler and Mussolini, was critical of the crowd. He observed that crowds were closely akin to "primitive beings," "always irritable and impulsive." They tended to go "at once to extremes" and to think in terms of "images."[10] In Le Bon's words, a crowd was "a servile flock that is incapable of ever doing without a master."[11] The art of rulership therefore depended on leaders who wielded "a very despotic authority" to understand and exploit the mentality of the masses.[12] One of their methods was to use images and words as a means of influence and domination. Le Bon's

"crowds" were driven by emotions, and he taught the political leaders to use theatrical means to direct and control them.

Le Bon's views resembled Lenin's, although the Soviet leader perceived crowd behavior from an entirely different angle, that of class struggle. Lenin had little faith in the masses to conduct a revolution. His idea of a socialist revolution, spelled out in *What Is to Be Done?* centered on an army of professional revolutionaries. The working class, in his view, could never move beyond trade unionism and would easily sink into the bourgeois quagmire unless they were directed by a disciplined revolutionary army. As such, Lenin's theory of the vanguard party opposed spontaneous action by the masses.[13]

The Chinese Communists, notwithstanding Mao's hyperbolic slogan "To serve the people," were inherently as contemptuous as Lenin was of the common people. The national parades, as I have argued, were not meant to be a festive event initiated freely by the populace but was, instead, intended as political theater carefully directed by the state. In the processions, as in other political-cultural forms, the masses became totally politicized. The merging of public objectives (represented by the Party) with the masses was tantamount to a denial of individual autonomy, subsuming everyone under a higher collective goal. Representing the Party, Mao assumed a supreme position atop Tiananmen Gate and was cheered by hundreds of thousands of paraders as he commanded their every move in the ritual theater of Tiananmen Square.

A Nationalistic Propaganda State

Peter Kenez saw the Soviet Union as a "propaganda state."[14] The description applies to the PRC as well, but with a strong dose of nationalism that was not evident in the Soviet Union at the time. China in the 1950s was a nationalistic propaganda state driven by a fervent desire to establish its own identity; this became even more pronounced in the late 1950s when the country's relations with the Soviet Union became severely strained. International politics, whether the armed conflicts in the Korean Peninsula in the early PRC or Soviet de-Stalinization in the mid-1950s, certainly influenced the development of new political-cultural forms throughout the 1950s. The Resist America, Aid Korea Campaign was a case in point. Mao and his senior colleagues were also politically committed to international socialism. They had no choice but to win critical support from the Soviet Union to guarantee China's security, and they were also eager to learn from the Soviets' advanced experience in a planned economy and industrialization. But I argue that nationalism was both the quintessence of and unifying force in these political-cultural forms.

A number of themes are discernable in this nationalistic campaign. In the first place, there was a remarkable continuity in the use of artistic symbols and techniques from the Yan'an era, during which left-wing activists drew heavily from the rural traditions of Shaanxi to fashion a propaganda strategy. The

original idea and directive, of course, came from Mao. The chairman's "Yan'an Talks" demanded that art should be subordinated to politics and that writers and artists must use their creative works to serve the people and the cause of socialism. Following Mao's directive, artists and propagandists used culturally specific symbols—yangge dances and the nianhua prints, for example—to depict stalwart soldiers, heroic workers, and contented peasants in fields of plenty. After 1949 propagandists continued to use these techniques with renewed vigor.

Second, nationalistic appeals were commonly associated with popular or traditional symbolic items—what the Chinese Communists called "familiar and pleasing items" (*xiwen lejian*), things that were homegrown, rooted in tradition, and easily comprehensible to the masses, in order to win their support. This was often done by the ingenious appropriation of time-honored emblems. The Monument to the People's Heroes, for example, was modeled after a Tang dynasty stele, and was embellished with pines and cypresses, popular symbols of longevity, to affirm a Chinese identity. Similarly, the traditional lotus dance in the grand parades, and the red lanterns and chrysanthemums—symbols of joy and prosperity—in Dong Xiwen's *The Founding Ceremony of the Nation*, were familiar objects that the local populace could easily identify with and embrace.

Third, inherent in these political-cultural campaigns was China's desire to go its own way in its development. Even with their pro-Soviet policy in the 1950s, Chinese leaders were never comfortable with close supervision from abroad, including from Moscow. China's past humiliating history of foreign domination was never far from the leaders' minds. Back in the Yan'an days, Mao had already warned against blindly following foreign models. He cautioned: "Many comrades . . . can only cite odd quotations from Marx, Engels, Lenin and Stalin in a one-sided manner, but are unable to apply the stand, viewpoint and method of Marx, Engels, Lenin and Stalin to the concrete study of China's present conditions.[15] Mao understood and manipulated China's past humiliations, for the people were both obsessed with and haunted by them, and did not seem to believe that things had changed even with the founding of a new regime. The CCP's decision not to turn Tiananmen Square into a second Red Square was reflected in this national apprehension; it was natural for the top leaders to plan a square much larger than its Soviet counterpart in order to show the nation's independence and pride.

Fourth, in line with this reasoning, the CCP had long positioned itself as the repository of patriotism, as a political party that could best serve the interests of the Chinese people in a land long ravaged by incessant armed conflicts, social chaos, and economic woes. Mao and his top leaders understood clearly that they derived much of their legitimacy from portraying themselves as the sole guardians of the country's sovereignty; this sharply contrasted with the image of the Nationalists, who were often ridiculed as corrupt and in obsequious collusion with avaricious foreigners to continuously exploit the Chinese people and infringe on national independence. The founding of the PRC

proclaimed the dawning of a new era. Euphoria and jubilation were the order of the day. National self-respect became the most persistent of all the leitmotifs of the political-cultural forms, and these forms became tools to demonstrate the promises of a new China. The nature of national parades, in Mao's words, must "center on China,"[16] as attested by the popular "Great National Unity Dance."[17]

And, finally, Mao strongly believed that uplifting mass movements were the best occasions for educating the masses, inculcating in them ideals of patriotism and socialism. The singing of "Ode to the Motherland" (Gechang zuguo) by thousands of paraders was a collective tribute to China's greatness.[18] The shared goals could best be spurred in a state of mobilization or group activities. In grand rallies (such as parades) as well as obligatory activities (such as schoolchildren visiting the state museums), citizens were not regarded as private individuals but as members of a larger community. At the heart of these mass campaigns was Mao, the personification of new China. In national parades, his arrival at ceremonies was announced by the playing of "The East Is Red," a reinvented folk song from northern Shaanxi, where Yan'an was located, glorifying the chairman's supreme position in the history of the CCP.[19] Every speech the chairman uttered seemed like a divine word from on high, inspiring the masses to follow collectively. The giant portrait of Mao, hung in front of Tiananmen Gate and overlooking the vast square, formed an intimate bond between the leader and his admiring flocks, and represented the great unity of the Chinese people.

The Impact

One of the most difficult problems for historians is how to assess the effectiveness of propaganda. How much did the people believe in nationalistic pride and the socialist messages these political-cultural campaigns tried to communicate? Which forms proved to be most influential? The difficulties of measuring the effectiveness of propaganda stem partly from the diversity of the government's target audiences: some propaganda catered to mass audiences (as in parades), other messages were for private readership as cartoons in official newspapers, and still others clearly targeted specific national minorities, as when propaganda was directed at the Cultural Palace of Nationalities. The objectives were also modified to reach diverse audiences of varied backgrounds with their own individual biases. Another problem in assessing the impact of propaganda is that the effect can vary significantly depending on the specific time period and level of reception by the public. Although we may be confident that there are sufficient sources available to reconstruct the organization and operation of the CCP's propaganda networks, independent evidence of the success of the campaign is hard to gather. Sources, if available at all, are often unreliable, and thus the audience is often a serious missing link.

The government-controlled media, of course, painted a glowing picture of

these official activities by reminding the people of the state's great accomplishments. Chinese officials also used multiple means to publicize the sanguine vision inherent in communism. School textbooks, for example, incorporated such subjects as Fang Zhimin's *My Beloved China* and the Great Hall of the People;[20] the *People's Daily* also told us how "happy Young Pioneers," as part of their patriotic education, were bused to Tiananmen Square to lay wreaths in front of the Monument to the People's Heroes in order to train them to appreciate past sacrifices.[21] The tales of extraordinary heroism thus live on as an inevitable stage in the construction of revolution. These touching reports, however, must be viewed with caution, for, in the PRC, the Party dictated the items newspapers could print and which subjects school could teach.

Although few independent sources are available and the Central Party Archives remain closed to outsiders, the partial opening in recent years of regional and municipal archival information did reveal that the propaganda campaigns encountered many problems. In a December 1949 report issued by the Propaganda Bureau of the Beijing Municipal Party, officials admitted that shortages of cadres and teaching materials hampered the political education of the workers.[22] In 1951, at the height of the Resist America, Aid Korea Campaign, Municipal Party propagandists realized that many groups that they described as "unorganized or weakly organized masses," including shopkeepers, housewives, and rickshaw men, were "totally unaware" of this major political campaign. Even Communist enthusiasts among the masses had only "scant knowledge" of it. According to the officials, "an all-out propaganda effort had to be mounted to remedy this void in propaganda work."[23] In yet another anti-U.S. and anti–Chiang Kai-shek rally held in the capital in late December 1954 to protest the signing of a mutual defense pact between Taiwan and the United States, officials acknowledged that most of the Beijing populace was hardly aware of the international situation and that suitable art propaganda works were difficult to create.[24] The new yangge campaign waned, and the disappointing sales of the reformed nianhua prints were undoubtedly another headache for the government.

These setbacks notwithstanding, I still contend that, overall, theses state-sponsored political-cultural campaigns had a considerable impact on the populace in the first decade of the People's Republic. First, an initial euphoria followed the Communist takeover in the early days of the PRC, not surprising given that people longed for national unity and peace after many frustrating years of wars and economic problems. Shortly after the Red Army entered Beiping in January 1949, Derk Bodde observed: "What, then, is the real attitude of Peking's residents toward their new 'conquerors'? My own subjective opinion, for what it may be worth, is that the reaction is enthusiastic on the part of many, favorable or at least acquiescent on the part of most, and definitely antagonistic on the part of a relatively small minority."[25] The painter Xu Beihong and the architect Liang Sicheng could be counted among the initial supporters of the new regime, for they saw a hopeful future in the promising new political

order, irrespective of its political philosophy.[26] Communist propagandists realized that this initial euphoria could dim easily, so the challenge for them was to find ways to sustain this enthusiasm and excitement. They proceeded, therefore, with a multitude of continuous, timely propaganda campaigns. The May Day and National Day processions in Tiananmen Square were among those created to draw multitudes of Chinese to heap praise on the Party. Former National Day paraders whom I interviewed recently still reminisced about their elation on seeing their great leaders in Tiananmen Square in the 1950s, especially during the ritual of "Advancing to Gold Water Bridge," which afforded them a closer look at their revered leaders.

The Chinese propagandists knew that a huge linguistic gulf separated them from the undereducated populace, and so they learned to craft a written vocabulary and symbolic images that the public could understand. Whereas the Soviets and the Germans often used language and forms borrowed directly from religious liturgy to reach out to their populace,[27] the CCP largely drew its inspiration from folk traditions. The auspicious motifs of bumper harvests, benevolent symbols of longevity, and colorful displays of scenes of everyday life were used in mass gatherings, and official decorations enhanced the chance that their messages would be accepted by the public.

The campaigns exercised considerable impact also because of the technique of repetition. Jacques Ellul reminds us that repetition is a key ingredient in propaganda. "Propaganda," he writes, "must be continuous and lasting. . . . It is based on slow, constant impregnation. It creates convictions and compliance through imperceptible influences that are effective only by continuous repetition."[28] Annual celebrations and commemorations are forms of political repetition. Massive group participation in these perennial events created a shared experience among people that reinforced their collective memory of great Party-led events and deceased socialist heroes who had helped to win China's independence.

Force and coercion were potent means to guarantee that official messages were delivered with a certain degree of success. Propaganda is an art of persuasion, but, ironically, its implementation in an authoritarian state is often associated with terror and retribution. This coercive aspect of persuasion could appear either as direct threats or as indirect, veiled attacks against alleged enemies. In the PRC, the Anti-Rightist Campaign in 1957 was a combination of both. The use of force and veiled attacks, together with the CCP's propaganda networks, ensured that the Party's messages were heeded and followed at the grassroots, however unwillingly, for anyone who ignored them would face dire consequences.

Finally, we can assume that the mobilization campaigns did make a difference, not necessarily because the Party had convinced the populace of its overblown achievements but because the people had no choice. The monopoly of information ensured that the populace, like it or not, heard only one voice from the top. In oil paintings, as discussed earlier, art students at the Central Academy

of Fine Arts in the 1950s studied only Soviet works, for these were the only materials available at the time, as American and European art objects were deemed degenerate and were banned. This restriction guaranteed that official state versions were properly delivered, if not altogether well received. In conclusion, one can argue that although it is extremely difficult to ascertain what the masses actually thought of these political-cultural forms, it may be reasonably safe to say that the forms exercised considerable impact on the populace, not necessarily because people welcomed them but simply because there were few, if any, alternatives available for anyone to consider.

The reasons why the Chinese Communists were able to seize power and consolidate their rule in the first decade of the PRC are certainly complex, and conventional studies generally turn for explanations to the CCP's ability to launch successfully land reforms and efficient industrial programs. Above all, of course, was the Party's willingness to use repressive measures against opponents, who were often demonized as "counterrevolutionaries." However, I argue that a vital but often overlooked reason for the CCP's success was its creative use of propaganda and mass mobilization to win the hearts and minds of the Chinese people. A series of political-cultural propaganda forms were invented or brought back from Chinese history or folklore as tools of political education. Through persuasion or by coercion, the Communists taught the masses to become active supporters of the new regime.

I am aware, of course, that based on the examination of a number of topics and events in only a limited number of localities (mainly Beijing and key cities such as Shanghai) in the postrevolutionary period, I risk overgeneralizing my findings. I make no pretense, however, regarding the extensiveness of the topics covered or the exhaustiveness of the sources presented. I am also aware that there are huge disparities across the vast expanse of China that warn against simplistic conclusions. Further works undoubtedly would show that inhabitants in different localities viewed these propaganda campaigns differently, and their responses to them probably varied as well. But these differences do not necessarily mean that a grand narrative did not exist. Although a master narrative may oversimplify the issues and fail to account for the diverse opinions prevailing among top leaders, the fact is that the CCP's authoritarian control of the country enabled the Party to paint a more or less glorious picture of itself by means of its many political-cultural forms and mass-mobilization campaigns. The diverse symbols, rituals, political rhetoric, and pictorial languages created by the Communist leaders were woven together to generate shared visions and shape people's lives. In the end, this carefully crafted grand narrative forged by Chinese Communists enabled the Party to consolidate its authority, affirm its legitimacy, and tighten its hold on political power.

Notes

Introduction

1. Mao Zedong (Mao Tse-tung), "The Chinese People Have Stood Up!" in Mao, *Selected Works of Mao Tse-tung*, 5 vols. (Peking: Foreign Languages Press, 1967–77), 5:16–17.

2. Raymond Williams, *Keywords: A Vocabulary of Culture and Society*, rev. ed. (New York: Oxford University Press, 1989), 11–26.

3. Frederick C. Corney, *Telling October: Memory and the Making of the Bolshevik Revolution* (Ithaca: Cornell University Press, 2004), 8–9. See also Orlando Figes and Boris Kolonitskii, *Interpreting the Russian Revolution: The Language and Symbols of 1917* (New Haven: Yale University Press, 1999), 104–52.

4. See, for example, *Jiefang ribao* (Liberation daily); William Hinton, *Fanshen: A Documentary of Revolution in a Chinese Village* (New York: Vintage Books, 1968); Mao's "Problems of War and Strategy," in Mao, *Selected Works*, 2:225.

5. Mao Zedong, "Guanyu zhenya fangeming" (On suppressing antirevolutionaries), in *Mao Zedong wenji* (Collected works of Mao Zedong), ed. Zhonggong zhongyang wenxian yanjiushi, 8 vols. (Beijing: Renmin chubanshe, 1993–99), 6:117.

6. Mao, "The Chinese People Have Stood Up!" 16.

7. Mao Zedong, "Report to the Second Plenary Session of the Seventh Central Committee of the Communist Party of China," in Mao, *Selected Works*, 4:363.

8. Mao Zedong, "Zai Zhongguo gongchandang diqici quanguo daibiao dahui shang de koutou zhengzhi baogao" (Oral political report at the Seventh National Congress of the Chinese Communist Party), in Mao, *Mao Zedong wenji*, 3:332–33.

9. Bo Yibo, *Ruogan zhongda juece yu shijian de huigu* (A retrospect of some crucial decisions and events), rev. ed., 2 vols. (Beijing: Renmin chubanshe, 1997), 1:17.

10. Steven I. Levine, *Anvil of Victory: The Communist Revolution in Manchuria, 1945–1948* (New York: Columbia University Press, 1987), 162–68.

11. James Z. Gao, *The Communist Takeover of Hangzhou: The Transformation of City and Cadre, 1949–1954* (Honolulu: University of Hawai'i Press, 2004), 42–64.

12. Mao Zedong, "On the People's Democratic Dictatorship," in Mao, *Selected Works*, 4:421.

13. Julia C. Strauss, "Paternalist Terror: The Campaign to Suppress Counterrevolutionaries and Regime Consolidation in the People's Republic of China, 1950–1953," *Comparative Studies in Society and History* 44, no. 1 (January 2002): 80–105; Yang Kuisong, "Reconsidering the Campaign to Suppress Counterrevolutionaries," *China Quarterly*, no. 193 (March 2008): 102–21.

14. Ezra F. Vogel, *Canton under Communism: Programs and Politics in a Provincial Capital, 1949–1968* (Cambridge: Harvard University Press, 1969).

15. Kenneth G. Lieberthal, *Revolution and Tradition in Tientsin, 1949–1952* (Stanford: Stanford University Press, 1980).

16. Rudolf G. Wagner, *The Contemporary Chinese Historical Drama* (Berkeley: University of California Press, 1990); Xiaomei Chen, *Acting the Right Part: Political Theater and Popular Drama in Contemporary China* (Honolulu: University of Hawai'i Press, 2002); R. David Arkush, "Love and Marriage in North Chinese Peasant Operas," in *Unofficial China: Popular Culture and Thought in the People's Republic,* ed. Perry Link, Richard Madsen, and Paul G. Pickowicz (Boulder, CO: Westview Press, 1989), 72–87.

17. Michael Schoenhals, *Doing Things with Words in Chinese Politics: Five Studies* (Berkeley: Institute of East Asian Studies, University of California, 1992).

18. Julia F. Andrews, *Painters and Politics in the People's Republic of China, 1949–1979* (Berkeley: University of California Press, 1994); Ellen Johnston Laing, *The Winking Owl: Art in the People's Republic of China* (Berkeley: University of California Press, 1988).

19. Paul Clark, *Chinese Cinema: Culture and Politics since 1949* (Cambridge: Cambridge University Press, 1987).

20. Richard Curt Kraus, *Pianos and Politics in China: Middle-Class Ambitions and the Struggle over Western Music* (New York: Oxford University Press, 1989).

21. Timothy Cheek, *Propaganda and Culture in Mao's China: Deng Tuo and the Intelligentsia* (Oxford: Clarendon Press, 1997); Merle Goldman, *China's Intellectuals: Advise and Dissent* (Cambridge: Harvard University Press, 1981).

22. Gao, *Communist Takeover of Hangzhou.*

23. Perry Link, "The Crocodile Bird: *Xiangsheng* in the Early 1950s," in *Dilemmas of Victory: The Early Years of the People's Republic of China,* ed. Jeremy Brown and Paul G. Pickowicz (Cambridge: Harvard University Press, 2007), 207–31.

24. Gabriel A. Almond and Sidney Verba, *The Civic Culture: Political Attitudes and Democracy in Five Nations* (Newbury Park, CA: Sage Publications, 1989), 1–44.

25. François Furet, *Interpreting the French Revolution,* trans. Elborg Forster (Cambridge: Cambridge University Press, 1981); Mona Ozouf, *Festivals and the French Revolution,* trans. Alan Sheridan (Cambridge: Harvard University Press, 1988); Lynn Hunt, *Politics, Culture, and Class in the French Revolution* (Berkeley: University of California Press, 1984).

26. Furet, *Interpreting the French Revolution,* 28–61.

27. Maurice Agulhon, *Marianne into Battle: Republican Imagery and Symbolism in France, 1789–1880,* trans. Janet Lloyd (Cambridge: Cambridge University Press, 1981); Hunt, *Politics, Culture, and Class.*

28. See, for example, Sean Wilentz, ed., *Rites of Power: Symbolism, Ritual, and Politics since the Middle Ages* (Philadelphia: University of Pennsylvania Press, 1985); Jonathan Brown and J. H. Elliott, *A Palace for a King: The Buen Retiro and the Court of Philip IV* (New Haven: Yale University Press, 1980).

29. See, for example, James von Geldern, *Bolshevik Festivals, 1917–1920* (Berkeley: University of California Press, 1993); Simonetta Falasca-Zamponi, *Fascist Spectacle: The Aesthetics of Power in Mussolini's Italy* (Berkeley: University of California Press, 1997).

30. Clifford Geertz, *Local Knowledge: Further Essays in Interpretive Anthropology* (New York: Basic Books, 1983), 124, 146.

31. Corney, *Telling October,* 126–48.

32. W. J. T. Mitchell, *Picture Theory: Essays on Verbal and Visual Representation* (Chicago: University of Chicago Press, 1994), 11–34.

33. Wu Hung, *Remaking Beijing: Tiananmen Square and the Creation of a Political Space* (Chicago: University of Chicago Press, 2005).

34. See, for example, Qu Qiubai, "Chidu xinshi" (Impressions of the Red capital seen through the mind), in *Qu Qiubai wenji* (Collected writings of Qu Qiubai), vol. 1 (Beijing: Renmin wenxue chubanshe, 1985), 144–46.

35. Ozouf, *Festivals and the French Revolution,* 126–57.

36. Hou Renzhi and Wu Liangyong, "Tiananmen guangchang lizan: Cong gongting guangchang dao renmin guangchang de yanbian he gaizao" (Paean to Tiananmen Square: Its transformation from a palace square to a people's square), *WW,* no. 9 (September 1977): 1–15.

37. Victor Turner, introduction to *Celebration: Studies in Festivity and Ritual,* ed. Victor Turner (Washington, DC: Smithsonian Institution Press, 1982), 20.

38. Eric Hobsbawm and Terence Ranger, eds., *The Invention of Tradition* (Cambridge: Cambridge University Press, 1983), 1–14.

39. Zhang Geng, "Luyi gongzuotuan duiyu yangge de yixie jingyan" (Experience of performing yangge of Luyi's Work Team), *JFRBY,* May 15, 1944, 4; interview with Zhang Geng, October 14, 1989, Beijing.

40. Jacques Ellul, *Propaganda: The Formation of Men's Attitudes,* trans. Konrad Kellen and Jean Lerner (New York: Vintage Books, 1973), 76.

41. Lien-sheng Yang, "The Organization of Chinese Official Historiography: Principles and Methods of the Standard Histories from the T'ang through the Ming Dynasty," in *Historians of China and Japan,* ed. W. G. Beasley and E. G. Pulleyblank (London: Oxford University Press, 1961), 44–59.

42. Maurice Agulhon, "Politics and Images in Post-Revolutionary France," in *Rites of Power: Symbolism, Ritual, and Politics since the Middle Ages,* ed. Sean Wilentz, 189; von Geldern, *Bolshevik Festival,* 199–207.

43. Mao Zedong, "The Role of the Chinese Communist Party in the National War," in Mao, *Selected Works,* 2:209.

44. Mao Zedong, "On New Democracy," in Mao, *Selected Works,* 2:339–84.

45. Benkan jizhe (Wang Yeqiu), "Zhongguo gemin bowuguan xunli" (A tour of the Museum of the Chinese Revolution), *WW,* no. 7 (July 1961): 27–37.

46. Hu Qiaomu, *Zhongguo gongchandang de sanshinian* (Thirty years of the Communist Party of China) (Beijing: Renmin chubanshe, 1951).

47. See *WW,* no. 7 (July 1961): photos; *RMRB,* August 12, 1961, 8.

48. Boris Groys, "The Struggle against the Museum; or, The Display of Art in Totalitarian Space," in *Museum Culture: Histories, Discourses, Spectacles,* ed. Daniel J. Sherman and Irit Rogoff (Minneapolis: University of Minnesota Press, 1994), 144.

49. Chang-tai Hung, *War and Popular Culture: Resistance in Modern China, 1937–1945* (Berkeley: University of California Press, 1994), 234–44.

50. Peter Kenez, *The Birth of the Propaganda State: Soviet Methods of Mass Mobilization, 1917–1929* (Cambridge: Cambridge University Press, 1985), 13–14.

51. Mao Zedong, "Serve the People," in Mao, *Selected Works,* 3:177–78.

52. Maurice Halbwachs, *The Collective Memory,* tran. Francis J. Ditter Jr. and Vida Yazdi Ditter (New York: Harper and Row, 1980), 48.

53. Pierre Nora, "General Introduction: Between Memory and History," in *Realms of Memory: Rethinking the French Past,* vol. 1, *Conflicts and Divisions,* ed. Pierre Nora, trans. Arthur Goldhammer (New York: Columbia University Press, 1996), 3.

54. *RMRB,* October 1, 1949, 1.

55. Halbwachs, *Collective Memory,* 156.

56. Pierre Nora, ed., *Realms of Memory: Rethinking the French Past*, 3 vols., trans. Arthur Goldhammer: vol. 1, *Conflicts and Divisions;* vol. 2, *Traditions;* vol. 3, *Symbols* (New York: Columbia University Press, 1996–98).

57. George L. Mosse, *Fallen Soldiers: Reshaping the Memory of the World Wars* (New York: Oxford University Press, 1990), 34–50.

58. For a survey of China's monuments, see Liu Guofu and Wei Jingfu, eds., *Guohun dian* (Dictionary of national souls) (Changchun: Jilin renmin chubanshe, 1993).

59. Mao Zedong, "Eternal Glory to the Heroes of the People!" in Mao, *Selected Works,* 5:22 (with minor modifications).

60. Hannah Arendt, *The Origins of Totalitarianism* (New York: World Publishing, 1958), 341, 344.

61. Kenez, *Birth of the Propaganda State*, 251.

62. Ibid., 123.

63. Nicolai Volland, "The Control of the Media in the People's Republic of China" (PhD diss., University of Heidelberg, 2003), 34–61.

64. Quoted in Yuan Ying, *Fengyun ceji: Wo zai Renmin ribao fukan de suiyue* (Sideline reports: My years working at the literary supplement of the *People's Daily*) (Beijing: Zhongguo dang'an chubanshe, 2006), 58.

65. Mao Zedong, "On the People's Democratic Dictatorship," 412.

66. Interview with Zhan Jianjun, August 2, 2005, Beijing.

1. Tiananmen Square

1. Derk Bodde, *Peking Diary: A Year of Revolution* (New York: Henry Schuman, 1950), illustration 8.

2. *RMRB*, October 3, 1949, 2.

3. James A. Leith, *Space and Revolution: Projects for Monuments, Squares, and Public Buildings in France, 1789–1799* (Montreal: McGill-Queen's University Press, 1991), 33–56, 151–214.

4. Ozouf, *Festivals and the French Revolution*, 126–57.

5. Christina Lodder, "Lenin's Plan for Monumental Propaganda," in *Art of the Soviets: Painting, Sculpture and Architecture in a One-Party State, 1917–1992*, ed. Matthew Cullerne Bown and Brandon Taylor (Manchester, UK: Manchester University Press, 1993), 16–32.

6. Chang-tai Hung, "Kongjian yu zhengzhi: Kuojian Tiananmen guangchang" (Space and politics: Expanding Tiananmen Square), in *Liang'an fentu: Lengzhan chuqi de zhengjing fazhan* (Parting ways: Politics and economics across the Taiwan Straits since 1949), ed. Chen Yung-fa (Taipei: Institute of Modern History, Academia Sinica, 2006), 207–59; Wang Jun, *Chengji* (On Beijing) (Beijing: Sanlian shudian, 2003). For literature on the commemorative nature of Tiananmen Square, see Wu Hung, *Remaking Beijing;* Rudolf G. Wagner, "Reading the Chairman Mao Memorial Hall in Peking: The Tribulations of the Implied Pilgrim," in *Pilgrims and Sacred Sites in China*, ed. Susan Naquin and Chün-fang Yü (Berkeley: University of California Press, 1992), 378–423.

7. "Dushi jihua weiyuanhui chengli dahui jilu" (Minutes of the inauguration meeting of the Municipal Planning Committee), BMA, 150–1-1.

8. Lin Zhu, *Dajiang de kunhuo* (The puzzlement of a great architect) (Beijing: Zuojia chubanshe, 1991); Wilma Fairbank, *Liang and Lin: Partners in Exploring China's Architectural Past* (Philadelphia: University of Pennsylvania Press, 1994).

9. Liang Sicheng, "Beijing: Dushi jihua de wubi jiezuo" (Beijing: The unparalleled masterpiece in city planning), in Liang Sicheng, *Liang Sicheng wenji* (Collected writ-

ings of Liang Sicheng), 4 vols. (Beijing: Zhongguo jianzhu gongye chubanshe, 1986), 4:58.

10. Liang Sicheng and Chen Zhanxiang, "Guanyu Zhongyang renmin zhengfu xingzheng zhongxinqu weizhi de jianyi" (Proposals on the location of the administrative center of the central government), in Liang, *Liang Sicheng wenji*, 4:1–31. Interview with Chen Zhanxiang, December 16, 1994, Beijing.

11. Akira Koshizawa, "City Planning of Peking, 1937–1945," trans. Shyh-meng Huang, as "Beijing de dushi jihua," *Guoli Taiwan daxue jianzhu yu chengxiang yanjiu xuebao* (Bulletin of Architecture and City Planning, National Taiwan University), 3, no. 1 (September 1987): 235–45.

12. "Zhu Zhaoxue, Zhao Dongri dui shoudu jianshe jihua de yijian" (Zhu Zhaoxue and Zhao Dongri's opinions on the design of the capital), in *Jianguo yilai de Beijing chengshi jianshe ziliao* (Materials on the construction of the city of Beijing since the founding of the nation), vol. 1, *Chengshi guihua* (City planning), ed. Beijing jianshe shishu bianji weiyuanhui bianjibu (Beijing: n.p., 1987), 203.

13. Mao Zedong, "On the People's Democratic Dictatorship," in Mao, *Selected Works,* 4:415.

14. Between 1949 and 1960, more than eighteen thousand Soviet advisers and experts arrived in China. See Shen Zhihua, *Sulian zhuanjia zai Zhongguo* (Soviet experts in China) (Beijing: Zhongguo guoji guangbo chubanshe, 2003), 4, 408. Only a few studies on this topic have appeared in the West; see Deborah A. Kaple, "Soviet Advisors in China in the 1950s," in *Brothers in Arms: The Rise and Fall of the Sino-Soviet Alliance, 1945–1963,* ed. Odd Arne Westad (Washington, DC: Woodrow Wilson Center Press; Stanford: Stanford University Press, 1998), 117–40.

15. "Guanyu zeng Sulian zhuanjia Abulamofu deng shiqiwai tongzhi jingzhuang *Mao Zedong xuanji* de youguan wenjian" (Documents concerning the presentation of the clothbound *Selected Works of Mao Zedong* to Soviet expert Abramov and his sixteen colleagues as a gift), BMA, 1–6-688.

16. Balannikefu (Barannikov), "Beijingshi jianglai fazhan jihua de wenti" (Problems concerning the plan for Beijing's future development), *ZGDS*, no. 76 (December 2000): 8; see also BCCA, C3–85-1.

17. "Shizheng zhuanjiazu lingdaozhe Bo Abulamofu tongzhi zai taolunhui shang de jiangci" (Speech delivered at the forum by Comrade P. Abramov, head of the municipal administrative team of experts), *ZGDS*, no. 76 (December 2000): 19.

18. Interviews with Li Zhun, October 28, 2002; January 16, 2004; and August 9, 2004, Beijing. Li Zhun was the chief architect of the Municipal Planning Management Bureau in Beijing.

19. Chen Gan, *Jinghua daisilu* (Reflections on the capital) (Beijing: Beijingshi chengshi guihua sheji yanjiuyuan, n.d.), 219.

20. Guihuaju, "Beijingshi zongti guihua gangyao (caogao), 1958–1972" (Outline of the overall plan of the development of Beijing [draft], 1958–1972), BMA, 47–1-57.

21. Peng Zhen, *Peng Zhen wenxuan, 1941–1990* (Selected writings of Peng Zhen, 1941–1990) (Beijing: Renmin chubanshe, 1991), 178.

22. "Dushi jihua weiyuanhui chengli dahui jilu."

23. Zheng Tianxiang and Tong Zheng, "Zhuanjiazu de yixie gebie fanying (1)" (Some individual reactions of the team of experts [no. 1]), BMA, 151–1-6

24. Zheng Tianxiang, *Xingcheng jilüe* (Travel notes) (Beijing: Beijing chubanshe, 1994), 130–33.

25. "Shizheng zhuanjiazu lingdaozhe Bo Abulamofu," 18; see also BCCA, C1–308-1.

26. Mao Zedong, "The May 4th Movement", in Mao, *Selected Works*, 2:237.

27. *Chang'anjie: Guoqu, xianzai, weilai* (Chang'an Avenue: The past, the present, and the future), ed. Beijingshi guihua weiyuanhui and Beijing chengshi guihua xue-hui (Beijing: Jixie gongye chubanshe, 2004), 62. For a history of Republican Beijing, see Madeleine Yue Dong, *Republican Beijing: The City and Its Histories* (Berkeley: University of California Press, 2003).

28. *RMRB*, August 31, 1949, 4.

29. *GMRB*, September 1, 1950, 4; Shu Jun, *Tiananmen guangchang lishi dang'an* (Historical documents on Tiananmen Square) (Beijing: Zhonggong zhongyang dan-gxiao chubanshe, 1998), 21–28.

30. Dong Guangqi, "Tiananmen guangchang de gaijian yu kuojian" (The reconstruction and expansion of Tiananmen Square), *BJWSZL*, no. 49 (November 1994): 6.

31. Interview with Zhang Kaiji, September 16, 1996, Beijing.

32. Zheng Tianxiang, *Xingcheng jilüe*, 148.

33. Guoqing gongcheng bangongshi, "Guanyu qingzhu guoqing shizhounian jian-fang shigong anpai de baogao" (Report on the construction of housing for the purpose of celebrating the tenth anniversary of National Day), BMA, 125–1-1233.

34. See Zhao Pengfei's preface in Zhao Dongri, *Jianzhu sheji dashi Zhao Dongri zuopinxuan* (Selected works of master architect and designer Zhao Dongri), ed. Bei-jingshi jianzhu sheji yanjiuyuan (Beijing: Kexue chubanshe, 1998).

35. Dong Guangqi, "Tiananmen guangchang," 1–2; *JZXB*, nos. 9–10 (October 20, 1959).

36. Beijingshi chengshi jianshe weiyuanhui, "Tiananmen guangchang gongcheng de jiben qingkuang" (Basic conditions of the Tiananmen Square project), BMA, 47–1-92.

37. "Kuojian Tiananmen guangchang dengchu gongcheng chaiqian gongzuo zongjie baogao" (Summary on the dismantling and resettling of homes for the expansion of Tiananmen Square and others), BMA, 47–1-61.

38. "Dushi jihua yijiuwuernian gongzuo zongjie" (The 1952 summary of city plan-ning work), BMA, 150–1-56.

39. Zhonggong Beijing shiwei, "Bao song gaijian yu kuojian Beijingshi guihua cao'an he guihua caotu" (Draft plans and maps on the reconstruction and expansion of the city of Beijing), BMA, 1–5-90.

40. Liang Sicheng, "Wo dui Sulian jianzhu yishu de yidian renshi" (My understand-ing of the art of Soviet architecture), in Liang, *Liang Sicheng quanji* (Complete works of Liang Sicheng), 9 vols. (Beijing: Zhongguo jianzhu gongye chubanshe, 2001), 5:175–76.

41. "Disanci changwu weiyuanhui huiyi jilu" (Minutes of the third standing com-mittee meeting [of the Municipal Planning Committee]), BMA, 150–1-30.

42. On Mukhin, see "Sulian zhuanjia Moxin dui Beijingshi zongti guihua de yijian" (Soviet adviser Mukhin's opinions on the overall planning of Beijing), BCCA, C3–86-1; Document no. 5 (vol. 2, 1952), case no. 2, FEBA. On Baragin, see "Pinqing di 29 juan" (The recruitment, no. 29) (May 3, 1955), FEBA.

43. "Beijingshi guiweihui yijiuwuwunian zhuanjia gongzuo jihua" (The working schedule of experts in 1955, Municipal Development Committee), BMA, 151–1-5.

44. Zhang Bo, *Wo de jianzhu chuangzuo daolu* (My career as an architect) (Beijing: Zhongguo jianzhu gongye chubanshe, 1994), 71.

45. BMA, 150–1-69.

46. "Liang Sicheng guanyu minzu xingshi, baoliu guwu yanlun yijian" (Liang Si-cheng's opinions on national forms and the preservation of cultural relics), BCCA, C3–80-2.

47. Interviews with Li Zhun, October 28, 2002; January 16, 2004; and August 9, 2004, Beijing.

48. *Zuzhishi ziliao, 1949–1992* (Materials on the history of organization, 1949–1992), ed. Beijingshi chengshi guihua guanliju and Beijingshi chengshi guihua sheji yanjiuyuan dangshi zhengji bangongshi (Beijing: n.p., 1995), 32–36.

49. "Beijingshi renmin weiyuanhui guanyu shencha yijiuwuqinian pinqing Sulian zhuanjia de baogao" (Report of Beijing Municipal People's Committee on assessing the 1957 recruitment of the Soviet advisers), BMA, 151–1-45.

50. BMA, 151–1-4.

51. "Beijingshi guiweihui yijiuwuwunian."

52. *Dangshi dashi tiaomu, 1949–1992* (Major events in the history of the CCP, 1949–1992), ed. Beijingshi chengshi guihua guanliju and Beijingshi chengshi guihua sheji yanjiuyuan dangshi zhengji bangongshi (Beijing: n.p., 1995), 38–40.

53. *Chang'anjie*, 62–66.

54. Balannikefu, "Beijingshi jianglai fazhan jihua," 3.

55. Zhonggong Beijing shiwei, "Gaijian yu kuojian Beijingshi guihua cao'an de yaodian" (Main points of the draft on reconstructing and expanding the city of Beijing), BMA, 1–5-90.

56. "Beijingshi guiweihui yijiuwuwunian."

57. A. M. Zhuravlev, A. V. Ikonnikov, and A. G. Rochegov, *Arkhitektura Soveskoi Rossii* (Architecture of the Soviet Union) (Moscow: Stroiizdat, 1987), 129–77; Tong Jun, *Sulian jianzhu: Jianshu Dong Ou xiandai jianzhu* (Soviet architecture: With additional discussion on modern architecture in Eastern Europe) (Beijing: Zhongguo jianzhu gongye chubanshe, 1982), 32–34.

58. S. Boldirev and P. Goldenberg, "Ulitsa Gorkogo v proshlom i nastoyashchem" (The past and present of Gorky Street), *Arkhitektura SSSR*, no. 4 (1938): 14–19; Greg Castillo, "Gorki Street and the Design of the Stalin Revolution," in *Streets: Critical Perspectives on Public Space*, ed. Zeynep Çelik, Diane Favro, and Richard Ingersoll (Berkeley: University of California Press, 1994), 57–70.

59. Boldirev and Goldenberg, "Ulitsa Gorkogo"; Andrei Ikonnikov, *Russian Architecture of the Soviet Period*, trans. Lev Lyapin (Moscow: Raduga, 1988), 185.

60. Richard Stites, *Revolutionary Dreams: Utopian Vision and Experimental Life in the Russian Revolution* (New York: Oxford University Press, 1989), 243.

61. Tong Jun, *Sulian jianzhu*, 37.

62. Matthew Cullerne Bown, *Art under Stalin* (New York: Holmes and Meier, 1991), 15.

63. *Chang'anjie*, 62.

64. Zhang Bo, *Wo de jianzhu*, 88. Interview with Zhang Bo, December 14, 1994, Beijing.

65. *Peng Zhen shizhang* (Mayor Peng Zhen), ed. Li Haiwen (Taiyuan: Zhonggong dangshi chubanshe and Shanxi renmin chubanshe, 2003), 197.

66. Yang Nian, "Yiduan wenxin de huiyi" (Warm recollections), in *Guihua chunqiu* (Chronicles of city planning), ed. Beijingshi chengshi guihua guanliju and Beijingshi chengshi guihua sheji yanjiuyuan dangshi zhengji bangongshi (Beijing: n.p., 1995), 161. Yang Nian was a Chinese interpreter for the Soviet advisers.

67. "Sulian zhuanjia dui Tiananmen guangchang guihua cao'an moxing de yixie yijian" (Soviet advisers' opinions on the draft models of the planning of Tiananmen Square), BCCA, 3–7-14.

68. Ibid.

69. "Zhuanjia tanhua jiyao (400)" (Notes of the experts' talks [no. 400]), BCCA, 3–7-14.

70. Yang Nian, "Yiduan wenxin," 161.

71. "Zhuanjia tanhua jiyao (58)" (Notes of the experts' talks [no. 58]), BCCA, 3–7-14.

72. "Shiyue shiri Peng Zhen tongzhi zai Shiwei changwei shang guanyu chengshi guihua wenti de fayan" (Comrade Peng Zhen's speech on the city planning delivered at the standing committee meeting of the Beijing Municipal Committee on October 10), BMA, 151–1-17.

73. Peng Zhen, "Guanyu Beijing de chengshi guihua wenti" (Issues concerning Beijing's city planning), in Peng, *Peng Zhen wenxuan,* 309.

74. "Zhuanjia tanhua jiyao (130)" (Notes of the experts' talks [no. 130]), BCCA, 3–7-14.

75. BCCA, 3–7-14.

76. "Zhuanjia tanhua jiyao (130)."

77. Ibid.

78. Yang Nian, "Yiduan wenxin," 161.

79. Ibid.

80. "Zhuanjia tanhua jiyao (58)."

81. "Balajin zhuanjia dui daolu kuandu he fenqi jianshe deng wenti de yijian" (Adviser Baragin's opinions on issues related to the width of the roads and the stages of construction), BCCA, C3–87-1.

82. "Liang Sicheng dui Beijing shizheng jianshe de jidian yijian" (Liang Sicheng's opinions on the Beijing Municipal Government's construction plans), *NBCK,* no. 2152 (March 14, 1957), 257.

83. Liang Sicheng, "Wei Dong Chang'anjie zhongyang gebu jianzhu sheji wenti shang Zhou zongli shu" (Letter to Premier Zhou on the construction problems regarding the offices of the central government on East Chang'an Avenue), BCCA, C3–80-1.

84. BCCA, C2–46-2.

85. Liang Sicheng, "Guanyu Beijing chengqiang cunfei wenti de taolun" (Discussions on the preservation or demolition of the old city walls in Beijing), in Liang, *Liang Sicheng wenji,* 4:48.

86. "Liang Sicheng guanyu minzu xingshi."

87. Beijingshi dushi guihua weiyuanhui, "Guanyu chengqiang chaichu wenti de yijian" (Opinions on demolishing city walls), BMA, 151–1-73.

88. Mao Zedong, "Combat Bourgeois Ideas in the Party," in Mao, *Selected Works,* 5:109 (with minor modifications).

89. *NBCK,* no. 107 (May 11, 1955), 145–46.

90. Yang Nian, "Yiduan wenxin," 162.

91. Zhang Bo, *Wo de jianzhu,* 89; see also Yang Nian, "Yiduan wenxin," 162.

92. Peng Zhen, "Guanyu Beijing de chengshi," 307–8.

93. BCCA, C2–46-2.

94. Ibid.

95. Anatole Kopp, *Town and Revolution: Soviet Architecture and City Planning, 1917–1935,* trans. Thomas E. Burton (New York: George Braziller, 1970), 52.

96. Zheng Tianxiang, *Xingcheng jilüe,* 639.

97. Yang Nian, "Yiduan wenxin," 159–60.

98. Peng Zhen, "Guanyu Beijing de chengshi," 311.

99. MAEA, ref. no. 3873.

100. *Jianguo yilai de Beijing chengshi jianshe* (Beijing's city construction since the

founding of the nation), ed. Beijing jianshe shishu bianji weiyuanhui (Beijing: n.p., 1986), 47.

101. Hou Renzhi and Wu Liangyong, "Tiananmen guangchang lizan," 12.

102. Vitruvius, *Ten Books of Architecture*, trans. Ingrid D. Rowland (Cambridge: Cambridge University Press, 1999), book 5, chap. 1, 64.

103. Leon Battista Alberti, *The Ten Books of Architecture* (The 1755 Leoni Edition) (New York: Dover, 1986), book 4, chap. 1, 64; book 8, chap. 6, 173.

104. George R. Collins and Christiane Crasemann Collins, *Camillo Sitte: The Birth of Modern City Planning*, with a translation of the 1889 Austrian edition of his *City Planning according to Artistic Principles* (New York: Rizzoli, 1986), chap. 1, 151.

105. Leith, *Space and Revolution*, 6.

106. Ozouf, *Festivals and the French Revolution*, 128.

107. Setha M. Low, *On the Plaza: The Politics of Public Space and Culture* (Austin: University of Texas Press, 2000), 31–37, 180–204, 238–47.

108. *RMRB*, September 27, 1959, 2.

109. *JFRBS*, September 30, 1951, 2. *JBRB*, September 28, 1949, 3.

110. Luo Jianmin, "Shiping Tiananmen guangchang de guihua" (An evaluation of the design of Tiananmen Square), *JZXB*, no. 5 (May 20, 1981): 28–33.

111. Vladimir Paperny, "Moscow in the 1930s and the Emergence of a New City," in *The Culture of the Stalin Period*, ed. Hans Günther (New York: St. Martin's Press, 1990), 232.

2. Ten Monumental Buildings

1. Harold D. Lasswell, in collaboration with Merritt B. Fox, *The Signature of Power: Buildings, Communication, and Policy* (New Brunswick, NJ: Transaction, 1979), xiii–xiv, 84.

2. Ikonnikov, *Russian Architecture*, 176–226.

3. Barbara Miller Lane, *Architecture and Politics in Germany, 1918–1945* (Cambridge: Harvard University Press, 1985), 188.

4. Igor Golomstock, *Totalitarian Art in the Soviet Union, the Third Reich, Fascist Italy and the People's Republic of China*, trans. Robert Chandler (New York: IconEditions, 1990), 273–75.

5. *RMRB*, March 28, 1955, 1.

6. *JZXB*, nos. 9–10 (October 1959).

7. Zhonggong Beijing shiwei, "Zhonggong Beijing shiwei guanyu jinian guoqing shizhounian de choujian qingkuang he wenti de baogao" (The Beijing Municipal Party's report on the preparation and problems encountered relating to the construction work for the commemoration of the tenth anniversary of National Day), BMA, 125-1-1254.

8. Shen Bo, *Beiping jiefang, shoudu jianshe zhaji* (Notes on the liberation of Beiping and the construction of the capital), ed. Beijingshi chengshi jianshe dang'anguan (Beijing: n.p., n.d.), 114.

9. Wan Li, *Wan Li wenxuan* (Selected writings of Wan Li) (Beijing: Renmin chubanshe, 1995), 48–50.

10. BMA, 2–11-137.

11. *JZXB*, nos. 9–10 (October 1959): 30.

12. Beijingshi jianzhu gongchengju, "Shixiang gonggong jianzhu de shigong qingkuang gaikuang jieshao" (A brief introduction to the conditions concerning the construction of the ten public buildings), BMA, 125–1-1218.

13. Wan Li, *Wan Li wenxuan*, 51.

14. BMA, 125–1-1243.

15. "Kuojian Tiananmen guangchang dengchu."

16. BMA, 125–1-1219; BMA, 125–1-1233.

17. Guoqing gongcheng bangongshi, "Guanyu muqian guoqing gongcheng jinxing qingkuang de baogao" (A status report on the progress of the National Day projects), BMA, 125–1-1233.

18. "Wan Li tongzhi zai guoqing gongcheng xuanchuan baodao huiyi jianghua tigang" (An outline of the speech given by Comrade Wan Li at the conference on reporting the National Day construction projects), BMA, 2–11-138.

19. Guoqing gongcheng bangongshi, "Guanyu muqian guoqing gongcheng."

20. "Wan Li tongzhi zai Beijingshi guoqing gongcheng wuji ganbu huiyi shang de baogao (jilu zhaiyao)" (A report by Comrade Wan Li at Beijing's conference for the National Day projects for the fifth-level cadres [an abstract]), BMA, 125–1-1228. See also BMA, 125–1-1242.

21. JZXB, nos. 9–10 (October 1959): 33. See also BMA, 125–1-1269.

22. BMA, 47–1-71.

23. Guoqing gongcheng bangongshi, "Zhongguo geming, lishi bowuguan gongcheng zongjie" (Summary report on the construction of the Museum of the Chinese Revolution and the Museum of Chinese History), BMA, 125–1-1223.

24. Wan Li, "Guanyu guoqing gongcheng jinzhan qingkuang he cunzai wenti de baogao" (Report on the progress and existing problems of the National Day projects), BMA, 47–1-72.

25. Shen Bo, Beiping jiefang, 126.

26. Wan Li, "Guanyu Renda huitang wujia gangcai zhiliang buhege yaoqiu yanzhong yingxiang shigong jindu de baogao" (A report on the faulty quality of the steel for the roof frame in the construction of the Great Hall of the People and its serious impact on the progress of the construction), BMA, 2–11-128.

27. BMA, 125–1-1261.

28. Beijingshi chengshi jianshe weiyuanhui, "Guanyu jianshe Chang'an fandian de jingyan zongjie" (Summary on the task of constructing the Chang'an Hotel), BMA, 47–1-71.

29. Zhonggong shijian yigongsi weiyuanhui, "Renda gongcheng qingkuang jianbao (no. 78)" (A brief report on the construction of the Great Hall of the People, no. 78), BMA, 125–1-1226.

30. Wan Li, Wan Li wenxuan, 51.

31. BMA, 131–1-359.

32. Zhonggong Beijing shiwei, "Zhonggong Beijing shiwei guanyu jinian guoqing shizhounian gongcheng de choujian qingkuang he wenti de baogao" (The Beijing Municipal Party's report on the preparation and problems encountered relating to the construction work for the commemoration of the tenth anniversary of National Day), BMA, 47–1-60.

33. Zhao Pengfei, et al., "Guanyu jinian guoqing shizhounian jianzhu gongcheng shigong liliang bushu de baogao" (Report on the planning of the construction projects for commemorating the tenth anniversary of the founding of the nation), BMA, 47–1-51.

34. Wan Li, "Guanyu guoqing gongcheng jinzhan."

35. Guoqing gongcheng bangongshi, "Guoqing gongcheng jianbao, di 15 hao" (A brief report on the National Day projects, no. 15), BMA, 125–1-1217.

36. Guoqing gongcheng bangongshi, "Guanyu guoqing gongcheng de qingkuang he

1959 nian diyijidu shigong anpai de baogao (chugao)" (Report on the construction of the National Day projects in the first quarter of 1959 [draft]), BMA, 125–1-1233.

37. Wan Li, "Guanyu guoqing gongcheng jinzhan."

38. Beijingshi jianzhu gongchengju, "Shixiang gonggong jianzhu."

39. Ibid.

40. Interview with Architect A, January 24, 2007, Beijing.

41. "Guoqing gongcheng jianzhu zaojia fenxiang tongjibiao" (Cost statistics of the National Day construction projects), BMA, 2–12-138.

42. *JZXB*, nos. 9–10 (October 1959): 23.

43. Guoqing gongcheng bangongshi, "Quanguo Renmin daibiao dahuitang gong-cheng de jiben qingkuang" (Basic conditions concerning the construction of the Great Hall of the People's Representatives), BMA, 125–1-1218.

44. *JZSJ*, no. 9 (September 25, 1959): 36.

45. BMA, 125–1-1224.

46. Shen Bo, *Beiping jiefang*, 90.

47. BMA, 125–1-32. See also Shen Bo, *Beiping jiefang*, 90–91.

48. Zhao Dongri, *Jianzhu sheji dashi*, 6.

49. At a price tag of 101 million yuan, the cost for building the Great Hall was almost three times that of the second most expensive building—the Museums of the Chinese Revolution and of Chinese History—which cost a total of 35 million yuan to build. See "Guoqing gongcheng jianzhu zaojia."

50. Shen Bo, *Beiping jiefang*, 104–5.

51. Zhang Bo, *Wo de jianzhu*, 150.

52. Ibid., 202.

53. Zhao Dongri, *Jianzhu sheji dashi*, 157–62.

54. Ibid., 95, 124.

55. See Xiong Ming's foreword in Zhao Dongri, *Jianzhu sheji dashi*.

56. Zhao Dongri, *Jianzhu sheji dashi*, 160.

57. Ibid.

58. Zhang Bo, *Wo de jianzhu*, 156.

59. Ibid., 153.

60. Ibid., 153–54.

61. Guoqing gongcheng sheji shencha huiyi bangongshi, "Guoqing gongcheng sheji shencha huiyi jianbao, dierhao" (The second brief report on the review session of the National Day projects), BMA, 131–1-359.

62. Interview with Architect A, January 24, 2007, Beijing.

63. Zhao Dongri, "Tiananmen guangchang" (Tiananmen Square), *JZXB*, nos. 9–10 (October 1959): 19.

64. Zhang Bo, *Wo de jianzhu*, 153.

65. Spiro Kostof, *A History of Architecture: Settings and Rituals*, rev. by Greg Castillo (New York: Oxford University Press, 1995), 717.

66. Shen Bo, *Beiping jiefang*, 121.

67. Zhang Bo, *Wo de jianzhu*, 145.

68. Zhao Dongri, *Jianzhu sheji dashi*, 161.

69. Interview with Architect B, January 22, 2007, Beijing.

70. Interview with Architect A, January 24, 2007, Beijing.

71. Vladimir Paperny, *Architecture in the Age of Stalin: Culture Two*, trans. John Hill and Roann Barris, in collaboration with the author (Cambridge: Cambridge University Press, 2002), 56.

72. Albert Speer, *Inside the Third Reich: Memoirs,* trans. Richard and Clara Winston (London: Weidenfeld and Nicolson, 1970), 155.

73. See Anders Aman, *Architecture and Ideology in Eastern Europe during the Stalin Era: An Aspect of Cold War History* (New York: Architectural History Foundation; Cambridge: MIT Press, 1992), 96.

74. "Quanguo Renmin daibiao dahuitang gongcheng de jiben qingkuang" (Basic conditions concerning the construction of the Great Hall of the People's Representatives), BMA, 2–11-138; "Zhongguo geming he Zhongguo lishi bowuguan gongcheng de jiben qingkuang" (Basic conditions concerning the construction of the Museums of the Chinese Revolution and of Chinese History), BMA, 2–11-138.

75. "Shoudu guoqing gongcheng jieshao (chugao)" (A draft introduction to the National Day projects in the capital), BMA, 131–1-361.

76. *JZXB,* nos. 9–10 (October 1959): 33.

77. Zhao Dongri, "Huiyi Renmin dahuitang sheji guocheng" (Remembering the design of the Great Hall of the People," *BJWSZL,* no. 49 (November 1994): 17.

78. Zhao Dongri, *Jianzhu sheji dashi,* 124.

79. *JZXB,* nos. 9–10 (October 1959): 26.

80. I am indebted to the architect Wang Wei-jen for this observation.

81. Shen Bo, *Beiping jiefang,* 135–36.

82. Zhao Dongri, *Jianzhu sheji dashi,* 5.

83. Zhang Bo, *Wo de jianzhu,* 153.

84. Zhao Dongri, *Jianzhu sheji dashi,* 91.

85. Zhang Bo, *Wo de jianzhu,* 157.

86. *JZXB,* nos. 9–10 (October 1959): 29.

87. Zhang Bo, *Wo de jianzhu,* 85. Interview with Zhang Bo, December 14, 1994, Beijing.

88. Interview with Zhang Kaiji, September 16, 1996, Beijing.

89. Interview with Liu Xiaoshi, January 24, 2007, Beijing.

90. Zhonghua renmin gongheguo jianzhu gongchengbu, "Guanyu xuanchuan shoudu yipi xinjian gongcheng wei zhuyi tidao Sulian zhuanjia de bangzhu de baogao" (Report on the discounting of Soviet experts' assistance in the propaganda concerning the capital's newly built projects), BMA, 125–1-1254. See also BMA, 125–1-1242.

91. Zhonghua renmin gongheguo jianzhu gongchengbu, "Guanyu xuanchuan shoudu."

92. Ibid.

93. Guihuaju, "Beijingshi zongti guihua gangyao (caogao), 1958–1972."

94. "Beijingshi guiweihui guanyu Beijingshi dierpi daolu mingming qingdan (Xijiao bufen)" (A second list of the renaming of the streets in Beijing [Western suburb section] issued by the Planning Committee of Beijing), BMA, 151–1-71.

95. *The Constitution of the People's Republic of China* (Peking: Foreign Languages Press, 1954), 9.

96. Wan Li, "Guanyu guoqing gongcheng jinzhan."

97. Feng Peizhi and Shen Bo, "Guoqing gongcheng de shengli jiancheng (chugao)" (The successful completion of the National Day projects [draft]), BMA, 131–1-362.

98. Beijingshi chengshi jianshe weiyuanhui, "Guanyu jianshe Chang'an fandian."

99. Golomstock, *Totalitarian Art,* 275.

100. BMA, 102–1-54.

101. BMA, 125–1-1226.

102. Shen Bo, *Beiping jiefang,* 113.

103. Interview with Architect A, January 24, 2007, Beijing.

3. Yangge

1. David Holm, *Art and Ideology in Revolutionary China* (Oxford: Clarendon, 1991).

2. Zhang Hua, *Zhongguo minjianwu yu nonggeng xinyang* (China's folk dances and peasant beliefs) (Changchun: Jilin jiaoyu chubanshe, 1992), 16.

3. Holm, *Art and Ideology*, 115–341.

4. Mao Zedong, "Talks at the Yenan Forum on Literature and Art," in Mao, *Selected Works*, 3:69–98.

5. Ai Siqi, et al., *Yangge lunwen xuanji* (Selected essays on yangge) (N.p.: Xinhua shudian, 1944), 14.

6. Holm, *Art and Ideology*, 259.

7. Telephone interview with yangge Dancer A, June 29, 2003.

8. Dai Ailian, "Wo de wudao shengya" (My life as a dancer), in *Zhonghua wenshi ziliao wenku* (Source materials on Chinese literature and history), vol. 15 (Beijing: Zhongguo wenshi chubanshe, 1996), 482; Dai Ailian, *Wo de yishu yu shenghuo* (My art and life) (Beijing: Renmin yinyue chubanshe, Huayue chubanshe, 2003), 112, 153. Interview with Dai Ailian, October 16, 2002, Beijing.

9. *JFRBS*, June 10, 1946, 4.

10. Interview with yangge Dancer B, October 15, 2002, Beijing.

11. *Zhonghua quanguo wenxue yishu gongzuozhe daibiao dahui jinian wenji* (A commemorative volume of the All-China Writers and Artists Congress), ed. Zhonghua quanguo wenxue yishu gongzuozhe daibiao dahui xuanchuanchu (N.p.: Xinhua shudian, 1950), 287.

12. Interview with yangge Dancer B, October 15, 2002, Beijing.

13. Bodde, *Peking Diary*, 103.

14. *GMRB*, July 9, 1949, 1; *YHB*, November 10, 1949, 1.

15. *Wudao yishu* (Dance art), no. 4 (November 1992), 48.

16. Holm, *Art and Ideology*, 168.

17. Telephone interview with yangge Dancer A, April 2, 2003.

18. "Beijingshi wenyi gongzuo weiyuanhui gongzuo baogao" (The report of the Beijing Literary and Art Committee), BMA, 1–12-3.

19. *RMRB*, January 23, 1950, 4.

20. *YHB*, December 14, 1949, 4.

21. *YHB*, October 19, 1949, 3.

22. von Geldern, *Bolshevik Festivals*.

23. Liu Junxiang, ed., *Zhongguo wudao yishu* (China's dance art) (Nanjing: Jiangsu wenyi chubanshe, 1992), 34.

24. *GMRB*, October 1, 1949, 4.

25. *GMRB*, January 15, 1951, 3; *RMRB*, February 18, 1951, 5.

26. Jin-Cha-Ji wenyi yanjiuhui, ed., *Wenyi zhanshi hua dangnian* (Reminiscences of cultural warriors) (Beijing: n.p., 2001), 211.

27. *GMRB*, June 21, 1949, 1.

28. Ai Ke'en, ed., *Yan'an yishujia* (Yan'an artists) (Xi'an: Shaanxi renmin jiaoyu chubanshe, 1992), 325–28.

29. Hu Sha, "Xiangqi zai Yan'an nao yangge de jijianshi" (Reminiscences of dancing yangge in Yan'an), *RMRB*, May 24, 1962, 6.

30. Dai, "Wo de wudao shengya," 479.

31. Hu Sha, "*Renmin shengli wansui dagewu* chuangzuo jingguo" (The creation of *The Great Musical of Long Live the People's Victory*), *RMRB*, November 1, 1949, 6.

32. Ibid.

33. Mao Zedong, "Some Questions Concerning Methods of Leadership," in Mao, *Selected Works*, 3:119.

34. Hu Sha, *"Renmin shengli wansui"*; Dong Xijiu, *"Renmin shengli wansui* xiangche Zhongnanhai" (The magnificent performance of *Long Live the People's Victory* in Zhongnanhai), *Wudao* (Dance), no. 5 (1999): 52–53; Long Yinpei, "Toushen geming wenyi" (Participating in revolutionary art and literature), *Wenyi bao*, no. 121 (October 16, 1999): 1; Wang Kefen and Long Yinpei, eds., *Zhongguo jinxiandai dangdai wudao fazhanshi: 1840–1996* (A history of dance from the modern to the contemporary period: 1840–1996) (Beijing: Renmin yinyue chubanshe, 1999), 178–80. Interview with Dong Xijiu, October 15, 2002, Beijing.

35. Interview with yangge Dancer C, October 18, 2002, Beijing.

36. Telephone interview with yangge Dancer B, June 29, 2003.

37. Dong Xijiu, *"Renmin shengli wansui,"* 53.

38. Hu Sha, *"Renmin shengli wansui."*

39. Interviews with yangge Dancers A, D, and E, October 18, 2002, Beijing.

40. Telephone interview with yangge Dancer B, July 6, 2003.

41. Long, "Toushen geming wenyi."

42. Zhao Yunge (Peng Song), *"Jianshe zuguo dayangge* zongjie" (A summary report of *The Great Yangge of Building the Motherland*), *Xiju xuexi*, no. 1 (April 2, 1950): 6.

43. Ibid.

44. *JFRBY*, May 15, 1944, 4.

45. Interview with Peng Song, October 17, 2002, Beijing.

46. *"Jianshe zuguo dayangge"* (*The Great Yangge of Building the Motherland*), *RMRB*, February 23, 1950, 3.

47. Telephone interview with yangge Dancer F, March 30, 2003.

48. Zhao Yunge, *"Jianshe zuguo dayangge."*

49. Ibid.

50. *RMRB*, February 23, 1950, 3.

51. von Geldern, *Bolshevik Festivals*, 1–3, 199–207.

52. Albert Lord, *The Singer of Tales* (Cambridge: Harvard University Press, 1960).

53. Wang and Long, *Zhongguo jinxiandai dangdai*, 180.

54. Tian Han, "Renmin gewu wansui" (Long live the people's dances), *RMRB*, November 7, 1949, 6.

55. Zhao Yunge, *"Jianshe zuguo dayangge."*

56. Interview with yangge Dancer A, October 18, 2002, Beijing.

57. David Kidd, *Peking Story: The Last Days of Old China* (New York: Clarkson N. Potter, 1988), 72.

58. *JBRB*, June 7, 1949, 4.

59. Choi Seung-hee, "Zhongguo wudao yishu de jianglai" (The future of Chinese dance), *RMRB*, February 18, 1951, 5.

60. *The Common Program and Other Documents of the First Plenary Session of the Chinese People's Political Consultative Conference* (Peking: Foreign Languages Press, 1950), 2.

61. *JBRB*, June 7, 1949, 4.

62. Wang and Long, *Zhongguo jinxiandai dangdai*, 181.

63. Zhao Yunge, *"Jianshe zuguo dayangge."* Interview with Peng Song, October 17, 2002, Beijing.

64. *RMRB*, October 8, 1949, 3; November 15, 1952, 3.

65. *RMRB*, November 16, 1952, 3.

66. Conservatives disparaged Dai's ballet dance: "Workers, peasants, and soldiers cannot bear to see the sight of thighs prancing around the stage" (Dai Ailian, *Wo de yishu yu shenghuo*, 155).

67. Ibid., 164–65, 190–95.

68. "Niu yangge zhuyi sidian" (Four points needing attention when dancing yangge), *JBRB*, June 28, 1949, 3.

69. *RMRB*, October 19, 1951, 3.

70. Zhou Yang, *Zhou Yang wenji* (Collected writings of Zhou Yang), 4 vols. (Beijing: Renmin wenxue chubanshe, 1984–1991), 2:237.

71. *RMRB*, February 18, 1951, 5.

72. Yangge dancing declined in popularity in the early 1950s. However, since the early 1990s it has been revived in northern China, especially in Beijing and Shenyang; indeed, I saw many such street performances in Beijing on my research trips there in recent years. But unlike the earlier political yangge, these dances are performed mostly by senior citizens and retirees largely for fitness or medical purposes. The government views the dances as benign and nonthreatening, and therefore ignores them. Further information on this development can be found in *Wudao yishu*, no. 1 (1994): 9–14; Yoshida Jirobee, "Beijing xin yangge de diaocha yu sikao" (A survey of, and reflection on, Beijing's new yangge dances) (MA thesis, Beijing Normal University, 1997).

4. Parades

1. Bodde, *Peking Diary*, 103–4.

2. *Mianhuai Liu Ren tongzhi* (Remembering comrade Liu Ren) (Beijing: Beijing chubanshe, 1979), 111.

3. Dong Xiaoping, *Tianye minsuzhi* (Folklore fieldwork) (Beijing: Beijing shifan daxue chubanshe, 2003), 612–26.

4. Geertz, *Local Knowledge*, 124.

5. Ozouf, *Festivals and the French Revolution*, 126–57.

6. George L. Mosse, *The Nationalization of the Masses: Political Symbolism and Mass Movements in Germany from the Napoleonic Wars through the Third Reich* (Ithaca: Cornell University Press, 1975), 100–26.

7. Christel Lane, *The Rites of Rulers: Ritual in Industrial Society—The Soviet Case* (Cambridge: Cambridge University Press, 1981), 153–88.

8. Mary Ryan, "The American Parade: Representations of the Nineteenth-Century Social Order," in *The New Cultural History*, ed. Lynn Hunt (Berkeley: University of California Press, 1989), 138.

9. Henrietta Harrison, *The Making of the Republican Citizen: Political Ceremonies and Symbols in China, 1911–1929* (Oxford: Oxford University Press, 2000), 93–132.

10. Wu, *Remaking Beijing*, 85–104.

11. Wang Fengde, "Baogao" (Report), SMA, A22–2–894.

12. *SB*, October 14, 1914, 2; October 11, 1916, 2; October 12, 1929, 11.

13. Schools sometimes organized impromptu celebrations. For example, on October 10, 1917, more than 4,757 students in Shanghai participated in a parade to celebrate National Day. See *SB*, October 11, 1917, 10.

14. *SB*, October 12, 1917, 7; October 10, 1929, 13, 15.

15. *RMRB*, December 24, 1949, 1.

16. Lane, *Rites of Rulers*, 172.

17. "Yijiuwuwunian Wuyijie shirong buzhi gongzuo jihua" (Work plans for decorating the city during the 1955 May Day festival), SMA, B56–2–3.

18. "Guanyu jige zhuyao de gaolou dasha de jufu biaoyu de buzhi" (On the decoration of huge posters on the key high-rises), SMA, B56-2-2.

19. "Guanyu Wuyi youxing he wanhui zhunbei qingkuang de baogao" (Report on the preparation for the May Day parades and evening parties), Beijing Municipal Archives (BMA), 99–1-110.

20. *Zhuangyan de qingdian: Guoqing shoudu qunzhong youxing jishi* (Solemn festivities: Records of the people's parades in the capital during the National Day celebrations), ed. Zhongguo renmin zhengzhi xieshang huiyi Beijingshi weiyuanhui wenshi ziliao weiyuanhui (Beijing: Beijing chubanshe, 1996), 151.

21. *RMHB* 1, no. 1 (July 1950), photos.

22. Shu Jun, *Tiananmen guangchang*, 227.

23. Lane, *Rites of Rulers*, 179.

24. "Qunzhong youxing duiwu zuzhi fang'an deng" (The plan for organizing contingents of the procession for the people's parade and others), BMA, 99–1-1.

25. "Youxing duiwu xulie he xingjin luxian" (Order of processions and the procession routes), BMA, 99–1-61.

26. "Biandui gongzuo de jixiang guiding" (Rules concerning group formations), BMA, 99–1-200.

27. "Qunzhong youxing duiwu."

28. *RMRB*, May 3, 1952, 1.

29. Interview with Marcher A, January 6, 2006, Beijing; interview with Marcher B, January 13, 2006, Beijing.

30. Interview with Marcher C, January 4 and 5, 2006, Beijing.

31. "Yijiuwuyinian guoqingjie youxing jihua" (Plan of the parade at the 1951 National Day celebrations), BMA, 99–1-1.

32. "Youxing duiwu jieshao" (Introduction to groups that participated in the parades), BMA, 99–1-162.

33. "Gongzuo richeng he jianbao" (Work schedule and brief reports), BMA, 99–1-13.

34. On Shanghai's torch relay race, see SMA, B55–2-6.

35. "Biandui gongzuo."

36. "Youxing renshu" (The number of people who participated in the parades), BMA, 99–1-94.

37. Ibid.; *Zhuangyan de qingdian*, 83.

38. Interview with Marcher D, January 5, 2006, Beijing.

39. "Qunzhong youxing zhunbei gongzuo qingkuang de baogao" (Report on the preparation of the people's parade), BMA, 99–1-94.

40. "Ge duiwu duirong qingkuang" (Specific conditions in each parade group), BMA, 99–1-45.

41. "Lingxiuxiang pailie shunxu ji qizhi pailie de guiding" (Rules concerning the order of the leaders' portraits and the banners), BMA, 99–1-1. See also SMA, B55–1-5.

42. Stuart R. Schram, "Party Leader or True Ruler? Foundations and Significance of Mao Zedong's Personal Power," in *Foundations and Limits of State Power in China*, ed. Stuart Schram (London: School of Oriental and African Studies, University of London; Hong Kong: Chinese University Press, 1987), 203–56.

43. "Qingzhu yijiuwuwunian guoqing qunzhong youxing yizhangdui tai lingxiuxiang pailie shunxu" (The order of the portraits of leaders during the people's parade to celebrate the 1955 National Day festival), BMA, 99–1-61.

44. *Putian tongqing* (The whole world joins in the celebration), a film produced by Beijing dianying zhipianchang (Beijing Film Studio), 1950; *Yijiuwuyinian guoqingjie:*

Daxing jilupian (The 1951 National Day celebrations: A major documentary), a film produced by Zhongyang dianyingju Beijing dianying zhipianchang (Beijing Film Studio, Central Film Bureau), 1951.

45. "Wuyijie youxing duiwu lingxiuxiang pailie banfa" (Methods to arrange the order of the leaders' portraits during the May Day parade), BMA, 99–1-3.

46. "Shaoxiandui" (The Young Pioneers group), BMA, 99–1-196.

47. Hunt, *Politics, Culture, and Class,* 19–51; Lane, *Rites of Rulers,* 167.

48. Pierre Bourdieu, *Language and Symbolic Power,* ed. and intro. John B. Thompson, trans. Gino Raymond and Matthew Adamson (Cambridge: Harvard University Press, 1991), 190.

49. "Huhan de kouhao" (Slogans used), BMA, 99–1-94.

50. Interview with Marcher C, January 4 and 5, 2006, Beijing.

51. Interviews with Marchers A (January 6, 2006, Beijing), B (January 13, 2006, Beijing), C (January 4 and 5, 2006, Beijing), and D (January 5, 2006, Beijing); and interview with Marcher E, January 7, 2006, Beijing.

52. "Beijingshi qingzhu guoqing dahui kouhao" (Slogans used in Beijing for the National Day celebrations), BMA, 99–1-11.

53. "Guanyu Wuyi youxing."

54. "Ge duiwu duirong qingkuang" (Specific conditions in each parade group), BMA, 99–1-61.

55. "Youxing jihua" (Plans for the parade), BMA, 99–1-2.

56. Lane, *Rites of Rulers,* 156.

57. "Disanci zhihuibu huiyi" (The third meeting of the command center), BMA, 99–1-47. See also *Zhuangyan de qingdian,* 50.

58. On Shanghai's celebrations of this special occasion, see SMA, B55–1-14.

59. *Zhuangyan de qingdian,* 487.

60. Ibid., 90.

61. "Shoudu qingzhu shizhounian guoqingjie youxing zuzhi gongzuo yaodian (cao'an)" (Key points concerning the parade during the tenth anniversary of the National Day celebration: a draft), BMA, 99–1-193.

62. "Shanghaishi gejie renmin qingzhu Wuyi guoji laodongjie de xuanchuan yaodian he jinian banfa" (Methods and propaganda techniques used by Shanghai's citizens to celebrate the international May Day festival), SMA, A22–2-88.

63. "Yijiuwuwunian guoqingjie qunzhong youxingshi huhan de kouhao" (Slogans used during the people's parades in the 1955 National Day celebrations), BMA, 99–1-61.

64. "Yijiuwujiunian guoqingjie qunzhong youxing duiwu duirong jiankuang" (An outline of the parade groups in the people's parades during the 1959 National Day festival), BMA, 99–1-208.

65. *Zhuangyan de qingdian,* 89, 271.

66. "Jihua renshu" (The projected figures), BMA, 99–1-2.

67. BMA, 99–1-94.

68. Interview with Marcher E, January 7, 2006, Beijing.

69. "Shaoxiandui."

70. "Peng Zhen tongzhi zhaoji de Wuyi choubei gongzuo huiyi jilu" (The minutes of the preparatory work meeting concerning the May Day parades called by Comrade Peng Zhen), BMA, 99–1-93.

71. "Waibin dui youxing duiwu de fanying" (Foreign guests' reactions to the parades), BMA, 99–1-48.

72. "Gongzuo richeng" (Work schedule), BMA, 99–1-32.

73. *Zhuangyan de qingdian*, 47.

74. Interview with Marcher A, January 6, 2006, Beijing.

75. "Guanyu Wuyi youxing." See also *Zhuangyan de qingdian*, 425.

76. "Wenyi dadui muqian gongzuo jinxing qingkuang" (The progress of the work of the art group), BMA, 99–1-95.

77. "Zuzhi gongzuo yaodian" (Important organizational matters), BMA, 99–1-178.

78. Geertz, *Local Knowledge*, 121–46.

79. *Zhuangyan de qingdian*, 321. This practice, however, was ended in 1954.

80. Ibid., 56.

81. "Guanyu yijiuwulingnian eryue liuri Yangshupu fadianchang zaoshou Guomindang feiji hongzha de baogao" (Report on the bombing of Yangshupu's power plant by Guomindang planes on February 6, 1950), SMA, B1–2-390–1.

82. *RMRB*, August 18, 1951, 3–4.

83. "Guanyu Wuyi youxing."

84. "Qingzhu yijiuwuwunian shoudu guoqingjie wenyi dadui gongzuo zongjie" (Final report on the work of the art group during the 1955 National Day celebrations in the capital), BMA, 99–1-62.

85. "Gongzuo jianbao" (Brief reports), BMA, 99–1-46.

86. "Dierci zhihuibu huiyi" (The second meeting of the command center), BMA, 99–1-47.

87. SMA, B55–1-6.

88. "Disanci zhihuibu huiyi."

89. "Qingzhu yijiuwuwunian shoudu guoqingjie."

90. Ibid.

91. "Zhou zongli dui Shigeweihui guanyu yijiuqiernian Wuyijie qingzhu huodong de qingshi de pishi" (Premier Zhou's decision on the petition submitted by the Beijing Municipal Revolutionary Committee concerning the 1972 May Day celebratory activities), BMA, 99–1-784.

92. Wang Fengde, "Baogao."

93. Qu Qiubai, "Chidu xinshi," 145.

94. *Zhuangyan de qingdian*, 5.

95. "Yijiuwusinian bayue siri guoqingjie choubeihui" (Preparatory committee meeting on August 4, 1954 concerning the National Day celebrations), BMA, 99–1-33.

96. von Geldern, *Bolshevik Festivals*, 40–71.

97. Lane, *Rites of Rulers*, 166–73.

98. "Zuzhi qunzhong zai Xi Chang'anjie canguan yuebing, youxing de gongzuo jihua" (The work plan for organizing people to view the military parade and the procession along West Chang'an Avenue), BMA, 99–1-75. In this document Mao was reported to have said, "The people have now been highly organized."

99. Victoria E. Bonnell, *Iconography of Power: Soviet Political Posters under Lenin and Stalin* (Berkeley: University of California Press, 1997), 193; Lane, *Rites of Rulers*, 168.

100. Of course negative symbols such as the paper tiger were used during the anti-imperialist demonstrations, as in the Resist America, Aid Korea Campaign in the early 1950s. See *RMRB*, December 18, 1950, 1.

101. *RMRB*, February 18, 1951, 5.

102. "Waibin dui youxing duiwu."

103. "Zhongzhi ge jiguan tongzhi dui Wuyi youxing de yijian" (Opinions of the comrades of the central bureaus concerning May Day parades), BMA, 99–1-48.

104. "Beijing qingzhu yijiuwuwunian Wuyi laodongjie choubei huiyi" (Preparatory meeting for the celebration of the 1955 May Day festival in Beijing), BMA, 99–1–60. But the document does not indicate what safety measures were taken.

105. Ibid.

106. Ibid.

107. "Peng Zhen tongzhi zhaoji de Wuyi choubei gongzuo."

108. *Zhuangyan de qingdian*, 187.

109. See Mosse, *Nationalization of the Masses*, 73–74.

110. Ozouf, *Festivals and the French Revolution*.

111. "Disanci zhihuibu huiyi."

112. "Peng Zhen tongzhi zhaoji de guoqingjie youxing ji baowei gongzuo huiyi." (The meeting called by Comrade Peng Zhen concerning the National Day parades and their security matters), BMA, 99–1–78.

113. David I. Kertzer, *Ritual, Politics, and Power* (New Haven: Yale University Press, 1988), 42.

114. Interview with Marcher F, October 17, 2002, Beijing.

5. The Red Line

1. *Huiyi Wang Yeqiu* (Remembering Wang Yeqiu), ed. Guojia wenwuju (Beijing: Wenwu chubanshe, 1995), 37–38, 140.

2. *Jiefangqu zhanlanhui ziliao* (Materials on exhibition in the liberated areas), ed. Zhongguo geming bowuguan (Beijing: Wenwu chubanshe, 1988), 5.

3. Ibid.

4. *Huiyi Wang Yeqiu*, 58–95.

5. *WWCKZL*, nos. 1–6 (October 1950), 5–8.

6. Albina Danilova, *Dedicated to the Muses* (Moscow: Novosti, 1990), 16–17.

7. *RMRB*, May 4, 1949, 5.

8. *Huiyi Wang Yeqiu*, 44–45.

9. *WWCKZL*, nos. 1–6 (October 1950), 33–35.

10. Wang Yeqiu, "Fang Su guangan" (Impressions of a visit to the Soviet Union), *WWCKZL*, no. 11 (November 30, 1950): 118–19.

11. Ibid., 115–25.

12. Wang Yeqiu, "Sulian guoli geming bowuguan" (Soviet National Museum of the Revolution), *WWCKZL*, no. 10 (October 31, 1950): 66–77.

13. Wang Yeqiu, "Fang Su guangan," 120.

14. Jian Bozan, "Canguan Sulian bowuguan de yinxiang" (Impressions upon visiting Soviet museums), *WWCKZL*, no. 4 (May 30, 1953): 30–31.

15. *Huiyi Wang Yeqiu*, 40–43.

16. Translated into Chinese as *Sulian bowuguanxue jichu* (Beijing: Wenwu chubanshe, 1957).

17. Yang Boda, "Sulian bowuguan gongzuo jieshao (yi)" (An introduction to Soviet museum work, part 1), *WWCKZL*, no. 4 (April 30, 1954): 99.

18. Jian Bozan, "Canguan Sulian bowuguan," 40.

19. *WWCKZL*, no. 10 (October 31, 1950): 79.

20. Andrew McClellan, *Inventing the Louvre: Art, Politics, and the Origins of the Modern Museum in Eighteenth-Century Paris* (Berkeley: University of California Press, 1994), 91.

21. Carol Duncan and Alan Wallach, "The Universal Survey Museum," *Art History* 3, no. 4 (December 1980): 456.

22. Groys, "The Struggle against the Museum," 144.

23. Wang Yeqiu, "Sulian guoli geming bowuguan."

24. *Huiyi Wang Yeqiu.*, 48.

25. *RMRB*, February 13, 1950, 3.

26. *Huiyi Wang Yeqiu*, 151.

27. *Huiyi Wang Yeqiu*, 143, 165; *RMRB*, February 21, 1950, 3.

28. *Huiyi Wang Yeqiu*, 144–45.

29. Ibid., 149.

30. "Guanyu Geming, Lishi liang bowuguan choujian qingkuang de baogao" (A report on the preparation for the construction of the Museum of the Chinese Revolution and the Museum of Chinese History), BMA, 164–1-31.

31. Interview with Zhang Kaiji, September 16, 1996, Beijing. See also Zhang Kaiji, "Canjia guoqing gongcheng sheji de diandi huiyi" (Reminiscences of my participation in the National Day projects), *BJWSZL*, no. 49 (November 1994): 40.

32. Mao Zedong, "A Single Spark Can Start a Prairie Fire," in Mao, *Selected Works*, 1:117–28.

33. Interview with Zhang Kaiji, September 16, 1996, Beijing.

34. *JZXB*, nos. 9–10 (1959): 33.

35. "Zhongguo geming, lishi bowuguan gongcheng jiben zongjie" (A summary of the construction work of the Museum of the Chinese Revolution and the Museum of Chinese History), BMA, 47–1-90.

36. Nicholas M. Pearson, *The State and the Visual Arts: A Discussion of State Intervention in the Visual Arts in Britain, 1760–1981* (Milton Keynes, UK: Open University Press, 1982), 26.

37. Interview with museum Staffer A, January 22, 2005, Beijing.

38. *Beijing bowuguan nianjian, 1912–1987* (The year book of Beijing museums, 1912–1987), ed. Beijing bowuguan xuehui (Beijing: Beijing yanshan chubanshe, 1989), 197.

39. Ibid.

40. Ibid., 197–98.

41. Fang Kongmu, "Chenlie gongzuo de lishi fazhan" (The history of the development of the exhibitions), in *Zhongguo geming bowuguan fazhan jishi* (Chronicles of the development of the Museum of the Chinese Revolution) (N.p.: n.d.), 5.

42. Ibid.

43. BMA, 164–1-31; *Zhongguo geming bowuguan wushinian* (Fifty years of the Museum of the Chinese Revolution), ed. Zhongguo geming bowuguan wushinian bianweihui (Shenzhen: Haitian chubanshe, 2001), 139.

44. *Zhongguo geming bowuguan wushinian*, 140.

45. Interview with museum Staffer B, January 21, 2005, Beijing; interview with museum Staffer A, January 22, 2005, Beijing.

46. Fang Kongmu, "Chenlie gongzuo," 4.

47. Yu Jian, "Zhou Yang yu bowuguan" (Zhou Yang and museums), *Zhongguo wenwubao*, no. 42 (October 27, 1989): 2.

48. Yu Jian, "Shencha Zhongguo geming bowuguan chenlie" (Inspecting the exhibitions of the Museum of the Chinese Revolution), in *Zhou Enlai yu Beijing* (Zhou Enlai and Beijing), ed. Zhongguo renmin zhengzhi xieshang huiyi Beijingshi weiyuanhui wenshi ziliao weiyuanhui (Beijing: Zhongyang wenxian chubanshe, 1998), 266–75. Interview with Yu Jian, January 22, 2005, Beijing.

49. Yu Jian, "Zhou Yang."

50. Liu Zhonghai, Zheng Hui, and Cheng Zhongyuan, eds., *Huiyi Hu Qiaomu* (Remembering Hu Qiaomu) (Beijing: Dangdai Zhongguo chubanshe, 1994), 35.

51. Ibid., 43–44, 53.

52. Chen Qingquan and Song Guangwei, *Lu Dingyi zhuan* (Biography of Lu Dingyi) (Beijing: Zhonggong dangshi chubanshe, 1999), 378.

53. *RMRB*, August 17, 1959, 2; August 2, 1960, 1. Interview with museum Staffer C, January 10, 2005, Beijing.

54. *Beijing bowuguan nianjian*, 198.

55. Fang Kongmu, "Chenlie gongzuo," 5.

56. Ibid., 5–6.

57. Ibid., 7.

58. Hu Qiaomu, *Zhongguo gongchandang*.

59. Yu Jian, "Shencha," 267–68.

60. Ibid., 272.

61. Ibid., 273.

62. *Beijing bowuguan nianjian*, 199.

63. Fang Kongmu, "Chenlie gongzuo," 6.

64. Ibid, 6–7.

65. Interview with museum Staffer D, January 13, 2005, Beijing.

66. Yu Jian, "Zhou Yang."

67. Fang Kongmu, "Tan dangshi gongzuo zhong de jige wenti" (On several issues related to the research on Party history), in *Dangshi yanjiu ziliao* (Research materials on Party history), vol. 1 (Chengdu: Sichuan renmin chubanshe, 1980), 477.

68. Fang Kongmu, "Chenlie gongzuo," 7.

69. Susan M. Pearce, *Museums, Objects, and Collections: A Cultural Study* (Washington, DC: Smithsonian Institution Press, 1993), x.

70. The primary sources are: photo illustrations from *WW*, no. 7 (July 1961); Benkan jizhe (Wang Yeqiu), "Zhongguo geming bowuguan xunli" (A tour of the Museum of the Chinese Revolution), *WW*, no. 7 (July 1961): 27–37; *Zhongguo geming bowuguan fazhan jishi*, illustration 37; *GMBWG*, no. 3 (1984): 3, and illustrations. Interviews with museum Staffers A (January 22, 2005, Beijing), B (January 21, 2005, Beijing), C (January 10, 2005, Beijing), and D (January 13, 2005, Beijing).

71. *RMRB*, July 1, 1961, 1; interview with museum Staffer D, January 13, 2005, Beijing.

72. Mao Zedong, "On the People's Democratic Dictatorship," in Mao, *Selected Works*, 4:413.

73. *WW*, no. 7 (July 1961).

74. Mao Zedong, "The Bankruptcy of the Idealist Conception of History," in Mao, *Selected Works*, 4:456.

75. *RMRB*, February 15, 1962, 6.

76. Interview with Luo Gongliu, January 16, 2004, Beijing.

77. *Zhongguo geming bowuguan wushinian*, 143–44, 148–49.

78. Interview with museum Staffer D, January 13, 2005, Beijing.

79. Kenneth Lieberthal, "The Great Leap Forward and the Split in the Yenan Leadership," in *The Cambridge History of China*, ed. Roderick MacFarquhar and John K. Fairbank, vol. 14 (Cambridge: Cambridge University Press, 1987), 321.

80. Interviews with museum Staffers A (January 22, 2005, Beijing), B (January 21, 2005, Beijing), C (January 10, 2005, Beijing), and D (January 13, 2005, Beijing).

81. Roderick MacFarquhar, *The Origins of the Cultural Revolution*, vol. 2, *The Great Leap Forward, 1958–1960* (New York: Columbia University Press, 1983), 336.

82. Interview with museum Staffer C, January 10, 2005, Beijing.

83. Duncan and Wallach, "The Universal Survey Museum," 450–51.

6. Oil Paintings and History

1. *Luo Gongliu yishu duihualu* (A dialogue about art with Luo Gongliu), ed. Liu Xiaochun (Taiyuan: Shanxi jiaoyu chubanshe, 1999), 119.

2. Bo Songnian, ed., *Zhongguo yishushi tuji* (A pictorial history of Chinese art) (Shanghai: Shanghai wenyi chubanshe, 2004), 253.

3. Jiang Feng, *Jiang Feng meishu lunji* (Jiang Feng's collected essays on art), ed. Jiang Feng meishu lunji bianjizu (Beijing: Renmin meishu chubanshe, 1983), 1:92.

4. Jin Shangyi, in collaboration with Cao Wenhan, *Wo de youhua zhi lu: Jin Shangyi huiyilu* (My life as an oil painter: Memoirs of Jin Shangyi) (Changchun: Jilin meishu chubanshe, 2000), 62–64. Interviews with Jin Shangyi, August 4, 2004, and January 7, 2006, Beijing.

5. Bown, *Art under Stalin*, 140, 214.

6. For the term "revolutionary history paintings" (*geming lishihua*), see Quan Shanshi, "Cong cuozhe zhong jian guangming" (Seeing the light after adversities), *MS*, no. 1 (February 6, 1962), 50.

7. Andrews, *Painters and Politics*, 75–86, 228–46. Kirk A. Denton, "Visual Memory and the Construction of a Revolutionary Past: Paintings from the Museum of the Chinese Revolution," *Modern Chinese Literature and Culture* 12, no. 2 (Fall 2000): 203–35.

8. *Zhongguo geming bowuguan wushinian*, 136–37.

9. Wang Yeqiu, "Sulian Guoli geming bowuguan."

10. *Zhongguo geming bowuguan wushinian*, 137. Interviews with Yan Han, January 15, 2004, and January 3, 2006, Beijing.

11. *Lou Gongliu yishu duihualu*, 32.

12. *RMRB*, November 27, 1949, 4.

13. Matthew Cullerne Bown, *Socialist Realist Painting* (New Haven: Yale University Press, 1998), 131–204.

14. Interviews with Bo Songnian, January 11, 2004, and August 6, 2005, Beijing.

15. Xu Beihong, "Zai Sulian Jieke canguan meishu de jianlüe baogao" (A brief report on art during a visit to the Soviet Union and Czechoslovakia), in *Xu Beihong yishu wenji* (Xu Beihong's collected essays on art), ed. Wang Zhen and Xu Boyang (Yinchuan: Ningxia renmin chubanshe, 2001), 546.

16. Bown, *Socialist Realist Painting*, 184–87.

17. "Renmin yishujia Yiliya Liebin," (Ilya Repin: The people's artist), *RMMS* 1, no. 4 (August 1, 1950): 13–14.

18. Chang Nadan, "Xianshizhuyi de lishi huajia Sulikefu" (Surikov: A realist history painter), *RMMS* 1, no. 5 (October 1, 1950): 38–40.

19. *RMMS* 1, no. 5 (October 1, 1950): 47–49.

20. *RMRB*, September 30, 1954, 3; Jin Shangyi, *Wo de youhua*, 23.

21. Jin Shangyi, *Wo de youhua*, 23.

22. Interview with Tong Jinghan (b. 1933), Maksimov's interpreter in China, August 2, 2004, Beijing; See also Jizhe, "Huanyin Sulian youhuajia K. M. Makeximofu" (Welcome Soviet oil painter K. M. Maksimov), *MS*, no. 3 (March 15, 1955): 39.

23. Interviews with Jin Shangyi, August 4, 2004, and January 7, 2006, Beijing.

24. Interview with Wu Biduan, July 30, 2004, Beijing.

25. Interviews with Jin Shangyi, August 4, 2004, and January 7, 2006, Beijing.

26. Cai Ruohong, "Wei chuangzao zui xin zui mei de yishu er fendou" (Striving to create the newest and most beautiful art), *MS*, nos. 8–9 (1960): 3.

27. Bown, *Socialist Realist Painting*, 136.

28. *Lou Gongliu yishu*, 92–94.

29. Hou Yimin, "Wo he wo de geming lishihua" (I, the artist, and my revolutionary history paintings), *Meishu bolan*, no. 17 (June 25, 2005): 33. Interview with Zhan Jianjun, August 2, 2005, Beijing.

30. Interviews with Hou Yimin, August 1, 2004, and January 9, 2006, Beijing; interview with Zhan Jianjun, August 2, 2005, Beijing; interviews with Jin Shangyi, August 4, 2004, and January 7, 2006, Beijing.

31. Interview with Zhan Jianjun, August 2, 2005, Beijing.

32. Ibid.

33. Igor Golomstock, "Problems in the Study of Stalinist Culture," in *The Culture of the Stalin Period*, ed. Hans Günther (New York: St. Martin's, 1990), 114.

34. Zhu Di, "Tan lishi ticai de meishu chuangzuo" (On historical topics in art) *MS*, no. 3 (June 6, 1961): 41.

35. Cai Ruohong, "Wei chuangzao zui xin," 5.

36. Although a full inventory of the oil paintings is not available, some journals printed photographs of the exhibition. See *WW*, no. 7 (July 1961).

37. Jin Shangyi, *Wo de youhua*, 48. Interviews with Jin Shangyi, August 4, 2004, and January 7, 2006, Beijing.

38. Jin Shangyi, *Wo de youhua*, 49–50.

39. Interviews with Jin Shangyi, August 4, 2004, and January 7, 2006, Beijing.

40. Jin Shangyi, *Wo de youhua*, 49.

41. Ibid.

42. Luo acknowledged Rembrandt's influence on his paintings. See *Luo Gongliu yishu*, 54. Interview with Luo Gongliu, January 16, 2004, Beijing.

43. Liu Xiaochun, "Luo Gongliu," *Jujiang meishu zhoukan: Zhongguo xilie* (Masters of Chinese painting), no. 111 (October 12, 1996): 8. See also *Luo Gongliu yishu*, 130–33.

44. *Luo Gongliu yishu*, 125.

45. Ibid., 126.

46. Mao Zedong, "On Coalition Government," in Mao, *Selected Works*, 3:211. Quoted in Quan Shanshi, "Cong cuozhe zhong," 48.

47. Abram Tertz, *On Socialist Realism*, intro. Czeslaw Milosz (New York: Pantheon, 1960), 48.

48. Quan Shanshi, "Cong cuozhe zhong," 49.

49. Ibid., 50.

50. Ibid.

51. Zhan Jianjun, "Zou wanlu yougan" (Reflections on taking a roundabout course), *MS*, no. 6 (December 6, 1961): 31.

52. Ibid.

53. Zhu Di, "Guangming zai qian" (The future is bright), *MS*, no. 4 (August 6, 1961): 26.

54. Bao Jia, "Cong zhanzheng da changmian zhong biaoxian shidai jingshen" (Expressing the spirit of the time through great war scenes), *MS*, no. 6 (December 6, 1961): 30.

55. Ibid.

56. Mao Zedong, "The Present Situation and Our Tasks," in Mao, *Selected Works*, 4:157, 169, 173.

57. Aleksandr Gerasimov visited China in 1954 and was warmly received. See *RMRB*, October 24, 1954, 5.

58. Jin Shangyi, "Chuangzuo *Mao zhuxi zai shieryue huiyi shang* de tihui" (My

reflections on painting *Chairman Mao at the December Conference*), *MS*, no. 6 (December 6, 1961): 10–11.

59. Interviews with Jin Shangyi, August 4, 2004, and January 7, 2006, Beijing.

60. A replica of Serov's painting was sent as a gift by the Soviet Union and displayed in the same museum in 1961. *WW*, no. 7 (July 1961): n. p. (photo).

61. Jin Shangyi, *Wo de youhua*, 131. Interviews with Hou Yimin, August 1, 2004, and January 9, 2006, Beijing.

62. Interviews with Hou Yimin, August 1, 2004, and January 9, 2006, Beijing.

63. Hou Yimin, *"Liu Shaoqi tongzhi he Anyuan kuanggong* de gousi" (The conception of the painting *Comrade Liu Shaoqi and the Anyuan Miners*), *MS*, no. 4 (August 6, 1961): 21.

64. He Rong, "Geming fengbao zhong de yingxiong xingxiang" (The image of the hero in the storm of revolution), *MS*, no. 4 (August 6, 1961): 6.

65. Hou Yimin, *"Liu Shaoqi tongzhi,"* 24.

66. Interviews with Hou Yimin, August 1, 2004, and January 9, 2006, Beijing.

67. *WW*, 7 (July 1961): 27–37.

68. Dong Xiwen, "Youhua *Kaiguo dadian* de chuangzuo jingyan" (How I created *The Founding Ceremony of the Nation*), *XGC*, no. 21 (November 1, 1953): 24–25.

69. Jiang Feng, *Jiang Feng*, 92.

70. Interviews with Jin Shangyi, August 4, 2004, and January 7, 2006, Beijing.

71. Bo Songnian, *Zhongguo yishushi tuji*, 253.

72. Ibid.

73. Golomstock, *Totalitarian Art*, 121–30, 216–65.

74. Boris Groys, *The Total Art of Stalinism: Avant-Garde, Aesthetic Dictatorship, and Beyond*, trans. Charles Rougle (Princeton: Princeton University Press, 1992), 33.

75. Wang Zhaowen, "Biaoxian renmin qunzhong de yingxiong shidai" (An age of heroism that reflects the people), *MS*, nos. 8–9 (1960): 35.

76. Jin Shangyi, "Chuangzuo *Mao zhuxi*," 11.

77. Bonnell, *Iconography of Power*, 147.

78. Dong Xiwen, "Cong Zhongguo huihua de biaoxian fangfa tandao youhua de Zhongguofeng" (From the expressive methods of Chinese painting to Chinese characteristics of oil painting), *MS*, no. 1 (January 1, 1957): 6.

79. Dong Xiwen, "Youhua *Kaiguo dadian*," 25.

80. Ibid.

81. Wu Zuoren, "Youhua de xinmao" (The novelty of oil painting), *MS*, nos. 8–9 (September 1960): 42.

82. Zhou Enlai, "Zai yinyue wudao zuotanhui shang de jianghua" (Talk at the music and dance forum), in *Zhou Enlai lun wenyi* (Zhou Enlai on literature and art), ed. Wenhuabu wenxue yishu yanjiuyuan (Beijing: Renmin wenxue chubanshe, 1979), 181.

83. *Lou Gongliu yishu*, 49.

7. Devils in the Drawings

1. *Zhonghua quanguo wenxue yishu gongzuozhe*, 227, 231, 234.

2. Francis Haskell, *History and Its Images: Art and the Interpretation of the Past* (New Haven: Yale University Press, 1995), 217–35.

3. Hung, *War and Popular Culture*, 221–69.

4. See, for example, *JFRBY*, November 3, 1944, 1.

5. David Low, *Low Visibility: A Cartoon History, 1945–1953* (London: Collins, 1953), 5.

6. Wang Zhaowen, "Guanyu shishi manhua" (On cartoons about current events), *RMRB*, November 12, 1950, 7.

7. See, for example, *RMRB*, December 29, 1949, 4; *JFRBS*, October 21, 1949, 1.

8. Interview with Fang Cheng, October 26, 2002, Beijing.

9. *JFRBY*, August 21, 1941, 1.

10. *RMRB*, May 17, 1950, 4.

11. *RMRB*, August 6, 1949, 2; December 31, 1949, 4.

12. Jiang Weipu and Wang Su, *Lianhuanhua yishu xinshang* (An appreciation of the art of serial picture stories) (Taiyuan: Shanxi jiaoyu chubanshe, 1997), 39.

13. *RMRB*, April 22, 1951, 6.

14. Mao Dun, "Lianhuantuhua xiaoshuo" (Serial picture stories), in *Mao Dun quanji* (Complete works of Mao Dun), (Beijing: Renmin wenxue chubanshe, 1991), 19:340.

15. Interviews with Yan Han, January 15, 2004, and January 3, 2006, Beijing.

16. Shanghaishi wenhuaju, "Shanghai lianhuantuhua gaikuang" (A survey of serial picture books in Shanghai), SMA, B172-1-23.

17. *JBRB*, May 15, 1950, 1.

18. *RMRB*, December 30, 1949, 3.

19. *RMRB*, February 13, 1950, 3. Interview with Feng Zhen, January 13, 2004, Beijing.

20. For example, *RMRB*, April 2, 1949, 4; *Gongren ribao* (Workers' daily), July 16–28, 1949; *JFRBS*, October 31, 1949, 8.

21. *RMRB*, April 9, 1956, 3.

22. Judith O'Sullivan, *The Great American Comic Strip: One Hundred Years of Cartoon Art* (Boston: Little, Brown, 1990), 10.

23. Bonnell, *Iconography of Power*, 199.

24. "Guanyu ruchenghou de gongzuo fangzhen" (Guiding principles after the occupation of the city), BMA, 1–12-19.

25. Bonnell, *Iconography of Power*, 187–94.

26. Mao Zedong, "Farewell, Leighton Stuart!" in Mao, *Selected Works*, 4:433.

27. Ralph E. Shikes, *The Indignant Eye: The Artist as Social Critic in Prints and Drawings from the Fifteenth Century to Picasso* (Boston: Beacon, 1969), 53–54.

28. Wolfram Eberhard, *A Dictionary of Chinese Symbols: Hidden Symbols in Chinese Life and Thought* (London: Routledge, 1986), 268.

29. See Zhang E's cartoons, *JFRBY*, October 10, 1945, 4; November 26, 1945, 4.

30. C. A. S. Williams, *Chinese Symbolism and Art Motifs: An Alphabetical Compendium of Antique Legends and Beliefs, as Reflected in the Manners and Customs of the Chinese*, intro. Terence Barrow (Rutland, VT: C. E. Tuttle, 1988), 440.

31. Hua Junwu, *Lang de qiaozhuang* (The wolf's disguise), *XGC*, no. 1 (January 1, 1953): 28.

32. See, for example, Fang Cheng, *Wo de manhua shenghuo: Fang Cheng* (My life as a cartoonist) (Beijing: Wuzhou chuanbo chubanshe, 2004), 59; Hua Junwu, *Hua Junwu zhengzhi fengcihua xuanji* (Selected works of Hua Junwu's political satirical cartoons) (Beijing: Renmin meishu chubanshe, 1954), 12; *RMRB*, March 26, 1952, 4; May 16, 1957, 5.

33. *XGC* 2, no. 1 (January 10, 1951): cover.

34. *RMRB*, August 9, 1950, 4.

35. *RMRB*, January 30, 1950, 1; August 12, 1950, 1; May 5, 1954, 1.

36. *XGC*, no. 2 (January 16, 1952): 5.

37. *RMRB*, March 7, 1951, 4; July 11, 1954, 4.

38. Mao Zedong, "Talk with the American Correspondent Anna Louise Strong," in Mao, *Selected Works*, 4:100.

39. Fang Cheng, "Xiang Sulian manhuajia zhihe" (Salute Soviet cartoonists), *MS*, no. 11 (November 15, 1957): 10.

40. *JBRB*, November 27, 1952, 4.

41. *Dazhong ribao* (Popular daily) (Jinan, Shandong), January 19, 1950, 5.

42. Interview with Fang Cheng, October 26, 2002, Beijing; Fang Cheng, *Wo de manhua shenghuo*, 24.

43. Hua Junwu, *Manhua manhua* (On cartoons) (Beijing: Zhongguo gongren chubanshe, 1999), 142–44.

44. Fang Cheng, *Wo de manhua shenghuo*, 24.

45. Hua Junwu, *Hua Junwu zhengzhi*, 4.

46. Hua Junwu, *Wo zenyang xiang he zenyang hua manhua* (How I think and draw cartoons) (Shijiazhuang: Hebei jiaoyu chubanshe, 1999), 4.

47. Ellul, *Propaganda*, 17–18.

48. Hua Junwu, *Hua Junwu zhengzhi*, 16.

49. *Jiefang zhige* (Songs of liberation), ed. Zhongguo renmin jiefangjun shisan bingtuan zhengzhibu xuanchuandui (N. p.: n. d.), 61–62.

50. *JFRBY*, August 25, 1943, 4.

51. *RMRB*, September 21, 1949, 6.

52. Jeffrey Brooks, *Thank You, Comrade Stalin! Soviet Public Culture from Revolution to Cold War* (Princeton: Princeton University Press, 2000), 145.

53. *Common Program and Other Documents*, 4.

54. *Jianguo yilai zhongyao wenxian xuanbian* (Selected important documents after the founding of the nation), ed. Zhonggong zhongyang wenxian yanjiushi (Beijing: Zhongyang wenxian chubanshe, 1992), 1:141–43.

55. Yang Kuisong, "Reconsidering the Campaign," 120.

56. *RMRB*, February 22, 1951, 1.

57. Bonnell, *Iconography of Power*, 219.

58. *XGC* 2, no. 11 (June 10, 1951): 6.

59. Tang Yuping, "Lianhuanhua: Kaizhan zhenya fangeming xuanchuan de youli wuqi" (Lianhuanhua: A potent tool for the propaganda of the Campaign to Suppress Counterrevolutionaries), *JFRBS*, May 26, 1951, 4.

60. Hua Junwu, "Mantan neibu fengci de manhua" (On internal satirical cartoons), *MS*, no. 5 (May 15, 1957): 14.

61. Li Hanzhang, *Qige xiaoyingxiong zhiqin tewu* (Seven little heroes use ingenuity to apprehend spies), *RMRB*, June 4–8, 1951.

62. *RMRB*, March 28–31, 1951.

63. *RMRB*, August 18, 1951, 1, 3–4.

64. Miao Di and Zhao Zhifang, *Fensui Meidiguozhuyi de jiandie huodong* (Smashing the espionage of American imperialism), *RMRB*, September 5, 1951, 3.

65. "Jingjiao qudi Yiguandao gongzuo zongjie" (A summary of the ban of the Unity Sect in the rural vicinity of Beijing), BMA, 1–14-165.

66. Mao Zedong, "Guanyu gonghui gongzuo de fangzhen" (Guiding principles for the labor unions), in Mao, *Mao Zedong wenji*, 5:326–27.

67. Tian Zuoliang, *Xianban* (The class of the immortals), *RMRB*, May 12, 1951, 3.

68. *RMRB*, December 11, 1955, 3.

69. *RMRB*, June 4, 1951, 3.

70. See, for example, *JFRBY*, October 29, 1942, 3.

71. *JBRB*, January 10, 1952, 4.

72. Zhang Wenyuan, *Xinhui tu* (Bribery), *JBRB,* January 12, 1952, 4.

73. Bonnell, *Iconography of Power,* 188.

74. *XGC* 2, no. 8 (April 25, 1951): 14.

75. *RMRB,* August 10, 1955, 3.

76. *MS,* no. 8 (August 15, 1955): 57.

77. *RMRB,* June 7, 1955, 3; June 6, 1955, 3.

78. Fang Cheng and Zhong Ling, *Gehai yaoji* (Memorial service across the strait), *RMRB,* June 5, 1955, 3.

79. Hua Junwu, *Huazhuang wuhui* (Masquerade party), *RMRB,* June 26, 1955, 3.

80. Mao Zedong, "Combat Liberalism," in Mao, *Selected Works,* 2:32.

81. Bonnell, *Iconography of Power,* 188.

82. Stephen White, *The Bolshevik Poster* (New Haven: Yale University Press, 1988), 3.

83. Bonnell, *Iconography of Power,* 107.

84. *JFRBY,* April 12, 1945, 4.

85. Hua Junwu, *Manhua manhua,* 142–44.

86. Ibid., 143.

87. For Liao Bingxiong's cartoon, see *YHB,* April 20, 1950, 4.

88. Interview with Fang Cheng, October 26, 2002, Beijing.

89. Jiang Weipu, *Lianhuanhua yishu lun* (On the art of serial picture stories) (Shenyang: Liaoning meishu chubanshe, 1986), 125.

90. Peter Burke, *Eyewitnessing: The Uses of Images as Historical Evidence* (Ithaca: Cornell University Press, 2001), 64.

91. Hua Junwu, "Cong xiaxiang shangshan tandao manhua de dazhonghua he minzuhua" (From working in the countryside and mountain areas to making cartoons popular and nationalistic), *MS,* no. 2 (February 15, 1958): 13–14.

92. Chen Qingquan and Song Guangwei, *Lu Dingyi zhuan,* 384.

93. Pierre Bourdieu, *The Field of Cultural Production: Essays on Art and Literature,* ed. and intro. Randal Johnson (New York: Columbia University Press, 1993), 215–66.

94. Hua, "Cong xiaxiang shangshan," 13.

95. Interview with Fang Cheng, October 26, 2002, Beijing.

96. *RMRB,* November 16, 1960, 7.

97. *RMRB,* December 28, 1963, 2.

98. Boris Groys, "The Art of Totality," in *The Landscape of Stalinism: The Art and Ideology of Soviet Space,* ed. Evgeny Dobrenko and Eric Naiman (Seattle: University of Washington Press, 2003), 99.

99. *RMRB,* September 7, 1955, 2.

100. Ye Qianyu, *Xixu cangsang ji liunian* (Memoirs), 2 vols. (Beijing: Qunyan chubanshe, 1992), 2:280, 282.

101. Interview with Fang Cheng, October 26, 2002, Beijing.

102. Liu Xun, "Lianhuanhua chuangzuo zhong de jige wenti" (Several problems in creating lianhuanhua), *MS,* no. 7 (July 15, 1954): 7.

103. Hua Junwu, *Manhua manhua,* 149.

104. Fang Cheng, *Wo de manhua shenghuo,* 47.

105. Interview with Zhong Ling, October 26, 2002, Beijing.

8. New Year Prints and Peasant Resistance

1. *RMRB,* November 27, 1949, 4; see also *GMRB,* November 27, 1949, 4.

2. For a brief history of nianhua, see Bo Songnian, *Zhongguo nianhuashi* (History of Chinese New Year prints) (Shenyang: Liaoning meishu chubanshe, 1986), esp. 1–74.

3. For example, Yangliuqing was known for its meticulous fine-line printing and Yangjiabu for its lively rustic patterns.

4. *Yangjiabu cunzhi* (History of the village of Yangjiabu), ed. Shandongsheng Weifangshi Hantingqu Yangjiabu cunzhi bianzuan weiyuanhui (Jinan: Qilu shushe, 1993), 381–94.

5. Ye Youxin, "Weixian minjian muban nianhua de chuantong tezheng" (Traditional characteristics of Weixian's folk New Year prints), *MS*, no. 12 (December 15, 1954): 18.

6. For the Communists' use of nianhua prints in the Yan'an days, see Chang-tai Hung, "Two Images of Socialism: Woodcuts in Chinese Communist Politics," *Comparative Studies in Society and History* 39, no. 1 (January 1997): 34–60.

7. See, for example, a special issue of new nianhua published a few days before the Chinese Lunar New Year in *RMRB*, February 11, 1950, 5.

8. See, for example, *RMMS* 1, no. 2 (April 1, 1950).

9. Cheng Yanqiu and Du Yingtao, "Hanting de nianhua" (Hanting's New Year prints), *Minjian wenyi jikan*, no. 2 (May 15, 1951): 29–33.

10. On the reform of folk artists, see Xie Changyi, "Xiang minjian nianhua xuexi" (Learn from folk New Year prints), *MS*, no. 2 (February 15, 1960): 36–38. On Yang Wandong, see *Yangjiabu cunzhi*, 388–89.

11. *RMRB*, February 21, 1950, 3.

12. *RMRB*, April 16, 1950, 4.

13. *RMRB*, September 5, 1952, 3.

14. *MS*, no. 2 (March 25, 1978): 7.

15. von Geldern, *Bolshevik Festivals*.

16. Hung, *War and Popular Culture*, 221–69.

17. "Jingjiao qudi Yiguandao."

18. Wang Zhaowen, "Guanyu xuexi jiu nianhua xingshi" (On learning from the form of old New Year prints), *RMRB*, March 19, 1950, 5.

19. *RMRB*, April 26, 1949, 4.

20. *JFRBY*, April 12, 1945, 4.

21. *RMRB*, October 26, 1951, 3.

22. See, for example, Shandongsheng renmin zhengfu wenhua shiye guanliju, "Guanyu ruhe duidai zaoma de yijian" (On how to deal with the Stove God print) (November 12, 1953), mimeographed document, Jinan, Shandong province.

23. Tai Yi, "Fengxiang muban nianhua jianwenji" (Notes on Fengxiang woodblock New Year prints), *MSYJ*, no. 2 (May 15, 1985): 72–75.

24. Zhang Dianying, *Yangjiabu muban nianhua* (Yangjiabu's woodblock New Year prints) (Beijing: Renmin meishu chubanshe, 1990), 29–31. Interviews with Xie Changyi, June 8, 9, 1997, Jinan, Shandong province.

25. *Weifang nianhua yanjiu* (Studies on Weifang's New Year prints), ed. Zheng Jinlan (Shanghai: Xuelin chubanshe, 1991), 25.

26. Bo Songnian, *Zhongguo zaojun shenma* (China's Stove God and paper horses) (Taipei: Bohaitang wenhua shiye youxian gongsi, 1993), 13–31.

27. Arthur H. Smith, *Village Life in China: A Study in Sociology* (New York: Fleming H. Revell, 1899), 199.

28. *Weifang nianhua yanjiu*, 143; Shandongsheng renmin zhengfu wenhua shiye guanliju, "Guanyu ruhe duidai."

29. *Yangjiabu nianhua* (Yangjiabu's New Year prints), ed. Shandongsheng Weifangshi bowuguan and Yangjiabu muban nianhua yanjiusuo (Beijing: Wenwu chubanshe, 1990), plate 134. The print was originally made in the 1950s and was reissued in 1985. See "Explanation of Plates," 14, 51.

30. *MSYJ*, no. 2 (May 15, 1984): 23. See also Zhang Ding, "Taohuawu nianhua" (Taohuawu's New Year prints), *MS*, no. 8 (August 15, 1954): 44–45.

31. Bo Songnian, *Zhongguo nianhuashi*, 2.

32. Wang Shucun, *Men yu menshen* (Doors and door gods) (Beijing: Xueyuan chubanshe, 1994), 180–202.

33. See, for example, *Nianhua xuanbian, 1949–1959* (Selected New Year prints, 1949–1959), ed. Renmin meishu chubanshe (Beijing: Renmin meishu chubanshe, 1961), plates 2, 4, and 9.

34. It was later discovered that many production figures from Dazhai were inflated and incorrectly reported.

35. The print was originally designed in the mid-1950s by the New Year Print Production Team in Weifang City, near Yangjiabu. It was repeatedly singled out for praise. See *MS*, no. 1 (January 15, 1956): 12; *MS*, no. 3 (March 15, 1956): illustration.

36. This image reflects the official discourse of sexuality in the People's Republic in the 1950s. See Harriet Evans, *Women and Sexuality in China: Female Sexuality and Gender Since 1949* (New York: Continuum, 1997), 6.

37. *MS*, no. 6 (June 15, 1958): 32.

38. Sheila Fitzpatrick, *Stalin's Peasants: Resistance and Survival in the Russian Village after Collectivization* (New York: Oxford University Press, 1994), 45, 59–62; Lynne Viola, *Peasant Rebels under Stalin: Collectivization and the Culture of Peasant Resistance* (New York: Oxford University Press, 1996), 38–44.

39. Richard Stites, *Russian Popular Culture: Entertainment and Society since 1900* (Cambridge: Cambridge University Press, 1992), 53–54.

40. White, *Bolshevik Poster*, 6–7.

41. Xie Changyi, "Yaoqianshu de fazhan he yanbian" (The development and evolution of *The Money Tree*), *Gugong wenwu yuekan*, 11, no. 11 (February 1994): 124.

42. *Weifang nianhua yanjiu*, 35.

43. *RMRB*, April 16, 1950, 4. Interview with Zhang Ding, August 12, 2005, Beijing.

44. Beatrice Farnsworth, "Village Women Experience the Revolution," in *Bolshevik Culture: Experiment and Order in the Russian Revolution,* ed. Abbott Gleason, Peter Kenez, and Richard Stites (Bloomington: Indiana University Press, 1985), 239.

45. See *Nianhua xuanbian, 1949–1959,* plate 4. The print won second prize in the 1951–52 national nianhua competition. See *RMRB*, September 5, 1952, 3. Besides Mao, other Communist leaders such as Zhu De, Liu Shaoqi, Zhou Enlai, and Deng Xiaoping also figured prominently in the new prints.

46. *RMRB*, September 5, 1952, 3. The print was well received. See, for example, He Rong, "Qunyinghui shang de Zhao Guilan" (Zhao Guilan at the heroes' reception), *MS*, no. 2 (February 15, 1960): 18.

47. *RMRB*, April 16, 1950, 4.

48. Quoted in Roger Chartier, *Cultural History: Between Practices and Representations,* trans. Lydia G. Cochrane (Cambridge: Polity Press, 1988), 27.

49. Zhang Dianying, *Yangjiabu muban nianhua*, 183–86. See also *Yangjiabu cunzhi*, 401–17.

50. See, for example, *MS*, no. 6 (June 15, 1958): 31.

51. Wang Shucun, *Zhongguo minjian nianhuashi lunji* (Essays on the history of the Chinese folk New Year prints) (Tianjin: Tianjin Yangliuqing huashe, 1991), 243.

52. Ye Wenxi, "Shitan nianhua de zuoyong he tedian" (A preliminary investigation into the functions and characteristics of the New Year prints), *MS*, no. 2 (March 25, 1978): 42.

53. Feng Zhen, "Nianhua diaochaji" (An investigation of New Year prints), *MSYJ*, no. 4 (November 15, 1980): 58. Interview with Feng Zhen, January 13, 2004, Beijing.

54. Herbert J. Gans, *Popular Culture and High Culture: An Analysis and Evaluation of Taste* (New York: Basic Books, 1974), 67–69, 127–29; and Pierre Bourdieu, *Distinction: A Social Critique of the Judgement of Taste*, trans. Richard Nice (Cambridge: Harvard University Press, 1984), 177–200.

55. Bourdieu, *Distinction*, 34–41.

56. Feng Zhen, "Nianhua diaochaji," 58.

57. Yu Fei'an, *Zhongguohua yanse de yanjiu* (Colors in Chinese paintings) (Beijing: Zhaohua meishu chubanshe, 1955), 36., trans. Jerome Silbergeld and Amy McNair as *Chinese Painting Colors: Studies on Their Preparation and Application in Traditional and Modern Times* (Hong Kong: Hong Kong University Press; Seattle: University of Washington Press, 1988), 43, with modifications.

58. Ibid.

59. Ye Youxin, "Weixian minjian muban," 20.

60. *MS*, no. 12 (December 15, 1956): 52.

61. Lin Chen, "Nianhua de secai" (The use of color in the New Year prints), *MS*, no. 12 (December 15, 1956): 51–52.

62. Ibid., 51.

63. Quoted in Li Qun, "Lun nianhua de xingshi wenti" (On the question of form of the New Year prints), *MS*, no. 3 (March 15, 1956): 14.

64. Quoted in Lin Chen, "Nianhua de secai," 51

65. *MS*, no. 6 (June 15, 1958): 31.

66. Quoted in Yu Feng, "Xiang minjian nianhua xuexi" (Learn from folk New Year prints), *MS*, no. 3 (March 15, 1956): 10.

67. *MS*, no. 1 (January 15, 1956): 11.

68. *MS*, no. 12 (December 15, 1956): 51.

69. Ye Youxin, "Weixian minjian muban," 20.

70. Ibid.

71. *MS*, no. 1 (January 15, 1956): 11.

72. Andrews, *Painters and Politics*, 110–75.

73. Bo Songnian and Wang Shucun, "Shinianlai woguo xin nianhua de fazhan he chengjiu" (The development and success of the new nianhua in China over the last ten years), *MSYJ*, no. 2 (May 15, 1959): 12–17, esp. 14.

74. Ibid.

75. C. K. Yang, *Religion in Chinese Society: A Study of Contemporary Social Functions of Religion and Some of Their Historical Factors* (Berkeley: University of California Press, 1961).

76. *MS*, no. 1 (January 25, 1978): 43.

77. Ye Wenxi, "Shitan nianhua," 42.

78. *Weifang nianhua yanjiu*, 143; *MS*, no. 1 (January 25, 1978): 44.

79. Zhang Dianying, *Yangjiabu muban nianhua*, 183.

80. Xu Ling, "Nianhua gongzuo zhong cunzai de zhuyao wenti" (The key problems of the New Year print campaign), *MS*, no. 4 (April 15, 1958): 6–9.

81. Wu Dong, "Xin nianhua ying liqiu bode nongmin huanxin" (The new nianhua should make every effort to win the peasants' hearts), *MS*, no. 9 (September 20, 1982): 19.

82. Wang Shucun, "Xianhua menshen" (Notes on door gods), *Meishu shilun congkan*, no. 2 (August 1983): 220.

83. *Shanghai yishu tupian, 1997* (Shanghai's art photographs, 1997) (Shanghai: Shanghai renmin meishu chubanshe meishu tupianbu, 1997), 35–36.

84. For a brief history of calendar posters, see *Chinese Women and Modernity: Calendar Posters of the 1910s–1930s,* compiled by Ng Chun Bong et al. (Hong Kong: Joint Publishing, 1996).

85. Arendt, *Origins of Totalitarianism.*

86. Antonio Gramsci, *Selections from the Prison Notebooks,* ed. and trans. Quintin Hoare and Geoffrey Nowell Smith (London: Lawrence and Wishart, 1971).

87. Barrington Moore, Jr., *Social Origins of Dictatorship and Democracy: Lord and Peasant in the Making of the Modern World* (Boston: Beacon Press, 1966); Eric Wolf, *Peasant Wars of the Twentieth Century* (New York: Harper and Row, 1969); and James C. Scott, *Weapons of the Weak: Everyday Forms of Peasant Resistance* (New Haven: Yale University Press, 1985).

88. E. P. Thompson, "History from Below," *Times Literary Supplement,* April 7, 1966, 279–81.

89. Michel de Certeau, *The Practice of Everyday Life,* trans. Steven Rendall (Berkeley: University of California Press, 1984), xi, 29–42.

90. See Stites, *Russian Popular Culture.*

91. Samuel L. Popkin, *The Rational Peasant: The Political Economy of Rural Society in Vietnam* (Berkeley: University of California Press, 1979), 31.

92. *Shanghai yishu tupian,* 1997, 2.

93. Ellen Johnston Laing, "The Persistence of Propriety in the 1980s," in *Unofficial China: Popular Culture and Thought in the People's Republic,* ed. Perry Link, Richard Madsen, and Paul G. Pickowicz (Boulder, CO: Westview Press, 1989), 156–71.

9. The Cult of the Red Martyr

1. Mao Zedong, "Serve the People," in Mao, *Selected Works,* 3:177–78.

2. "Zhonggong Qida daibiao ji Yan'an renmin daibiao dui Zhongguo geming sinan lieshi de jiwen" (A eulogy on the revolutionary martyrs by the representatives of the Seventh Congress of the Chinese Communist Party and of the Yan'an people," in *Zhonggong zhongyang wenjian xuanji* (Selected documents of the Chinese Communist Party Central Committee), ed. Zhongyang dang'anguan (Beijing: Zhonggong zhongyang dangxiao chubanshe, 1991), vol. 15, 138–39.

3. James L. Watson and Evelyn S. Rawski, eds., *Death Ritual in Late Imperial and Modern China* (Berkeley: University of California Press, 1988); Arthur Waldron, "China's New Remembering of World War II: The Case of Zhang Zizhong," *Modern Asian Studies* 30, no. 4 (October 1996): 945–78; Henrietta Harrison, "Martyrs and Militarism in Early Republican China," *Twentieth-Century China* 23, no. 2 (April 1998): 41–70.

4. Laurence A. Schneider, *A Madman of Ch'u: The Chinese Myth of Loyalty and Dissent* (Berkeley: University of California Press, 1980); Hellmut Wilhelm, "From Myth to Myth: The Case of Yüeh Fei's Biography," in *Confucian Personalities,* ed. Arthur F. Wright and Denis Twitchett (Stanford: Stanford University Press, 1962), 146–61.

5. Harrison, "Martyrs and Militarism," 41–42.

6. Waldron, "China's New Remembering."

7. Harrison, "Martyrs and Militarism," 43, 56–58.

8. Catherine Merridale, *Night of Stone: Death and Memory in Twentieth-Century Russia* (New York: Penguin Books, 2000), 142.

9. Hu Sheng, ed., *Zhongguo gongchandang de qishinian* (Seventy years of the Chinese Communist Party) (Beijing: Zhonggong dangshi chubanshe, 1991), 201.

10. Of the 1.31 million casualties, 263,800 were killed and 1,048,900 were wounded. The casualties of the Guomindang troops totaled 1.71 million. *Zhongguo renmin jiefangjun zhanshi* (The military history of the People's Liberation Army), ed. Junshi kexueyuan junshi lishi yanjiubu (Beijing: Junshi kexue chubanshe, 1987), vol. 3, appendix 8.

11. *RMRB*, October 1, 1949, 1.

12. "Guanyu geming lieshi de jieshi" (Explaining the term Revolutionary Martyr), *RMRB*, October 15, 1950, 1.

13. *RMRB*, April 6, 1952, 2.

14. "Minzhengju yijiuwusannian shangbannian gongzuo baogao" (The first half year of 1953 report of the Bureau of Civil Affairs), BMA, 196-2-25.

15. Ozouf, *Festivals and the French Revolution,* 126–96.

16. Stites, *Revolutionary Dreams,* 79–100.

17. *RMRB*, March 18, 1949, 1.

18. *RMRB*, April 11, 1949, 2.

19. *RMRB*, April 3, 1950, 1.

20. *RMRB*, April 6, 1950, 4.

21. *RMRB*, April 8, 1950, 3.

22. Halbwachs, *Collective Memory,* 48.

23. Nora, "General Introduction," 3.

24. Jay W. Baird, *To Die for Germany: Heroes in the Nazi Pantheon* (Bloomington: Indiana University Press, 1990), 225.

25. *RMRB*, April 3, 1952, 2.

26. Nora, "General Introduction," 1.

27. Jay Winter, *Sites of Memory, Sites of Mourning: The Great War in European Cultural History* (Cambridge: Cambridge University Press, 1995), 79.

28. Zhongguo Guomindang zhongyang zhixing weiyuanhui jianzhu zhenwang jiangshi gongmu choubei weiyuanhui, *Guomin gemingjun zhenwang jiangshi gongmu luocheng dianli jiniankan* (A memorial publication on the Public Cemetery of the Commanders and Soldiers of the National Revolutionary Army) (Nanjing: n.p., 1935), esp. 66–67.

29. Sun Junting, ed., *Zhongguo geming lieshi yuanlin* (Revolutionary martyrs cemeteries in China) (Beijing: Beijing chubanshe, 1993), 168.

30. *RMRB*, April 3, 1991, 4.

31. Sun Junting, ed., *Zhongguo geming lieshi yuanlin,* 14.

32. Ibid., 14–16.

33. Ibid., 96–97.

34. Hua Yingshen, ed., *Zhongguo gongchandang lieshizhuan* (Biographies of the Chinese Communist martyrs) (Hong Kong: Xin minzhu chubanshe, 1949).

35. Zhou Naiji, "Jieshao *Zhongguo gongchandang lieshizhuan*" (An introduction to *Biographies of the Chinese Communist Martyrs*), *RMRB*, June 17, 1951, 6.

36. Ibid.

37. Hua Yingshen, *Zhongguo gongchandang lieshizhuan,* 99.

38. *RMRB*, June 4, 1952, 3.

39. *RMRB*, August 26, 1951, 3.

40. *RMRB*, July 18, 1951, 1.

41. Ibid.

42. Elizabeth A. Wood, *Performing Injustice: Agitation Trials in Early Soviet Russia* (Ithaca: Cornell University Press, 2005), 193–220.

43. Winter, *Sites of Memory*, esp. 78–116

44. *RMRB*, April 27, 1951, 2.

45. *RMRB*, April 5, 1949, 3.

46. "Minzhengju yijiuwusannian."

47. Song Lin, "You Luo Binghui yanjiu xiangdao lieshi yanjiu de jige wenti" (The study of Luo Binghui and questions relating to the study of martyrs), *Lieshi yu jinianguan yanjiu* (Research on martyrs and memorial halls), ed. Longhua lieshi jinianguan (Shanghai: Shanghai shehui kexueyuan chubanshe, 1996), 1:81–83.

48. Beijingshi Minzhengju youfuke, "Guanyu shenqing lieshi xisheng fuxu yu youguan danwei laiwang de wenshu" (Correspondence with various agencies concerning compensation for the martyrs' families), BMA, 196–2-101.

49. Ibid.

50. "Beijing Babaoshan geming gongmu" (Beijing's Babaoshan Revolutionary Cemetery), mimeograph, issued by the Babaoshan Revolutionary Cemetery Office, n.d.

51. Ibid.

52. Ibid. On the tomb of Gang Bing, see Liu Tong and Yu Yizheng, *Dijing jingwulüe* (Scenes of the capital) (Beijing: Beijing guji chubanshe, 1982; lst pub. 1635), 279.

53. Beijingshi Minzhengju, "Guanyu qianzou Geming gongmu nei taijian fenmu de qingshi" (Requesting instructions concerning the removal of the eunuchs' tombs from the Revolutionary Cemetery), BMA, 196–2-135.

54. Ibid.

55. Ibid.

56. Ibid.

57. "Geming gongmu anzang zanxing guize" (Temporary rules for burial in the Revolutionary Cemetery), BMA, 2–3-58.

58. "Beijingshi Geming gongmu guanli qingkuang" (The management of the Beijing Revolutionary Cemetery), BMA, 196–2-179.

59. "Geming gongmu anzang zanxing guize." See also "Beijing Babaoshan geming gongmu."

60. "Geming gongmu anzang zanxing guize."

61. "Guanyu Geming gongmu jiancha qingkuang ji jinhou maizang yijian de baogao" (A report on the conditions of the Revolutionary Cemetery and matters regarding future burial), BMA, 2–3-58.

62. "Xiuzheng Geming gongmu (ni gaiming Babaoshan gongmu) anzang zanxing guize (cao'an)" (Draft concerning the revision of temporary rules of burial in the Revolutionary Cemetery: A proposal to change the name Revolutionary Cemetery to Babaoshan Cemetery), BMA, 2–7-57.

63. "Beijingshi Geming gongmu guanli qingkuang."

64. "Guanyu Geming lieshi gongmu anzang zanxing guize xizhao benfu xingzheng huiyi jueding chuli" (Follow the decision of the executive council of the municipal government to implement the temporary rules for burial in the Revolutionary Cemetery), BMA, 2–3-58.

65. "Beijing Babaoshan geming gongmu."

66. "Wei kuoda Geming gongmu yongdi mianji ni goumai shandi yiduan qing heshi" (Requesting permission to purchase additional land to expand the Revolutionary Cemetery), BMA, 2–6-194.

67. "Guanyu Geming lieshi gongmu anzang zanxing guize xizhao benfu." See also "Beijingshi renmin weiyuanhui guanyu xiuzheng Geming gongmu anzang zanxing guize de tongzhi" (An announcement concerning the revision of temporary rules of

burial at the Revolutionary Cemetery issued by the Beijing Municipal People's Committee), BMA, 2–9-60.

68. "Niding Geming gongmu guanli zanxing guize" (Drawing up temporary rules for the management of the Revolutionary Cemetery), BMA, 2–7-57.

69. Ibid.

70. "Beijingshi Geming gongmu guanli qingkuang."

71. Richard A. Etlin, *The Architecture of Death: The Transformation of the Cemetery in Eighteenth-Century Paris* (Cambridge: MIT Press, 1984), 163–228.

72. "Beijing Babaoshan geming gongmu."

73. Avner Ben-Amos, *Funeral, Politics, and Memory in Modern France, 1789–1996* (Oxford: Oxford University Press, 2000), 39–43.

74. Merridale, *Night of Stone*, 145–53.

75. *RMRB*, October 28, 1950, 1; *GMRB*, October 28, 1950, 1.

76. *RMRB*, October 29, 1950, 1.

77. Ibid.

78. Ren Yuanyuan, ed., *Jinian Ren Bishi* (In memory of Ren Bishi) (Beijing: Wenwu chubanshe, 1986), photos no. 301 and 302.

79. Zhang Chengping, ed., *Babaoshan geming gongmu beiwenlu* (Tombstone inscriptions at the Babaoshan Revolutionary Cemetery) (Beijing: Gaige chubanshe, 1990), 1.

80. Merridale, *Night of Stone*, 83–84.

81. Ben-Amos, *Funeral, Politics, and Memory*, 9.

82. Nina Tumarkin, *Lenin Lives! The Lenin Cult in Soviet Russia*, enlarged ed. (Cambridge: Harvard University Press, 1997), 165–206.

83. *RMRB*, October 20, 1950, 1.

84. *RMRB*, December 12, 1949, 1.

85. *RMRB*, June 19, 1955, 1.

86. Zhang Chengping, ed., *Babaoshan geming gongmu*, 3.

87. Beijingshi Minzhengju youfuke, "Guanyu yizang lieshi Fan Hongjie yu Geming gongmu de wenshu cailiao" (Documents concerning the reburial of Martyr Fan Hongjie at the Revolutionary Cemetery), BMA, 196–2-88; "Guanyu yizang geming lieshi fenmu xiujian libei ji liaojie xisheng jingguo de wenshu cailiao" (Documents on the reburials of martyrs, the construction of their tombstones, and on how they sacrificed their lives), BMA, 196–2-102.

88. "Guanyu yizang geming lieshi fenmu."

89. Ibid.

90. "Guanyu yizang lieshi Fan Hongjie."

91. "Guanyu Geming gongmu jiancha qingkuang."

92. Ibid.

93. Zhonggong Beijing shiwei, "Zhongyang" ([A letter to] the Central Committee [of the Chinese Communist Party]), BMA, 2–7-57.

94. Ibid.

95. "Beijingshi Geming gongmu guanli qingkuang."

96. *RMRB*, November 15, 1986, 4.

97. *RMRB*, September 10, 1989, 2.

98. A plaque outside the cemetery, installed by the Beijing Municipal Government in 1997, reads, "Beijing's Center for Patriotic Education."

99. *RMRB*, April 3, 1991, 4.

100. Mosse, *Fallen Soldiers*, 70–106.

101. James E. Young, *The Texture of Memory: Holocaust Memorials and Meaning* (New Haven: Yale University Press, 1993), 3.

102. "Neiwubu guanyu lieshi jinian jianzhuwu xiujian he guanli gongzuo de baogao" (Ministry of Internal Affairs report on the construction and management of memorials honoring martyrs), BMA, 196–2-179.

103. *RMRB*, March 14, 1980, 4.

104. "Jiujiu geming jinianguan" (Save the revolutionary museums!), *Dangshi xinxibao*, September 1, 1994, 1.

105. Ibid.

10. The Monument to the People's Heroes

1. Wu Hung, *Remaking Beijing*, 24–36.

2. Philippe Ariès, *Western Attitudes toward Death: From the Middle Ages to the Present*, trans. Patricia M. Ranum (Baltimore: Johns Hopkins University Press, 1974), 75.

3. Halbwachs, *Collective Memory*, 140.

4. Pierre Nora, introduction to *Realms of Memory: The Construction of the French Past*, vol. 3, *Symbols*, ed. Pierre Nora, trans. Arthur Goldhammer (New York: Columbia University Press, 1998), ix.

5. Wu Liangyong, "Renmin yingxiong jinianbei de chuangzuo chengjiu" (The creative achievement of the Monument to the People's Heroes), *JZXB*, no. 2 (June 1978): 4.

6. Mao Zedong, "The Orientation of the Youth Movement," in Mao, *Selected Works*, 2:245; and Mao, "The May 4th Movement," in Mao, *Selected Works*, 2:237.

7. Wu Liangyong, "Renmin yingxiong jinianbei."

8. Zhao Luo and Shi Shuqing, *Tiananmen* (Tiananmen Gate) (Beijing: Beijing chubanshe, 1957), 37.

9. "Pinqing Sulian zhuanjia lai Hua zhidao gongzuoan" (The hiring of Soviet experts to provide guidance to the Chinese), BMA, 23–1-77.

10. "Guanyu Renmin yingxiong jinianbei sheji wenti de yixie wenti de baogao" (Report on the problems concerning the construction of the Monument to the People's Heroes), BMA, 1–5-90.

11. Liang Sicheng, "Renmin yingxiong jinianbei sheji de jingguo," (The designing of the Monument to the People's Heroes), *JZXB*, no. 6 (1991): 28.

12. *RMRB*, August 13, 1954, 2.

13. "Diyici huiyi jilu" (Minutes of the first meeting), BMA, 23–1-6.

14. Liang Sicheng, "Renmin yingxiong jinianbei," 28.

15. For a discussion of the influence of Soviet socialist realism on art and literature in China, see Laing, *Winking Owl*, 20–23.

16. Zhang Bo, *Wo de jianzhu*, 67.

17. See Liang Sicheng's discussion, in Liang, *Liang Sicheng wenji*, 4:32–34.

18. Liang Sicheng, "Zhongguo jianzhu de tezheng" (The major characteristics of Chinese architecture), in *Liang Sicheng wenji*, 4:96–103.

19. Wu Liangyong, "Renmin yingxiong jinianbei"; *RMRB*, August 13, 1954, 2.

20. Liang Sicheng, "Renmin yingxiong jinianbei," 27.

21. Ibid., 28.

22. Ibid.

23. Ibid.

24. Liang's letter to Mayor Peng Zhen, in Liang, *Liang Sicheng wenji*, 4:42–45.

25. *RMRB*, July 29, 1953, 3.

26. *RMRB*, August 13, 1954, 2; April 23, 1958, 1; *MS*, May 15, 1958; see also Wu Liangyong, "Renmin yingxiong jinianbei."

27. Wu Liangyong, "Renmin yingxiong jinianbei," 6.

28. Hua Tianyou, "Rang diaosu yishu dao renmin qunzhong zhong qu" (Let sculpture speak to the people), *RMRB*, December 26, 1957, 7.

29. See Zhang Bo, *Wo de jianzhu*, 187.

30. Liang Sicheng, "Renmin yingxiong jinianbei," 28; Wu Liangyong, "Renmin yingxiong jinianbei," 6; Zhao Luo and Shi Shuqing, *Tiananmen*, 40.

31. For a discussion of the north-south axis and buildings oriented to the south, especially palaces, see Hou Renzhi, "Shilun Beijing chengshi guihua jianshe zhong de sange lichengbei" (A preliminary discussion of the three major developmental stages in the construction of Beijing), *Chengshi guihua*, no. 6 (November 9, 1994): 4–9.

32. Wu Liangyong, "Renmin yingxiong jinianbei," 7.

33. Interviews with Yan Han, January 15, 2004, and January 3, 2006, Beijing; Bai Yan, "Renmin yingxiong jinianbei fudiao ji qita gaishu" (The reliefs of the Monument to the People's Heroes and other accounts), *Beijing wanbao*, September 2, 2000, 22; Bai Yan, *Wo he Yan Han* (Yan Han and I) (Hong Kong: Tianma tushu youxian gongsi, 2002), 31–32. Bai Yan is the wife of the artist Yan Han.

34. *RMRB*, October 1, 1949, 2; September 7, 1953, 3; November 18, 1955, 1. See also *MS*, no. 5 (May 15, 1958); *WW*, no. 5 (May 27, 1958).

35. *RMRB*, October 25, 1952, 6.

36. *RMRB*, August 13, 1954, 2.

37. Ibid.

38. Mao Zedong, "Eternal Glory to the Heroes of the People!" in Mao, *Selected Works*, 5:22, with minor changes in translation.

39. Zhang Bo, *Wo de jianzhu*, 87–88, 177.

40. Fan Wenlan, *Fan Wenlan lishi lunwen xuanji* (Selected historical essays of Fan Wenlan) (Beijing: Zhongguo shehui kexue chubanshe, 1979), 360.

41. Ibid.

42. Fan Wenlan, *Hanjian guizishou Zeng Guofan de yisheng* (The life of the traitor-butcher Zeng Guofan) (Xi'an: Xibei xinhua shudian, 1949), 1.

43. Fan Wenlan, *Fan Wenlan*, 225.

44. Ibid., 226.

45. Ibid., 222–28.

46. "Diyici huiyi jilu."

47. "Dierci huiyi jilu" (Minutes of the second meeting), BMA, 23–1-6.

48. Zhou Yang's letter to the Construction Commission of the Monument to the People's Heroes, BMA, 23–1-6.

49. Fan Wenlan's letter to Liang Sicheng, BMA, 23–1-6.

50. "Dierci huiyi jilu."

51. Liang Sicheng, "Renmin yingxiong jinianbei," 28.

52. Ibid.

53. Mao Zedong, "Chinese Revolution and the Chinese Communist Party," in Mao, *Selected Works*, 2:314.

54. Mao Zedong, "On Protracted War," in Mao, *Selected Works*, 2:152–53.

55. Mao Zedong, "The Bankruptcy of the Idealist Conception of History," in Mao, *Selected Works*, 4:455–58, with minor changes in translation.

56. Interviews with Yan Han, January 15, 2004, and January 3, 2006, Beijing; Bai Yan, "Renmin yingxiong jinianbei." Yan Han later was purged as a rightist during the 1957 Anti-Rightist Campaign. His compensation for the monument project was

confiscated, and his contribution was never mentioned in the official media. See BMA 47–1-52.

57. Interviews with Yan Han, January 15, 2004, and January 3, 2006, Beijing; Bai Yan, "Renmin yingxiong jinianbei."

58. Michael Sullivan, *Art and Artists of Twentieth-Century China* (Berkeley: University of California Press, 1996), 159–69.

59. Liu Kaiqu, "Diaosu yishu shenghuo manyi" (Remembering sculpture), in *Zhonghua wenshi ziliao wenku* (Source materials on Chinese literature and history) (Beijing: Zhongguo wenshi chubanshe, 1996), 15:336.

60. Ibid., 338.

61. *MSYJ*, no. 3 (August 15, 1991): 24.

62. Fu Tianchou, *Yiqing de yishu: Zhongguo diaosu chutan* (Art that can transform sentiments: A preliminary investigation of Chinese sculpture) (Shanghai: Shanghai renmin meishu chubanshe, 1986), 203.

63. Liu Kaiqu, "Diaosu yishu," 339.

64. Zhou Yang, *Zhou Yang wenji*, 2:182–91.

65. *RMRB*, September 30, 1954, 3, 5; October 15, 1954, 3.

66. Liu Kaiqu, "Xiang Sulian diaosu yishu xuexi" (Let's learn from Soviet sculpture), *RMRB*, October 15, 1954, 3.

67. Mitchell, *Picture Theory*, 378.

68. Fu Tianchou, *Yiqing de yishu*, 219.

69. Fan Wenlan, "Shui shi lishi de zhuren?" (Who are the masters of history?), *JBRB*, May 29, 1949, 4.

70. Mao Zedong, "On Protracted War," in Mao, *Selected Works*, 2:143.

71. Quoted in Laing, *Winking Owl*, 24.

72. Liu Kaiqu, *Liu Kaiqu meishu lunwenji* (Liu Kaiqu's essays on art) (Jinan: Shandong meishu chubanshe, 1984), 62.

73. For a survey of China's monuments, see Liu Guofu and Wei Jingfu, eds., *Guohun dian* (Dictionary of national souls) (Changchun: Jinin renmin chubanshe, 1993); and Sun Junting, ed., *Zhongguo geming lieshi yuanlin*.

74. Ellul, *Propaganda*, 70–79.

75. Liu Kaiqu, "Shoudu Renmin yingxiong jinianbei de lishi fudiao" (The historical reliefs of the capital's Monument to the People's Heroes), *RMRB*, January 1, 1957, 8.

76. Interviews with Yan Han, January 15, 2004, and January 3, 2006, Beijing.

77. Bai Yan, *Wo he Yan Han*, 31–32.

Conclusion

1. Mao Zedong, "The Role of the Chinese Communist Party in the National War," in Mao, *Selected Works*, 2:195–211.

2. Sheila Fitzpatrick, *Tear Off the Masks! Identity and Imposture in Twentieth-Century Russia* (Princeton: Princeton University Press, 2005), 29.

3. V. I. Lenin, *What Is to Be Done?* trans. Joe Fineberg and George Hanna (London: Penguin Books, 1989), section 4, esp. 197.

4. Andrew G. Walder, *Communist Neo-Traditionalism: Work and Authority in Chinese Industry* (Berkeley: University of California Press, 1986), 121.

5. Yung-fa Chen, *Making Revolution: The Communist Movement in Eastern and Central China, 1937–1945* (Berkeley: University of California Press, 1986); Odoric Y. K. Wou, *Mobilizing the Masses: Building Revolution in Henan* (Stanford: Stanford University Press, 1994).

6. Levine, *Anvil of Victory*.

7. Beipingshi junguanhui mishuchu, "Youguan rucheng de tongzhi" (Instructions on entering the city), BMA, 1–6-280.

8. Arendt, *Origins of Totalitarianism*, 311–17.

9. Ibid., 308.

10. Gustave Le Bon, *The Crowd*, with an introduction by Robert A. Nye (New Brunswick, NJ: Transaction, 1995), 56, 58–59, 61, 70.

11. Ibid., 140.

12. Ibid., 142.

13. Lenin, *What Is to Be Done?*

14. Kenez, *Birth of the Propaganda State.*

15. Mao Zedong, "Reform Our Study," in Mao, *Selected Works*, 3:19.

16. *Zhuangyan de qingdian*, 47.

17. "Yijiuwujiunian guoqingjie qunzhong youxing."

18. *Zhuangyan de qingdian*, 392.

19. Ibid., 43–44.

20. *Ershi shiji Zhongguo zhongxiaoxue kecheng biaozhun, jiaoxue dagang huibian: Yuwenjuan* (Standard curricula and teaching outlines for Chinese primary and middle schools in the twentieth century: Language and literature), ed. Kecheng jiaocai yanjiusuo (Beijing: Renmin jiaoyu chubanshe, 2001), 365, 432.

21. *RMRB*, June 2, 1958, 2.

22. Zhonggong Beijing shiwei xuanchuanbu, "Beijingshi gongren jiaoyu gongzuo baogao" (Report on the education of the workers in the City of Beijing), BMA, 1–12-9.

23. Zhonggong Beijing shiwei xuanchuanbu, "Zai puji shenru Kang Mei Yuan Chao yundong zhong zuzhi qunzhong jiji fenzi de xuanchuan duiwu" (To organize active propaganda teams among the masses during the popularization and deepening of the Resist America, Aid Korea Campaign), BMA, 1–12-80.

24. Zhonggong Beijing shiwei xuanchuanbu, "Fandui Mei-Chiang tiaoyue xuanchuan yundong qingkuang jianbao, diyihao" (A brief report on the propaganda works to oppose the U.S.-Chiang treaty, issue no. 1), BMA, 1–12-175.

25. Bodde, *Peking Diary*, 110.

26. Xu Beihong, "Wo shenghuo zai Beijing jiefang yinianlai de ganxiang" (Reflections on my life a year after Beijing's liberation), *GMRB*, January 31, 1950, 4; Liang Sicheng, *Liang Sicheng quanji*, 5:82–83.

27. Bonnell, *Iconography of Power*, 146–50; Mosse, *Nationalization of the Masses*, 73–99.

28. Ellul, *Propaganda*, 17–18.

Names, books, and periodicals that appear in the bibliography are omitted in the glossary.

Ai Zhongxin 艾中信

Babaoshan geming gongmu 八宝山革命公墓

Baowei zuguo! hanwei heping! 保卫祖国! 捍卫和平!

Baozhong huguosi 褒忠护国寺

Beijing qingzhu Wuyi guoji laodongjie choubei weiyuanhui 北京庆祝五一国际劳动节筹备委员会

beiwen 碑文

biaoyu 标语

bicheng 必成

bu huobao 不火爆

bu xinxian 不新鲜

buhe women de daodao 不合我们的道道

Cai Hesen 蔡和森

Caishen 财神

Cao Yanxing 曹言行

Cao Yu 曹禺

Chang'an fandian 长安饭店

Chen Boda 陈伯达

Chen Tanqiu 陈潭秋

Chen Yi 陈毅

Chen Yonggui 陈永贵

Chen Youren 陈友仁

Chen Yun 陈云

Chen Zhanxiang 陈占祥

Chen Zhi 陈植

Cheng Yanqiu 程砚秋

Chiang Kai-shek 蒋介石

coushu 凑数

da 大

da er wu dang 大而无当

da jianmiezhan 打歼灭战

dawuding 大屋顶

Dazhong tushu chubanshe 大众图书出版社

Deng Tuo 邓拓

Deng Xiaoping 邓小平

Deng Zhongxia 邓中夏

dianxinghua 典型化

Diaohua shiliao bianshen weiyuanhui 雕画史料编审委员会

diguozhuyi de zougou 帝国主义的走狗

Dong Biwu 董必武

Dongfang fandian 东方饭店

Dongfang hong 东方红

Dongjiao tiyuchang 东郊体育场

Dongjiaominxiang 东交民巷

dougong 斗拱

douzheng yangge 斗争秧歌

Dushi guihua weiyuanhui 都市规划委员会

Dushi jihua weiyuanhui 都市计划委员会

eba 恶霸

fan geming fenzi 反革命分子

Fan Hongjie 范鸿劼

Fang Bowu 方伯务

Fang Zhimin 方志敏

fanshen 翻身

Feng Fasi 冯法祀

Feng Jiping 冯基平

fenting kangli 分庭抗礼

Gang Bing 刚炳

Gao Gang 高岗

Gechang zuguo 歌唱祖国

Geming gongmu 革命公墓

Geming lieshi gongmu 革命烈士公墓

geming lishihua 革命历史画

Geming lishihua chuangzuo lingdao xiaozu 革命历史画创作领导小组

Gongren tiyuchang 工人体育场

Gu Yuan 古元

Guang Weiran (Zhang Guangnian) 光未然（张光年）

guohua 国画

Guoji fandian 国际饭店

guojia renwu 国家任务

Guoqing gongcheng 国庆工程

He Long 贺龙

He Shuheng 何叔衡

Hong Xiuquan 洪秀全

hongxian 红线

hou jin bo gu 厚今薄古

Hu Feng 胡风

Hu Sha 胡沙

Hu Shi 胡适

Hu Yaobang 胡耀邦

Hua Nangui 华南圭

Hua Tianyou 滑田友

Huabei daxue (Huada) 华北大学（华大）

Huai-Hai dajie 淮海大捷

Huairentang 怀仁堂

huaju 话剧

Huangshulang gei ji bainian—buan haoxin 黄鼠狼给鸡拜年—不安好心

huoren budui siren 活人不对死人

Huozhong 火种

Jiang Qing 江青

Jiang Tingfu 蒋廷黻

Jianshe zuguo dayangge 建设祖国大秧歌

jiefang 解放

Jin-Ji-Lu-Yu 晋冀鲁豫

Jinshuiqiao 金水桥

jitizhuyi 集体主义

jiuping zhuang xinjiu 旧瓶装新酒

Kaiguo dadian 开国大典

Kang Sheng 康生

Ke'ai de Zhongguo 可爱的中国

kouhao 口号

Langyashan wu zhuangshi 狼牙山五壮士

Leiyu 雷雨

Li Dazhao 李大钊

Li Fuchun 李富春

Li Keran 李可染

Li Zongren 李宗仁

Li Zhun 李准

lian 莲 [连]

Lian sheng gui zi 莲生贵子

Liang Qichao 梁启超

lianhuanhua 连环画

Lianhuanhua bao 连环画报

Liao Bingxiong 廖冰兄

lieshi 烈士

Lieshi jinianjie 烈士纪念节

Lieshi jinianta 烈士纪念塔

lieshu 烈属

Lin Biao 林彪

Lin Boqu 林伯渠

Lin Gang 林岗

Lin Huiyin 林徽因

Lin Xiangqian 林祥谦

Lin Zexu 林则徐

lingmu 陵墓

Liu Bocheng 刘伯承

Liu Chunhua 刘春华

Liu Hulan 刘胡兰

Liu Jiyou 刘继卣

Liu Ren 刘仁

Liu Runfang 刘润芳

Liu Shaoqi 刘少奇

Liu Shaoqi tongzhi he Anyuan kuanggong 刘少奇同志和安源矿工

Liu Xiaoshi 刘小石

Liu Xiqi 刘熹奇

Liu Zhidan 刘志丹

Liu Zhidan he chiwei duiyuan 刘志丹和赤卫队员

Lu Dingyi 陆定一

Lu Xun 鲁迅

luding 盝顶

Luo Cheng 洛丞

Luo Ronghuan 罗荣桓

Luo Shengjiao 罗盛教

Ma Ke 马可

Mama jiao wo xue xiuhua; wo jiao mama xue wenhua 妈妈教我学绣花，我教妈妈学文化

Mao zhuxi he nongmin tanhua 毛主席和农民谈话

Mao zhuxi qu Anyuan 毛主席去安源

Mao zhuxi zai shieryue huiyi shang 毛主席在十二月会议上

Maxunban 马训班

mei kantou 没看头

Menshen 门神

Mianzhu 绵竹

Minjian gewushe 民间歌舞社

minjian yiren 民间艺人

Minzu fandian 民族饭店

minzuhua 民族化

nianhua 年画

Nie Rongzhen 聂荣臻

Niu Yonggui guacai 牛永贵挂彩

Niuwang 牛王

Nonglitu 农历图

pangwawa 胖娃娃

Peng Dehuai 彭德怀

Peng Pai 彭湃

Peng Song 彭松

Qian Junrui 钱俊瑞

Qianpu houji 前仆后继

qicheng 期成

Qin Qiong 秦琼

Qingzhu jiefang dayangge 庆祝解放大秧歌

Qinjian chijia 勤俭持家

qiyi 起义

Qu Yuan 屈原

Qunyinghui shang de Zhao Guilan 群英会上的赵桂兰

qunzhong youxing 群众游行

Rao Shushi 饶漱石

Ren Bishi 任弼时

Renmin dahuitang 人民大会堂

Renmin guangchang 人民广场

Renmin shengli wansui dagewu 人民胜利万岁大歌舞

Renmin yingxiong jinianbei 人民英雄纪念碑

Renmin yingxiong jinianbei xingjian weiyuanhui 人民英雄纪念碑兴建委员会

Renmin yingxiong yongchui buxiu 人民英雄永垂不朽

Rong Gaotang 荣高棠

santou 伞头

Sanzuomen 三座门

Shaan-Gan-Ning 陕甘宁

shehuo 社火

Shen Qi 沈其

Shen Shu 神荼

Shen Yanbing (Mao Dun) 沈雁冰
 （茅盾）

sheng 笙

Shengxiandao 圣贤道

shi 十

Shi Banghua 施邦华

Shi Lu 石鲁

Shida jianzhu 十大建筑

shiquan shimei 十全十美

shishi manhua 时事漫画

Shisong Hongjun 十送红军

Shoudu qingzhu Zhonghua renmin
 gongheguo guoqingjie choubei
 weiyuanhui 首都庆祝中华人民共和
 国国庆节筹备委员会

shuangchong lingdao 双重领导

Songbie 送别

suona 唢呐

tai xiang zhen de 太像真的

Taohuawu 桃花坞

tewu 特务

Tian Han 田汉

Tian Jiaying 田家英

Tiananmen guangchang 天安门广场

Tiyuchang 体育场

Tong Jinghan 佟景韩

tuichi 推迟

Wang Bingzhao 王丙召

Wang Ersheng 王二生

Wang Hebo 王荷波

Wang Huabin 王华彬

Wang Jincai 王进才

Wang Jinmei 王尽美

Wang Jinxi 王进喜

Wang Linyi 王临乙

Wang Shikuo 王式廓

Wang Yi 王毅

wenfa 文法

Wenwuju 文物局

Wu Biduan 伍必端

Wu Han 吴晗

Wu Peifu 吴佩孚

Wuyingdian 武英殿

Xian Xinghai 冼星海

xiangsheng 相声

xianmiao 线描

Xiantiandao 先天道

Xiao Chuanjiu 萧传玖

Xie Juezai 谢觉哉

xiehouyu 歇后语

xin nianhua 新年画

Xin Xiuming 信修明

Xin Zhongguo de ertong 新中国的儿童

Xinhua ribao 新华日报

Xiongmei kaihuang 兄妹开荒

xiwen lejian 喜闻乐见

xuanzhi 宣纸

Xue Daqing! Xue Dazhai! 学大庆! 学
 大寨!

Xue Zizheng 薛子正

Xueyi 血衣

xumizuo 须弥座

Yamaguchi Ryuichi 山口隆一

Yan Han 彦涵

Yan Zhenduo 阎振铎

Yang Tingbao 杨廷宝

Yang Wandong 杨万东

Yang Zhihua 杨之华

yangge 秧歌

yangge xi 秧歌戏

Yangjiabu 杨家埠

Yangliuqing 杨柳青

yaoqianshu 摇钱树

Ye Jianying 叶剑英

Ye Ting 叶挺

Ye Zhenxing 叶振兴

yi wo weizhu 以我为主

yi xu yi shi 一虚一实

Yiguandao 一贯道

Yingyong buqu 英勇不屈

Yongxiang Jinshuiqiao 涌向金水桥

Youfuke 优抚科

Yu Lu 郁垒

Yu Xing 于行

Yuanmingyuan 圆明园

yubei 玉碑

Yuchi Gong 尉迟恭

Yue Fei 岳飞

yuefenpai 月份牌

Yuhuatai 雨花台

Zaojun 灶君

Zeng Guofan 曾国藩

Zeng Zhushao 曾竹韶

Zhang E 张谔

Zhang Fagen 张法根

Zhang Geng 张庚

Zhang Lan 张澜

Zhang Leping 张乐平

Zhang Side 张思德

Zhang Songhe 张松鹤

Zhang Youyu 张友渔

Zhang Zizhong 张自忠

Zhang Zuolin 张作霖

zhanqu 战区

Zhao Jixian 赵继贤

Zhao Yu 赵域

Zheng Zhenduo 郑振铎

Zheshi zhenzheng de yaoqianshu 这是真正的摇钱树

zhima 纸马

Zhong Kui 钟馗

zhong zhong zhi zhong 重中之重

Zhonggong zhongyang xuanchuanbu (Zhongxuanbu) 中共中央宣传部（中宣部）

Zhongguo geming bowuguan 中国革命博物馆

Zhongguo guojia bowuguan 中国国家博物馆

Zhongguo renmin zhan qilai le 中国人民站起来了

Zhongguo tongshi jianbian 中国通史简编

Zhongnanhai 中南海

Zhongyang geming bowuguan choubeichu 中央革命博物馆筹备处

Zhou Huaide 周怀德

Zhu De 朱德

Zhuan zhan Shaanbei 转战陕北

zhuti 主题

Zhuxianzhen 朱仙镇

Zuguo a, Muqin! 祖国啊，母亲！

Zuo Quan 左权

Bibliography

Archives

Beijingshi chengshi jianshe dang'anguan 北京市城市建设档案馆 (Beijing City Construction Archives) (BCCA)

Beijingshi dang'anguan 北京市档案馆 (Beijing Municipal Archives) (BMA)

Shanghaishi dang'anguan 上海市档案馆 (Shanghai Municipal Archives) (SMA)

Zhonghua renmin gongheguo Guowuyuan waiguo zhuanjiaju dang'anshi 中华人民共和国国务院外国专家局档案室 (Foreign Expert Bureau Archives, the State Council, the People's Republic of China) (FEBA)

Zhonghua renmin gongheguo Jianzhu gongchengbu dang'anshi 中华人民共和国建筑工程部档案室 (Ministry of Architectural Engineering Archives, the People's Republic of China) (MAEA)

Newspapers and Journals

Beijing wenshi ziliao 北京文史资料 (Historical materials on Beijing) (*BJWSZL*)

Chengshi guihua 城市规划 (City planning review)

Dangshi xinxibao 党史信息报 (Party history news)

Dazhong ribao 大众日报 (Popular daily)

Geming bowuguan gongzuo yanjiu 革命博物馆工作研究 (Journal of the Museum of the Chinese Revolution) (*GMBWG*)

Gongren ribao 工人日报 (Workers' daily)

Guangming ribao 光明日报 (Enlightenment daily) (*GMRB*)

Jianzhu sheji 建筑设计 (Architectural design) (*JZSJ*)

Jianzhu xuebao 建筑学报 (Architectural journal) (*JZXB*)

Jiefang ribao 解放日报 (Liberation daily), Shanghai 上海 (*JFRBS*)

Jiefang ribao 解放日报 (Liberation daily), Yan'an 延安 (*JFRBY*)

Jinbu ribao 进步日报 (Progressive daily) (*JBRB*)

Meishu 美术 (Art) (*MS*)

Meishu yanjiu 美术研究 (Art research) (*MSYJ*)

Neibu cankao 内部参考 (Internal references) (*NBCK*)

Renmin huabao 人民画报 (China pictorials) (*RMHB*)

Renmin meishu 人民美术 (People's art) (*RMMS*)

Renmin ribao 人民日报 (People's daily) (*RMRB*)

Shenbao 申报 (Shanghai daily) (*SB*)

Wenwu 文物 (Cultural relics) (*WW*)

Wenwu cankao ziliao 文物参考资料 (Research materials on cultural relics) (later renamed *Wenwu*) (*WWCKZL*)

Wudao 舞蹈 (Dance)
Wudao yishu 舞蹈艺术 (Dance art)
Xin guancha 新观察 (New observer) (*XGC*)
Yuehua bao 越华报 (Guangzhou post) (*YHB*)
Zhonggong dangshi ziliao 中共党史资料 (Materials on the history of the Chinese Communist Party) (*ZGDS*)

Books and Articles

Agulhon, Maurice. *Marianne into Battle: Republican Imagery and Symbolism in France, 1789–1880.* Translated by Janet Lloyd. Cambridge: Cambridge University Press, 1981.

——. "Politics and Images in Post-Revolutionary France." In *Rites of Power: Symbolism, Ritual, and Politics since the Middle Ages,* edited by Sean Wilentz. Philadelphia: University of Pennsylvania Press, 1985.

Ai Ke'en 艾克恩, ed. *Yan'an yishujia* 延安艺术家 (Yan'an artists). Xi'an: Shaanxi renmin jiaoyu chubanshe, 1992.

Ai Siqi 艾思奇, et al. *Yangge lunwen xuanji* 秧歌论文选集 (Selected essays on yangge). N.p.: Xinhua shudian, 1944.

Alberti, Leon Battista. *The Ten Books of Architecture* (The 1755 Leoni Edition). New York: Dover, 1986.

Almond, Gabriel A., and Sidney Verba. *The Civic Culture: Political Attitudes and Democracy in Five Nations.* Newbury Park, CA: Sage Publications, 1989.

Aman, Anders. *Architecture and Ideology in Eastern Europe during the Stalin Era: An Aspect of Cold War History.* New York: Architectural History Foundation; Cambridge: MIT Press, 1992.

Andrews, Julia F. *Painters and Politics in the People's Republic of China, 1949–1979.* Berkeley: University of California Press, 1994.

Arendt, Hannah. *The Origins of Totalitarianism.* New York: World Publishing, 1958.

Ariès, Philippe. *Western Attitudes toward Death: From the Middle Ages to the Present.* Translated by Patricia M. Ranum. Baltimore: Johns Hopkins University Press, 1974.

Arkush, R. David. "Love and Marriage in North Chinese Peasant Operas." In *Unofficial China: Popular Culture and Thought in the People's Republic,* edited by Perry Link, Richard Madsen, and Paul G. Pickowicz. Boulder, CO: Westview Press, 1989.

Bai Yan 白炎. "Renmin yingxiong jinianbei fudiao ji qita gaishu" 人民英雄纪念碑浮雕及其他概述 (The reliefs of the Monument to the People's Heroes and other accounts). *Beijing wanbao,* September 2, 2000, 22.

——. *Wo he Yan Han* 我和彦涵 (Yan Han and I). Hong Kong: Tianma tushu youxian gongsi, 2002.

Baird, Jay W. *To Die for Germany: Heroes in the Nazi Pantheon.* Bloomington: Indiana University Press, 1990.

"Balajin zhuanjia dui daolu kuandu he fenqi jianshe deng wenti de yijian" 巴拉金专家对道路宽度和分期建设等问题的意见 (Adviser Baragin's opinions on issues related to the width of the roads and the stages of construction). BCCA, C3–87-1.

Balannikefu (Barannikov) 巴兰尼克夫. "Beijingshi jianglai fazhan jihua de wenti" 北京市将来发展计划的问题 (Problems concerning the plan for Beijing's future development). *ZGDS,* no. 76 (December 2000): 3–12.

Bao Jia 鲍加. "Cong zhanzheng da changmian zhong biaoxian shidai jingshen" 从战争大场面中表现时代精神 (Expressing the spirit of the time through great war scenes). *MS*, no. 6 (December 6, 1961): 11–12, 30.

"Beijing Babaoshan geming gongmu" 北京八宝山革命公墓 (Beijing's Babaoshan Revolutionary Cemetery). Mimeograph, issued by the Babaoshan Revolutionary Cemetery Office, n.d.

Beijing bowuguan nianjian, 1912–1987 北京博物馆年鉴,1912–1987 (The year book of Beijing museums, 1912–1987). Edited by Beijing bowuguan xuehui 北京博物馆学会. Beijing: Beijing yanshan chubanshe, 1989.

"Beijing qingzhu yijiuwuwunian Wuyi laodongjie choubei huiyi" 北京庆祝一九五五年五一劳动节筹备会议 (Preparatory meeting for the celebration of the 1955 May Day festival in Beijing). BMA, 99-1-60.

Beijingshi chengshi jianshe weiyuanhui 北京市城市建设委员会. "Guanyu jianshe Chang'an fandian de jingyan zongjie" 关于建设长安饭店的经验总结 (Summary on the task of constructing the Chang'an Hotel). BMA, 47-1-71.

——. "Tiananmen guangchang gongcheng de jiben qingkuang" 天安门广场工程的基本情况 (Basic conditions of the Tiananmen Square project). BMA, 47-1-92.

Beijingshi dushi guihua weiyuanhui 北京市都市规划委员会. "Guanyu chengqiang chaichu wenti de yijian" 关于城墙拆除问题的意见 (Opinions on demolishing city walls). BMA, 151-1-73.

"Beijingshi Geming gongmu guanli qingkuang" 北京市革命公墓管理情况 (The management of the Beijing Revolutionary Cemetery). BMA, 196-2-179.

"Beijingshi guiweihui guanyu Beijingshi dierpi daolu mingming qingdan (Xijiao bufen)" 北京市规委会关于北京市第二批道路命名清单(西郊部分) (A second list of the renaming of the streets in Beijing [Western suburb section] issued by the Planning Committee of Beijing). BMA, 151-1-71.

"Beijingshi guiweihui yijiuwuwunian zhuanjia gongzuo jihua" 北京市规委会1955年专家工作计划 (The working schedule of experts in 1955, Municipal Development Committee). BMA, 151–1-5.

Beijingshi jianzhu gongchengju 北京市建筑工程局. "Shixiang gonggong jianzhu de shigong qingkuang gaikuang jieshao" 十项公共建筑的施工情况概况介绍 (A brief introduction to the conditions concerning the construction of the ten public buildings). BMA, 125-1-1218.

Beijingshi Minzhengju 北京市民政局. "Guanyu qianzou Geming gongmu nei taijian fenmu de qingshi" 关于迁走革命公墓内太监坟墓的请示 (Requesting instructions concerning the removal of the eunuchs' tombs from the Revolutionary Cemetery). BMA, 196-2-135.

Beijingshi Minzhengju youfuke 北京市民政局优抚科. "Guanyu shenqing lieshi xisheng fuxu yu youguan danwei laiwang de wenshu" 关于申请烈士牺牲抚恤与有关单位来往的文书 (Correspondence with various agencies concerning compensation for the martyrs' families). BMA, 196-2-101.

——. "Guanyu yizang lieshi Fan Hongjie yu Geming gongmu de wenshu cailiao" 关于移葬烈士范鸿劼于革命公墓的文书材料 (Documents concerning the reburial of Martyr Fan Hongjie at the Revolutionary Cemetery). BMA, 196-2-88.

"Beijingshi qingzhu guoqing dahui kouhao" 北京市庆祝国庆大会口号 (Slogans used in Beijing for the National Day celebrations). BMA, 99-1-11.

"Beijingshi renmin weiyuanhui guanyu shencha yijiuwuqinian pinqing Sulian zhuanjia de baogao" 北京市人民委员会关于审查1957年聘请苏联专家的报

告 (Report of Beijing Municipal People's Committee on assessing the 1957 recruitment of the Soviet advisers). BMA, 151–1-45.

"Beijingshi renmin weiyuanhui guanyu xiuzheng Geming gongmu anzang zanxing guize de tongzhi" 北京市人民委员会关于修正革命公墓安葬暂行规则的通知 (An announcement concerning the revision of temporary rules of burial at the Revolutionary Cemetery issued by the Beijing Municipal People's Committee). BMA, 2–9-60.

"Beijingshi wenyi gongzuo weiyuanhui gongzuo baogao" 北京市文艺工作委员会工作报告 (The report of the Beijing Literary and Art Committee). BMA, 1–12-3.

Beipingshi junguanhui mishuchu 北平市军管会秘书处. "Youguan rucheng de tongzhi" 有关入城的通知 (Instructions on entering the city). BMA, 1–6-280.

Ben-Amos, Avner. *Funeral, Politics, and Memory in Modern France, 1789–1996.* Oxford: Oxford University Press, 2000.

Benkan jizhe 本刊记者 (Wang Yeqiu 王冶秋). "Zhongguo geming bowuguan xunli" 中国革命博物馆巡礼 (A tour of the Museum of the Chinese Revolution). *WW*, no. 7 (July 1961): 27–37.

"Biandui gongzuo de jixiang guiding" 编队工作的几项规定 (Rules concerning group formations). BMA, 99–1-200.

Bo Songnian 薄松年. *Chinese New Year Pictures.* Beijing: Cultural Relics Publishing House, 1995.

——. *Zhongguo nianhuashi* 中国年画史 (History of Chinese New Year prints). Shenyang: Liaoning meishu chubanshe, 1986.

——, ed. *Zhongguo yishushi tuji* 中国艺术史图集 (A pictorial history of Chinese art). Shanghai: Shanghai wenyi chubanshe, 2004.

——. *Zhongguo zaojun shenma* 中国灶君神禡 (China's Stove God and paper horses). Taipei: Bohaitang wenhua shiye youxian gongsi, 1993.

Bo Songnian and Wang Shucun 王树村. "Shinianlai woguo xin nianhua de fazhan he chengjiu" 十年来我国新年画的发展和成就 (The development and success of the new nianhua in China over the last ten years). *MSYJ*, no. 2 (May 15, 1959): 12–17.

Bo Yibo 薄一波. *Ruogan zhongda juece yu shijian de huigu* 若干重大决策与事件的回顾 (A retrospect of some crucial decisions and events). Rev. ed. 2 vols. Beijing: Renmin chubanshe, 1997.

Bodde, Derk. *Peking Diary: A Year of Revolution.* New York: Henry Schuman, 1950.

Boldirev, S., and P. Goldenberg, "Ulitsa Gorkogo v proshlom i nastoyashchem" (The past and present of Gorky Street). *Arkhitektura SSSR*, no. 4 (1938): 14–19.

Bonnell, Victoria E. *Iconography of Power: Soviet Political Posters under Lenin and Stalin.* Berkeley: University of California Press, 1997.

Bourdieu, Pierre. *Distinction: A Social Critique of the Judgement of Taste.* Translated by Richard Nice. Cambridge: Harvard University Press, 1984.

——. *The Field of Cultural Production: Essays on Art and Literature.* Edited and introduction by Randal Johnson. New York: Columbia University Press, 1993.

——. *Language and Symbolic Power.* Edited and introduction by John B. Thompson, translated by Gino Raymond and Matthew Adamson. Cambridge: Harvard University Press, 1991.

Bown, Matthew Cullerne. *Art under Stalin.* New York: Holmes and Meier, 1991.

——. *Socialist Realist Painting.* New Haven: Yale University Press, 1998.

Brooks, Jeffrey. *Thank You, Comrade Stalin! Soviet Public Culture from Revolution to Cold War*. Princeton: Princeton University Press, 2000.

Brown, Jonathan, and J. H. Elliott. *A Palace for a King: The Buen Retiro and the Court of Philip IV*. New Haven: Yale University Press, 1980.

Burke, Peter. *Eyewitnessing: The Uses of Images as Historical Evidence*. Ithaca: Cornell University Press, 2001.

Cai Ruohong 蔡若虹. "Wei chuangzao zui xin zui mei de yishu er fendou" 为创造最新最美的艺术而奋斗 (Striving to create the newest and most beautiful art). *MS*, nos. 8–9 (1960): 1–11.

Castillo, Greg. "Gorki Street and the Design of the Stalin Revolution." In *Streets: Critical Perspectives on Public Space*, edited by Zeynep Çelik, Diane Favro, and Richard Ingersoll. Berkeley: University of California Press, 1994.

Certeau, Michel de. *The Practice of Everyday Life*. Translated by Steven Rendall. Berkeley: University of California Press, 1984.

Chang Nadan 常那丹. "Xianshizhuyi de lishi huajia Sulikefu" 现实主义的历史画家苏里柯夫 (Surikov: A realist history painter). *RMMS* 1, no. 5 (October 1, 1950): 38–40.

Chang'anjie: Guoqu, xianzai, weilai 长安街:过去、现在、未来 (Chang'an Avenue: The past, the present, and the future). Edited by Beijingshi guihua weiyuanhui and Beijing chengshi guihua xuehui 北京市规划委员会,北京城市规划学会. Beijing: Jixie gongye chubanshe, 2004.

Chartier, Roger. *Cultural History: Between Practices and Representations*. Translated by Lydia G. Cochrane. Cambridge: Polity Press, 1988.

Cheek, Timothy. *Propaganda and Culture in Mao's China: Deng Tuo and the Intelligentsia*. Oxford: Clarendon Press, 1997.

Chen Gan 陈干. *Jinghua daisilu* 京华待思录 (Reflections on the capital). Beijing: Beijingshi chengshi guihua sheji yanjiuyuan, n.d.

Chen Qingquan 陈清泉 and Song Guangwei 宋广渭. *Lu Dingyi zhuan* 陆定一传 (Biography of Lu Dingyi). Beijing: Zhonggong dangshi chubanshe, 1999.

Chen, Xiaomei. *Acting the Right Part: Political Theater and Popular Drama in Contemporary China*. Honolulu: University of Hawai'i Press, 2002.

Chen, Yung-fa. *Making Revolution: The Communist Movement in Eastern and Central China, 1937–1945*. Berkeley: University of California Press, 1986.

Cheng Yanqiu 程砚秋 and Du Yingtao 杜颖陶. "Hanting de nianhua" 寒亭的年画 (Hanting's New Year prints). *Minjian wenyi jikan*, no. 2 (May 15, 1951): 29–33.

Chinese Women and Modernity: Calendar Posters of the 1910s–1930s. Compiled by Ng Chun Bong et al. Hong Kong: Joint Publishing, 1996.

Choi Seung-hee 崔承喜. "Zhongguo wudao yishu de jianglai" 中国舞蹈艺术的将来 (The future of Chinese dance). *RMRB*, February 18, 1951, 5.

Clark, Paul. *Chinese Cinema: Culture and Politics since 1949*. Cambridge: Cambridge University Press, 1987.

Collins, George R., and Christiane Crasemann Collins. *Camillo Sitte: The Birth of Modern City Planning*, with a translation of the 1889 Austrian edition of his *City Planning according to Artistic Principles*. New York: Rizzoli, 1986.

The Common Program and Other Documents of the First Plenary Session of the Chinese People's Political Consultative Conference. Peking: Foreign Languages Press, 1950.

The Constitution of the People's Republic of China. Peking: Foreign Languages Press, 1954.

Corney, Frederick C. *Telling October: Memory and the Making of the Bolshevik Revolution.* Ithaca: Cornell University Press, 2004.

Dai Ailian 戴爱莲. "Wo de wudao shengya" 我的舞蹈生涯 (My life as a dancer). In *Zhonghua wenshi ziliao wenku* 中华文史资料文库 (Source materials on Chinese literature and history). Vol. 15. Beijing: Zhongguo wenshi chubanshe, 1996.

——. *Wo de yishu yu shenghuo* 我的艺术与生活 (My art and life). Beijing: Renmin yinyue chubanshe; Huayue chubanshe, 2003.

Dangshi dashi tiaomu, 1949–1992 党史大事条目,1949–1992 (Major events in the history of the CCP, 1949–1992). Edited by Beijingshi chengshi guihua guanliju and Beijingshi chengshi guihua sheji yanjiuyuan dangshi zhengji bangongshi 北京市城市规划管理局, 北京市城市规划设计研究院党史征集办公室. Beijing: n.p., 1995.

Danilova, Albina. *Dedicated to the Muses.* Moscow: Novosti, 1990.

Denton, Kirk A. "Visual Memory and the Construction of a Revolutionary Past: Paintings from the Museum of the Chinese Revolution." *Modern Chinese Literature and Culture* 12, no. 2 (Fall 2000): 203–35.

"Dierci huiyi jilu" 第二次会议记录 (Minutes of the second meeting). BMA, 23-1-6.

"Dierci zhihuibu huiyi" 第二次指挥部会议 (The second meeting of the command center). BMA, 99-1-47.

"Disanci changwu weiyuanhui huiyi jilu" 第三次常务委员会会议记录 (Minutes of the third standing committee meeting [of the Municipal Planning Committee]). BMA, 150-1-30.

"Disanci zhihuibu huiyi" 第三次指挥部会议 (The third meeting of the command center). BMA, 99-1-47.

"Diyici huiyi jilu" 第一次会议记录 (Minutes of the first meeting). BMA, 23-1-6.

Dong Guangqi 董光器. "Tiananmen guangchang de gaijian yu kuojian" 天安门广场的改建与扩建 (The reconstruction and expansion of Tiananmen Square). *BJWSZL*, no. 49 (November 1994): 1–11.

Dong, Madeleine Yue. *Republican Beijing: The City and Its Histories.* Berkeley: University of California Press, 2003.

Dong Xiaoping 董晓萍. *Tianye minsuzhi* 田野民俗志 (Folklore fieldwork). Beijing: Beijing shifan daxue chubanshe, 2003.

Dong Xijiu 董锡玖. *"Renmin shengli wansui* xiangche Zhongnanhai" 人民胜利万岁响彻中南海 (The magnificent performance of *Long Live the People's Victory* in Zhongnanhai). *Wudao,* no. 5 (1999): 52–53.

Dong Xiwen 董希文. "Cong Zhongguo huihua de biaoxian fangfa tandao youhua de Zhongguofeng" 从中国绘画的表现方法谈到油画的中国风 (From the expressive methods of Chinese painting to Chinese characteristics of oil painting). *MS,* no. 1 (January 1, 1957): 6–9.

——. "Youhua *Kaiguo dadian* de chuangzuo jingyan" 油画开国大典的创作经验 (How I created *The Founding Ceremony of the Nation*). *XGC,* no. 21 (November 1, 1953): 24–25.

Duncan, Carol, and Alan Wallach. "The Universal Survey Museum." *Art History* 3, no. 4 (December 1980): 448–69.

"Dushi jihua weiyuanhui chengli dahui jilu" 都市计划委员会成立大会记录 (Minutes of the inauguration meeting of the Municipal Planning Committee). BMA, 150-1-1.

"Dushi jihua yijiuwuernian gongzuo zongjie" 都市计划一九五二年工作总结 (The 1952 summary of city planning work). BMA, 150–1-56.

Eberhard, Wolfram. *A Dictionary of Chinese Symbols: Hidden Symbols in Chinese Life and Thought*. London: Routledge, 1986.

Ellul, Jacques. *Propaganda: The Formation of Men's Attitudes*. Translated by Konrad Kellen and Jean Lerner. New York: Vintage Books, 1973.

Ershi shiji Zhongguo zhongxiaoxue kecheng biaozhun, jiaoxue dagang huibian: Yuwenjuan 二十世纪中国中小学课程标准，教学大纲汇编:语文卷 (Standard curricula and teaching outlines for Chinese primary and middle schools in the twentieth century: Language and literature). Edited by Kecheng jiaocai yanjiusuo 课程教材研究所. Beijing: Renmin jiaoyu chubanshe, 2001.

Etlin, Richard A. *The Architecture of Death: The Transformation of the Cemetery in Eighteenth-Century Paris*. Cambridge: MIT Press, 1984.

Evans, Harriet. *Women and Sexuality in China: Female Sexuality and Gender Since 1949*. New York: Continuum, 1997.

Fairbank, Wilma. *Liang and Lin: Partners in Exploring China's Architectural Past*. Philadelphia: University of Pennsylvania Press, 1994.

Falasca-Zamponi, Simonetta. *Fascist Spectacle: The Aesthetics of Power in Mussolini's Italy*. Berkeley: University of California Press, 1997.

Fan Wenlan 范文澜. *Fan Wenlan lishi lunwen xuanji* 范文澜历史论文选集 (Selected historical essays of Fan Wenlan). Beijing: Zhongguo shehui kexue chubanshe, 1979.

——. *Hanjian guizishou Zeng Guofan de yisheng* 汉奸刽子手曾国藩的一生 (The life of the traitor-butcher Zeng Guofan). Xi'an: Xibei xinhua shudian, 1949.

——. "Shui shi lishi de zhuren?" 谁是历史的主人? (Who are the masters of history?). *JBRB*, May 29, 1949, 4.

Fang Cheng 方成. "Dianchuanshi" 点传师 (The high priest). *RMRB*, August 4, 1955, 2.

——. *Wo de manhua shenghuo: Fang Cheng* 我的漫画生活:方成 (My life as a cartoonist). Beijing: Wuzhou chuanbo chubanshe, 2004.

——. "Xiang Sulian manhuajia zhihe" 向苏联漫画家致贺 (Salute Soviet cartoonists). *MS*, no. 11 (November 15, 1957): 10.

Fang Cheng and Zhong Ling 锺灵. *Gehai yaoji* 隔海遥祭 (Memorial service across the strait). *RMRB*, June 5, 1955, 3.

Fang Kongmu 方孔木. "Chenlie gongzuo de lishi fazhan" 陈列工作的历史发展 (The history of the development of the exhibitions). In *Zhongguo geming bowuguan fazhan jishi* 中国革命博物馆发展纪事 (Chronicles of the development of the Museum of the Chinese Revolution). N.p., n.d.

——. "Tan dangshi gongzuo zhong de jige wenti" 谈党史工作中的几个问题 (On several issues related to the research on Party history). In *Dangshi yanjiu ziliao* 党史研究资料 (Research materials on Party history). Vol. 1. Chengdu: Sichuan renmin chubanshe, 1980.

Farnsworth, Beatrice. "Village Women Experience the Revolution." In *Bolshevik Culture: Experiment and Order in the Russian Revolution*, edited by Abbott Gleason, Peter Kenez, and Richard Stites. Bloomington: Indiana University Press, 1985.

Feng Peizhi 冯佩之 and Shen Bo 沈勃. "Guoqing gongcheng de shengli jiancheng (chugao)" 国庆工程的胜利建成(初稿) (The successful completion of the National Day projects [draft]). BMA, 131–1-362.

Feng Zhen 冯真. "Nianhua diaochaji" 年画调查记 (An investigation of New Year prints). *MSYJ*, no. 4 (November 15, 1980): 57–60.

Figes, Orlando, and Boris Kolonitskii. *Interpreting the Russian Revolution: The Language and Symbols of 1917.* New Haven: Yale University Press, 1999.

Fitzpatrick, Sheila. *Stalin's Peasants: Resistance and Survival in the Russian Village after Collectivization.* New York: Oxford University Press, 1994.

——. *Tear Off the Masks! Identity and Imposture in Twentieth-Century Russia.* Princeton: Princeton University Press, 2005.

Fu Tianchou 傅天仇. *Yiqing de yishu: Zhongguo diaosu chutan* 移情的艺术:中国雕塑初探 (Art that can transform sentiments: A preliminary investigation of Chinese sculpture). Shanghai: Shanghai renmin meishu chubanshe, 1986.

Furet, François. *Interpreting the French Revolution.* Translated by Elborg Forster. Cambridge: Cambridge University Press, 1981.

Gans, Herbert, J. *Popular Culture and High Culture: An Analysis and Evaluation of Taste.* New York: Basic Books, 1974.

Gao, James Z. *The Communist Takeover of Hangzhou: The Transformation of City and Cadre, 1949–1954.* Honolulu: University of Hawai'i Press, 2004.

"Ge duiwu duirong qingkuang" 各队伍队容情况 (Specific conditions in each parade group). BMA, 99–1-45.

"Ge duiwu duirong qingkuang" 各队伍队容情况 (Specific conditions in each parade group). BMA, 99–1-61.

Geertz, Clifford. *Local Knowledge: Further Essays in Interpretive Anthropology.* New York: Basic Books, 1983.

"Geming gongmu anzang zanxing guize" 革命公墓安葬暂行规则 (Temporary rules for burial in the Revolutionary Cemetery). BMA, 2–3-58.

Goldman, Merle. *China's Intellectuals: Advise and Dissent.* Cambridge: Harvard University Press, 1981.

Golomstock, Igor. "Problems in the Study of Stalinist Culture." In *The Culture of the Stalin Period,* edited by Hans Günther. New York: St. Martin's, 1990.

——. *Totalitarian Art in the Soviet Union, the Third Reich, Fascist Italy and the People's Republic of China.* Translated by Robert Chandler. New York: IconEditions, 1990.

"Gongzuo jianbao" 工作简报 (Brief reports). BMA, 99–1-46.

"Gongzuo richeng" 工作日程 (Work schedule). BMA, 99–1-32.

"Gongzuo richeng he jianbao" 工作日程和简报 (Work schedule and brief reports). BMA, 99–1-13.

Gramsci, Antonio. *Selections from the Prison Notebooks.* Edited and translated by Quintin Hoare and Geoffrey Nowell Smith. London: Lawrence and Wishart, 1971.

Groys, Boris. "The Art of Totality." In *The Landscape of Stalinism: The Art and Ideology of Soviet Space,* edited by Evgeny Dobrenko and Eric Naiman. Seattle: University of Washington Press, 2003.

——. "The Struggle against the Museum; or, The Display of Art in Totalitarian Space." In *Museum Culture: Histories, Discourses, Spectacles,* edited by Daniel J. Sherman and Irit Rogoff. Minneapolis: University of Minnesota Press, 1994.

——. *The Total Art of Stalinism: Avant-Garde, Aesthetic Dictatorship, and Beyond.* Translated by Charles Rougle. Princeton: Princeton University Press, 1992.

"Guanyu Geming gongmu jiancha qingkuang ji jinhou maizang yijian de baogao"

关于革命公墓检查情况及今后埋葬意见的报告 (A report on the conditions of the Revolutionary Cemetery and matters regarding future burial). BMA, 2–3-58.

"Guanyu geming lieshi de jieshi" 关于革命烈士的解释 (Explaining the term Revolutionary Martyr). *RMRB*, October 15, 1950, 1.

"Guanyu Geming lieshi gongmu anzang zanxing guize xizhao benfu xingzheng huiyi jueding chuli" 关于革命烈士公墓安葬暂行规则希照本府行政会议决定处理 (Follow the decision of the executive council of the municipal government to implement the temporary rules for burial in the Revolutionary Cemetery). BMA, 2–3-58.

"Guanyu Geming, Lishi liang bowuguan choujian qingkuang de baogao" 关于革命、历史两博物馆筹建情况的报告 (A report on the preparation for the construction of the Museum of the Chinese Revolution and the Museum of Chinese History). BMA, 164–1-31.

"Guanyu jige zhuyao de gaolou dasha de jufu biaoyu de buzhi" 关于几个主要的高楼大厦的巨幅标语的布置 (On the decoration of huge posters on the key high-rises). SMA, B56–2-2.

"Guanyu Renmin yingxiong jinianbei sheji wenti de yixie wenti de baogao" 关于人民英雄纪念碑设计问题的一些问题的报告 (Report on the problems concerning the construction of the Monument to the People's Heroes). BMA, 1–5-90.

"Guanyu ruchenghou de gongzuo fangzhen" 关于入城后的工作方针 (Guiding principles after the occupation of the city). BMA, 1–12-19.

"Guanyu Wuyi youxing he wanhui zhunbei qingkuang de baogao" 关于五一游行和晚会准备情况的报告 (Report on the preparation for the May Day parades and evening parties). BMA, 99–1-110.

"Guanyu yijiuwulingnian eryue liuri Yangshupu fadianchang zaoshou Guomindang feiji hongzha de baogao" 关于一九五零年二月六日杨树浦发电厂遭受国民党飞机轰炸的报告 (Report on the bombing of Yangshupu's power plant by Guomindang planes on February 6, 1950). SMA, B1–2-390–1.

"Guanyu yizang geming lieshi fenmu xiujian libei ji liaojie xisheng jingguo de wenshu cailiao" 关于移葬革命烈士坟墓修建立碑及了解牺牲经过的文书材料 (Documents on the reburials of martyrs, the construction of their tombstones, and on how they sacrificed their lives). BMA, 196–2-102.

"Guanyu zeng Sulian zhuanjia Abulamofu deng shiqiwei tongzhi jingzhuang *Mao Zedong xuanji* de youguan wenjian" 关于赠苏联专家阿布拉莫夫等十七位同志精装毛泽东选集的有关文件 (Documents concerning the presentation of the clothbound *Selected Works of Mao Zedong* to Soviet expert Abramov and his sixteen colleagues as a gift). BMA, 1–6-688.

Guihuaju 规划局. "Beijingshi zongti guihua gangyao (caogao), 1958–1972" 北京市总体规划纲要(草稿), 1958–1972 (Outline of the overall plan of the development of Beijing [draft], 1958–1972). BMA, 47–1-57.

Guoqing gongcheng bangongshi 国庆工程办公室. "Guanyu guoqing gongcheng de qingkuang he 1959 nian diyijidu shigong anpai de baogao (chugao)" 关于国庆工程的情况和1959年第一季度施工安排的报告(初稿) (Report on the construction of the National Day projects in the first quarter of 1959 [draft]). BMA, 125–1-1233.

——. "Guanyu muqian guoqing gongcheng jinxing qingkuang de baogao" 关于目前国庆工程进行情况的报告 (A status report on the progress of the National Day projects). BMA, 125–1-1233.

——. "Guanyu qingzhu guoqing shizhounian jianfang shigong anpai de baogao"

关于庆祝国庆十周年建房施工安排的报告 (Report on the construction of housing for the purpose of celebrating the tenth anniversary of National Day). BMA, 125–1-1233.

——. "Guoqing gongcheng jianbao, di 15 hao" 国庆工程简报第15号 (A brief report on the National Day projects, no. 15). BMA, 125–1-1217.

——. "Quanguo Renmin daibiao dahuitang gongcheng de jiben qingkuang" 全国人民代表大会堂工程的基本情况 (Basic conditions concerning the construction of the Great Hall of the People's Representatives). BMA, 125–1-1218.

——. "Zhongguo geming, lishi bowuguan gongcheng zongjie" 中国革命、历史博物馆工程总结 (Summary report on the construction of the Museum of the Chinese Revolution and the Museum of Chinese History). BMA, 125–1-1223.

"Guoqing gongcheng jianzhu zaojia fenxiang tongjibiao" 国庆工程建筑造价分项统计表 (Cost statistics of the National Day construction projects). BMA, 2–12-138.

Guoqing gongcheng sheji shencha huiyi bangongshi 国庆工程设计审查会议办公室. "Guoqing gongcheng sheji shencha huiyi jianbao, dierhao" 国庆工程设计审查会议简报,第二号 (The second brief report on the review session of the National Day projects). BMA, 131–1-359.

Halbwachs, Maurice. *The Collective Memory*. Translated by Francis J. Ditter Jr. and Vida Yazdi Ditter. New York: Harper and Row, 1980.

Harrison, Henrietta. *The Making of the Republican Citizen: Political Ceremonies and Symbols in China, 1911–1929*. Oxford: Oxford University Press, 2000.

——. "Martyrs and Militarism in Early Republican China." *Twentieth-Century China* 23, no. 2 (April 1998): 41–70.

Haskell, Francis. *History and Its Images: Art and the Interpretation of the Past*. New Haven: Yale University Press, 1995.

He Rong 何溶. "Geming fengbao zhong de yingxiong xingxiang" 革命风暴中的英雄形象 (The image of the hero in the storm of revolution). *MS*, no. 4 (August 6, 1961): 6–7.

——. "Qunyinghui shang de Zhao Guilan" 群英会上的赵桂兰 (Zhao Guilan at the heroes' reception). *MS*, no. 2 (February 15, 1960): 18.

Hinton, William. *Fanshen: A Documentary of Revolution in a Chinese Village*. New York: Vintage Books, 1968.

Hobsbawm, Eric, and Terence Ranger, eds. *The Invention of Tradition*. Cambridge: Cambridge University Press, 1983.

Holm, David. *Art and Ideology in Revolutionary China*. Oxford: Clarendon, 1991.

Hou Renzhi 侯仁之. "Shilun Beijing chengshi guihua jianshe zhong de sange lichengbei" 试论北京城市规划建设中的三个里程碑 (A preliminary discussion of the three major developmental stages in the construction of Beijing). *Chengshi guihua*, no. 6 (November 9, 1994): 4–9.

Hou Renzhi and Wu Liangyong 吴良镛. "Tiananmen guangchang lizan: Cong gongting guangchang dao renmin guangchang de yanbian he gaizao" 天安门广场礼赞:从宫廷广场到人民广场的演变和改造 (Paean to Tiananmen Square: Its transformation from a palace square to a people's square). *WW*, no. 9 (September 1977): 1–15.

Hou Yimin 侯一民 (侯逸民). "*Liu Shaoqi tongzhi he Anyuan kuanggong de gousi*" 刘少奇同志和安源矿工的构思 (The conception of the painting *Comrade Liu Shaoqi and the Anyuan Miners*). *MS*, no. 4 (August 6, 1961): 21–24.

——. "Wo he wo de geming lishihua" 我和我的革命历史画 (I, the artist, and my revolutionary history paintings). *Meishu bolan*, no. 17 (June 25, 2005): 20–54.

Hu Qiaomu 胡乔木. *Zhongguo gongchandang de sanshinian* 中国共产党的三十年 (Thirty years of the Communist Party of China). Beijing: Renmin chubanshe, 1951.

Hu Sha 胡沙. "*Renmin shengli wansui dagewu* chuangzuo jingguo" 人民胜利万岁大歌舞创作经过 (The creation of *The Great Musical of Long Live the People's Victory*). *RMRB*, November 1, 1949, 6.

——. "Xiangqi zai Yan'an nao yangge de jijianshi" 想起在延安闹秧歌的几件事 (Reminiscences of dancing yangge in Yan'an). *RMRB*, May 24, 1962, 6.

Hu Sheng 胡绳, ed. *Zhongguo gongchandang de qishinian* 中国共产党的七十年 (Seventy years of the Chinese Communist Party). Beijing: Zhonggong dangshi chubanshe, 1991.

Hua Junwu 华君武. "Cong xiaxiang shangshan tandao manhua de dazhonghua he minzuhua" 从下乡上山谈到漫画的大众化和民族化 (From working in the countryside and mountain areas to making cartoons popular and nationalistic). *MS*, no. 2 (February 15, 1958): 13–14.

——. *Hua Junwu zhengzhi fengcihua xuanji* 华君武政治讽刺画选集 (Selected works of Hua Junwu's political satirical cartoons). Beijing: Renmin meishu chubanshe, 1954.

——. *Huazhuang wuhui* 化装舞会 (Masquerade party). *RMRB*, June 26, 1955, 3.

——. *Lang de qiaozhuang* 狼的乔装 (The wolf's disguise). *XGC*, no. 1 (January 1, 1953): 28.

——. *Manhua manhua* 漫画漫话 (On cartoons). Beijing: Zhongguo gongren chubanshe, 1999.

——. "Mantan neibu fengci de manhua" 漫谈内部讽刺的漫画 (On internal satirical cartoons). *MS*, no. 5 (May 15, 1957): 13–14.

——. *Wo zenyang xiang he zenyang hua manhua* 我怎样想和怎样画漫画 (How I think and draw cartoons). Shijiazhuang: Hebei jiaoyu chubanshe, 1999.

Hua Tianyou 滑田友. "Rang diaosu yishu dao renmin qunzhong zhong qu" 让雕塑艺术到人民群众中去 (Let sculpture speak to the people). *RMRB*, December 26, 1957, 7.

Hua Yingshen 华应申, ed. *Zhongguo gongchandang lieshizhuan* 中国共产党烈士传 (Biographies of the Chinese Communist martyrs). Hong Kong: Xin minzhu chubanshe, 1949.

Huadong minjian nianhua 华东民间年画 (East China's folk New Year prints). Edited by Chen Yanqiao 陈烟桥, Chen Qiucao 陈秋草, and Zhu Shiji 朱石基. Shanghai: Shanghai renmin meishu chubanshe, 1955.

"Huhan de kouhao" 呼喊的口号 (Slogans used). BMA, 99-1-94.

Huiyi Wang Yeqiu 回忆王冶秋 (Remembering Wang Yeqiu). Edited by Guojia wenwuju 国家文物局. Beijing: Wenwu chubanshe, 1995.

Hung, Chang-tai 洪长泰. "Kongjian yu zhengzhi: Kuojian Tiananmen guangchang" 空间与政治:扩建天安门广场 (Space and politics: Expanding Tiananmen Square). In *Liang'an fentu: Lengzhan chuqi de zhengjing fazhan* 两岸分途:冷战初期的政经发展 (Parting ways: Politics and economics across the Taiwan Straits since 1949), edited by Chen Yung-fa 陈永发. Taipei: Institute of Modern History, Academia Sinica, 2006.

——. "Two Images of Socialism: Woodcuts in Chinese Communist Politics." *Comparative Studies in Society and History* 39, no. 1 (January 1997): 34–60.

——. *War and Popular Culture: Resistance in Modern China, 1937–1945.* Berkeley: University of California Press, 1994.

Hunt, Lynn. *Politics, Culture, and Class in the French Revolution.* Berkeley: University of California Press, 1984.

Ikonnikov, Andrei. *Russian Architecture of the Soviet Period.* Translated by Lev Lyapin. Moscow: Raduga, 1988.

Jian Bozan 翦伯赞. "Canguan Sulian bowuguan de yinxiang" 参观苏联博物馆的印象 (Impressions upon visiting Soviet museums). *WWCKZL*, no. 4 (May 30, 1953): 29–42.

Jiang Feng 江丰. *Jiang Feng meishu lunji* 江丰美术论集 (Jiang Feng's collected essays on art). Edited by Jiang Feng meishu lunji bianjizu 江丰美术论集编辑组. Vol. 1. Beijing: Renmin meishu chubanshe, 1983.

Jiang Weipu 姜维朴. *Lianhuanhua yishu lun* 连环画艺术论 (On the art of serial picture stories). Shenyang: Liaoning meishu chubanshe, 1986.

Jiang Weipu and Wang Su 王素. *Lianhuanhua yishu xinshang* 连环画艺术欣赏 (An appreciation of the art of serial picture stories). Taiyuan: Shanxi jiaoyu chubanshe, 1997.

Jianguo yilai de Beijing chengshi jianshe 建国以来的北京城市建设 (Beijing's city construction since the founding of the nation). Edited by Beijing jianshe shishu bianji weiyuanhui 北京建设史书编辑委员会. Beijing: n.p., 1986.

Jianguo yilai zhongyao wenxian xuanbian 建国以来重要文献选编 (Selected important documents after the founding of the nation). Edited by Zhonggong zhongyang wenxian yanjiushi 中共中央文献研究室. Vol. 1. Beijing: Zhongyang wenxian chubanshe, 1992.

"*Jianshe zuguo dayangge*" 建设祖国大秧歌 (*The Great Yangge of Building the Motherland*). *RMRB*, February 23, 1950, 3.

Jiefang zhige 解放之歌 (Songs of liberation). Edited by Zhongguo renmin jiefangjun shisan bingtuan zhengzhibu xuanchuandui 中国人民解放军十三兵团政治部宣传队. N.p., n.d.

Jiefangqu zhanlanhui ziliao 解放区展览会资料 (Materials on exhibition in the liberated areas). Edited by Zhongguo geming bowuguan 中国革命博物馆. Beijing: Wenwu chubanshe, 1988.

"Jihua renshu" 计划人数 (The projected figures). BMA, 99–1–2.

Jin-Cha-Ji wenyi yanjiuhui 晋察冀文艺研究会, ed. *Wenyi zhanshi hua dangnian* 文艺战士话当年 (Reminiscences of cultural warriors). Beijing: n.p., 2001.

Jin Shangyi 靳尚谊. "Chuangzuo *Mao zhuxi zai shieryue huiyi shang* de tihui" 创作毛主席在十二月会议上的体会 (My reflections on painting *Chairman Mao at the December Conference*). *MS*, no. 6 (December 6, 1961): 10–11.

——. "Chuangzuo *Mao zhuxi zai shieryue huiyi shang* de tihui" 创作毛主席在十二月会议上的体会 (My reflections on painting *Chairman Mao at the December Conference*). In *Geming lishihua chuangzuo jingyan tan* 革命历史画创作经验谈 (On the creation of revolutionary history paintings). Beijing: Renmin meishu chubanshe, 1963.

——, in collaboration with Cao Wenhan 曹文汉. *Wo de youhua zhi lu: Jin Shangyi huiyilu* 我的油画之路:靳尚谊回忆录 (My life as an oil painter: Memoirs of Jin Shangyi). Changchun: Jilin meishu chubanshe, 2000.

"Jingjiao qudi Yiguandao gongzuo zongjie" 京郊取缔一贯道工作总结 (A summary of the ban of the Unity Sect in the rural vicinity of Beijing). BMA, 1–14-165.

"Jiujiu geming jinianguan" 救救革命纪念馆 (Save the revolutionary museums!). *Dangshi xinxibao,* September 1, 1994, 1.

Jizhe 记者. "Huanyin Sulian youhuajia K. M. Makeximofu" 欢迎苏联油画家康·麦·马克西莫夫 (Welcome Soviet oil painter K. M. Maksimov). *MS,* no. 3 (March 15, 1955): 39.

Kaple, Deborah A. "Soviet Advisors in China in the 1950s." In *Brothers in Arms: The Rise and Fall of the Sino-Soviet Alliance, 1945–1963,* edited by Odd Arne Westad. Washington, DC: Woodrow Wilson Center Press; Stanford: Stanford University Press, 1998.

Kenez, Peter. *The Birth of the Propaganda State: Soviet Methods of Mass Mobilization, 1917–1929.* Cambridge: Cambridge University Press, 1985.

Kertzer, David I. *Ritual, Politics, and Power.* New Haven: Yale University Press, 1988.

Kidd, David. *Peking Story: The Last Days of Old China.* New York: Clarkson N. Potter, 1988.

Kopp, Anatole. *Town and Revolution: Soviet Architecture and City Planning, 1917–1935.* Translated by Thomas E. Burton. New York: George Braziller, 1970.

Koshizawa, Akira 越沢明. "City Planning of Peking, 1937–1945." Translated by Shyh-meng Huang 黄世孟 as "Beijing de dushi jihua" 北京的都市计划. In *Guoli Taiwan daxue jianzhu yu chengxiang yanjiu xuebao* 国立台湾大学建筑与城乡研究学报 (Bulletin of Architecture and City Planning, National Taiwan University), 3, no. 1 (September 1987): 235–45.

Kostof, Spiro. *A History of Architecture: Settings and Rituals.* Revised by Greg Castillo. New York: Oxford University Press, 1995.

Kraus, Richard Curt. *Pianos and Politics in China: Middle-Class Ambitions and the Struggle over Western Music.* New York: Oxford University Press, 1989.

"Kuojian Tiananmen guangchang dengchu gongcheng chaiqian gongzuo zongjie baogao" 扩建天安门广场等处工程拆迁工作总结报告 (Summary on the dismantling and resettling of homes for the expansion of Tiananmen Square and others). BMA, 47–1-61.

Laing, Ellen Johnston. "The Persistence of Propriety in the 1980s." In *Unofficial China: Popular Culture and Thought in the People's Republic,* edited by Perry Link, Richard Madsen, and Paul G. Pickowicz. Boulder, CO: Westview Press, 1989.

———. *The Winking Owl: Art in the People's Republic of China.* Berkeley: University of California Press, 1988.

Lane, Barbara Miller. *Architecture and Politics in Germany, 1918–1945.* Cambridge: Harvard University Press, 1985.

Lane, Christel. *The Rites of Rulers: Ritual in Industrial Society—The Soviet Case.* Cambridge: Cambridge University Press, 1981.

Lasswell, Harold D., in collaboration with Merritt B. Fox. *The Signature of Power: Buildings, Communication, and Policy.* New Brunswick, NJ: Transaction, 1979.

Le Bon, Gustave. *The Crowd.* With an introduction by Robert A. Nye. New Brunswick, NJ: Transaction, 1995.

Leith, James A. *Space and Revolution: Projects for Monuments, Squares, and Public Buildings in France, 1789–1799.* Montreal: McGill-Queen's University Press, 1991.

Lenin, V. I. *What Is to Be Done?* Translated by Joe Fineberg and George Hanna. London: Penguin Books, 1989.

Levine, Steven I. *Anvil of Victory: The Communist Revolution in Manchuria, 1945–1948*. New York: Columbia University Press, 1987.

Li Hanzhang 李汉章. *Qige xiaoyingxiong zhiqin tewu* 七个小英雄智擒特务 (Seven little heroes use ingenuity to apprehend spies). *RMRB*, June 4–8, 1951.

Li Qun 力群. "Lun nianhua de xingshi wenti" 论年画的形式问题 (On the question of form of the New Year prints). *MS*, no. 3 (March 15, 1956), 14, 17.

Liang Sicheng 梁思成. "Beijing: Dushi jihua de wubi jiezuo" 北京:都市计划的无比杰作 (Beijing: The unparalleled masterpiece in city planning). In Liang Sicheng, *Liang Sicheng wenji*, 4: 51–66.

——. "Guanyu Beijing chengqiang cunfei wenti de taolun" 关于北京城墙存废问题的讨论 (Discussions on the preservation or demolition of the old city walls in Beijing). In Liang Sicheng, *Liang Sicheng wenji*, 4: 46–50.

——. "Liang Sicheng dui Beijing shizheng jianshe de jidian yijian" 梁思成对北京市政建设的几点意见 (Liang Sicheng's opinions on the Beijing Municipal Government's construction plans). *NBCK*, no. 2152 (March 14, 1957): 257–58.

——. *Liang Sicheng quanji* 梁思成全集 (Complete works of Liang Sicheng). 9 vols. Beijing: Zhongguo jianzhu gongye chubanshe, 2001.

——. *Liang Sicheng wenji* 梁思成文集 (Collected writings of Liang Sicheng). 4 vols. Beijing: Zhongguo jianzhu gongye chubanshe, 1986.

——. "Renmin yingxiong jinianbei sheji de jingguo" 人民英雄纪念碑设计的经过 (The designing of the Monument to the People's Heroes). *JZXB*, no. 6 (1991): 27–28.

——. "Wei Dong Chang'anjie zhongyang gebu jianzhu sheji wenti shang Zhou zongli shu" 为东长安街中央各部建筑设计问题上周总理书 (Letter to Premier Zhou on the construction problems regarding the offices of the central government on East Chang'an Avenue). BCCA, C3-80-1.

——. "Wo dui Sulian jianzhu yishu de yidian renshi" 我对苏联建筑艺术的一点认识 (My understanding of the art of Soviet architecture). In Liang Sicheng, *Liang Sicheng quanji*, 5: 175–78.

——. "Zhongguo jianzhu de tezheng" 中国建筑的特征 (The major characteristics of Chinese architecture). In Liang Sicheng, *Liang Sicheng wenji*, 4: 96–103.

Liang Sicheng and Chen Zhanxiang 陈占祥. "Guanyu Zhongyang renmin zhengfu xingzheng zhongxinqu weizhi de jianyi" 关于中央人民政府行政中心区位置的建议 (Proposals on the location of the administrative center of the central government). In Liang Sicheng, *Liang Sicheng wenji*, 4:1–31.

"Liang Sicheng guanyu minzu xingshi, baoliu guwu yanlun yijian" 梁思成关于民族形式、保留古物言论意见 (Liang Sicheng's opinions on national forms and the preservation of cultural relics). BCCA, C3-80-2.

Lieberthal, Kenneth G. "The Great Leap Forward and the Split in the Yenan Leadership." In *The Cambridge History of China*, edited by Roderick MacFarquhar and John K. Fairbank. Vol. 14. Cambridge: Cambridge University Press, 1987.

——. *Revolution and Tradition in Tientsin, 1949–1952*. Stanford: Stanford University Press, 1980.

Lin Chen 林辰. "Nianhua de secai" 年画的色彩 (The use of color in the New Year prints). *MS*, no. 12 (December 15, 1956): 51–52.

Lin Zhu 林洙. *Dajiang de kunhuo* 大匠的困惑 (The puzzlement of a great architect). Beijing: Zuojia chubanshe, 1991.

"Lingxiuxiang pailie shunxu ji qizhi pailie de guiding" 领袖像排列顺序及旗帜排

列的规定 (Rules concerning the order of the leaders' portraits and the banners). BMA, 99–1-1.

Link, Perry. "The Crocodile Bird: *Xiangsheng* in the Early 1950s." In *Dilemmas of Victory: The Early Years of the People's Republic of China*, edited by Jeremy Brown and Paul G. Pickowicz. Cambridge: Harvard University Press, 2007.

Liu Guofu 刘国福 and Wei Jingfu 卫景福, eds. *Guohun dian* 国魂典 (Dictionary of national souls). Changchun: Jilin renmin chubanshe, 1993.

Liu Junxiang 刘峻骧, ed. *Zhongguo wudao yishu* 中国舞蹈艺术 (China's dance art). Nanjing: Jiangsu wenyi chubanshe, 1992.

Liu Kaiqu 刘开渠. "Diaosu yishu shenghuo manyi" 雕塑艺术生活漫忆 (Remembering sculpture). In *Zhonghua wenshi ziliao wenku* 中华文史资料文库 (Source materials on Chinese literature and history). Vol. 15. Beijing: Zhongguo wenshi chubanshe, 1996.

——. *Liu Kaiqu meishu lunwenji* 刘开渠美术论文集 (Liu Kaiqu's essays on art). Jinan: Shandong meishu chubanshe, 1984.

——. "Shoudu Renmin yingxiong jinianbei de lishi fudiao" 首都人民英雄纪念碑的历史浮雕 (The historical reliefs of the capital's Monument to the People's Heroes). *RMRB*, January 1, 1957, 8.

——. "Xiang Sulian diaosu yishu xuexi" 向苏联雕塑艺术学习 (Let's learn from Soviet sculpture). *RMRB*, October 15, 1954, 3.

Liu Tong 刘侗 and Yu Yizheng 于奕正. *Dijing jingwulüe* 帝京景物略 (Scenes of the capital). Beijing: Beijing guji chubanshe, 1982; lst pub. 1635.

Liu Xiaochun 刘骁纯. "Luo Gongliu" 罗工柳. *Jujiang meishu zhoukan: Zhongguo xilie* 巨匠美术周刊:中国系列 (Masters of Chinese painting), no. 111 (October 12, 1996): 1–32.

Liu Xun 刘迅. "Lianhuanhua chuangzuo zhong de jige wenti" 连环画创作中的几个问题 (Several problems in creating *lianhuanhua*). *MS*, no. 7 (July 15, 1954): 7–11.

Liu Zhonghai 刘中海, Zheng Hui 郑惠, and Cheng Zhongyuan 程中原, eds. *Huiyi Hu Qiaomu* 回忆胡乔木 (Remembering Hu Qiaomu). Beijing: Dangdai Zhongguo chubanshe, 1994.

Lodder, Christina. "Lenin's Plan for Monumental Propaganda." In *Art of the Soviets: Painting, Sculpture and Architecture in a One-Party State, 1917–1992*, edited by Matthew Cullerne Bown and Brandon Taylor. Manchester, UK: Manchester University Press, 1993.

Long Yinpei 隆荫培. "Toushen geming wenyi" 投身革命文艺 (Participating in revolutionary art and literature). *Wenyi bao*, no. 121 (October 16, 1999): 1.

Lord, Albert. *The Singer of Tales*. Cambridge: Harvard University Press, 1960.

Low, David. *Low Visibility: A Cartoon History, 1945–1953*. London: Collins, 1953.

Low, Setha M. *On the Plaza: The Politics of Public Space and Culture*. Austin: University of Texas Press, 2000.

Luo Gongliu yishu duihualu 罗工柳艺术对话录 (A dialogue about art with Luo Gongliu). Edited by Liu Xiaochun 刘骁纯. Taiyuan: Shanxi jiaoyu chubanshe, 1999.

Luo Jianmin 罗健敏. "Shiping Tiananmen guangchang de guihua" 试评天安门广场的规划 (An evaluation of the design of Tiananmen Square). *JZXB*, no. 5 (May 20, 1981): 28–33.

MacFarquhar, Roderick. *The Origins of the Cultural Revolution*. Vol. 2, *The Great Leap Forward, 1958–1960*. New York: Columbia University Press, 1983.

Mao Dun 茅盾. "Lianhuantuhua xiaoshuo" 连环图画小说 (Serial picture stories). In *Mao Dun quanji* 茅盾全集 (Complete works of Mao Dun). Vol. 19. Beijing: Renmin wenxue chubanshe, 1991.

Mao Zedong (Mao Tse-tung) 毛泽东. *Mao Zedong wenji* 毛泽东文集 (Collected works of Mao Zedong). Edited by Zhonggong zhongyang wenxian yanjiushi 中共中央文献研究室. 8 vols. Beijing: Renmin chubanshe, 1993–99.

——. *Selected Works of Mao Tse-tung.* 5 vols. Peking: Foreign Languages Press, 1967–77.

McClellan, Andrew. *Inventing the Louvre: Art, Politics, and the Origins of the Modern Museum in Eighteenth-Century Paris.* Berkeley: University of California Press, 1994.

Merridale, Catherine. *Night of Stone: Death and Memory in Twentieth-Century Russia.* New York: Penguin Books, 2000.

Mianhuai Liu Ren tongzhi 缅怀刘仁同志 (Remembering comrade Liu Ren). Beijing: Beijing chubanshe, 1979.

Miao Di 苗地 and Zhao Zhifang 赵志方. *Fensui Meidiguozhuyi de jiandie huodong* 粉碎美帝国主义的间谍活动 (Smashing the espionage of American imperialism). *RMRB*, September 5, 1951, 3.

"Minzhengju yijiuwusannian shangbannian gongzuo baogao" 民政局一九五三年上半年工作报告 (The first half year of 1953 report of the Bureau of Civil Affairs). BMA, 196–2-25.

Mitchell, W. J. T. *Picture Theory: Essays on Verbal and Visual Representation.* Chicago: University of Chicago Press, 1994.

Moore, Barrington, Jr. *Social Origins of Dictatorship and Democracy: Lord and Peasant in the Making of the Modern World.* Boston: Beacon Press, 1966.

Mosse, George L. *Fallen Soldiers: Reshaping the Memory of the World Wars.* New York: Oxford University Press, 1990.

——. *The Nationalization of the Masses: Political Symbolism and Mass Movements in Germany from the Napoleonic Wars through the Third Reich.* Ithaca: Cornell University Press, 1975.

"Neiwubu guanyu lieshi jinian jianzhuwu xiujian he guanli gongzuo de baogao" 内务部关于烈士纪念建筑物修建和管理工作的报告 (Ministry of Internal Affairs report on the construction and management of memorials honoring martyrs). BMA, 196–2-179.

Nianhua xuanbian, 1949–1959 年画选编, 1949–1959 (Selected New Year prints, 1949–1959). Edited by Renmin meishu chubanshe. Beijing: Renmin meishu chubanshe, 1961.

"Niding Geming gongmu guanli zanxing guize" 拟定革命公墓管理暂行规则 (Drawing up temporary rules for the management of the Revolutionary Cemetery). BMA, 2–7-57.

"Niu yangge zhuyi sidian" 扭秧歌注意四点 (Four points needing attention when dancing yangge). *JBRB*, June 28, 1949, 3.

Nora, Pierre. "General Introduction: Between Memory and History." In *Realms of Memory: Rethinking the French Past.* Vol. 1, *Conflicts and Divisions,* edited by Pierre Nora and translated by Arthur Goldhammer. New York: Columbia University Press, 1996.

——, ed. *Realms of Memory: Rethinking the French Past.* 3 vols. Translated by Arthur

Goldhammer, vol. 1, *Conflicts and Divisions;* vol. 2, *Traditions;* vol. 3, *Symbols.* New York: Columbia University Press, 1996–98.

O'Sullivan, Judith. *The Great American Comic Strip: One Hundred Years of Cartoon Art.* Boston: Little, Brown, 1990.

Ozouf, Mona. *Festivals and the French Revolution.* Translated by Alan Sheridan. Cambridge: Harvard University Press, 1988.

Paperny, Vladimir. *Architecture in the Age of Stalin: Culture Two.* Translated by John Hill and Roann Barris, in collaboration with the author. Cambridge: Cambridge University Press, 2002.

——. "Moscow in the 1930s and the Emergence of a New City." In *The Culture of the Stalin Period,* edited by Hans Günther. New York: St. Martin's Press, 1990.

Pearce, Susan M. *Museums, Objects, and Collections: A Cultural Study.* Washington, DC: Smithsonian Institution Press, 1993.

Pearson, Nicholas M. *The State and the Visual Arts: A Discussion of State Intervention in the Visual Arts in Britain, 1760–1981.* Milton Keynes, UK: Open University Press, 1982.

Peking: A Tourist Guide. Peking: Foreign Languages Press, 1960.

Peng Zhen 彭真. "Guanyu Beijing de chengshi guihua wenti" 关于北京的城市规划问题 (Issues concerning Beijing's city planning). In Peng Zhen, *Peng Zhen wenxuan, 1941–1990,* 307–12.

——. *Peng Zhen wenxuan, 1941–1990* 彭真文选, 1941–1990 (Selected writings of Peng Zhen, 1941–1990). Beijing: Renmin chubanshe, 1991.

Peng Zhen shizhang 彭真市长 (Mayor Peng Zhen). Edited by Li Haiwen 李海文. Taiyuan: Zhonggong dangshi chubanshe and Shanxi renmin chubanshe, 2003.

"Peng Zhen tongzhi zhaoji de guoqingjie youxing ji baowei gongzuo huiyi" 彭真同志召集的国庆节游行及保卫工作会议 (The meeting called by Comrade Peng Zhen concerning the National Day parades and their security matters). BMA, 99-1-78.

"Peng Zhen tongzhi zhaoji de Wuyi choubei gongzuo huiyi jilu" 彭真同志召集的五一筹备工作会议记录 (The minutes of the preparatory work meeting concerning the May Day parades called by Comrade Peng Zhen). BMA, 99-1-93.

"Pinqing di 29 juan" 聘请第29卷 (The recruitment, no. 29) (May 3, 1955). FEBA.

"Pinqing Sulian zhuanjia lai Hua zhidao gongzuoan" 聘请苏联专家来华指导工作案 (The hiring of Soviet experts to provide guidance to the Chinese). BMA, 23-1-77.

Popkin, Samuel L. *The Rational Peasant: The Political Economy of Rural Society in Vietnam.* Berkeley: University of California Press, 1979.

Putian tongqing 普天同庆 (The whole world joins in the celebration), a film produced by Beijing dianying zhipianchang 北京电影制片厂 (Beijing Film Studio), 1950.

"Qingzhu yijiuwuwunian guoqing qunzhong youxing yizhangdui tai lingxiuxiang pailie shunxu" 庆祝一九五五年国庆群众游行仪仗队抬领袖像排列顺序 (The order of the portraits of leaders during the people's parade to celebrate the 1955 National Day festival). BMA, 99-1-61.

"Qingzhu yijiuwuwunian shoudu guoqingjie wenyi dadui gongzuo zongjie" 庆祝一九五五年首都国庆节文艺大队工作总结 (Final report on the work of the art group during the 1955 National Day celebrations in the capital). BMA, 99-1-62.

Qu Qiubai 瞿秋白. "Chidu xinshi" 赤都心史 (Impressions of the Red capital seen through the mind). In *Qu Qiubai wenji* 瞿秋白文集 (Collected writings of Qu Qiubai). Vol. 1. Beijing: Renmin wenxue chubanshe, 1985.

Quan Shanshi 全山石. "Cong cuozhe zhong jian guangming" 从挫折中见光明 (Seeing the light after adversities). *MS*, no. 1 (February 6, 1962): 48–50.

"Quanguo Renmin daibiao dahuitang gongcheng de jiben qingkuang" 全国人民代表大会堂工程的基本情况 (Basic conditions concerning the construction of the Great Hall of the People's Representatives). BMA, 2–11-138.

"Qunzhong youxing duiwu zuzhi fang'an deng" 群众游行队伍组织方案等 (The plan for organizing contingents of the procession for the people's parade and others). BMA, 99–1-1.

"Qunzhong youxing zhunbei gongzuo qingkuang de baogao" 群众游行准备工作情况的报告 (Report on the preparation of the people's parade). BMA, 99–1-94.

Ren Yuanyuan 任远远, ed. *Jinian Ren Bishi* 纪念任弼时 (In memory of Ren Bishi). Beijing: Wenwu chubanshe, 1986.

"Renmin yishujia Yiliya Liebin" 人民艺术家伊里亚•列宾 (Ilya Repin: The people's artist). *RMMS* 1, no. 4 (August 1, 1950): 13–14.

Ryan, Mary. "The American Parade: Representations of the Nineteenth-Century Social Order." In *The New Cultural History*, edited by Lynn Hunt. Berkeley: University of California Press, 1989.

Schneider, Laurence A. *A Madman of Ch'u: The Chinese Myth of Loyalty and Dissent.* Berkeley: University of California Press, 1980.

Schoenhals, Michael. *Doing Things with Words in Chinese Politics: Five Studies.* Berkeley: Institute of East Asian Studies, University of California, 1992.

Schram, Stuart R. "Party Leader or True Ruler? Foundations and Significance of Mao Zedong's Personal Power." In *Foundations and Limits of State Power in China*, edited by Stuart Schram. London: School of Oriental and African Studies, University of London; Hong Kong: Chinese University Press, 1987.

Scott, James C. *Weapons of the Weak: Everyday Forms of Peasant Resistance.* New Haven: Yale University Press, 1985.

Shandongsheng renmin zhengfu wenhua shiye guanliju 山东省人民政府文化事业管理局. "Guanyu ruhe duidai zaoma de yijian" 关于如何对待灶马的意见 (On how to deal with the Stove God print) (November 12, 1953). Mimeographed document, Jinan, Shandong province.

Shanghai yishu tupian, 1997 上海艺术图片, 1997 (Shanghai's art photographs, 1997). Shanghai: Shanghai renmin meishu chubanshe meishu tupianbu, 1997.

"Shanghaishi gejie renmin qingzhu Wuyi guoji laodongjie de xuanchuan yaodian he jinian banfa" 上海市各界人民庆祝五一国际劳动节的宣传要点和纪念办法 (Methods and propaganda techniques used by Shanghai's citizens to celebrate the international May Day festival). SMA, A22–2-88.

Shanghaishi wenhuaju 上海市文化局. "Shanghai lianhuantuhua gaikuang" 上海连环图画概况 (A survey of serial picture books in Shanghai). SMA, B172–1-23.

"Shaoxiandui" 少先队 (The Young Pioneers group). BMA, 99–1-196.

Shen Bo 沈勃. *Beiping jiefang, shoudu jianshe zhaji* 北平解放，首都建设札记 (Notes on the liberation of Beiping and the construction of the capital). Edited by Beijingshi chengshi jianshe dang'anguan 北京市城市建设档案馆. Beijing: n.p., n.d.

Shen Zhihua 沈志华. *Sulian zhuanjia zai Zhongguo* 苏联专家在中国 (Soviet experts in China). Beijing: Zhongguo guoji guangbo chubanshe, 2003.

Shikes, Ralph E. *The Indignant Eye: The Artist as Social Critic in Prints and Drawings from the Fifteenth Century to Picasso.* Boston: Beacon, 1969.

"Shiyue shiri Peng Zhen tongzhi zai Shiwei changwei shang guanyu chengshi guihua wenti de fayan" 10月10日彭真同志在市委常委上关于城市规划问题的发言 (Comrade Peng Zhen's speech on the city planning delivered at the standing committee meeting of the Beijing Municipal Committee on October 10). BMA, 151–1–17.

"Shizheng zhuanjiazu lingdaozhe Bo Abulamofu tongzhi zai taolunhui shang de jiangci" 市政专家组领导者波•阿布拉莫夫同志在讨论会上的讲词 (Speech delivered at the forum by Comrade P. Abramov, head of the municipal administrative team of experts). ZGDS, no. 76 (December 2000): 18–22.

"Shoudu guoqing gongcheng jieshao (chugao)" 首都国庆工程介绍(初稿) (A draft introduction to the National Day projects in the capital). BMA, 131–1–361.

"Shoudu qingzhu shizhounian guoqingjie youxing zuzhi gongzuo yaodian (cao'an)" 首都庆祝十周年国庆节游行组织工作要点(草案) (Key points concerning the parade during the tenth anniversary of the National Day celebration: a draft). BMA, 99–1-193.

Shu Jun 树军. Tiananmen guangchang lishi dang'an 天安门广场历史档案 (Historical documents of Tiananmen Square). Beijing: Zhonggong zhongyang dangxiao chubanshe, 1998.

Smith, Arthur H. Village Life in China: A Study in Sociology. New York: Fleming H. Revell, 1899.

Song Lin 宋霖. "You Luo Binghui yanjiu xiangdao lieshi yanjiu de jige wenti" 由罗炳辉研究想到烈士研究的几个问题 (The study of Luo Binghui and questions relating to the study of martyrs). In Lieshi yu jinianguan yanjiu 烈士与纪念馆研究 (Research on martyrs and memorial halls), edited by Longhua lieshi jinianguan 龙华烈士纪念馆. Vol. 1. Shanghai: Shanghai shehui kexueyuan chubanshe, 1996.

Speer, Albert. Inside the Third Reich: Memoirs. Translated by Richard and Clara Winston. London: Weidenfeld and Nicolson, 1970.

Stites, Richard. Revolutionary Dreams: Utopian Vision and Experimental Life in the Russian Revolution. New York: Oxford University Press, 1989.

——. Russian Popular Culture: Entertainment and Society since 1900. Cambridge: Cambridge University Press, 1992.

Strauss, Julia C. "Paternalist Terror: The Campaign to Suppress Counterrevolutionaries and Regime Consolidation in the People's Republic of China, 1950–1953." Comparative Studies in Society and History 44, no. 1 (January 2002): 80–105.

Sulian bowuguanxue jichu 苏联博物馆学基础 (Principles of Soviet museum management). Beijing: Wenwu chubanshe, 1957.

"Sulian zhuanjia dui Tiananmen guangchang guihua cao'an moxing de yixie yijian" 苏联专家对天安门广场规划草案模型的一些意见 (Soviet advisers' opinions on the draft models of the planning of Tiananmen Square). BCCA, 3–7-14.

"Sulian zhuanjia Moxin dui Beijingshi zongti guihua de yijian" 苏联专家莫辛对北京市总体规划的意见 (Soviet adviser Mukhin's opinions on the overall planning of Beijing). BCCA, C3–86-1.

Sullivan, Michael. Art and Artists of Twentieth-Century China. Berkeley: University of California Press, 1996.

Sun Junting 孙峻亭, ed. Zhongguo geming lieshi yuanlin 中国革命烈士园林 (Revolutionary martyrs cemeteries in China). Beijing: Beijing chubanshe, 1993.

Tai Yi 邰怡. "Fengxiang muban nianhua jianwenji" 凤翔木版年画见闻记 (Notes on Fengxiang woodblock New Year prints). MSYJ, no. 2 (May 15, 1985): 72–75.

Tang Yuping 唐豫萍. "Lianhuanhua: Kaizhan zhenya fangeming xuanchuan de youli wuqi" 连环画:开展镇压反革命宣传的有力武器 (Lianhuanhua: A potent tool for the propaganda of the Campaign to Suppress Counterrevolutionaries). *JFRBS*, May 26, 1951, 4.

Tertz, Abram. *On Socialist Realism.* Introduction by Czeslaw Milosz. New York: Pantheon, 1960.

Thompson, E. P. "History from Below." *Times Literary Supplement.* April 7, 1966, 279–81.

Tian Han 田汉. "Renmin gewu wansui" 人民歌舞万岁 (Long live the people's dances). *RMRB*, November 7, 1949, 6.

Tian Zuoliang 田作良. *Xianban* 仙班 (The class of the immortals). *RMRB*, May 9–12, 1951, 3.

Tong Jun 童寯. *Sulian jianzhu: Jianshu Dong Ou xiandai jianzhu* 苏联建筑:兼述东欧现代建筑 (Soviet architecture: With additional discussion on modern architecture in Eastern Europe). Beijing: Zhongguo jianzhu gongye chubanshe, 1982.

Tumarkin, Nina. *Lenin Lives! The Lenin Cult in Soviet Russia.* Enlarged ed. Cambridge: Harvard University Press, 1997.

Turner, Victor, ed. *Celebration: Studies in Festivity and Ritual.* Washington, DC: Smithsonian Institution Press, 1982.

Viola, Lynne. *Peasant Rebels under Stalin: Collectivization and the Culture of Peasant Resistance.* New York: Oxford University Press, 1996.

Vitruvius. *Ten Books of Architecture.* Translated by Ingrid D. Rowland. Cambridge: Cambridge University Press, 1999.

Vogel, Ezra F. *Canton under Communism: Programs and Politics in a Provincial Capital, 1949–1968.* Cambridge: Harvard University Press, 1969.

Volland, Nicolai. "The Control of the Media in the People's Republic of China." PhD. diss., University of Heidelberg, 2003.

von Geldern, James. *Bolshevik Festivals, 1917–1920.* Berkeley: University of California Press, 1993.

Wagner, Rudolf G. *The Contemporary Chinese Historical Drama.* Berkeley: University of California Press, 1990.

——. "Reading the Chairman Mao Memorial Hall in Peking: The Tribulations of the Implied Pilgrim." In *Pilgrims and Sacred Sites in China,* edited by Susan Naquin and Chün-fang Yü. Berkeley: University of California Press, 1992.

"Waibin dui youxing duiwu de fanying" 外宾对游行队伍的反映 (Foreign guests' reactions to the parade). BMA, 99-1-48.

Walder, Andrew G. *Communist Neo-Traditionalism: Work and Authority in Chinese Industry.* Berkeley: University of California Press, 1986.

Waldron, Arthur. "China's New Remembering of World War II: The Case of Zhang Zizhong." *Modern Asian Studies* 30, no. 4 (October 1996): 945–78.

Wan Li 万里. "Guanyu guoqing gongcheng jinzhan qingkuang he cunzai wenti de baogao" 关于国庆工程进展情况和存在问题的报告 (Report on the progress and existing problems of the National Day projects). BMA, 47-1-72.

——. "Guanyu Renda huitang wujia gangcai zhiliang buhege yaoqiu yanzhong yingxiang shigong jindu de baogao" 关于人大会堂屋架钢材质量不合格要求严重影响施工进度的报告 (A report on the faulty quality of the steel for the roof

frame in the construction of the Great Hall of the People and its serious impact on the progress of the construction). BMA, 2–11-128.

——. *Wan Li Wenxuan* 万里文选 (Selected writings of Wan Li). Beijing: Renmin chubanshe, 1995.

"Wan Li tongzhi zai Beijingshi guoqing gongcheng wuji ganbu huiyi shang de baogao (jilu zhaiyao)" 万里同志在北京市国庆工程五级干部会议上的报告(记录摘要) (A report by Comrade Wan Li at Beijing's conference for the National Day projects for the fifth-level cadres [an abstract]). BMA, 125–1-1228.

"Wan Li tongzhi zai guoqing gongcheng xuanchuan baodao huiyi jianghua tigang" 万里同志在国庆工程宣传报道会议讲话提纲 (An outline of the speech given by Comrade Wan Li at the conference on reporting the National Day construction projects). BMA, 2–11-138.

Wang Fengde 王丰德. "Baogao" 报告 (Report). SMA, A22–2-894.

Wang Jun 王军. *Chengji* 城记 (On Beijing). Beijing: Sanlian shudian, 2003.

Wang Kefen 王克芬 and Long Yinpei 隆荫培, eds. *Zhongguo jinxiandai dangdai wudao fazhanshi: 1840–1996* 中国近现代当代舞蹈发展史:1840–1996 (A history of dance from the modern to the contemporary period: 1840–1996). Beijing: Renmin yinyue chubanshe, 1999.

Wang Shucun 王树村. *Men yu menshen* 门与门神 (Doors and door gods). Beijing: Xueyuan chubanshe, 1994.

——. *Paper Joss: Deity Worship through Folk Prints*. Beijing: New World Press, 1992.

——. "Xianhua menshen" 闲话门神 (Notes on door gods). *Meishu shilun congkan*, no. 2 (August 1983): 220–23.

——. *Zhongguo minjian nianhuashi lunji* 中国民间年画史论集 (Essays on the history of the Chinese folk New Year prints). Tianjin: Tianjin Yangliuqing huashe, 1991.

Wang Yeqiu 王冶秋. "Fang Su guangan" 访苏观感 (Impressions of a visit to the Soviet Union). *WWCKZL*, no. 11 (November 30, 1950): 115–25.

——. "Sulian guoli geming bowuguan" 苏联国立革命博物馆 (Soviet National Museum of the Revolution). *WWCKZL*, no. 10 (October 31, 1950): 66–77.

Wang Zhaowen 王朝闻. "Biaoxian renmin qunzhong de yingxiong shidai" 表现人民群众的英雄时代 (An age of heroism that reflects the people). *MS*, nos. 8–9 (1960): 30–36.

——. "Guanyu shishi manhua" 关于时事漫画 (On cartoons about current events). *RMRB*, November 12, 1950, 7.

——. "Guanyu xuexi jiu nianhua xingshi" 关于学习旧年画形式 (On learning from the form of old New Year prints). *RMRB*, March 19, 1950, 5.

Watson, James L., and Evelyn S. Rawski, eds. *Death Ritual in Late Imperial and Modern China*. Berkeley: University of California Press, 1988.

"Wei kuoda Geming gongmu yongdi mianji ni goumai shandi yiduan qing heshi" 为扩大革命公墓用地面积拟购买山地一段请核示 (Requesting permission to purchase additional land to expand the Revolutionary Cemetery). BMA, 2–6-194.

Weifang nianhua yanjiu 潍坊年画研究 (Studies on Weifang's New Year prints). Edited by Zheng Jinlan 郑金兰. Shanghai: Xuelin chubanshe, 1991.

"Wenyi dadui muqian gongzuo jinxing qingkuang" 文艺大队目前工作进行情况 (The progress of the work of the art group). BMA, 99–1-95.

White, Stephen. *The Bolshevik Poster*. New Haven: Yale University Press, 1988.

Wilentz, Sean, ed. *Rites of Power: Symbolism, Ritual, and Politics since the Middle Ages.* Philadelphia: University of Pennsylvania Press, 1985.

Wilhelm, Hellmut. "From Myth to Myth: The Case of Yüeh Fei's Biography." In *Confucian Personalities,* edited by Arthur F. Wright and Denis Twitchett. Stanford: Stanford University Press, 1962.

Williams, C. A. S. *Chinese Symbolism and Art Motifs: An Alphabetical Compendium of Antique Legends and Beliefs, as Reflected in the Manners and Customs of the Chinese.* Introduction by Terence Barrow. Rutland, VT: C. E. Tuttle, 1988.

Williams, Raymond. *Keywords: A Vocabulary of Culture and Society.* Rev. ed. New York: Oxford University Press, 1989.

Winter, Jay. *Sites of Memory, Sites of Mourning: The Great War in European Cultural History.* Cambridge: Cambridge University Press, 1995.

Wolf, Eric. *Peasant Wars of the Twentieth Century.* New York: Harper and Row, 1969.

Wood, Elizabeth A. *Performing Injustice: Agitation Trials in Early Soviet Russia.* Ithaca: Cornell University Press, 2005.

Wou, Odoric Y. K. *Mobilizing the Masses: Building Revolution in Henan.* Stanford: Stanford University Press, 1994.

Wu Dong 武栋. "Xin nianhua ying liqiu bode nongmin huanxin" 新年画应力求博得农民欢心 (The new nianhua should make every effort to win the peasants' hearts). *MS,* no. 9 (September 20, 1982): 19–20.

Wu, Hung. *Remaking Beijing: Tiananmen Square and the Creation of a Political Space.* Chicago: University of Chicago Press, 2005.

Wu Liangyong 吴良镛. "Renmin yingxiong jinianbei de chuangzuo chengjiu" 人民英雄纪念碑的创作成就 (The creative achievement of the Monument to the People's Heroes). *JZXB,* no. 2 (June 1978): 4–9.

Wu Zuoren 吴作人. "Youhua de xinmao" 油画的新貌 (The novelty of oil painting). *MS,* nos. 8–9 (September 1960): 41–42.

"Wuyijie youxing duiwu lingxiuxiang pailie banfa" 五一节游行队伍领袖像排列办法 (Methods to arrange the order of the leaders' portraits during the May Day parade). BMA, 99-1-3.

Xie Changyi 谢昌一. "Xiang minjian nianhua xuexi" 向民间年画学习 (Learn from folk New Year prints). *MS,* no. 2 (February 15, 1960): 36–38.

——. "Yaoqianshu de fazhan he yanbian" 摇钱树的发展和演变 (The development and evolution of *The Money Tree*). *Gugong wenwu yuekan,* 11, no. 11 (February 1994): 120–25.

"Xiuzheng Geming gongmu (ni gaiming Babaoshan gongmu) anzang zanxing guize (cao'an)" 修正革命公墓(拟改名八宝山公墓)安葬暂行规则(草案) (Draft concerning the revision of temporary rules of burial in the Revolutionary Cemetery: A proposal to change the name Revolutionary Cemetery to Babaoshan Cemetery). BMA, 2-7-57.

Xu Beihong 徐悲鸿. "Wo shenghuo zai Beijing jiefang yinianlai de ganxiang" 我生活在北京解放一年来的感想 (Reflections on my life a year after Beijing's liberation). *GMRB,* January 31, 1950, 4.

——. "Zai Sulian Jieke canguan meishu de jianlüe baogao" 在苏联捷克参观美术的简略报告 (A brief report on art during a visit to the Soviet Union and Czechoslovakia). In *Xu Beihong yishu wenji* 徐悲鸿艺术文集 (Xu Beihong's collected essays on art), edited by Wang Zhen 王震 and Xu Boyang 徐伯阳. Yinchuan: Ningxia renmin chubanshe, 2001.

Xu Ling 徐灵. "Nianhua gongzuo zhong cunzai de zhuyao wenti" 年画工作中存在的主要问题 (The key problems of the New Year print campaign). *MS*, no. 4 (April 15, 1958): 6–9.

Yang Boda 杨伯达. "Sulian bowuguan gongzuo jieshao (yi)" 苏联博物馆工作介绍 (一) (An introduction to Soviet museum work, part 1). *WWCKZL*, no. 4 (April 30, 1954): 95–100.

Yang, C. K. *Religion in Chinese Society: A Study of Contemporary Social Functions of Religion and Some of Their Historical Factors.* Berkeley: University of California Press, 1961.

Yang, Kuisong, "Reconsidering the Campaign to Suppress Counterrevolutionaries." *China Quarterly*, no. 193 (March 2008): 102–21.

Yang, Lien-sheng, "The Organization of Chinese Official Historiography: Principles and Methods of the Standard Histories from the T'ang through the Ming Dynasty." In *Historians of China and Japan*, edited by W. G. Beasley and E. G. Pulleyblank. London: Oxford University Press, 1961.

Yang Nian 杨念. "Yiduan wenxin de huiyi" 一段温馨的回忆 (Warm recollections). In *Guihua chunqiu* 规划春秋 (Chronicles of city planning), edited by Beijingshi chengshi guihua guanliju 北京市城市规划管理局 and Beijingshi chengshi guihua sheji yanjiuyuan dangshi zhengji bangongshi 北京市城市规划设计研究院党史征集办公室. Beijing: n.p., 1995.

Yangjiabu cunzhi 杨家埠村志 (History of the village of Yangjiabu). Edited by Shandongsheng Weifangshi Hantingqu Yangjiabu cunzhi bianzuan weiyuanhui 山东省潍坊市寒亭区杨家埠村志编纂委员会. Jinan: Qilu shushe, 1993.

Yangjiabu nianhua 楊家埠年畫 (Yangjiabu's New Year prints). Edited by Shandongsheng Weifangshi bowuguan 山东省潍坊市博物馆 and Yangjiabu muban nianhua yanjiusuo 楊家埠木版年畫研究所. Beijing: Wenwu chubanshe, 1990.

Ye Qianyu 叶浅予. *Xixu cangsang ji liunian* 细叙沧桑记流年 (Memoirs). 2 vols. Beijing: Qunyan chubanshe, 1992.

Ye Wenxi 叶文西. "Shitan nianhua de zuoyong he tedian" 试谈年画的作用和特点 (A preliminary investigation into the functions and characteristics of the New Year prints). *MS*, no. 2 (March 25, 1978): 41–42, 48.

Ye Youxin 叶又新. "Weixian minjian muban nianhua de chuantong tezheng" 潍县民间木板年画的传统特征 (Traditional characteristics of Weixian's folk New Year prints). *MS*, no. 12 (December 15, 1954): 18–20.

"Yijiuwujiunian guoqingjie qunzhong youxing duiwu duirong jiankuang" 一九五九年国庆节群众游行队伍队容简况 (An outline of the parade groups in the people's parades during the 1959 National Day festival). BMA, 99–1–208.

"Yijiuwusinian bayue siri guoqingjie choubeihui" 一九五四年八月四日国庆节筹备会 (Preparatory committee meeting on August 4, 1954, concerning the National Day celebrations). BMA, 99–1–33.

"Yijiuwuwunian guoqingjie qunzhong youxingshi huhan de kouhao" 一九五五年国庆节群众游行时呼喊的口号 (Slogans used during the people's parades in the 1955 National Day celebrations). BMA, 99–1–61.

"Yijiuwuwunian Wuyijie shirong buzhi gongzuo jihua" 一九五五年五一节市容布置工作计划 (Work plans for decorating the city during the 1955 May Day festival). SMA, B56–2–3.

Yijiuwuyinian guoqingjie: Daxing jilupian 一九五一年国庆节:大型纪录片 (The 1951 National Day celebrations: A major documentary), a film produced by Zhongyang

dianyingju Beijing dianying zhipianchang 中央电影局北京电影制片厂 (Beijing Film Studio, Central Film Bureau), 1951.

"Yijiuwuyinian guoqingjie youxing jihua" 一九五一年国庆节游行计划 (Plan of the parade at the 1951 National Day celebrations). BMA, 99–1-1.

Yoshida Jirobee 吉田治郎兵卫. "Beijing xin yangge de diaocha yu sikao" 北京新秧歌的调查与思考 (A survey of, and reflection on, Beijing's new yangge dances). MA thesis, Beijing Normal University, 1997.

Young, James E. *The Texture of Memory: Holocaust Memorials and Meaning*. New Haven: Yale University Press, 1993.

"Youxing duiwu jieshao" 游行队伍介绍 (Introduction to groups that participated in the parades). BMA, 99–1-162.

"Youxing duiwu xulie he xingjin luxian" 游行队伍序列和行进路线 (Order of processions and the procession routes). BMA, 99-1-61.

"Youxing jihua" 游行计划 (Plans for the parade). BMA, 99-1-2.

"Youxing renshu" 游行人数 (The number of people who participated in the parades). BMA, 99–1-94.

Yu Fei'an 于非闇. *Zhongguohua yanse de yanjiu* 中国画颜色的研究 (Colors in Chinese paintings). Beijing: Zhaohua meishu chubanshe, 1955. Translated by Jerome Silbergeld and Amy McNair as *Chinese Painting Colors: Studies on Their Preparation and Application in Traditional and Modern Times*. Hong Kong: Hong Kong University Press; Seattle: University of Washington Press, 1988.

Yu Feng 郁风. "Xiang minjian nianhua xuexi" 向民间年画学习 (Learn from folk New Year prints). *MS*, no. 3 (March 15, 1956): 9–11.

Yu Jian 于坚. "Shencha Zhongguo geming bowuguan chenlie" 审查中国革命博物馆陈列 (Inspecting the exhibitions of the Museum of the Chinese Revolution). In *Zhou Enlai yu Beijing* 周恩来与北京 (Zhou Enlai and Beijing), edited by Zhongguo renmin zhengzhi xieshang huiyi Beijingshi weiyuanhui wenshi ziliao weiyuanhui 中国人民政治协商会议北京市委员会文史资料委员会. Beijing: Zhongyang wenxian chubanshe, 1998.

——. "Zhou Yang yu bowuguan" 周扬与博物馆 (Zhou Yang and museums). *Zhongguo wenwubao*, no. 42 (October 27, 1989), 2.

Yuan Ying 袁鹰. *Fengyun ceji: Wo zai Renmin ribao fukan de suiyue* 风云侧记: 我在人民日报副刊的岁月 (Sideline reports: My years working at the literary supplement of the *People's Daily*). Beijing: Zhongguo dang'an chubanshe, 2006.

Zhan Jianjun 詹建俊. "Zou wanlu yougan" 走弯路有感 (Reflections on taking a roundabout course). *MS*, no. 6 (December 6, 1961): 30–31.

Zhang Bo 张镈. *Wo de jianzhu chuangzuo daolu* 我的建筑创作道路 (My career as an architect). Beijing: Zhongguo jianzhu gongye chubanshe, 1994.

Zhang Chengping 张承平, ed. *Babaoshan geming gongmu beiwenlu* 八宝山革命公墓碑文录 (Tombstone inscriptions in Babaoshan Revolutionary Cemetery). Beijing: Gaige chubanshe, 1990.

Zhang Dianying 张殿英. *Yangjiabu muban nianhua* 杨家埠木板年画 (Yangjiabu's woodblock New Year prints). Beijing: Renmin meishu chubanshe, 1990.

Zhang Ding 张仃. "Taohuawu nianhua" 桃花坞年画 (Taohuawu's New Year prints). *MS*, no. 8 (August 15, 1954): 44–45.

Zhang Geng 张庚. "Luyi gongzuotuan duiyu yangge de yixie jingyan" 鲁艺工作团对于秧歌的一些经验 (Experience of performing yangge of Luyi's Work Team). *JFRBY*. May 15, 1944, 4.

Zhang Hua 张华. *Zhongguo minjianwu yu nonggeng xinyang* 中国民间舞与农耕信仰 (China's folk dances and peasant beliefs). Changchun: Jilin jiaoyu chubanshe, 1992.

Zhang Kaiji 张开济. "Canjia guoqing gongcheng sheji de diandi huiyi" 参加国庆工程设计的点滴回忆 (Reminiscences of my participation in the National Day projects). *BJWSZL*, no. 49 (November 1994): 33–40.

Zhang Wenyuan 张文元. *Xinghui tu* 行贿图 (Bribery). *JBRB*, January 12, 1952, 4.

Zhao Dongri 赵冬日. "Huiyi Renmin dahuitang sheji guocheng" 回忆人民大会堂设计过程 (Remembering the design of the Great Hall of the People). *BJWSZL*, no. 49 (November 1994): 12–32.

———. *Jianzhu sheji dashi Zhao Dongri zuopinxuan* 建筑设计大师赵冬日作品选 (Selected works of master architect and designer Zhao Dongri). Edited by Beijingshi jianzhu sheji yanjiuyuan 北京市建筑设计研究院. Beijing: Kexue chubanshe, 1998.

———. "Tiananmen guangchang" 天安门广场 (Tiananmen Square). *JZXB*, nos. 9–10 (October 1959): 18–22.

Zhao Luo 赵洛 and Shi Shuqing 史树青. *Tiananmen* 天安门 (Tiananmen Gate). Beijing: Beijing chubanshe, 1957.

Zhao Pengfei 赵鹏飞, et al. "Guanyu jinian guoqing shizhounian jianzhu gongcheng shigong liliang bushu de baogao" 关于纪念国庆十周年建筑工程施工力量部署的报告 (Report on the planning of the construction projects for commemorating the tenth anniversary of the founding of the nation). BMA, 47–1-51.

Zhao Yunge 赵郓哥 (Peng Song 彭松). "*Jianshe zuguo dayangge* zongjie" 建设祖国大秧歌总结 (A summary report of *The Great Yangge of Building the Motherland*). *Xiju xuexi*, no. 1 (April 2, 1950): 6.

Zheng Tianxiang 郑天翔. *Xingcheng jilüe* 行程纪略 (Travel notes). Beijing: Beijing chubanshe, 1994.

Zheng Tianxiang and Tong Zheng 佟铮. "Zhuanjiazu de yixie gebie fanying (1)" 专家组的一些个别反映(一) (Some individual reactions of the team of experts [no. 1]). BMA, 151–1-6.

Zhonggong Beijing shiwei 中共北京市委. "Bao song gaijian yu kuojian Beijingshi guihua cao'an he guihua caotu" 报送改建与扩建北京市规划草案和规划草图 (Draft plans and maps on the reconstruction and expansion of the city of Beijing). BMA, 1–5-90.

———. "Gaijian yu kuojian Beijingshi guihua cao'an de yaodian" 改建与扩建北京市规划草案的要点 (Main points of the draft on reconstructing and expanding the city of Beijing). BMA, 1–5-90.

———. "Zhonggong Beijing shiwei guanyu jinian guoqing shizhounian de choujian qingkuang he wenti de baogao" 中共北京市委关于纪念国庆十周年的筹建情况和问题的报告 (The Beijing Municipal Party's report on the preparation and problems encountered relating to the construction work for the commemoration of the tenth anniversary of National Day). BMA, 125–1-1254.

———. "Zhonggong Beijing shiwei guanyu jinian guoqing shizhounian gongcheng de choujian qingkuang he wenti de baogao" 中共北京市委关于纪念国庆十周年工程的筹建情况和问题的报告 (The Beijing Municipal Party's report on the preparation and problems encountered relating to the construction work for the commemoration of the tenth anniversary of National Day). BMA, 47–1-60.

———. "Zhongyang" 中央 ([A letter to] the Central Committee [of the Chinese Communist Party]). BMA, 2–7-57.

Zhonggong Beijing shiwei xuanchuanbu 中共北京市委宣传部. "Beijingshi gongren jiaoyu gongzuo baogao" 北京市工人教育工作报告 (Report on the education of the workers in the City of Beijing). BMA, 1–12-9.

——. "Fandui Mei-Chiang tiaoyue xuanchuan yundong qingkuang jianbao, diyihao" 反对美蒋条约宣传运动情况简报,第一号) (A brief report on the propaganda works to oppose the U.S.-Chiang treaty, issue no. 1). BMA, 1–12-175.

——. "Zai puji shenru Kang Mei Yuan Chao yundong zhong zuzhi qunzhong jiji fenzi de xuanchuan duiwu" 在普及深入抗美援朝运动中组织群众积极分子的宣传队伍 (To organize active propaganda teams among the masses during the popularization and deepening of the Resist America, Aid Korea Campaign). BMA, 1–12-80.

"Zhonggong Qida daibiao ji Yan'an renmin daibiao dui Zhongguo geming sinan lieshi de jiwen" 中共七大代表暨延安人民代表对中国革命死难烈士的祭文 (A eulogy on the revolutionary martyrs by the representatives of the Seventh Congress of the Chinese Communist Party and of the Yan'an people." In *Zhonggong zhongyang wenjian xuanji* 中共中央文件选集 (Selected documents of the Chinese Communist Party Central Committee), edited by Zhongyang dang'anguan 中央档案馆. Vol. 15. Beijing: Zhonggong zhongyang dangxiao chubanshe, 1991.

Zhonggong shijian yigongsi weiyuanhui 中共市建一公司委员会. "Renda gongcheng qingkuang jianbao (no. 78)" 人大工程情况简报(78) (A brief report on the construction of the Great Hall of the People, no. 78). BMA, 125–1-1226.

Zhongguo geming bowuguan wushinian 中国革命博物馆五十年 (Fifty years of the Museum of the Chinese Revolution). Edited by Zhongguo geming bowuguan wushinian bianweihui中国革命博物馆50年编委会. Shenzhen: Haitian chubanshe, 2001.

"Zhongguo geming he Zhongguo lishi bowuguan gongcheng de jiben qingkuang" 中国革命和中国历史博物馆工程的基本情况 (Basic conditions concerning the construction of the Museums of the Chinese Revolution and of Chinese History). BMA, 2–11-138.

"Zhongguo geming, lishi bowuguan gongcheng jiben zongjie" 中国革命、历史博物馆工程基本总结 (A summary of the construction work of the Museum of the Chinese Revolution and the Museum of Chinese History). BMA, 47–1-90.

Zhongguo Guomindang zhongyang zhixing weiyuanhui jianzhu zhenwang jiangshi gongmu choubei weiyuanhui 中国国民党中央执行委员会建筑阵亡将士公墓筹备委员会. *Guomin gemingjun zhenwang jiangshi gongmu luocheng dianli jiniankan* 国民革命军阵亡将士公墓落成典礼纪念刊 (A memorial publication on the Public Cemetery of the Commanders and Soldiers of the National Revolutionary Army). Nanjing: n.p., 1935.

Zhongguo renmin jiefangjun zhanshi 中国人民解放军战史 (The military history of the People's Liberation Army). Edited by Junshi kexueyuan junshi lishi yanjiubu 军事科学院军事历史研究部. Vol. 3. Beijing: Junshi kexue chubanshe, 1987.

Zhonghua quanguo wenxue yishu gongzuozhe daibiao dahui jinian wenji 中华全国文学艺术工作者代表大会纪念文集 (A commemorative volume of the All-China Writers and Artists Congress). Edited by Zhonghua quanguo wenxue yishu gongzuozhe daibiao dahui xuanchuanchu 中华全国文学艺术工作者代表大会宣传处. N.p.: Xinhua shudian, 1950.

Zhonghua renmin gongheguo jianzhu gongchengbu 中华人民共和国建筑工程部.

"Guanyu xuanchuan shoudu yipi xinjian gongcheng wei zhuyi tidao Sulian zhuanjia de bangzhu de baogao" 关于宣传首都一批新建工程未注意提到苏联专家的帮助的报告 (Report on the discounting of Soviet experts' assistance in the propaganda concerning the capital's newly built projects). BMA, 125–1-1254.

"Zhongzhi ge jiguan tongzhi dui Wuyi youxing de yijian" 中直各机关同志对五一游行的意见 (Opinions of the comrades of the central bureaus concerning May Day parades). BMA, 99–1-48.

Zhou Enlai 周恩来. "Zai yinyue wudao zuotanhui shang de jianghua" 在音乐舞蹈座谈会上的讲话 (Talk at the music and dance forum). In *Zhou Enlai lun wenyi* 周恩来论文艺 (Zhou Enlai on literature and art), edited by Wenhuabu wenxue yishu yanjiuyuan 文化部文学艺术研究院. Beijing: Renmin wenxue chubanshe, 1979.

Zhou Naiji 周乃寂. "Jieshao *Zhongguo gongchandang lieshizhuan*" 介绍中国共产党烈士传 (An introduction to *Biographies of the Chinese Communist Martyrs*). *RMRB*, June 17, 1951, 6.

Zhou Yang 周扬. *Zhou Yang wenji* 周扬文集 (Collected writings of Zhou Yang). 4 vols. Beijing: Renmin wenxue chubanshe, 1984–91.

"Zhou zongli dui Shigeweihui guanyu yijiuqiernian Wuyijie qingzhu huodong de qingshi de pishi" 周总理对市革委会关于一九七二年五一节庆祝活动的请示的批示 (Premier Zhou's decision on the petition submitted by the Beijing Municipal Revolutionary Committee concerning the 1972 May Day celebratory activities). BMA, 99–1-784.

Zhu Di 朱狄. "Guangming zai qian" 光明在前 (The future is bright). *MS*, no. 4 (August 6, 1961): 25–27.

——. "Tan lishi ticai de meishu chuangzuo" 谈历史题材的美术创作 (On historical topics in art). *MS*, no, 3 (June 6, 1961): 41–46.

"Zhu Zhaoxue, Zhao Dongri dui shoudu jianshe jihua de yijian" 朱兆雪、赵冬日对首都建设计划的意见 (Zhu Zhaoxue and Zhao Dongri's opinions on the design of the capital). In *Jianguo yilai de Beijing chengshi jianshe ziliao* 建国以来的北京城市建设资料 (Materials on the construction of the city of Beijing since the founding of the nation). Vol. 1, *Chengshi guihua* 城市规划 (City planning), edited by Beijing jianshe shishu bianji weiyuanhui bianjibu 北京建设史书编辑委员会编辑部. Beijing: n.p., 1987.

Zhuangyan de qingdian: Guoqing shoudu qunzhong youxing jishi 庄严的庆典:国庆首都群众游行纪事 (Solemn festivities: Records of the people's parades in the capital during the National Day celebrations). Edited by Zhongguo renmin zhengzhi xieshang huiyi Beijingshi weiyuanhui wenshi ziliao weiyuanhui 中国人民政治协商会议北京市委员会文史资料委员会. Beijing: Beijing chubanshe, 1996.

"Zhuanjia tanhua jiyao (58)" 专家谈话纪要(58) (Notes of the experts' talks [no. 58]). BCCA, 3–7-14.

"Zhuanjia tanhua jiyao (130)" 专家谈话纪要(130) (Notes of the experts' talks [no. 130]). BCCA, 3–7-14.

"Zhuanjia tanhua jiyao (400)" 专家谈话纪要(400) (Notes of the experts' talks [no. 400]). BCCA, 3–7-14.

Zhuravlev, A. M., A. V. Ikonnikov, and A. G. Rochegov. *Arkhitektura Soveskoi Rossii* (Architecture of the Soviet Union). Moscow: Stroiizdat, 1987.

"Zuzhi gongzuo yaodian" 组织工作要点 (Important organizational matters). BMA, 99–1-178.

"Zuzhi qunzhong zai Xi Chang'anjie canguan yuebing, youxing de gongzuo jihua"
组织群众在西长安街参观阅兵、游行的工作计划 (The work plan for organizing
people to view the military parade and the procession along West Chang'an
Avenue). BMA, 99–1-75.

Zuzhishi ziliao, 1949–1992 组织史资料, 1949–1992 (Materials on the history of
organization, 1949–1992). Edited by Beijingshi chengshi guihua guanliju and
Beijingshi chengshi guihua sheji yanjiuyuan dangshi zhengji bangongshi 北京
市城市规划管理局,北京市城市规划设计研究院党史征集办公室. Beijing: n.p.,
1995.

Index

Page numbers in *italics* refer to illustrations.

Abramov, P. V., 30, 31, 37
Adenauer, Konrad, 159
Agulhon, Maurice, 6
Ai Zhongxin, 247
Alberti, Leon Battista, 47
allegory, 159–62, 166–67
Andrews, Julia, 129
Anti-Rightist Campaign, 4, 20, 133, 266, 304n56
Apsit, Aleksandr, 174
architecture: and power, 25, 51; Soviet influence on, 30, 31; Stalin on, 239; traditional Chinese, 54, 67–68, 239. *See also* Ten Monumental Buildings; *specific buildings*
Arendt, Hannah, 18, 207, 261
Ariès, Philippe, 235
art: institutionalization of, 89, 131; and politics, 129, 155, 180–81, 184, 249, 253, 263
Art Museum, proposal for, 56, 59
artists: elitist bent of, 203–4; political agendas and, 180; state and, 19–20, 133–34, 150
Aseev, G. A., 38, 39, 41, 42, 43
authoritarian rule: masses under, 261; propaganda and, 18–19, 266–67

Babaoshan Revolutionary Cemetery, 16, 215, 224–32, *225*; controversies surrounding, 231–32; expansion of, 227; political message of, 227, 259; reburials at, 229–31; rules for burial at, 226–27; tomb of Ren Bishi at, 228–29, *229*

Baksheev, Vasily, 149
Bao Jia, *A Great Victory in Huai-Hai*, 139, *140–41*, 141–42, 148
Baragin, D. D., 37, 38, 42, 43
Barannikov, M. G., 30, 37, 39
Barrett, David, 172
Beijing (Beiping): Communist takeover of, 8–9, 25, 92–93, 111, 158, 260; debate over reconstruction of, 26–31; demolition in, 35–36, *36*, 44–45, 57; dominating role of, 71–72; festivals in, 11, 94–95; Liang-Chen reconstruction proposal for, 27–29, *28–29*, 30–31; in Ming and Qing dynasties, 32; museums in, 112; Soviet influence and, 30, 31, 36–41, *39*; streets in, 43–44, 45; Zhu-Zhao reconstruction proposal for, 29–30. *See also* Tiananmen Square; *specific buildings*
Beijing Municipal Party: and city planning, 31, 33, 37; and parades, 11, 103, 104; on Unity Sect, 172; and *yangge* dance, 78
Beijing Railway Station, 68, 70; location of, *53*, 71; proposal for, 56, 59, 60
Ben-Amos, Avner, 229
Berlin: antiwar monument in, 232; Nazi plan for reconstruction of, 51, 66
Bo Songnian, 204
Bo Yibo, 119
Bodde, Derk, 77, 88, 92, 265
Boldyrev, S. A., 31, 38, 39–40, 41, 42, 44
Bonnell, Victoria, 149
Boucher, Jean, 247, 248
Bourdieu, Pierre, 98, 179, 201
Boxer Uprising, 120, 122, 244–46
Burke, Peter, 179

martyrs in, 216; slogans during, 99,
100; *yangge* during, 79
Krylov, Porfiri, 148
Kukryniksy, The, 148, 157, 165, 178
Kupriyanov, Mikhail, 148

landlords, campaign against, 174–76, *175*,
178
language, manipulation of, 266; Com-
munists and, 2; Mao Zedong and, 1–2,
5, 117, 258; in *nianhua*, 203; in parades,
98–100; Ten Monumental Buildings
and, 57–58
Lasswell, Harold, 51
Le Bon, Gustave, 261–62
Le Goff, Jacques, 200
Lenin, Vladimir: and architecture, 25;
and commemoration, 215; contribution
to Marxism, 260; funeral arrange-
ments for, 229; mausoleum for, 40, 49,
227; museums honoring, 114–15, 130;
portraits of, 98, 101, 145
Levine, Steven, 3
Li Dazhao: biography of, 220; followers of,
230; memorial service for, 217; museum
exhibits on, 111, 122, 123; tomb of, 232
Li Fuchun, 125
Li Hanzhang, 171
Li Keran, 204
Li Zhun, 38, 273n18
Li Zongren, 167
Liang Qichao, 27
Liang Sicheng, 27, 265; Beijing recon-
struction proposal by, 27–29, *28–29*,
30–31; on Great Hall design, 64–65;
and Monument to the People's Heroes,
238–40, 254; and National Day proj-
ects, 57; preservation efforts of, 44–45;
Soviet proposals and, 37, 38, 44; tomb
designed by, 228; and traditional archi-
tecture, 54, 67; vs. Zhao Dongri, 64–65
lianhuanhua (serial picture stories),
157–58, 259; capitalists depicted in, 174,
175; cartoons compared to, 169–70;
landlords depicted in, 174–76, *175*;
native traditions in, 179; and oil paint-
ings, 130, 157; popularity of, 179, 180;
and propaganda, 14, 169–70, *170–71*;
religious sects depicted in, 172–73
Liao Bingxiong, 178

Liberation Daily (newspaper), 156, 169
Lieberthal, Kenneth, 4, 125
Lin Biao, 92, 124, 125
Lin Boqu, 127, *128*, 129
Lin Gang, *Zhao Guilan at the Heroes'
Reception, 199*, 199–200
Lin Huiyin, 27, 239
Lin Xiangqian, 221, 222, 244; tomb of, 232
Lin Zexu, 122, 243, 249, 252
Liu Bocheng, 104
Liu Chunhua, 151
Liu Hulan, 116
Liu Jiyou: *Little Heroes Arrest a Spy, 170,*
170–71; *Master Dongguo,* 179
Liu Kaiqu, 240, 246, 247, 249, 253; *The
Yangzi Crossing, 248, 248,* 251, *251*
Liu Ren, 45, 63; and parade organization,
92, 104; and Ten Monumental Build-
ings, 65, 67
Liu Shaoqi, 98, 125; eulogy for Ren Bishi,
228; paintings depicting, 127, 128, *128,*
129, 145–46, *146,* 150–51, 297n45
Liu Xiaoshi, 70
Liu Xiqi, *China, My Motherland!,* 208–9,
209
Liu Zhidan, 220
Lord, Albert, 87
Low, David, 156
Lu Dingyi, 19, 116, 118, 119, 179, 230, 260,
261
Lu Xun, 176
Luo Cheng, *Defend Our Motherland!
Protect Peace!,* 190–92, *191,* 203
Luo Gongliu, 124, 130, 132, 150; *Behind the
Fallen Are Endless Successors,* 135–36,
136, 138–39; influences on, 135, 291n42;
The Rectification Report, 130, 133
Luo Jianmin, 48–49
Luo Ronghuan, 92
Luo Shengjiao, 216
Lutyens, Edwin, 232

MacArthur, Douglas: in cartoons, 159,
162, 162–63, 180; in *yangge,* 90
MacFarquhar, Roderick, 125
Maillol, Aristide, 247, 249
Maksimov, Konstantin, 131–32, 134,
144–45
Mao Zedong: alleged plot to kill, 102–3,
172; on art as political tool, 155, 184, 263;